A CENTURY OF CERAMICS
IN THE UNITED STATES
1878–1978

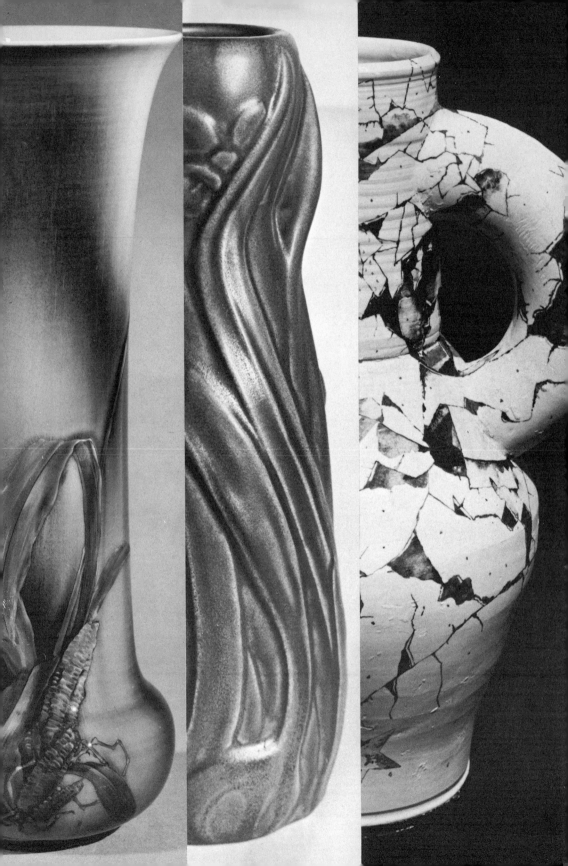

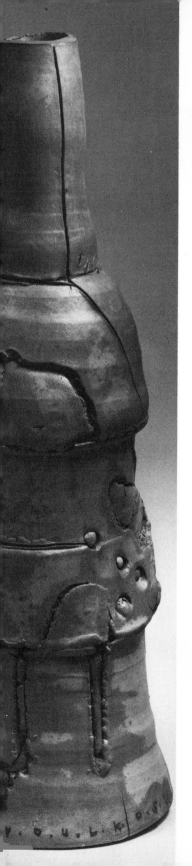

A CENTURY OF
CERAMICS
IN THE UNITED STATES
1878 – 1978

A STUDY OF ITS DEVELOPMENT

GARTH CLARK

FOREWORD BY RONALD A. KUCHTA

PREFACE BY MARGIE HUGHTO

NEW YORK

E.P. DUTTON

IN ASSOCIATION WITH

THE EVERSON MUSEUM OF ART

For information contact: E. P. Dutton, 2 Park Avenue, New York, N.Y. 10016

Library of Congress Catalog Card Number: 78-73341

ISBN: 0-525-07820-7 (cloth) 0-525-47574-5 (DP)

Published simultaneously in Canada by Clarke, Irwin & Company Limited, Toronto and Vancouver

10 9 8 7 6 5 4 3 2 1

First Edition

Published in conjunction with the exhibition "A Century of Ceramics in the United States 1878–1978" at the Everson Museum of Art, Syracuse, New York, May 5–September 23, 1979. It will also be at the Renwick Gallery of the National Collection of Fine Arts, Smithsonian Institution, Washington, D.C., November 9, 1979–January 27, 1980. An exhibition curated by Margie Hughto and Garth Clark. The exhibition is supported by a grant from the National Endowment for the Arts in Washington, D.C., and the New York State Council on the Arts.

The generous support of Philip Morris Incorporated and Miller Brewing Company for this exhibition is gratefully appreciated.

Acknowledgments

Ronald A. Kuchta, Director of the Everson Museum of Art since 1974, has repeatedly stressed the importance of ceramic art in Syracuse, and the continuation of the Everson's long involvement and commitment to the medium. We should like to thank Mr. Kuchta and the Trustees of the Everson Museum for their support, encouragement and confidence.

Without the help of Lynne Wagner, Mary Kay Goertz, Cathy Anderson, Linda Steigleder, and Charles E. Blitman, this exhibition and its book would not have materialized.

We are most grateful to all the artists and lenders who were so kind, gracious, patient, and helpful to us in conjunction with our research, photography, and travel. Conversations with Martin Eidelberg, Carol Macht, Fred Marer, Jan Nadelman, Jean and Robert Pfannebecker, Viktor Schreckengost, and Estelle and Martin Shack, and many of the lenders to the exhibition have been of great help and interest.

We should like to thank the following people for their cooperation in supplying material for the book: Sheila Alexander, Nolan Babin, Mel Bernstein, Todd Bogatay, Rena Bransten, Ruth Braunstein, Sylvia Brown, Thomas Brunk, Jane Clark, Joanna Dobson, Christine Droll, Helen Drutt, Anita Duquette, Edris Eckhardt, Charles Fiske, Viola Frey, Diana Fuller, Don Frith, Cleota Gabriel, Bea Garvin, Mack L. Graham, Tony Hepburn, Doug Humble, Janet Jainschigg, Kay Koeninger, W. G. Lawrence, Ed LeBow, Rebecca Lenchak, Sharon Leonard, Elaine Levin, John H. Lindenbusch, Debby Long, Richard Marshall, Michael McTwiggen, Rose Prinz, Myron and Joan Pyker, Janelle Reiring, Mary Riordan, Frances G. Safford, George Scherma, Judith S. Schwartz, Anne Snortum, Lynn E. Springer, Doris

and Rudi Staffel, Suzanne and John Stephenson, Kenneth Trapp, Suzanne Vanderwood, Virginia Voedisch, Todd Volpe, Kurt Weiser, and Nancy and James Yaw.

A special thank you is due to Cyril Nelson, Julie McGown, and Mell Cohen of E. P. Dutton for guiding this book to completion. Without their advice, support, and unflagging energy this volume could not have been completed in time.

A special debt is owed to the entire staff of Everson. Marina Lary Walker, Registrar, did an incredible job with the arrangements in the lending, packing, and shipping of the works, and Anthony Murrell, Preparator, in his designing and installing of these numerous and varied works of art.

We wish to thank James Melchert and Eudorah Moore at the National Endowment for the Arts for their advice and support. The Endowment's generosity contributed greatly toward making this exhibition possible. Thanks also to the New York State Council on the Arts, which likewise contributed toward the exhibition. Finally, we wish to thank Philip Morris Incorporated and Miller Brewing Company for their generous support for the exhibition.

CONTENTS

FOREWORD: *A Century of American Clay by Ronald A. Kuchta* ix

PREFACE *by Margie Hughto* xi

CHRONOLOGY xxi

INTRODUCTION 1

1878-1889 5
1890 19
1900 43
1910 67
1920 79
1930 93
1940 113
1950 129
1960 157
1970 195

NOTES 259

BIOGRAPHIES 269

BIBLIOGRAPHY 345

INDEX 363

Color plates follow page 156

Look at what our American ceramists have been doing. Springing out of our hardy native soil is a dynamic art form. Potters, craftsmen, ceramic artists—whatever one chooses to call them—are exploring clay for new characteristics and potentials, probing for new forms and images. In the process, and influenced by modern painting and sculpture, they are creating some of the country's most innovative and exciting art.

For the first time a comprehensive and dazzling review of this development has been documented. "A Century of Ceramics in the United States 1878–1978" is a show presenting America's bracing ingenuity and creative spirit and it reflects the impressive array of styles, approaches, and techniques in this one medium.

Philip Morris Incorporated and Miller Brewing Company are pleased to be able to participate in the presentation of this watershed exhibition, which has been brilliantly organized by the Everson Museum of Art.

Our support is prompted in good measure by the rich experiences we have enjoyed as a corporate sponsor of major exhibitions dealing with the art and culture of American Indians, blacks, and our frontier West, as well as landmark exhibitions of American folk art and the art of photography.

In tracing the history of ceramics since the pivotal 1876 Philadelphia Centennial Exposition we simultaneously gain a richer understanding of our cultural legacy and those who shaped it.

George Weissman
Chairman of the Board
Philip Morris Incorporated

FOREWORD
A Century of American Clay

Syracuse, New York, has been synonymous with ceramics for many artists, craftsmen, and collectors, and the Everson Museum of Art has continually helped to promote this reputation over the years. Early nineteenth-century stoneware was produced in this region, and Onondaga Pottery and Syracuse China Corporation continued the industrial ceramic tradition. Prominent art potters such as Adelaide Robineau and R. Guy Cowan made Syracuse their home, and the Everson (then the Syracuse Museum of Fine Arts), in terms of its collections and exhibitions, has emphasized ceramics since its acquisitions of the Robineau Collection and the Davidson Collection early in this century. The Ceramic National Exhibitions from the early 1930s through the early 1970s provided a catalyst for studio potters in America and even for some ceramists abroad (for example, Europe, South America).

This hundred-year history of American ceramics is perhaps the most ambitious exhibition the Everson has ever mounted in this field. It is hoped that it will serve to focus attention on an art form too long in the penumbra of the artistic showcase and will encourage much needed criticism, perspective, and appreciation.

Acknowledgment of the dedication, efficiency, and thoroughgoing absorption with the subject and compilation of information on the part of our two guest curators must be made. Margie Hughto and Garth Clark have formed an inspiring team on this project, and it is certainly because of their hard work and brilliance that this book and the large exhibition that accompanies it have been accomplished.

<div align="right">

Ronald A. Kuchta
Director, Everson Museum of Art

</div>

August 1978

PREFACE

The history of American ceramics from the celebration of the Centennial (1876) to the present day is rich, varied, and relatively undocumented. It is a period studded with men and women of genius, uncompromising ethical standards, and engaging eccentricity. The purpose of this exhibition and book is to present the history of American ceramics, its aesthetic and its influence, and so provide a perspective. Comprised of over 400 pieces—unique and inspired works—ranging from vases to monumental sculpture, the exhibition and book span one hundred years of creative endeavor. In the decade-by-decade presentation, a variety of styles, philosophies, and techniques of ceramic artists is shown. This is the first study focusing on the role of ceramics in the modern, decorative and fine arts of the United States.

In this preface I wish to concentrate on three specific topics. These are the Everson Museum's role in American ceramics and the museum's decision to mount this exhibition; the curating, organizing, presenting, and installing of the exhibition; and, finally, a discussion about the medium of clay itself and the ceramic artist.

The Everson Museum of Art has a long and proud history in American ceramics, and it is only fitting that this exhibition be organized in Syracuse. The museum has a permanent collection of contemporary American ceramics that numbers over 500 pieces and reflects both the history and development of ceramic art in the United States during the 1900s. It is a collection of great diversity and vitality: delicate porcelains, large, textured, and decorated wheel-thrown stoneware pieces, and significant works of clay sculpture. It has been an extremely rewarding experience for me to have worked with this collection since 1971 and to have come to know it so intimately.

For nearly half a century, international attention has been attracted to Syracuse by the Everson Museum's series of National and International Ceramic Exhibitions. A memorial to the celebrated Syracuse ceramist Adelaide Alsop Robineau (1865–1929), the Ceramic National, was inaugurated by Anna Wetherill Olmsted, director of the museum (then the Syracuse Museum of Fine Arts) from 1931 to 1957. Due in large part to her foresight and the vision of ceramist R. Guy Cowan, Everson's large collection of modern ceramics was acquired through the National shows. The competitive, juried, Everson-sponsored Ceramic National Exhibitions were held from 1932 to 1972 and were important because they established a national showplace for exhibiting work of both major ceramic artists and new talents. These Nationals presented each new thrust, were a reflection of the most visible ceramics of the time, and were a source of inspiration to the artists, as well as an opportunity for the American public to see some of the very best clay. They were always large exhibitions, consisting usually of 300 to 600 works. When these shows toured, they were booked by many museums, including the Boston Museum of Fine Arts, The Metropolitan Museum of Art, the Whitney Museum of American Art, the Philadelphia Museum of Art, Cleveland Museum of Art, The Detroit Institute of Arts, the Los Angeles County Museum of Art, and the San Francisco Museum of Art. Support for the shows came primarily from twenty ceramic companies.

In the foreword to the catalogue for the Fifth Ceramic National Exhibition (1936), Anna Wetherill Olmsted quoted Mr. William M. Milliken, Director of the Cleveland Museum of Art, "America has never before had so comprehensive a ceramic exhibition giving a most vivid statement of what America is accomplishing today in the Ceramic Field." In the foreword to the catalogue for the Eighth Ceramic National Exhibition (1939), Dorothy Liebes, Chairman of the Jury, wrote,

> There is less of the European tradition appearing in this field of American art and craftsmanship, and more feeling for the imaginative possibilities of this most ancient of arts. The National Ceramic Exhibition is perhaps the most unselfconscious art exhibition in American art at present. For without propaganda ceramists are devoting themselves to the essentials of form, color and texture, and their work, both utilitarian and non-utilitarian, is a personal expression.

By 1941, selections from the national exhibitions had been shown throughout the United States in forty-two cities, twenty-two states, and, by invitation, in four countries abroad. The Tenth Ceramic National was titled

"Contemporary Ceramics of the Western Hemisphere." Richard F. Bach, Dean of Education and Extension at The Metropolitan Museum of Art, wrote the foreword to its catalogue. In part, he said,

> This year, the Tenth Ceramic National further extends territory—an all-American collection, including Latin-American and Canadian examples —and a staggering total of over fourteen hundred pieces. At Syracuse and in these exhibitions ceramic artists and craftsmen have found not only a place of meeting, perhaps of contest, for their talents, but also fair judgment, under favorable auspices, of their craftsmanship and design —a point of concentration and a gauge of quality.

The Twentieth Ceramic show in 1958 consisted of 532 pieces and was an international presentation. Ceramist and painter Henry Varnum Poor wrote in the foreword to that catalogue,

> The ten European groups are well selected and are relatively small, which in showing will give them a much more single impact than the larger more sprawling American group . . . The vision and ambition of these groups is fine to see. It expresses itself in imaginative and spiritual freshness, while the ambitious American work too often expresses itself in size and complexity. But the American potters have nothing to be ashamed of. Their work holds its own technically, and probably a European would sense its national flavor more strongly than we do who are of it.

A fellowship of artists in clay grew around the Ceramic National Exhibitions, which met annually in Syracuse. This fellowship proved to be a great stimulus to the individual artists throughout the country. Several artists, including Peter Voulkos, Paul Soldner, and Rudi Staffel, told me how important the Syracuse Ceramic National had been in their careers, particularly as a means of gaining recognition. As in all things, time brings change. In 1972, after a forty-year existence, the Ceramic National Exhibition had become too vast. In the earlier years, there were only a few hundred artists working in clay. By the 1970s there were thousands of ceramic artists of varying talent and persuasions making thousands of pieces. With these numbers, the logistics and financing of a juried national show became impossible. In 1974, the Director and staff of Everson decided to change the format of future ceramic exhibitions and, instead, to organize shows with a particular focus. These would be shows of a historical nature, innovative exhibitions, one-person or small group shows, but, specifically, shows that would present special insight into and recognition of ceramic artists and their work. "A

Century of Ceramics in the United States: 1878–1978" is an exhibition that has evolved from this approach.

One of the questions I am frequently asked is how was it that Garth and I came to work together and curate this show. This should be explained because an exhibition is, of course, a reflection of those who put it together. It is their ideas, their judgments, their knowledge, and their tastes that provide the quality and type of exhibition. I am sure that if two other people had been responsible for a similar exhibition, it might have been quite different. Garth and I became the curators for this exhibition because of our common interest in modern ceramics and concern over the lack of historical scholarship and critical aesthetic standards. We had both been working with and researching contemporary American clay during the last few years and became deeply involved with it. We strongly felt that it was time for a formal presentation of modern ceramic art in the United States.

Initially, I received a letter from Garth late in 1975 stating that he was writing a book titled *Modern Ceramic Art*, to be published by Thames and Hudson in London. He had heard about the exhibition "New Works in Clay by Contemporary Painters and Sculptors," which I had organized, and asked me to send him a catalogue and photographs and all the information I had on the show and project. We finally met in February 1977 when he came to Everson to lecture on modern ceramics for two days. We spent some time looking at the Everson's ceramic collection and I told him about plans for this historic clay show. He said he would be interested in helping. In June he spent a week in Syracuse becoming familiar with the Everson collection, and we discussed further plans for this exhibition. In early July, I attended his five-day lecture series on twentieth-century ceramic art, "Palette of Fire," at Bennington College in Vermont, and we again discussed aspects of this exhibition. Originally, Garth had plans to write a book of his own on twentieth-century American ceramics, but instead he accepted the invitation to be co-curator for this show. In addition he made all the material and photographs from his research available and agreed to work on the catalogue. I am pleased and feel fortunate to have had Garth Clark working with me on this exhibition. I think we complement each other in terms of our ceramic knowledge, backgrounds and experience, and have formed a good team.

Garth Clark is an art historian, critic, lecturer, collector of modern ceramic art, and author of several excellent books. He has traveled throughout Europe and the United States visiting museums, galleries, ceramists, and collectors—looking, listening, writing, documenting, and discussing. Last

year, through the American Crafts Council, he lectured at many schools and museums all over America. This year he will do some teaching in California and continue traveling, lecturing, and conducting an occasional workshop.

As curators, our guiding principle in determining which artists would be included in the exhibition "A Century of Ceramics in the United States: 1878–1978" has been the extent to which their work has commanded critical attention or deflected the course of ceramic art. We chose works of quality and stature by those artists who, in our opinion, posited the major problems and solutions in the contemporary ceramic tradition. A safer and more classical show could have been mounted that was devoted to the works of the giants (such as Robineau, Ohr, Grotell, Lukens, Arneson, and Voulkos) alone. But there is a rich history in American clay that we wanted to re-create so that it might be better understood and recognized. We made no distinction between those who had worked in clay many years versus those who had worked for only a short period of time. There is only the unifying material of clay and artistic inspiration. The exhibition was planned in an open spirit from the standpoint of both the historian and the connoisseur. In a way, the show selected itself when Garth and I made the decision to present the show as a decade-by-decade narrative history. We felt this would allow people viewing the show to see more clearly the developments, the emphasis, and to measure the quality of the works. By taking this approach there were artists who had to be included because of their particular importance in a decade. We tried to balance the geographic spread, as well as the number of pieces in each decade.

The 1970s were especially difficult because artists who were well known for successful work in earlier decades are currently extending their visions and reputations into the present with some of their best work. Invariably artists want to feature their most recent work. It is understandable that as they change and develop they naturally feel closest to their most recent styles. In these cases, we tried to show a recent work. Then there were new or younger artists who also needed to be included, so the 1970s have at least twice the number of pieces of any other decade. In terms of younger artists, Garth and I tried to adhere to a given that the artist must have been graduated from school by 1972 and working and exhibiting for at least the last six years. In a show as broad as this one, we had to set a limit of two to six pieces for the work of most of the artists being shown. This cannot possibly show the full range of an individual's abilities and art work.

I should like to make a note here that given more time, or the opportunity to look back and reevaluate, there would have been other artists and

more pieces. There are many artists of quality who have not been included in the exhibition. All I can offer is that, with the time and money allotted, a curator must do the best he or she can do at that time.

Finally—the ceramic artist and the ceramic medium itself. Many ceramists working today know very little about their roots, and I was no exception. It was, therefore, a great pleasure to discover and, in some cases, meet the outstanding ceramic artists of both the past and the present and become so familiar with their work. Many of the figures are women. There are women who have made contributions at many levels, including the making of ceramic art, writing about ceramics, and promotion of ceramics. Some were involved in all three aspects. At first I had mixed feelings about being an artist and also writing and curating, but having discovered these women, it seems to be very much in the American ceramic tradition. Not that one can do all these things all the time but there are moments when one can reach out in several directions to become enriched and/or make a contribution to the field.

Interestingly enough, in almost every decade, there were articles about how ceramics was finally coming into its own. I had felt that the 1970s had been a rather explosive period, yet when I read articles, in particular one published in 1952 concerning the "ceramic explosion," I realized how many artists had been working in clay in these last decades and some of the recognition the medium had indeed received in past years. In every decade, there was a discussion of "is it art—or craft?" And this debate is still going on in the 1970s, although I think to a much lesser extent. This is a time when we are more open and flexible about what art can be made of—and just because it is made of clay does not mean it isn't art.

In his book *Pioneer Pottery*, Michael Cardew says that the difference between a craftsman and an artist consists not in the material he uses or the class of goods he produces, but in the kind of work he does. In 1951, André Malraux wrote *Les Voix du Silence*. "I call that man an artist who creates forms . . . I call that man a craftsman who reproduces forms, however great may be the charm of his craftsmanship . . . Painters and sculptors whenever they were great transfigured the forms they had inherited. . . ."

There is still a realm of the unknown in terms of judging the quality of ceramics. The number of ceramists working continues to expand, yet the criticism evaluating the work does not. But I do think we could say that in the 1970s ceramics is being accepted in our culture on a scale that even its most devoted champions of an earlier day might have hesitated to predict. We see the evidence of this progress in several areas. Museums and galleries

once restricted to painting and sculpture and the allied arts of drawing and printmaking now accord ceramics a place in both their exhibition schedules and their acquisition budgets. There are books in lavish profusion, especially the how-to-make-it type, and there seems to be no end to the courses, workshops, and conferences currently available. The art market, too, has responded to this development. The prices of early ceramic pieces (turn-of-the-century art pottery) and certain ceramic works by contemporary figures continue to soar. Just a few years ago one could attend a flea market and get a piece of art pottery for less than $20. Today that same piece (now more difficult to find) would probably bring many times that amount. Functional ceramists producing some of the best work and getting under $100 for an exceptional bowl or casserole just two years ago are now getting triple that amount for a similar piece. Such increases represent not inflation but a recognition and appreciation for the art. Those doing exceptional ceramic sculpture receive prices comparable to sculptors working in steel, fiber glass, etc. Clearly, the sheer interest in ceramics is now both intense and widespread.

In our travels and research, it was interesting to note how ceramics were treated, categorized, and presented in both exhibitions and museum collections. Ceramics could be listed under sculpture, crafts, or decorative arts; it could be in its own department, the crafts department, the contemporary arts department, or simply under American art. I feel that a large part of this variation and confusion originates with the way ceramics has evolved as well as the many varying approaches to making both objects and art with clay. There are no final solutions, either.

In a presentation such as this exhibition and book, it seems only fitting that there be some dialogue about the material of clay itself. It can even be said that its inherent qualities and history are directly responsible for the confusion of category and also the art made with it. The romance and seductiveness of the ceramic medium are fascinating. One hears its qualities described as expressive, sensuous, immediate, flexible, responsive, intimate, and earthy.

In her book, *Pottery: Form and Expression*, Marguerite Wildenhain says this about clay:

> The material . . . is a dangerous and elusive substance . . . It is the
> ground on which we tread and is the bottom of oceans, but it can be
> pressed, coiled, pinched, thrown on the wheel, cast or jiggered into any
> form imaginable. It can be made to look smooth as butter or gritty as
> coarse gravel; it can be polished to a glossy sheen, or remain dull and

earthy. It can be liquid, viscose, malleable, plastic, or hard as rock; it can be translucent and delicately fragile, or be refractory and withstand extreme pressure and heat. One can fire it at a low temperature with camel-dung or buffalo chips . . . or pass it through the highest degrees of heat . . . One can cover it with slips and glazes in all colors of the rainbow; . . . One can use brush, slip tracer . . . or scratch . . . drill, engrave, polish and sandblast it. It can be made to look like almost any other material that exists. . . .

When one is working with clay, it is easy to think in terms of *time, earth, fire.* I remember coming across articles titled "Trial by Fire" and "In Defense of Fire." The painter Paul Gauguin worked with the ceramic medium. In some of his correspondence, he spoke about its being "passed through the hell" of firing; in later letters, he talked of the pot surviving the firing, as a man burned to death in the fires of Hades is purged and reborn. Playing with fire, giving the work to fire, is a definite fascination when working with the medium. The clay is always open to a certain amount of accident and quality of the unknown. There is the possibility of flame pattern, warping, cracking, and slumping. This accidental quality is not necessarily something to be avoided. All the science and technical aspects connected with the clay medium can fill many books. Again, there is no one way. There is earthenware, stoneware, porcelain, low-fire, high-fire, shiny, mat, and glazed versus the naked clay surface. The involvement with glazes is endless. Types of firing —gas, electric, wood, reduction, oxidation, raku, salt—all contribute particular qualities and results. It all comes down to whether you as an artist have something to say and whether you will somehow be able to convey it in the vehicle, material, and technique most appropriate.

This exhibition reflects almost every possible type of involvement by ceramic artists and there is no doubt that one has to be amazed at the possibilities and varieties of the ceramic medium.

The text written by my co-curator Garth Clark provides a scholarly presentation of the development of ceramics in the United States from 1878 to 1978. We have tried to be as accurate as possible in all the information, which was not always easy. Not much has actually been documented about many American ceramists, even simple facts like birth and death dates. We had to go to historical societies or seek out people who knew so-and-so in order to verify some of the information. Much about the earlier decades has been literally buried. American ceramics has had few perceptive observers of and commentators on the subject. There have been few to recog-

nize the achievements and to locate them in terms of their uniqueness and their place in tradition. Because of the scope of the exhibition, some of the historical background could be dealt with only in broad and general terms, with capsule coverage on the particular works in the exhibition and concise biographies on the artists. Garth has enhanced the understanding of the art through the use of quotations from documents, articles, photographs, and other archival resources to substantiate this narrative history of American ceramics. We hope the material will serve as a reference for the study of the subject. An extensive bibliography has also been included to assist students and all others interested in modern American ceramics.

I should like to comment on the great amount of information and material we found while doing the research for this show covering one hundred years. Many of the artists in the show deserve a whole book just on their works alone. The same applies to some of the decades and movements. In the future, perhaps, some of these books and exhibitions will come to be, and this book and exhibition will have opened the door and served as a beginning.

Margie Hughto

November 1978

CHRONOLOGY

1876 Centennial Exposition in Philadelphia, Pennsylvania.

1878 The first successful underglaze slip-painted ware produced by Mary Louise McLaughlin.

1879 The Cincinnati (Ohio) Pottery Club formed.

McLaughlin receives an Honorable Mention for her wares at the Paris Exposition Universelle.

1880 The Cincinnati Pottery Club holds the First Annual Reception and Exhibition at the Frederick Dallas Pottery.

Maria Longworth Nichols (later Mrs. Bellamy Storer) founds the Rookwood Pottery in Cincinnati, Ohio.

McLaughlin publishes her Cincinnati Limoges technique in the handbook *Pottery Decoration Under the Glaze.*

1881 International Cotton Exposition, Atlanta, Georgia.

The Rookwood School for Pottery Decoration is opened in Cincinnati.

1882 Oscar Wilde visits Rookwood Pottery.

1883 Laura Anne Fry adapts the atomizer to apply colored slips to greenware.

1884 Cotton Centennial Exposition, New Orleans, Louisiana.

Rookwood Pottery discovers the tiger's-eye glaze.

1887 Porcelain and Pottery Exhibition, Philadelphia, sponsored by the Pennsylvania Museum and School of Industrial Art. Rookwood wins two first prizes.

Kataro Shirayamadani joins Rookwood Pottery.

Rookwood wins Special Mention at the 12th Annual Exhibition of Painting on China, London.

1889 Rookwood Pottery is awarded a Gold Medal at the Exposition Universelle in Paris. McLaughlin receives a Silver Medal for china painting.

1890 10th and Last Annual Reception and Exhibition of the Pottery Club, Cincinnati.

1892 Susan Frackelton forms the National League of Mineral Painters.

1893 World's Columbian Exposition,

Chicago, Illinois. Rookwood receives the Highest Award.

Edwin Atlee Barber's *Pottery and Porcelain of the United States* is published.

Ceramic Congress held in Chicago, Illinois.

1894 Ohio State University, Columbus, opens the first school of ceramics in the country, directed by Edward Orton, Jr.

1895 Newcomb Pottery is founded in New Orleans, Louisiana.

Cotton States and International Exposition, Atlanta, Georgia.

1897 William Grueby produces the first mat glazes.

1899 American Ceramic Society founded.

Keramik Studio is published, with Adelaide Robineau as editor.

1900 Paris, Exposition Universelle. Rookwood and Grueby win honors.

New York School of Clayworking and Ceramics, Alfred, New York, is founded under the direction of Charles Fergus Binns.

1901 Pan-American Exposition, Buffalo, New York.

Artus Van Briggle commences commercial production in Colorado Springs, Colorado.

First issue of the *Craftsman* is published.

1902 New Jersey School of Clayworking and Ceramics opens at Rutgers University, New Brunswick, under the direction of C. W. Parmelee.

1903 Pewabic Pottery founded in Detroit, Michigan.

1904 Louisiana Purchase International Exposition, St. Louis, Missouri.

1910 The School of Ceramic Art is formed at the People's University in University City, a suburb of St. Louis, with Taxile Doat as director.

1911 Turin Exposition, Italy. Robineau wins the highest award, the Grand Prix, for her porcelains as well as the Diploma della Benemerenza.

1915 Panama-Pacific International Exposition, San Francisco, California.

1916 Frederick Rhead publishes the first issue of *The Potter*.

1917 Syracuse University confers the degree of doctor of ceramic sciences on Adelaide Robineau.

1918 First issue of *American Ceramic Society Journal*.

1922 First issue of *The Bulletin of the American Ceramic Society,* Columbus, Ohio.

First issue of *Ceramic Age*.

1923 Henry Varnum Poor holds his first exhibition of ceramics in New York.

1924 *Keramik Studio* becomes *Design-Keramik Studio*.

1925 Paris Exposition Internationale des Arts Décoratifs et Industriels Modernes.

1926 The works of Bernard Leach exhibited in the United States.

1927 The Annual Exhibition of Work by Cleveland Artists and Craftsmen (the May Show) created a new category—Ceramic Sculpture. The first prize awarded to Alexander Blazys.

Maija Grotell immigrates to the United States.

1928 The American Federation of Arts holds the International Exhibi-

tion of Ceramic Art at The Metropolitan Museum of Art, New York.

1929 Adelaide Robineau dies; memorial exhibition held at The Metropolitan Museum of Art, New York.

1932 The First Robineau Memorial Ceramic Exhibition at the Syracuse Museum of Fine Arts, Syracuse, New York.

1933 Federal Art Project of the Works Progress Administration.

1934 Charles Fergus Binns dies.

1935 Memorial exhibition for Binns held at The Metropolitan Museum of Art, New York.

1937 Contemporary American Ceramics Exhibition tours Scandinavia.

1938 Waylande Gregory creates *The Fountain of Atoms* for New York World's Fair, comprising twelve figures, each weighing over a ton.
Contemporary American Ceramics shown at the Whitney Museum of American Art, New York.

1939 World's Fair, New York.
Sam Haile comes to the United States.
Golden Gate International Exposition, San Francisco, California.

1941 First issue of *Craft Horizons*.
Contemporary Ceramics of the Western Hemisphere at Syracuse Museum of Fine Arts, Syracuse, New York.

1948 Sam Haile Memorial Exhibition, Institute for Contemporary Art, Washington, D.C.

1950 Bernard Leach tours the United States and receives the Binns Medal from the American Ceramic Society.

1953 International Ceramics Symposium at Black Mountain School, near Asheville, North Carolina, with Bernard Leach, Shoji Hamada, Soetsu Yanagi, and Marguerite Wildenhain.
First issue of *Ceramics Monthly*.

1954 Peter Voulkos joins the Los Angeles County Art Institute (Otis Art Institute).
Rosanjin tours the United States and donates collection of his work to The Museum of Modern Art in New York.

1955 International Ceramic Exposition, Cannes, France; Gold Medal awarded to Peter Voulkos.

1958 Brussels World's Fair, Belgium.
Ceramic International, Syracuse Museum of Fine Arts, Syracuse, New York.

1959 International Ceramics Exhibitions, Ostend, Belgium. United States wins Grand Prix des Nations.

1962 "Adventures in Art," exhibition at Fine Arts Pavilion, Century 21 Exposition, Seattle, Washington.

1963 "Works in Clay by Six Artists," exhibition, San Francisco, California.
"Clay Today," exhibition at State University of Iowa, Ames.

1964 International Invitational Ceramics Exhibit, exhibition in Tokyo.

1965 "Ceramics by Twelve Artists," collaboration instigated by *Art in America* and presented by American Federation of Arts, New York City Gallery.

"New Ceramic Forms," exhibition at Museum of Contemporary Crafts, New York.

1966 John Coplans organizes "Abstract Expressionist Ceramics," exhibition at the University of California, Irvine.

John Mason, exhibition at Los Angeles County Museum of Art.

Roy Lichtenstein exhibits ceramics at Leo Castelli Gallery, New York.

National Council for Education in the Ceramic Arts (NCECA) founded out of Design Division of the American Ceramic Society. First conference at Michigan State University, East Lansing.

"Twenty American Studio Potters," exhibition at Victoria and Albert Museum, London.

1967 Peter Selz organizes "Funk Art," exhibition at University of California, Berkeley.

1968 "Objects USA," exhibition of the Johnson Wax Collection organized by Lee Nordness, opens at Renwick Gallery, Washington, D.C.

"Dada, Surrealism and Their Heritage," exhibition at The Museum of Modern Art, New York.

"Objects Are . . . ?," exhibition at Museum of Contemporary Crafts, New York.

1969 "25 Years of American Art in Clay," exhibition at Scripps College, Claremont, California.

"Bay Area Ceramics," exhibition at San Francisco Art Institute.

1970 "Unfired Clay," exhibition, Southern Illinois University, Carbondale.

1971 "Contemporary Ceramic Art: Canada, U.S.A., Mexico, Ja-

pan," exhibition at National Museum of Modern Art, Tokyo and Kyoto, Japan.

"Tea, Coffee and Other Cups," exhibition at Museum of Contemporary Crafts, New York.

1972 "International Ceramics," exhibition at Victoria and Albert Museum, London.

"Salt-Glaze Ceramics," exhibition at Museum of Contemporary Crafts, New York.

"A Decade of Ceramic Art: 1962–1972," exhibition at San Francisco Museum of Modern Art.

Jurors Jeff Schlanger, Robert Turner, and Peter Voulkos reject 4,500 entries for Twenty-seventh and last Ceramic National in Syracuse, New York.

"Sharp-Focus Realism," exhibition at Sidney Janis Gallery, New York, includes work of Marilyn Levine.

"Clayworks: Twenty Americans," exhibition at Museum of Contemporary Crafts, New York.

"The Cup Show," exhibition at David Stuart Galleries, Los Angeles, California.

1973 "Robert Hudson/Richard Shaw," exhibition at San Francisco Museum of Modern Art.

"Ceramics International '73," exhibition at Alberta College of Art, Calgary, Alberta, Canada.

1974 "Robert Arneson, Retrospective," exhibition at Museum of Contemporary Art, Chicago, and San Francisco Museum of Modern Art.

"Clay Images," exhibition at

University of California, Los Angeles.

"Clay," exhibition at Whitney Museum of American Art, New York.

1975 "Clay Works in Progress," exhibition at Los Angeles Institute of Contemporary Art.

1976 "New Works in Clay by Contemporary Painters and Sculptors," exhibition at Everson Museum of Art, exhibition and collaboration by Margie Hughto, Syracuse, New York.

"Soup Tureens," exhibition organized by Helen Drutt, Campbell Museum, Camden, New Jersey.

"The Object as Poet," exhibition at Renwick Gallery, Washington, D.C.

"Concepts in Clay: Ten Approaches," exhibition at Dartmouth College Museum and Galleries, Hanover, New Hampshire.

"Concepts: Clay," exhibition at Central Michigan University Gallery, Mt. Pleasant.

"American Crafts 76: An Aesthetic View," exhibition at Museum of Contemporary Art, Chicago, Illinois.

1977 "Contemporary Ceramic Sculpture," exhibition at William Hayes Ackland Memorial Art Center, Chapel Hill, North Carolina.

"Overglaze Imagery," exhibition at art gallery, California State University at Fullerton.

First course in modern ceramic art history, Bennington College, Vermont.

"Robert Arneson—Portraits," exhibition at Allan Frumkin Gallery, New York.

1978 "Peter Voulkos, Retrospective," exhibition opens at the San Francisco Museum of Modern Art.

"Happy's Curios: Kenneth Price," exhibition at Los Angeles County Museum of Art.

"Nine West Coast Clay Sculptors," exhibition at Everson Museum of Art, Syracuse, New York.

"New Works in Clay II," exhibition at Syracuse University, New York.

A CENTURY OF CERAMICS
IN THE UNITED STATES
1878–1978

INTRODUCTION

One of the most significant comments made about ceramics in this century was the belief of Sir Herbert Read, the distinguished historian and critic, that one should "judge the art of a country by this medium for it is the sure touchstone." [1] Read's contention was that it was an art form so fundamental, so tied to the needs of its society, that it must give expression to a national ethos. This was true of the art of Greece and China, of Peru and Mexico, of medieval England and Spain, and of Italy during the Renaissance. Although technological progress has now diminished the role of the ceramist as a producer of his society's functional vessels, the basic tenets of Read's thesis remain true in the twentieth century. This study and the exhibition that inspired it are therefore more than just a review of the creative use of ceramics and stand as a commentary on the cultural fabric of American society.

The study is a unique one, for it deals with a society that had, in the words of Bernard Leach, "no ceramic taproot." [2] The indigenous Indian pottery was archaic and resulted from a protected, tribal culture. The Europeans who settled the United States found little inspiration in this magnificent tradition. Instead they became caught up in an attempt to emulate the styles, processes, and tastes of their European origins.

American pottery therefore grew out of myriad concerns and influences, some of the dominant being the German salt-glazed wares, the Dutch slipwares, the creamwares of Staffordshire, and later the porcelains of Germany, France, and England. Interestingly the strongest American character can be found in the humbler wares, the Pennsylvania German pottery crocks and plates. As ceramics became more sophisticated and the concept of *artwares* was introduced, the styles became patently imitative.

Lacking the formal skills, the craftsmanship in some cases, and the foundation of an established national aesthetic identity, these pretentious works were indeed rootless—a jumbled pastiche of vogue styles from across the Atlantic.

The 1876 Centennial Exposition at Philadelphia was the United States' moment of truth, producing much the same confrontation experienced by England in 1851 at the Great Exhibition at the Crystal Palace in London, except the United States found its decorative arts not only in stylistic disarray but also lacking any sense of national character. In ceramics in particular, the "American attempts at artistic decoration were such as to make the judicious grieve . . . [there was] nothing to approach even the lower grades of European ware." [3] Yet underlying the poor design at the Centennial were the seeds of an American aesthetic, as could be seen in Karl Müller's *Century Vase* and Isaac Broome's *Baseball Vase*. The latter was of particular interest, drawing from indigenous experience to create an original, if slightly incongruous form. Also at that Centennial was a little-noticed display of painted china by a group of women artists in Cincinnati. The objects were not remarkable in themselves, but they were the first sign of a spirit of invention and achievement that was beginning to surface in this affluent Ohio city and that was to lead in the next four years to the founding of an art-pottery movement in the United States.

There followed a period of rapid growth wherein American ceramists Van Briggle, Grueby, Robineau, McLaughlin, and others achieved renown and America moved, if not into prominence, then at least into a place and a profile in the international ceramics arena.

The achievements of the period up to 1919 were, however, largely on Europe's terms. The Beaux-Arts, Art Nouveau, Arts and Crafts Movement, and Art Deco styles originated across the Atlantic. The grammar of the aesthetic remained European—only the accent was American.

The breakthrough came in the mid-1950s; the liberating energies came from Abstract Expressionism and Japanese folk pottery. These two influences produced a synergistic marriage of the traditional sensitivity to materials and processes and the potent, gestural force of contemporary painting. In the 1960s, Funk appeared—a Dadaesque inversion of Pop art with its lowbrow humor, hobbycraft aesthetic, and visceral, figurative imagery. These movements and subsequent achievements thrust American ceramics into the forefront of world ceramics, and it has maintained this leadership.

The journey of self-discovery and purpose that is surveyed in this exhibition is an extraordinary one. It takes the ceramic medium in the United

States from an imitative, exploratory stance in the late nineteenth century to a vanguardist role in the 1950s and beyond. The achievement is twofold. On the one hand, the American ceramists had established a beachhead for a traditional craft medium in the fine arts, redefining the vessel aesthetic and presenting ceramic sculpture as an intimate and meaningful alternative to the cerebral quality of postwar metal sculpture. More broadly, however, it reflects the triumph of a nation that has been able to achieve a cultural voice and identity through the ceramic arts in the brief space of one hundred years.

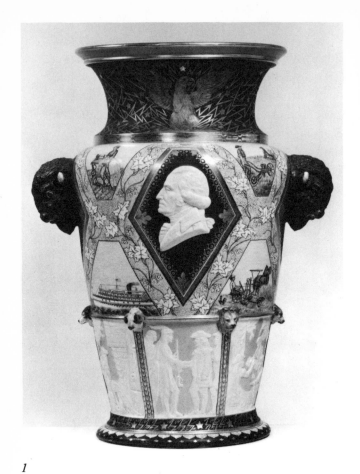
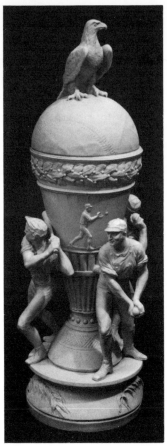

1

2

1. Karl Müller, Union Porcelain Works, Greenpoint, New York. *Century Vase,* 1876. Porcelain, H. 22½". Collection The Brooklyn Museum.

2. Isaac Broome, Ott and Brewer, Trenton, New Jersey. *Baseball Vase,* 1876. Parianware, H. 35". Collection New Jersey State Museum, Trenton, New Jersey.

1878-1889

The first phase of the art-pottery movement in the United States lasted from 1878 to 1889. This seminal period covers three important developments: the first mature creative use of what was later to become known as *Cincinnati faïence,* the founding of Rookwood Pottery in 1880, and in 1889, the first international recognition of American art pottery. These achievements were largely the result of the efforts of two socially prominent women, Mary Louise McLaughlin and Maria Longworth Nichols, central figures in the Cincinnati women's art movement. Both became involved in pottery decoration through an interest in china painting. Nichols was introduced to the "Devil's art" in 1873 by Karl Langenbeck, who had received the gift of a set of German china paints. In the following year, McLaughlin took instruction on china painting from Marie Eggers as part of Benn Pitman's course in wood carving at the Cincinnati School of Design.[4] The course was a popular success although Ms. Eggers knew little more of the technique than her students. Excited by the overglaze techniques, the students formed a committee to select china painted wares for the Centennial.

The painted china was exhibited alongside carved wood, needlework, and watercolors in the Cincinnati Room of the Woman's Pavilion. Although these objects lacked formal accomplishment—and at times showed unfortunate lapses of taste—they did represent one of the earliest attempts to employ ceramics as an independent art medium in the United States. Of more immediate significance at the Centennial were the wares of Haviland Auteuil. This Paris studio exhibited slip-painted *procès barbotine*[5] wares in the French Court, and these objects—with their rich Rembrandtesque underglaze surfaces in tones of brown, ocher, and blue—were the sensation of the

exposition, together with the Japanese ceramics display. Writing propheti- cally about what he called the "Limoges faïence," R. H. Soden Smith of the South Kensington Museum (The Victoria and Albert Museum) hailed the artistic excellence of the work and suggested that "it is not impossible that it will have an art influence on our time." [6] The words were prophetic indeed. For a time barbotine became the rage of Europe and was extensively imi- tated. But the interest across the Atlantic was short-lived, and in the United States the variants of this technique were the basis for early pioneering by McLaughlin, Charles Volkmar and Hugh Robertson, and Rookwood Pot- tery, becoming entrenched until the early twentieth century as the dominant technique in American art pottery.

McLaughlin began to experiment at the Patrick L. Coultry Pottery soon after the Centennial, attempting to reproduce the barbotine wares. At first she made the common error of painting underglaze with pure oxides. In 1877, she stumbled onto the fact that the depth and richness of the barbotine palette came from mixing the oxides with slip to form an engobe. In her first firing in October 1877, she applied the slips too thinly and the yellow color of the body showed through, marring the effect. But by January 1878 she had drawn the first technically successful piece from the kiln—a pilgrim bottle. The first exhibition of these wares took place under the auspices of the Women's Art Museum Association in May and were shown later in New York and Paris, receiving an Honorable Mention at the Exposition Universelle.[7]

McLaughlin's achievement was considerable, for she had stumbled upon a technique that Chaplet had taken years to perfect. She rapidly achieved a mature creative use of its potential, and the press gave enthusiastic coverage to McLaughlin's success, sparking a wide interest in all forms of pottery decoration in Cincinnati.[8]

The Coultry Pottery exploited the interest by offering instruction, and McLaughlin remembered this development with mixed feelings as it was her first experience of "what the world metes out to those who in the language of our day 'start Something.' " [9] Although McLaughlin had no part in the in- struction, she felt partly responsible for the work that emerged because she had been the first to show what could be done. Her recollections of this work are both amusing and revealing, for they show McLaughlin's distance from those who treated pottery as merely a dilettante pursuit:

> It may be imagined with what abandon the women of that time, whose
> efforts had been directed to the making of antimacassars or woolen
> Afghans, threw themselves into the fascinating occupation of working
> in wet clay. The potters imparted to them various tricks of the trade and

some fearful and wonderful things were produced. Not long ago the proud possessor of some of these treasures showed me a pair of vases with characteristic decoration of the period. While still wet they had been rolled or otherwise peppered with fragments dry clay until their surfaces were of the texture of nutmeg graters, while all over had been hung realistically coloured bunches of fruit. For a time, it was a wild ceramic orgy during which much perfectly good clay was spoiled and numerous freaks created.[10]

In order to set a standard amid this overenthusiastic response to ceramics, McLaughlin founded the Cincinnati Pottery Club in 1879 and presided over its activities first at Coultry Pottery for a short period and later at Frederick Dallas Pottery. The Pottery Club's purpose was "to uphold the standard of good craftsmanship of the best workers in the different branches of pottery." [11] It was the first club of its kind and served as the model for the pottery associations that opened in Chicago, New York, and other parts of the country. More broadly it contributed to the growth of the nascent women's art movement. Invitations to join the club were sent out to fifteen artists in Cincinnati. The invitation to Nichols was not delivered, and although attempts were later made to correct the omission, the imperious Nichols rejected all reconciliatory efforts and started working on her own, first at Dallas Pottery and then in 1880 opening her own studio, Rookwood Pottery, at 207 Eastern Avenue, sowing the seeds of a long feud between McLaughlin and Nichols.

The club held its first Annual Reception and Exhibition on May 29, 1880, and the event was a considerable success. Enough work was sold to balance the budget of the club for a year. The secretary of the club, Clara Chapman Newton, recalled the event:

> The whitewashed walls were hung with rugs as a background to the masses of dogwood and other fresh blooms. Throughout the appointed hours, crowds surged up and down the old wooden stairway and in and out of the kiln sheds which were also in gala array. In the middle of the afternoon Mr. Dallas, full of excitement, came to a small group of us to tell us that carriages were standing as far as you could see up and down the street and way around the corner. Those carriages were to him the outer and visible expression of reward and spiritual grace he had previously doubted the members of the club of possessing.[12]

An artist representing *Harper's Weekly* was in attendance, and the wood engraving of the show that appeared in the May 29 issue of the magazine was the first national acknowledgment of the ceramics movement that had gradually been developing momentum in Cincinnati. But the activities of the

club were threatened when on October 7 an injunction was served by Thomas J. Wheatley restraining both McLaughlin and Nichols at Rookwood Pottery from producing slip-painted underglaze. Wheatley had taken out a patent on the process earlier in the year and was granted patent number 232,791 on September 28. The spurious claim was eventually thrown out of court but not before the Cincinnati press had turned the tussle into a *cause célèbre,* reporting the claim with headlines such as "War Among Potters, T. J. Wheatley Secures a Patent on American Limoges."

In the journalistic investigation, it became apparent that McLaughlin was the true originator of Cincinnati faïence, and even Nichols rallied to her side, remarking in an interview that McLaughlin had produced the wares "before Wheatley ever thought of such a thing." [13] The publicity generated served only to heighten the interest in Cincinnati as a ceramic center. By 1881 women were coming from New York and Michigan to study and work in Cincinnati. At Coultry Pottery alone, the work of over 200 amateur artists was being regularly fired. The club eventually moved to the Rookwood Pottery, remaining there until their eviction in 1883. Unable to find a new home, the members returned to the china-painting techniques that had originally initiated the movement, and McLaughlin began to busy herself with other materials, concentrating on decorative metalwork.

The focus of Cincinnati faïence now turned to Rookwood Pottery. Nichols had drawn her first firing on Thanksgiving Day in 1880. One of her *Aladdin* vases was purchased by Tiffany and Co. in New York, and the pottery was shown during a lecture by Edward Atkinson in Boston. The pottery achieved early notoriety when in the fall of 1882 Oscar Wilde visited Rookwood. Clara Chapman Newton, an early decorator and the secretary of Rookwood Pottery, remembers meeting "the fashionable Disciple of the Aesthetic":

> I was not even at that time, when the newspapers contained accounts of his vagaries, prepared for the calla-lilly leaf overcoat and the shrimp pink necktie of the individual who was shuddering visibly over a vase which he was pronouncing "too branchy" as I entered the room. I did not claim the vase which heretofore appeared to my unenlightened eyes to be a very good and desirable piece of work. The next day in his lecture Mr. Wilde scored the pottery to the intense amusement of Mrs. Nichols who has a sense of humour and fully appreciated that artistically we had much to learn.[14]

Nichols began to employ decorators, and gradually the pottery developed purpose, becoming an art pottery in the true sense, concentrating on

unique wares although not exclusively so. In 1883 Nichols appointed William Watts Taylor as manager and from then on took an ever-diminishing role in the pottery's affairs. Taylor proved to be a shrewd manager, and although Newton never approved of Taylor personally, she rightly credits him with being responsible for the financial and artistic success of the pottery, saying that he was "due the honour of carrying the pottery up from the mud banks of the river to the heights of Mt. Adams." [15]

Taylor's first changes were to cease all transferware production and to evict the Pottery Club (with Nichols's consent), as he did not enjoy nurturing what he saw as a future competitor on the premises. Although businesslike in his handling of affairs, Taylor recognized that the independence of the artists and the encouragement of experiment were important. He was careful, however, to allow the production only of wares that were of a conservative nature and astutely avoided the bizarre and exotic. This meant eradicating the influence of Nichols's grotesque *Japonisme,* on which the early style of the pottery had been based.[16]

The influence of Japanese art remained the most vitalizing force upon the Rookwood style, which acquired new elegance and purpose with the arrival of a talented young Japanese artist, Kataro Shirayamadani, in 1887. The mawkishness of the first three years at Rookwood gave way to a more accomplished, and safe, Beaux-Arts style of slip painting, and significant technical innovation was introduced. In 1883 Laura Anne Fry had adapted a throat atomizer to apply the slips on greenware, a technique she later patented at the suggestion of Taylor.[17] Aware of the need to have greater control of the ceramic processes, Taylor employed Karl Langenbeck in 1884 as the first glaze chemist in the nation. Around the time of his arrival, the distinctive tiger's-eye, a crystalline or venturine glaze, was accidentally discovered. These and other early innovations caused much interest and were even copied by European factories such as Sèvres and Meissen.

The coming of age for the Cincinnati art-pottery movement was reached in 1889 when Rookwood received a coveted Gold Medal at the Paris Exposition Universelle in competition with Europe's finest potteries. The exposition was a double triumph for Cincinnati as a Silver Medal was awarded to McLaughlin for her overglaze decoration with metallic effects. This brought to an end what might be termed the period of innocence of the movement. Through sheer naïveté and empiric experiment, the movement's leaders had stumbled on a number of significant decorative techniques and glazes. A period of difficult sophistication, in both intent and aesthetics, lay ahead.

The East Coast played a minor role in art pottery until the late 1890s,

but it is necessary to discuss briefly two of the early pioneers, Hugh Cornwall Robertson and Charles Volkmar. Both had become involved in the production of barbotine wares. Soon after the Centennial, Robertson produced its *Bourg-la-Reine* wares at the family pottery, Chelsea Keramik Art Works (founded 1872), naming them in honor of the town where Chaplet had revived the process. Volkmar learned of the process while working with the *maître faïencier* Theodore Deck in Paris.[18] His wares, termed *Volkmar faïence*, were produced on his return to the United States in 1879 and were the closest in style and technique to the original barbotine wares. The bucolic landscapes in the style of the Barbizon School were painted onto forms derived from classical Greek models.

Robertson and Volkmar both turned from the slip-painted wares and became involved in Oriental techniques and glazes. Robertson's obsession was with the *flambé rouge* and *sang de boeuf* glazes; he became so preoccupied with these that he neglected the management of the pottery, and in 1888 it closed. In 1891, with a group of wealthy Bostonians, he established the Chelsea Pottery and continued his experiments. Volkmar moved his kilns first to Corona, Long Island, and then to Metuchen, New Jersey. Despite their importance historically—Robertson for his glaze science and Volkmar as a teacher—neither was an artist of consequence, and their achievements certainly did not rival those taking place in Cincinnati.

3

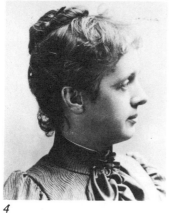

4

3. Japanese pottery and French *procès barbotine* wares by Haviland Auteuil in Paris, exhibited at the 1876 Centennial. Wood engraving reproduced from *Harper's Weekly,* November 25, 1876. Photograph: Museum of History and Technology, Smithsonian Institution, Washington, D.C.

4. Mary Louise McLaughlin. c. 1880. Photograph: Courtesy Cincinnati Historical Society, Cincinnati, Ohio.

5. Mary Louise McLaughlin, Patrick L. Coultry Pottery, Cincinnati, Ohio. *Pilgrim Jar,* 1878. Slip-painted underglaze earthenware, H. 10⅜″. Collection Cincinnati Art Museum, Cincinnati, Ohio.

5

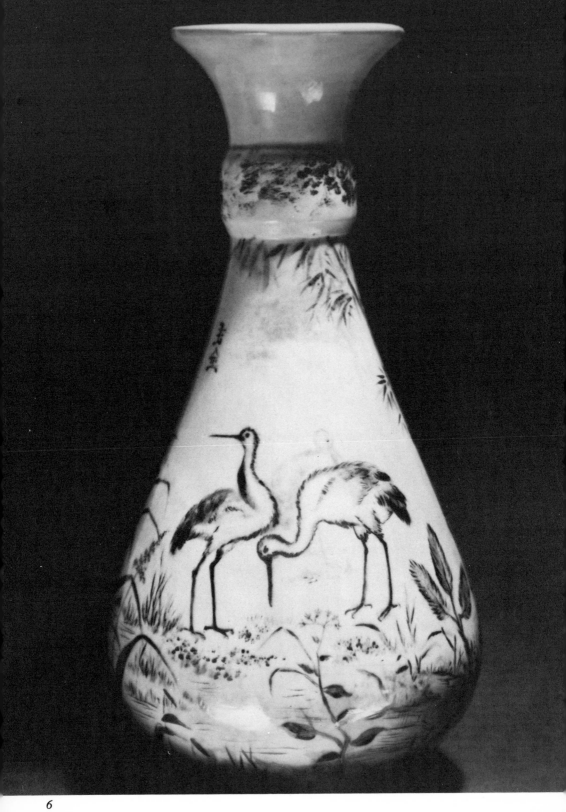

6

7

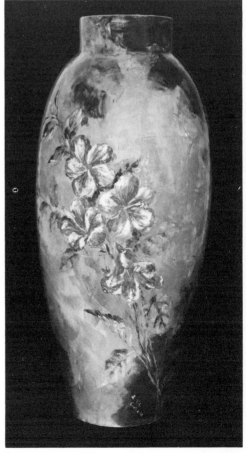

6. Maria Longworth Nichols, Cincinnati, Ohio.
Vase, 1879. Press-molded earthenware, blue
underglaze painting and gilt overglaze, H. 6″.
Collection Cincinnati Art Museum.

7. Wood engraving of works in the First An-
nual Reception and Exhibition of the Cincin-
nati Pottery Club at the Frederick Dallas Pot-
tery, 1880. Reproduced from *Harper's Weekly,*
May 29, 1880. Photograph: Cincinnati Art
Museum.

8. Mary Louise McLaughlin, Frederick Dallas
Pottery, Cincinnati, Ohio. *Ali Baba Vase,* 1880.
Earthenware, slip-painted underglaze, H. 36½″.
Collection Cincinnati Art Museum; Gift of
Rookwood Pottery.

8

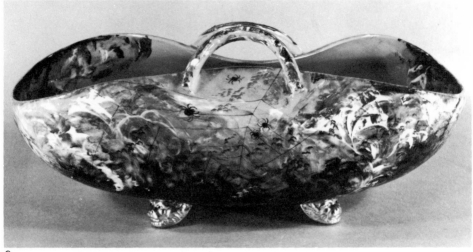

9

10

9. Maria Longworth Nichols, Rookwood Pottery, Cincinnati, Ohio. *Basket,* 1882. Earthenware, underglaze, L. 19½". Collection Cincinnati Art Museum.

10. Maria Longworth Nichols. c. 1880. Photograph: Courtesy Cincinnati Historical Society, Cincinnati, Ohio.

11. Laura Anne Fry, Cincinnati Pottery Club, Cincinnati, Ohio. *Plaque,* 1881. Glazed earthenware, Diam. 14¾". Collection The St. Louis Art Museum; Gift of the artist.

12. Clara Chapman Newton, Rookwood Pottery, Cincinnati, Ohio. *Pilgrim Flask,* 1881. Earthenware, on-glaze decoration, H. 6¾". Collection Cincinnati Art Museum. Photograph: Garth Clark/Lynne Wagner.

13. Albert R. Valentien, Rookwood Pottery, Cincinnati, Ohio. *Vase,* 1882. Earthenware, slip-painted underglaze with gilt on-glaze, H. 11". Collection National Museum of History and Technology, Smithsonian Institution, Washington, D.C.

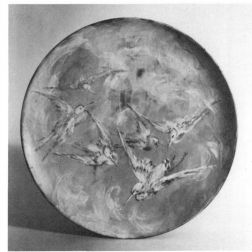

11

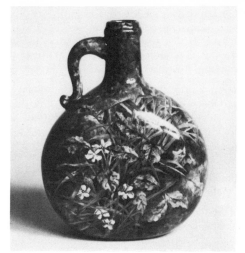

12

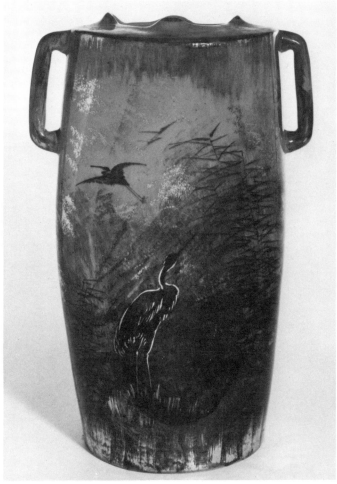

13

14. Hugh Robertson, Chelsea Keramik Art Works, Chelsea, Massachusetts. *Teapot,* c. 1879. Glazed earthenware, H. 7″. Collection National Museum of History and Technology, Smithsonian Institution, Washington, D.C.

15. Kataro Shirayamadani, Rookwood Pottery, Cincinnati, Ohio. *Vase,* 1889. Earthenware with slip-painted underglaze, H. 11″. Collection Jordan-Volpe Gallery, New York.

16. Albert R. Valentien, Rookwood Pottery, Cincinnati, Ohio. *Handled Vase,* 1890. Earthenware with slip-painted underglaze, H. 5″. Collection Jordan-Volpe Gallery, New York.

17. Albert R. Valentien, Rookwood Pottery, Cincinnati, Ohio. *Ewer,* 1889. Earthenware with slip-painted underglaze, H. 14″. Collection Jordan-Volpe Gallery, New York.

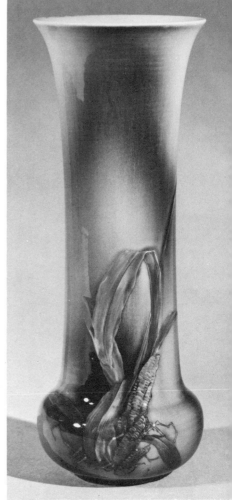

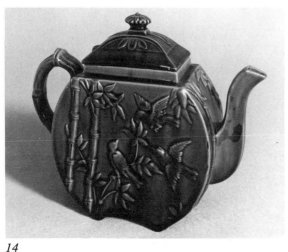

14

15

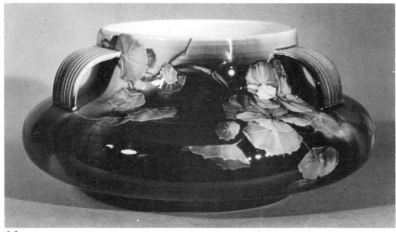

16

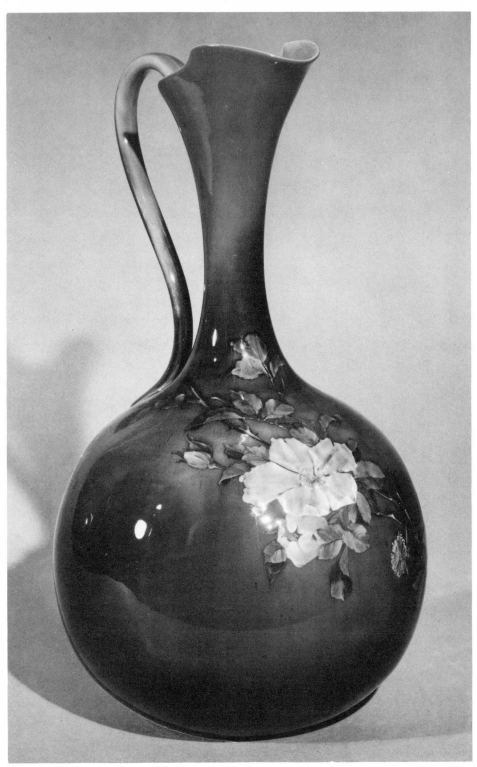

19

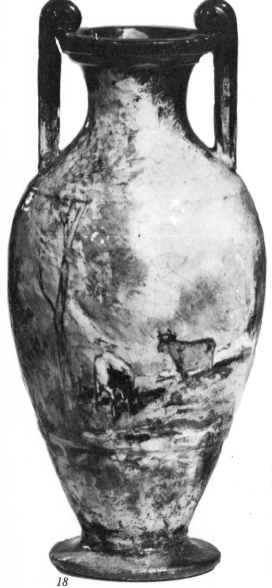

18

18. Charles Volkmar, Greenpoint, New York. *Handled Vase,* 1879–1881. Earthenware with underglaze slip-painting, H. 12½". Collection The Brooklyn Museum, New York; Gift of Leon Volkmar.

19. Charles Volkmar at work in his studio. 1903. Painting by Edwin B. Child. Photograph: Newark Public Library, Newark, New Jersey.

1890

The happy coincidence of what Carol Macht lists as "an Englishman, a new method of communication, a group of unusually talented and energetic ladies and an expanding Midwestern community yearning for culture, refinement and recognition equal to that of the older cities along the Eastern seaboard" [19] inspired the women's art movement in the United States and in so doing gave the first impetus to Arts and Crafts Movement ideals in the country. In the 1890s the interest in the movement became more sophisticated and more organized. Arts-and-crafts–exhibiting societies were formed in Chicago and Boston; the writings and works of William Morris, founder of the English movement, became known to the art intelligentsia; and a number of periodicals were published, including *House Beautiful,* 1896; *Common Clay* and *Ornamental Iron,* 1893; *International Studio,* 1897; *Brush and Pencil,* 1898; and *Keramik Studio* and *Fine Arts Journal,* 1899.

The decorative arts were becoming part of mainstream American culture, and as public awareness grew, a profitable market opened up for what the Victorians had euphemistically termed *art manufacture.* Ceramics proved to be one of the most rewarding areas, and during this decade, a number of new potteries opened and several existing functional potteries began to turn their attention to decorative wares. For the first part of the decade, Rookwood continued to dominate. But the opening of new potteries in competition, such as Lonhuda Pottery in Steubenville, Ohio (founded 1892), and the introduction of imitations of *Standard* Rookwood by Samuel A. Weller and J. B. Owens in Zanesville, Ohio, led to a proliferation of slip-painted wares. Their importance began to recede in favor of the simple forms and monochrome glazes that found favor during the latter part of the decade.

The 1893 World's Columbian Exposition in Chicago was the major focus during the formative stage of the 1890s. It was there that William Grueby saw the *flambé rouge* and mat glazed pots of Delaherche and Chaplet, which were later to lead to a revolution in pottery tastes. Also exhibited at the exposition were the proto–Art Nouveau ceramics of the brilliant Dutch ceramist Theodoor A. C. Colenbrander.[20] The women's movement still contributed much of the activity of American ceramics. The Cincinnati Pottery Club was re-formed for the exposition and exhibited wares in the Cincinnati Room of the Woman's Building. The exhibition of this work marked the end of an era in ceramics, as male, entrepreneurial ceramists began to dominate. Newton called the exposition "a fitting port in which to anchor the good ship, 'Cincinnati Pottery Club,' . . . the ripples that vessel made broadened into a great and far-reaching circle which had more influence than we realized possible over the ceramic art of the country." [21]

Susan Goodrich Frackelton, another major figure in the early china-painting movement, showed salt-glazed stonewares,[22] for which she received a Gold Award. In 1892 she sought to bring about a closer communication within the burgeoning china-painting movement and formed the National League of Mineral Painters. Following her success in Chicago, Frackelton developed the Frackelton Dry Colours (golds and bronzes), which were awarded medals by Leopold II, King of the Belgians, at a competition in Antwerp in 1894. Her prominence increased when in 1895 her book *Tried by Fire,* the bible of the china painters, was published in its third and enlarged edition.

The last major venture into painted decoration came in 1895 with the opening of the Newcomb Pottery in New Orleans. The pottery was a part of the Sophie Newcomb Memorial College for Women (today a division of Tulane University) and was conceived of as a practical training ground for women pottery decorators.[23] Mary G. Sheerer, a graduate of the Cincinnati Art Academy, joined the pottery at its inception to teach underglaze slip and china painting. The early wares were in imitation of *Standard* Rookwood, but the technique proved difficult to control. Around 1897 a new style emerged with which Newcomb was to be associated until 1910 and its change to mat glazes under Paul E. Cox. Designs were incised into wet clay and then painted with oxides after the first firing. The wares were then glazed with a transparent high-gloss glaze. Later the incising technique was discontinued.

These wares, with their distinctive palette of blue, green, yellow, and black, are the most original and freshly inventive of the later painted wares.

The choice of color and subject reflected the idyllic setting of the pottery in the Garden District of New Orleans above Canal Street, surrounded by magnolias and huge spreading oaks. In order to give the pottery a unique character, all motifs and landscapes used in decoration were drawn from the flora and fauna of New Orleans and the surrounding bayou country. The forms were either chosen from the "damp room" or designed by the decorators to suit their purpose and thrown by Joseph Fortune Meyer, a gifted and intuitive potter. None of the designs was ever repeated (unless requested by the purchaser) and they therefore retained their lively character. They were awarded numerous honors between 1900 and 1915.[24] The first decorators were undergraduates, but eventually a changing nucleus of four to five women, graduates of the college, were permanently employed. Apart from the accomplished work of Sheerer, one of the important early decorators was Mazie T. Ryan. Her decorations were carefully conceived within the three-dimensional frame they occupied and have a particular spontaneity and invention. Later stalwarts of the decorating team were Sadie Irvine, Frances "Fannie" Simpson, and Henrietta Bailey.

Decorative tastes began to change in the late 1890s, and a demand for simpler form and limited decoration began to replace the cluttered eclecticism of late Victorianism. This was a victory for the Arts and Crafts Movement purists such as Elbert Hubbard, Gustav Stickley, and Frank Lloyd Wright. In responding to new fashions, ceramics drew from the simplicity of Chinese and Japanese ceramics as interpreted by the French artist-potters, such as Chaplet and Delaherche. But inspiration also came directly from a connoisseurship of Oriental ceramics that was growing in the United States through public and private collectors.[25] A number of ceramists had begun to work in imitation of the Chinese potters, notably Robertson and Volkmar, but their achievements were uneven and their production was limited. Robertson was better known for his Dedham Pottery crackle wares with their blue framing of rabbit, whale, butterfly, and floral motifs.[26]

The work of William Grueby in Boston[27] was the most significant breakthrough in the new aesthetic and was based on the relationship between form and the unpainted texture and color of the surface. Grueby had begun experimenting, after seeing the works of Delaherche in 1893 at the World's Columbian Exposition in Chicago, to produce a natural mat glaze that could be achieved without bathing the glazed surface with acid—an artificial means of achieving mat surfaces at the time. He accomplished this feat in 1897–1898, producing a superb range of intense mat glazes in greens,

yellows, ochers, and browns. The most successful was his distinctive "Grueby green," which responded well to the relief-decorated form. The glaze broke to a lighter tone on the raised surfaces, and an overall veined effect, resembling a watermelon rind, enlivened the surface. The character of the glazes was unlike any other in use at the time. They represented a major breakthrough for the empiric art-pottery movement in the United States.

Unlike the glazes, which were an original development, the forms relied heavily upon a paraphrasing of the pottery of Delaherche, as a comparison with the work of Delaherche published in *The Studio* [28] in 1898 reveals. The early Grueby forms (1898–1901) were designed by George Prentiss Kendrick and show the same climactic use of the shoulder and the massive, monumental neck as Delaherche. However, some of the translations were inspired, notably Kendrick's adaptation of a multihandled vase, in which the use of the clay was livelier and less contrived.

The crispness of the final product resulted because no molds were used even though the designs were reproduced in quantity. Each form was thrown by an elderly potter, and then the relief decoration was applied by young girls culled from the local art schools. The wares were an immediate success and were given the all-important endorsement of Gustav Stickley, who had emerged as the leader of the Arts and Crafts Movement in the United States —incorporating Grueby wares into his interiors. Grueby won numerous awards both at home and abroad and was represented in Paris by Maison Bing l'Art Nouveau.

It is possibly this association that has led to Grueby's being linked to the Art Nouveau style. Although there was some affinity with the German variant, *Jugendstil,* even this was slight, and Grueby wares certainly lack the characteristics of French Art Nouveau: the whiplash line in decoration, the symbolic use of the female form, and what historian Tschudi Madsen calls the "linear thrall" of the forms. In essence the wares were a Mission-style adaptation of Delaherche's classic forms. The semantics of Grueby's aesthetic lineage were of little concern to the art-pottery movement, however, which now became involved in a scramble to copy the "eternal matt green with which every potter is trying to outdistance Grueby and win fame and fortune." [29]

Two other pioneers of note were active at the same time as Grueby: Mary Louise McLaughlin and the Biloxian, George E. Ohr. McLaughlin had returned to ceramics in 1895 and was working on an earthenware technique for inlaid decoration underglaze, which she patented, having learned her lesson from the Wheatley debacle. She was dissatisfied with these wares, as

they had to be produced with the assistance of a potter. Eager to have a more intimate contact with her material, she began to experiment with porcelain in 1898. After an arduous period of trial and error involving eighteen clay bodies and forty-six glazes, she perfected her first works in 1899. These *Losantiwares,* as she termed them, were small ovoid forms with a delicate carved decoration that was alive with the curvilinear energy and rhythm of Art Nouveau. Ironically McLaughlin was one of the most outspoken critics of this style, warning that it could not be "followed without reason or moderation except to the detriment and degradation of the beautiful." [30] Once again she had emerged in the vanguard of the art-pottery movement as one of the first artists to work in the self-sufficient manner of the studio potter. After 1906 her interest waned, although she continued intermittent production of her porcelains until 1914.

The work of George E. Ohr is more difficult to categorize. He was the great maverick of American ceramics and produced the most original work of his day. Ohr worked in Biloxi, Mississippi, where he ran the Biloxi Art Pottery. Around the turn of the century, he began to withdraw his major work from sale, selling only fair trinkets and "gimcracks." The reason was that Ohr believed himself to be a genius and that he wished his works to be "purchased entire" by the nation. In fact, the hoard of 6,000 pots that he set aside remained in the Ohr family warehouse until 1972, when a New York antiques dealer purchased them for resale. Although Ohr's work was too personal and complex to influence the aesthetic direction of the art-pottery movement, he was nonetheless an extremely conspicuous member of this activity and had the habit of accompanying his work to the major fairs and expositions. There he gave demonstrations, with his resplendent twenty-inch-long moustache tucked into his shirt or combed into a bizarre shape. Ohr developed extraordinary skill on the potter's wheel, which he responded to "like a mad duck in water" [31] and threw vulnerable earthenware forms to the point of collapse. He would then fold, ruffle, twist, and pummel the thin vessels and add sinuous, intricate handles. His glazes ranged from livid, mottled pinks to somber browns and metallic finishes. The manner in which he worked with the clay was not entirely without precedent. The ruffling of forms was popular in Victorian glass, and both Émile Gallé and the Danish craftsman-designer Theobald Bindesboll had produced pummeled and ruffled pots in the 1880s. These were more effetely decorative, however, whereas the work of Ohr was furiously gestural.

Ohr, who began working around 1879, was the first of the American

studio potters chronologically and also the first in stylistic terms. He led the assault on the boundaries of applied and fine art, blurring the distinctions between what critic John Coplans so succinctly terms "the hierarchy of media." This is implicit in his turning away from the controlled surface concerns of Victorian decorative art and plunging into the aesthetics of risk. He pushed the expressionist qualities of the material to the limit, dealt with form on a level of poetic anthropomorphism, and played a capricious game with function. Ohr was able to sidestep the limitations of European formalism in which others such as Adelaide Robineau and Charles Fergus Binns became embroiled. Ohr's work expresses the vision of the time, and he was the true prophet of American ceramics, anticipating the expressionism, verbal-visual, and surrealism that were to become mainstream concerns in the 1950s and 1960s.[32]

A few appreciated Ohr in his time. But their distinction makes up for their paucity in numbers: Binns, Barber, and William King. The last-named, in an address in Buffalo, made one of the most telling contemporary judgments of Ohr's work:

> Ohr is an American potter who stands in a class by himself, both in personality and in his pottery. Sometimes he is referred to as the "mad potter of Biloxi." He calls himself the "second Palissy"; issues a challenge to all potters of the world to compete with him in making shapes and producing colours. . . . While much of Mr. Ohr's work will not meet the requirements of accepted standards . . . there is art, real art —in this Biloxian's pottery.[33]

20. The Rookwood Pottery Studio in the 1890s. Photograph: Cincinnati Historical Society, Cincinnati, Ohio.

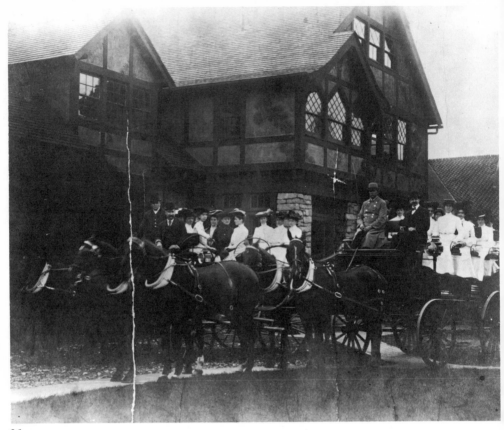

21

21. William Watts Taylor on an outing with the decorators at Rookwood Pottery. c. 1905. Photograph: Cincinnati Historical Society, Cincinnati, Ohio.

22. Albert R. Valentien, Rookwood Pottery, Cincinnati, Ohio. *Vase,* 1893. Earthenware, underglaze slip decoration, H. 12½″. Collection Cincinnati Art Museum. Photograph: Garth Clark/Lynne Wagner.

22

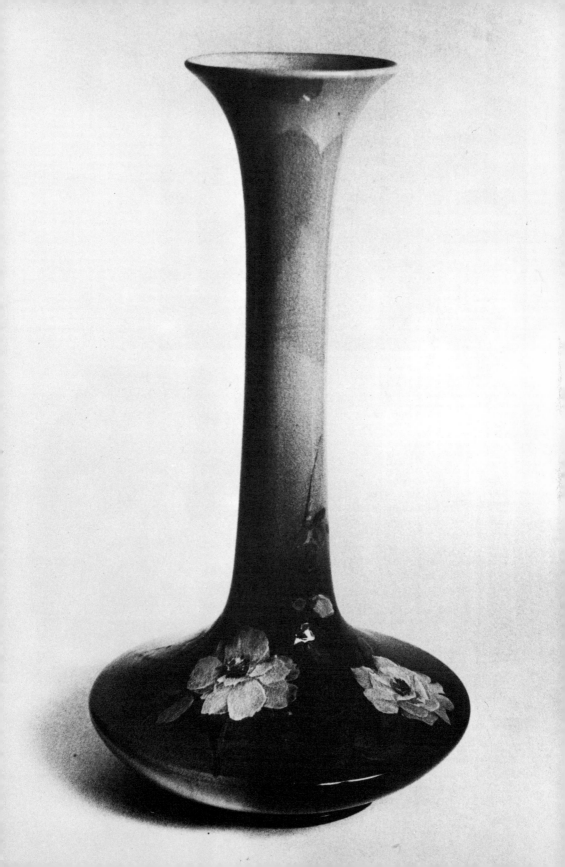

23

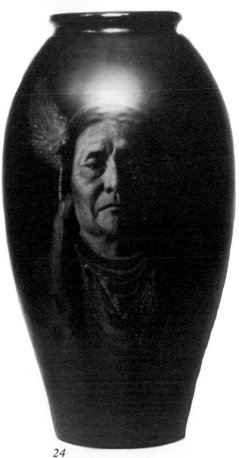

24

23. Kataro Shirayamadani, Rookwood Pottery, Cincinnati, Ohio. *A Trinity of Dragons—Earth, Fire and Water,* c. 1898. Earthenware plaque with underglaze slip decoration, L. 31½″. Collection Cincinnati Art Museum; Gift of Wm. Held MacDonnell, James M. Smith, and Ernest V. Thomas.

24. W. P. MacDonald, Rookwood Pottery, Cincinnati, Ohio. *Chief Joseph of the Nez Percés,* 1898. Slip-painted, underglaze earthenware, H. 14″. Collection The Metropolitan Museum of Art, New York; Gift of Wells M. Sawyer.

25. Artus Van Briggle, Rookwood Pottery, Cincinnati, Ohio. *Vase,* 1897. Earthenware, slip-painted underglaze, H. 11″. Collection Cincinnati Art Museum.

26. Matthew Andrew Daly, Rookwood Pottery, Cincinnati, Ohio. *Vase,* 1897. Earthenware, slip-painted underglaze, H. 8¼″. Collection Cincinnati Art Museum. Photograph: Garth Clark/Lynne Wagner.

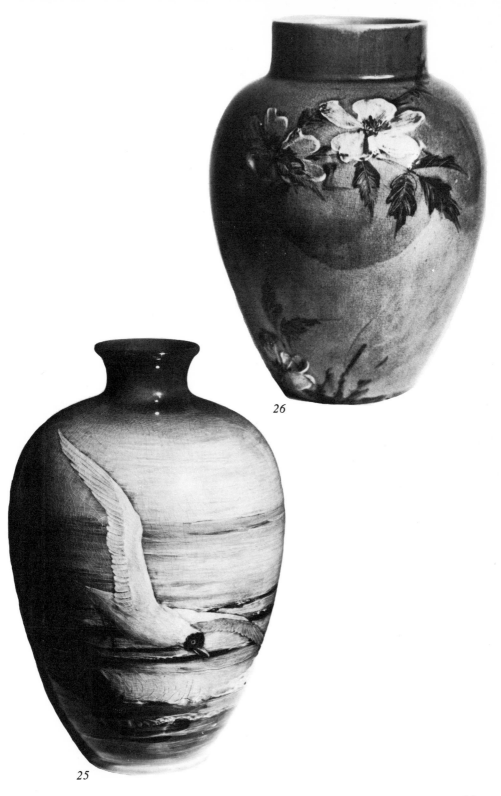

26

25

27

28

30

29

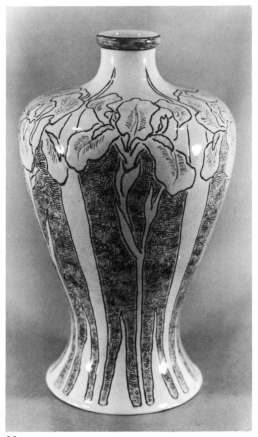

30

27. Susan Frackelton at work in her studio, Milwaukee, Wisconsin. c. 1893. Courtesy Milwaukee County Historical Society, Milwaukee, Wisconsin.

28. Susan Frackelton, Milwaukee, Wisconsin. *Olive Jar,* 1893. Salt-glazed stoneware, H. 30″. Collection Philadelphia Museum of Art, Philadelphia, Pennsylvania; Gift of John T. Morris.

29. Faculty and students at the Newcomb Pottery, New Orleans, Louisiana. c. 1897. Photograph: Courtesy J. W. Carpenter.

30. Mary G. Sheerer, decorator, and potter Joseph F. Meyer, Newcomb Pottery, New Orleans, Louisiana. *Vase,* 1898. Earthenware, with incised and underglaze decoration, H. 12″. Collection Cincinnati Art Museum; Gift of Miss Mary Sheerer.

31

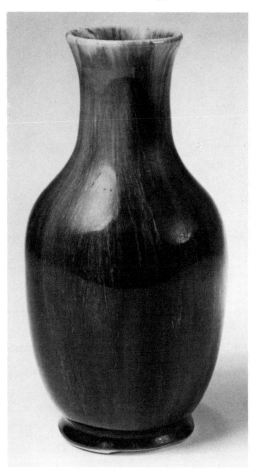

31. Dedham Pottery, Dedham, Massachusetts. *Plate,* c. 1898. Crackle glaze with blue whale border, Diam. 8¾". Collection Everson Museum of Art, Syracuse, New York. Photograph: Garth Clark/Lynne Wagner.

32. Hugh Cornwall Robertson, Dedham Pottery, Dedham, Massachusetts. *Vase,* 1896–1908. Stoneware, H. 6". Collection Philadelphia Museum of Art; Purchase: The Baugh-Barber Fund.

33. Grueby Pottery, Grueby Faience Company, Boston, Massachusetts. *Vase,* 1898–1902. Earthenware with mat green glaze, H. 11½". Private collection. Photograph: Garth Clark/Lynne Wagner.

34. Grueby Pottery, Grueby Faience Company, Boston, Massachusetts. *Handled Vase,* 1898–1902. Earthenware, mat green glaze, H. 8¾". Private collection. Photograph: Garth Clark/Lynne Wagner.

32

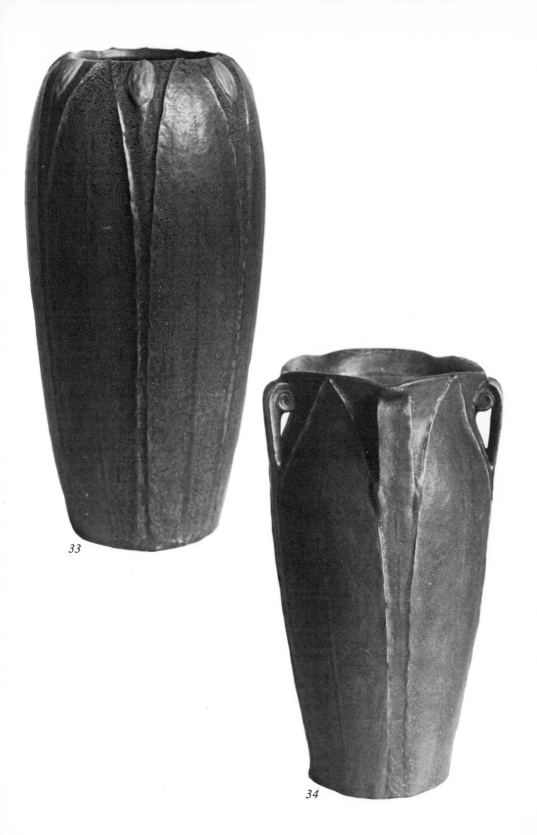

33

34

35. Grueby Pottery, form designed by George P. Kendrick and glaze by William Grueby, Grueby Faience Company, Boston, Massachusetts. *Vase,* 1898–1911. Earthenware, mat glaze, H. 12″. Collection Philadelphia Museum of Art; Purchase: The J. Stodgell Stokes Fund.

36. Wares by August Delaherche. Reproduced from *The Studio,* 12, 1898. Shows influence on both Grueby and Pewabic Pottery.

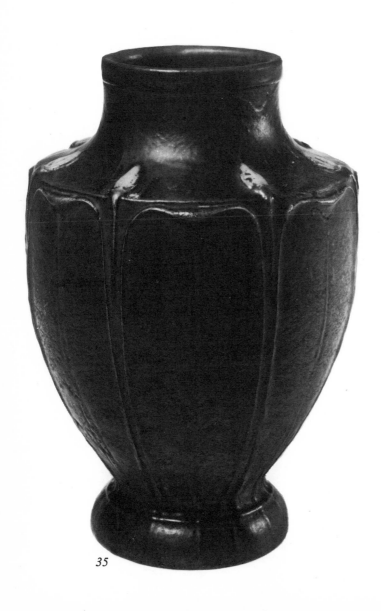

35

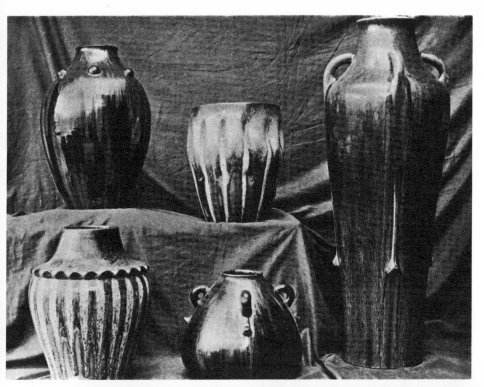

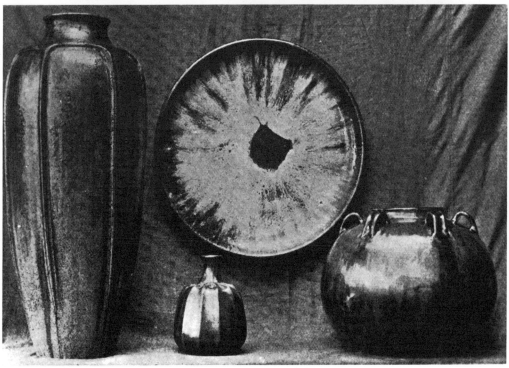

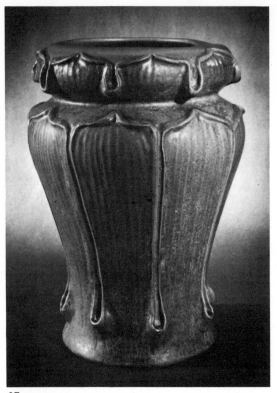

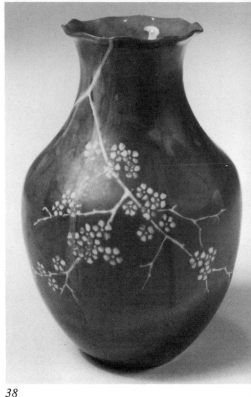

37 38

37. Grueby Pottery, Grueby Faience Company, Boston, Massachusetts. *Vase*, 1898–1902. Earthenware, mat green glaze, H. 12⅞" Collection Thomas W. Brunk. Photograph: Steven Benson.

38. Mary Louise McLaughlin, Cincinnati, Ohio. *Vase*, 1895. Earthenware, inlay decoration underglaze, H. 4½". Collection Philadelphia Museum of Art; Purchase: The Baugh-Barber Fund.

39. Mary Louise McLaughlin, Cincinnati, Ohio. *Vase*, Losantiware, 1905. Porcelain with gray glaze, H. 4". Collection Cincinnati Art Museum; Gift of the Porcelain League of Cincinnati.

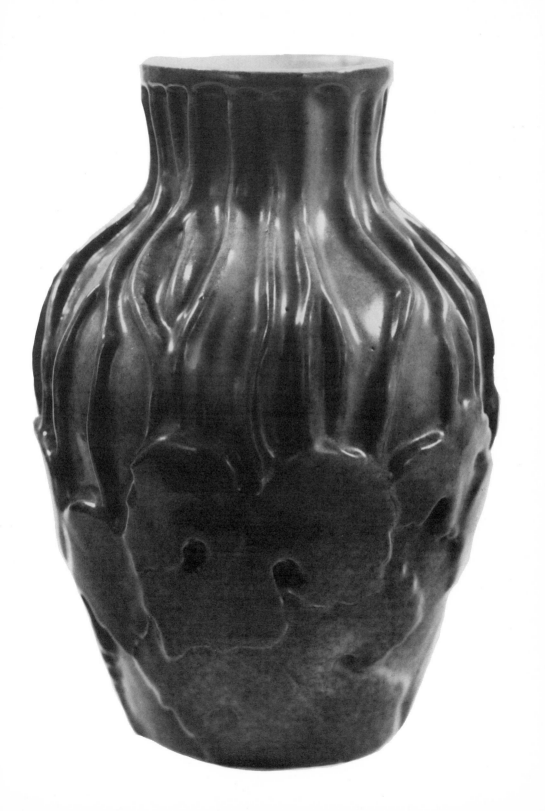

40. George E. Ohr exhibiting at the Atlanta Cotton Exposition, 1895. Photograph: Courtesy J. W. Carpenter.

41. George E. Ohr, Biloxi Art Pottery, Biloxi, Mississippi. *Pitcher,* c. 1898. Earthenware, mottled glaze with gunmetal streaking, H. 5″. Collection Martin and Estelle Shack. Photograph: Garth Clark/Lynne Wagner.

42. George E. Ohr, Biloxi Art Pottery, Biloxi, Mississippi. *Nine O'Clock in the Evening* and *Three O'Clock in the Morning,* c. 1899. Glazed earthenware, H. 10″ and H. 9⅜″. Collection National Museum of History and Technology, Smithsonian Institution, Washington, D.C.

43. George E. Ohr, Biloxi Art Pottery, Biloxi, Mississippi. *Vase,* c. 1898. Glazed, ruffled, earthenware, H. 9″. Collection Martin and Estelle Shack. Photograph: Garth Clark/Lynne Wagner.

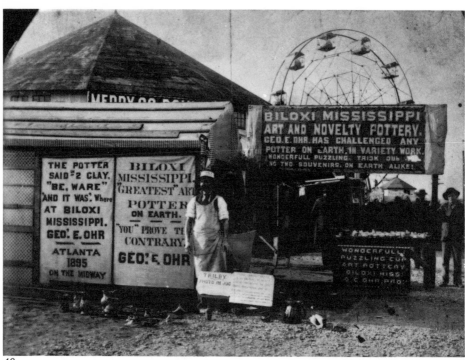

40

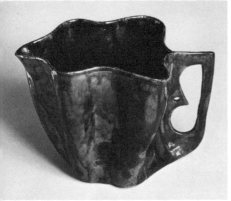

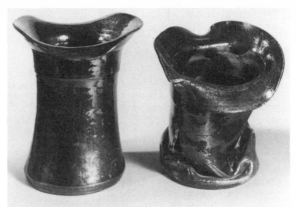

41

42

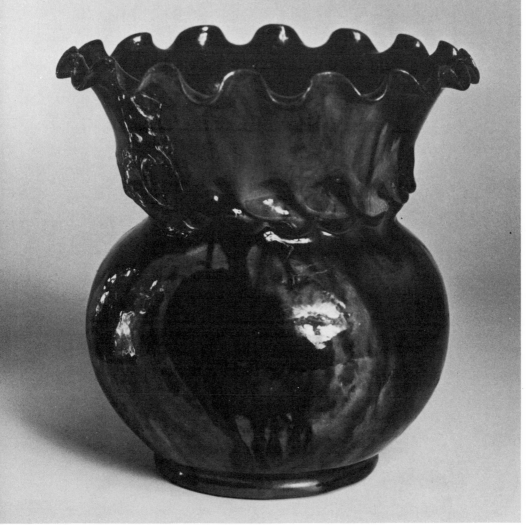

43

44. George E. Ohr, Biloxi Art Pottery, Biloxi, Mississippi. *Bank,* c. 1900. Earthenware, L. 3½". Collection Martin and Estelle Shack. Photograph: Garth Clark/Lynne Wagner. This money box is an early example of American Funk, later to become a mainstream movement in ceramics.

45. George E. Ohr, Biloxi Art Pottery, Biloxi, Mississippi. *Double Necked Vase,* after 1900. Glazed earthenware, H. 9¼". Collection Martin and Estelle Shack. Photograph: Garth Clark/Lynne Wagner.

46. George E. Ohr, Biloxi Art Pottery, Biloxi, Mississippi. *Handled Vase,* c. 1900. Earthenware glazed, H. 12". Collection Martin and Estelle Shack. Photograph: Garth Clark/Lynne Wagner.

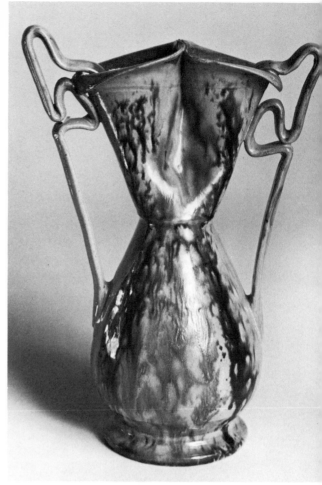

45

44

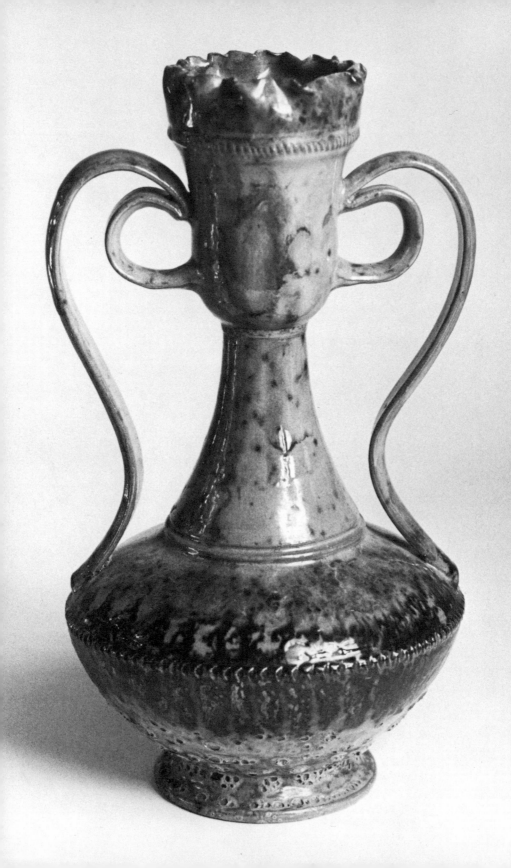

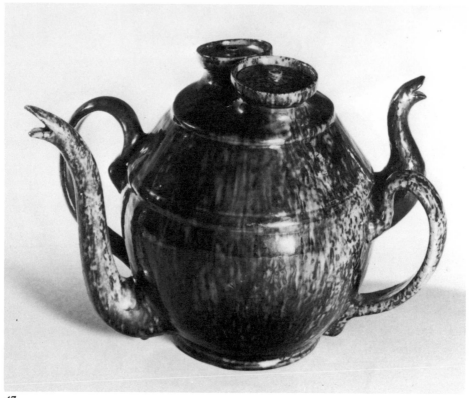

47

47. George E. Ohr, Biloxi Art Pottery, Biloxi, Mississippi.
Teapot and Coffee Pot, after 1900. Glazed earthenware,
H. 7¾". Collection National Museum of History and
Technology, Smithsonian Institution, Washington, D.C.

1900

The 1900 Exposition Universelle proved to be a real victory for American ceramics, confirming the promise of the first exposure of America's art pottery on the same platform eleven years earlier. Rookwood showed exceptional wares by Kataro Shirayamadani, Artus Van Briggle, William P. McDonald, Sara Sax, Carl Schmidt, John Wareham, and Harriet Wilcox and was awarded the Grand Prix. Many of Europe's leading museums purchased wares for their decorative art collections.[34] Grueby received one Silver and two Gold Medals, and with due justice the Grand Prix went to Auguste Delaherche. Medals also went to Newcomb Pottery, and Nichols (Mrs. Bellamy Storer), McLaughlin, and Frackelton were represented in the exposition.

The excellent reception of American ceramics at this pivotal world's fair was a moment of confidence. From 1900 onward, a spirited independence began to enter into American ceramics. The artists no longer worked with one eye toward recognition in Europe, and a series of expositions was held in the United States that became of greater importance to the American decorative arts. Several aspects characterize this decade: the growth of interest in sculptural form, the emergence of one of the finest pioneer studio potters (Adelaide Alsop Robineau), and the beginning of the role of the university in the ceramic arts.

The importance of Rookwood declined further during this decade. Attempts were made to sustain its leadership. New techniques and glazes were introduced by the new glaze chemist, and the slip-painting technique was improved to include cooler colors under a brilliant, clear glaze. A particular masterwork of this new style is in the collection of the Philadelphia Museum of Art. The vase is by Shirayamadani, by far the most talented and skilled of

Rookwood's decorators. The shoulder of the pot is wrapped in a swath of roses, painted in a trompe-l'oeil manner with a delicate green slip. The brilliant, clear glaze responded to the light relief of the painting, crackling slightly to enhance the illusionary depth of the work. But the public had tired of painted pottery, regardless of the skills presented, and those working in a more sculptural manner began to dominate.

Rookwood remained an ideal for the American Arts and Crafts Movement despite its gradual fall from favor. Oscar Lovell Triggs, founder of the Industrial Art League in Chicago, hailed the pottery as the perfect modern workshop:

> The pottery is not merely a workshop; it is in a sense a school of handicraft, an industrial art museum, and a social center. The craftsmen, creating and initiating on their own ground, constantly improve in skill and character. . . . A portion of the building is now devoted to exhibition. By means of lectures and other entertainments at the pottery, the public participates in some degree in the enterprise, and by reaction shapes the product. Here are all the elements needed for an ideal workshop—a self-directing workshop, an incidental school of craft, and an associative public.[35]

Rookwood responded to the interest in Art Nouveau wares, and some figurative wares were produced in this style by William McDonald and Anna Valentien, the latter's work showing the influence of a period of study with Rodin. Mary Chase Perry, at Pewabic Pottery, also worked on carved, sculpted forms, somewhat irregular in shape, although she kept to floral relief decoration and her work was closer in essence to that of Delaherche and Grueby. The two artists whose work dominated in the sculptural approach to the vessel were Artus Van Briggle and Louis Comfort Tiffany.

Van Briggle's work of this style dates from 1900 and his move from Rookwood to Colorado Springs for health reasons. There, with the assistance of chemist William H. Strieby at Colorado College, he adapted the local materials to his needs and established the Van Briggle Pottery. At the Paris Salon in 1903, he held the first exhibition of major works such as *Lorelei* and *Despondency*. The critical and commercial success of this showing was followed up in 1904 at the Louisiana Purchase International Exposition in St. Louis, where the wares received two Gold, one Silver, and two Bronze Medals. He was denied the Grand Prix only because of a rule prohibiting its award to first-time entries.[36] Van Briggle died while the exposition was in progress, and his exhibition cases were draped in black. Van Briggle had

managed to model a large number of works between 1900 and 1904, and the production of these was continued by his wife, Anne Gregory Van Briggle. He had in a short period managed to achieve his objective of "getting ceramics away from glass coating and let the pot itself carry its own beauty." [37]

The first appearance of Tiffany's Favrile pottery took place at the St. Louis exposition, although they had been in the research stage since the turn of the century. It was only in 1905 that they were offered for sale by Tiffany Studios. It is not known to what extent Louis Comfort Tiffany was directly involved in their creation.[38] The works of Tiffany were produced by anonymous craftsmen from his designs. However, the pottery reflects Tiffany's intuitive sensitivity to materials and his clear compositional style. In placing this work stylistically, it has been the tradition to refer to the pieces as being Art Nouveau. However, as pointed out by Martin Eidelberg, the work only occasionally shows use of the Art Nouveau grammar. The relief modeling is elegant but static. It resembles most closely the parianwares that were produced by Bennington Pottery around 1850, with the same tautness of line, the rhythmic growth of the stalks from the base of the forms, and the formal integration of the floral motifs and form.[39] This work by Tiffany, in common with many other "Art Nouveau" wares by Fulper, Grueby, and Weller, belongs most properly to a category that Kirsten Keen identifies in her catalogue *American Art Pottery* as "structural naturalism." [40]

Later in the decade the ceramists began to reject direct mainstream influences such as Art Nouveau and turned their back on painting and sculpture. They developed strongly personal aesthetics based on the interpretation and imitation of the rich past of ceramic history, as can be seen in the independent spirit of artists such as Charles Fergus Binns, Mary Chase Perry, Henry Chapman Mercer, and last, but most significant, Adelaide Alsop Robineau. This development was a mixed blessing. On the one hand, it resulted in an identity for ceramics based on its *own* roots and not a secondhand interpretation in clay of painting or sculpture. But this xenophobic stand meant that the revolutionary changes in concepts of surface and form that were beginning to emerge in the modern art movement had no influence on the potter. The vessel tradition remained an anachronistic pursuit for several decades as a result, related to the objet d'art aesthetic, with all its overtones of preciousness, bourgeois materialism, and pedantic craftsmanship. Nonetheless this period, with its unabashed sybaritism, has a lasting charm despite—or possibly because of—its distance from the stylistic changes that were beginning to sweep American art.

Charles Fergus Binns is a key figure in the development of a structure for studio pottery in America. At the time of his move to America in 1897, Binns was the superintendent of the Royal Worcester Porcelain Works and was being groomed to replace his father as director. His wealth of knowledge of ceramic science found an excellent outlet through the American Ceramic Society in 1899, which he was instrumental in founding, and the New York School of Clayworking and Ceramics, which he directed from its inception in 1900 until his retirement in 1931.[41] The school was the second of its kind in the country, and under Binns's astute direction, it rapidly established itself as the premier ceramics school in the nation.[42] The perfectionist aesthetic of restraint that Binns advocated and practiced was actively propagated and continued by his students and his students' students. The aesthetic grew out of Binns's fondness for the quieter periods of Chinese and Korean pottery. The "classic Alfred vessel," as it is colloquially known in ceramic circles, was distinguished by a sophisticated use of materials, clean and simple form, little or no ornament, and a strongly classical inspiration. This style brought about a welcome sophistication in craftsmanship and other formal values. But these were won at the expense of clay expressionist qualities. In many ways, the Binns legacy was inhibiting artistically, and it was not until the 1950s that Alfred began to demonstrate its freedom from this "less is more" regime.

By contrast, Mary Chase Perry was an adventurous artist with a love of color and experiment. Perry was a leading member of the National League of Mineral Painters together with her close friend Adelaide Robineau until 1903, when both artists gave up overglaze decoration, Robineau turning to porcelains and Perry setting up an art pottery in Detroit. Pewabic Pottery was established in partnership with her intimate friend and business associate Horace J. Caulkins. Together they had developed the Revelation kiln, a portable, kerosene-burning, muffle kiln that became the standard for the china-painting movement and was used by many of the leading art potteries. In her workshop, Perry adopted an open, modern approach to processes. She installed an electric kiln within a few months of opening the pottery and continued to be involved with innovatory kiln design and clay-handling techniques. However, her craft ethic was staunchly anti-industry, stating that it was not the aim of a pottery to become an "enlarged, systematised, commercial manufactory" but that it existed "to solve progressively the various ceramic problems that arise and working out the results and artistic effects that may remain as memorials, or at least to stamp a generation as one that brought about a revival of ceramic art." [43]

In her work, Perry chose not to deal with what she saw as purely mechanistic concerns and never learned to throw, having her forms produced by a potter, Joseph Herrick, from drawings while she busied herself with her first love, glaze chemistry. Because she adopted this nineteenth-century "white-collar" approach to pottery, the forms lacked the evolution and continuity of Binns and Robineau. Nonetheless she produced a few masterpieces whose beauty derives largely from her range of extraordinary glazes, from elusive, iridescent glazes to cloudy, rich inglaze lusters. Her real contribution as an artist can be found in her architectural commissions. The involvement of Pewabic in this area began when Charles L. Freer, a leading art connoisseur and patron of the pottery, introduced Perry to the architect Ralph Adams Cram. Cram was in the process of designing St. Paul's Cathedral in Detroit and incorporated Perry's tiles as a feature of the building. The commission was completed in 1908 and executed in a glowing palette of blues and deep, lustrous gold. The success of the installation drew attention from many of the nation's leading architects, and Pewabic worked for Cass Gilbert, Greene and Greene, Bryant Fleming, and others.[44] Perry undertook some massive projects that took up to eight years to complete, as in the case of the National Shrine of the Immaculate Conception in Washington, D.C., and these dominated the creative concerns of the pottery until the 1930s. Perry later directed her energies toward teaching and also directed the activities of Pewabic until her death in 1961 at the age of ninety-four.

At the turn of the century, the demand for tiles and architectural ceramics was strong. Most of this activity belongs more properly to a discussion of turn-of-the-century capitalism rather than art—with the exception of Perry and one of the Arts and Crafts Movement's most enigmatic and complex figures, Henry Chapman Mercer. Mercer was a lawyer-turned-archaeologist-turned-potter, and the Moravian Tile Works, which he established in Doylestown, Pennsylvania, in 1901, represented one man's mission to preserve and eulogize the craft achievements that he believed constituted the genius of civilization. He undertook this task with the contradictory qualities of visionary and retrogressive romantic that were so often the makeup of the Victorian Arts and Crafts leaders. On the one hand, he decried the progress of mechanization, and on the other, he designed and erected three of the first reinforced-concrete buildings in the country and devised ingenious equipment to reproduce his tiles. Mercer had at first intended to make pottery to reestablish the tradition of the Pennsylvania German potter, which to his dismay he discovered had died out. The clay proved intractable and suitable only for

tiles. The first designs came from the cast-iron Moravian stove plates that he collected. From these Mercer, a rapacious eclectic, used numerous influences to develop his narrative tile panels. He developed bright primary colors in his glazes as well as clay stains and often left his designs unglazed to highlight the free and unbounded values of his local red clay. Mercer's work was in great demand. In common with Perry, he was associated with many architects of the Arts and Crafts persuasion. In 1930 he died, leaving behind a vast legacy that has yet to be fully explored.[45]

Although each of these figures has an important position in the history of this decade, it is Adelaide Alsop Robineau who was the most formidable influence. She was the influential editor of the leading ceramics journal, *Keramik Studio;* a dedicated teacher; and the one American studio potter whose work was ranked, without qualification, alongside that of Europe's greatest masters. She was an inspirational example as an artist for both ceramics in general and the women's art movement in particular. Moreover, through the pages of *Keramik Studio,* she was responsible for introducing ceramists around the nation to the finest work of artists at home and abroad. She encouraged an intelligence in the use of ceramic processes and materials and herself provided a standard of artistry and skill.

At the time of founding *Keramik Studio* in 1899, with her husband, Samuel Robineau, and an associate as publishers, Robineau was still involved with the Beaux-Arts style of the china painter's movement, of which she was one of the most prominent decorators. Her work at this point comprised the painting of overglaze *chefs d'oeuvre* on commercially produced blanks that her contemporary, Frederick Rhead, described as "a veritable riot of gold and colour." [46] The seeds of her conversion to a more intimate use of the materials were just discernible in the first-issue editorial, in which she called for higher ideals and remarked that the ceramic arts had grown beyond the china-painted "stereotyped spray of flowers and the inevitable butterfly." [47]

The "decisive event" [48] in her life, which changed her conception of the art, was her contact with Taxile Doat, the distinguished French ceramist. In 1902 the magazine published an article by William P. Jervis on Doat and illustrated his fecund gourd forms with their luminous mat glazes. Intrigued by his work, the Robineaus obtained a treatise on *grand feu* (high-fired) ceramics that was published as a series in the magazine during 1903 and 1904 and in 1905 as a handbook, the first on its subject in the English language. Armed with Doat's thesis, an impression of his sensual porcelains, and three weeks of study with Charles Fergus Binns in Alfred, New York, Robineau

set up her first kiln in Syracuse, New York. At first she employed assistants, but the attempt to commercialize her talent was "a dismal failure . . . she did not like the casting process and even shapes thrown on the wheel by professional throwers from designs, however accurate they were, lacked that finishing touch that she alone could give them." [49]

It is important to stress the fact that Robineau's induction as a studio potter came primarily from an unhappiness with the sterile forms that were available to the china painter. Studies of her work have tended to overemphasize the decoration on Robineau's porcelains and not to give due tribute to Robineau's three-dimensional achievement. Her forms show an elegant finesse in line and proportion. The decoration that followed was successful because its form had a strength that matched and complemented the surface achievements. The early porcelains were undecorated crystalline-glazed bottles and vases, "many of which have disappeared for the Museums were not interested and sales were difficult and most people not understanding high fire porcelain work objected to the price which was around $30.00 or $35.00." [50]

From 1905 Robineau began to perfect the technique with which she was to become most closely associated, the carving and excising of dry but unfired porcelain, producing some of her most economical and finely resolved pieces, including the *Viking* and *Crab* vases now in the Everson Museum collection. Although bearing a relationship to carved Chinese porcelains, the interpretation was entirely personal and in no way imitative. Certain pieces were vaguely reminiscent of Doat's early work, Art Nouveau, proto–Art Deco, and other styles in vogue at the time. But her art does not fit any stylistic category and can be addressed only as an artist's individual and personal response to a material, its process, and its traditions. This uniqueness was won at high cost, for the techniques employed by Robineau were remorseless, and any error of judgment or skill would result in failure. Once Samuel Robineau wrote, seething with frustration and rage, "I have never felt so disgusted and discouraged in my life . . . every one of the new pieces is warped and blistered . . . anybody who is foolish enough to do cone 9 porcelains ought to be shut up in an insane asylum." [51] But the Robineaus persevered despite the indifference of the public and the vagaries of the kiln, and their triumph came early in the following decade.

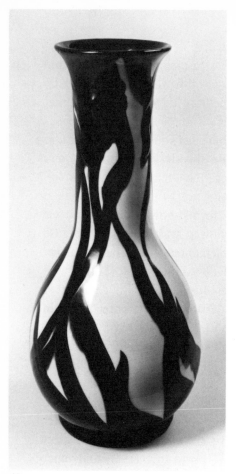

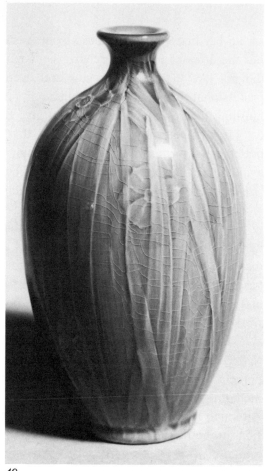

48 49

48. John "Dee" Wareham, Rookwood Pottery, Cincinnati, Ohio. *Bottle Vase,* 1898. Black decoration on white ground, H. 12″. Collection Cincinnati Art Museum; Gift of Mrs. Joyce Clancy.

49. Sara Sax, Rookwood Pottery, Cincinnati, Ohio. *Vase,* 1898. Earthenware, slip-painted underglaze, H. 5¾″. Collection Cincinnati Art Museum; Gift of Walter E. Schott, Margaret C. Schott, Charles M. Williams, and Lawrence H. Kyte.

50. Kataro Shirayamadani, Rookwood Pottery, Cincinnati, Ohio. *Vase,* 1900. Earthenware, underglaze slip painting, H. 17⅜″. Collection Philadelphia Museum of Art; Gift of John T. Morris.

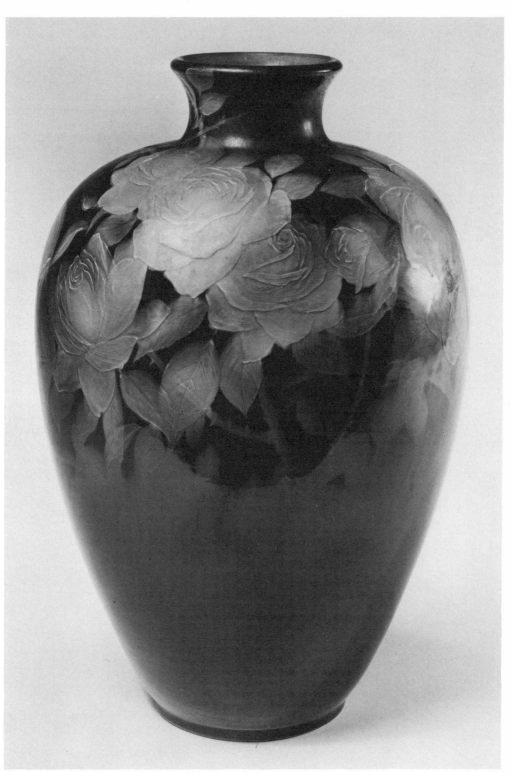

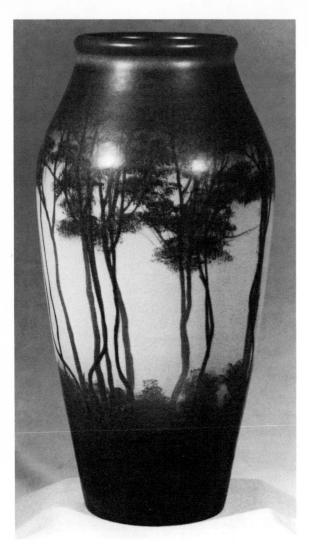

51

51. Edward T. Hurley, Rookwood Pottery, Cincinnati, Ohio. *Scenic Vellum,* 1909. Glazed stoneware, H. 13″. Collection Todd M. Volpe. Photograph: Taylor & Dull.

52. Anna Valentien, Rookwood Pottery, Cincinnati, Ohio. *Bowl,* 1901. Green mat glaze, earthenware, D. 6½″. Private collection. Photograph: Garth Clark/Lynne Wagner.

53. Artus Van Briggle, Van Briggle Pottery Company, Colorado Springs, Colorado. *Vase,* 1902–1905. Translucent green glazed earthenware with molded relief of conventionalized narcissi, H. 10½″. Private collection. Photograph: Garth Clark/Lynne Wagner.

54. Artus Van Briggle, Van Briggle Pottery Company, Colorado Springs, Colorado. *Vase,* 1903. Glazed earthenware with molded relief design, H. 9″. Collection National Museum of History and Technology, Smithsonian Institution, Washington, D.C.

55. Artus Van Briggle, Van Briggle Pottery Company, Colorado Springs, Colorado. *Vase,* 1904. Earthenware, conventionalized leaf decoration in relief with green glaze, H. 14¾″. Collection National Museum of History and Technology, Smithsonian Institution, Washington, D.C.; Gift of Van Briggle Pottery Company.

52

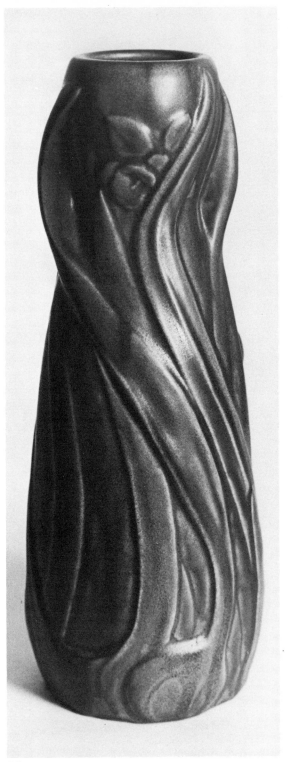

53

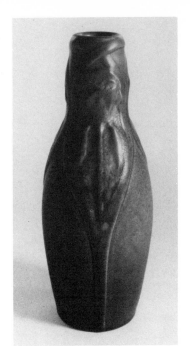

54

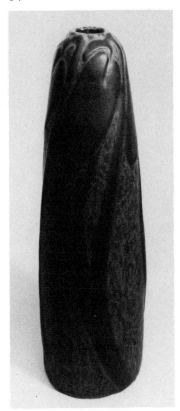

55

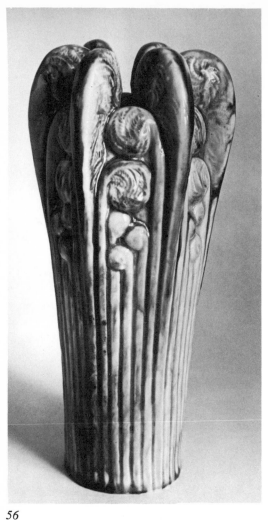
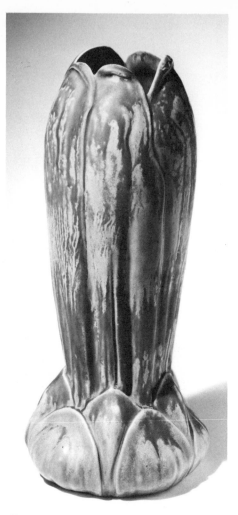

56 57

56. Louis Comfort Tiffany, Tiffany Studios, New York. *Vase*, 1905–1919. Porcelaneous clay with glossy translucent green glaze with conventionalized ferns in relief, H. 11¾". Private collection. Photograph: Garth Clark/ Lynne Wagner.

57. Louis Comfort Tiffany, Tiffany Studios, New York. *Artichoke Blossom Vase*, 1905–1919. Porcelaneous clay with mottled, mat green glaze, H. 10¾". Collection Philadelphia Museum of Art; Gift of Mr. and Mrs. Thomas E. Shipley, Jr.

58. Louis Comfort Tiffany, Tiffany Studios, New York. *Hollyhock Vase*, 1905–1919. Porcelaneous clay with ivory mat glaze shading to black, H. 10". Private collection. Photograph: Garth Clark/Lynne Wagner.

54

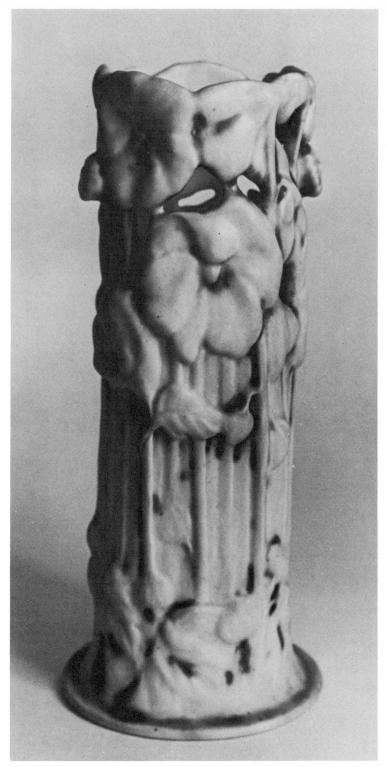

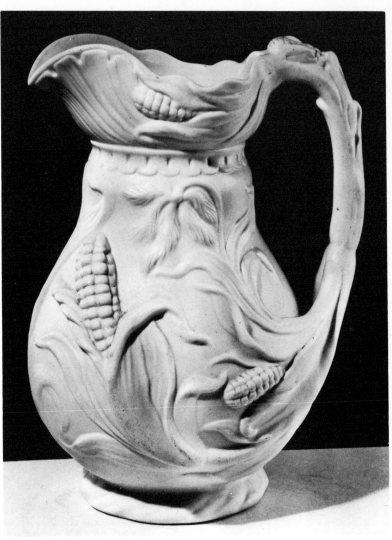

59

59. Parian pitcher, cornhusk design, made at Bennington, Vermont, c. 1850. H. 9⅝". Courtesy The Brooklyn Museum, Brooklyn, New York; Gift of Arthur W. Clement.

60. Parian pitcher, lily-pad design, made at Bennington, Vermont. c. 1850. H. 9". Collection Philadelphia Museum of Art; Purchase: The Baugh-Barber Fund.

61. Frederick Hurten Rhead, Weller Pottery, Zanesville, Ohio. *Plate,* 1902–1904. Earthenware, underglaze painting, Diam. 10½". Private collection. Photograph: Garth Clark/Lynne Wagner.

62. Jacques Sicard, Weller Pottery, Zanesville, Ohio. *Vase,* 1903–1907. Earthenware with iridescent glaze, H. 8¾". Collection Stanley and Evelyn Shapiro. Photograph: Garth Clark/Lynne Wagner.

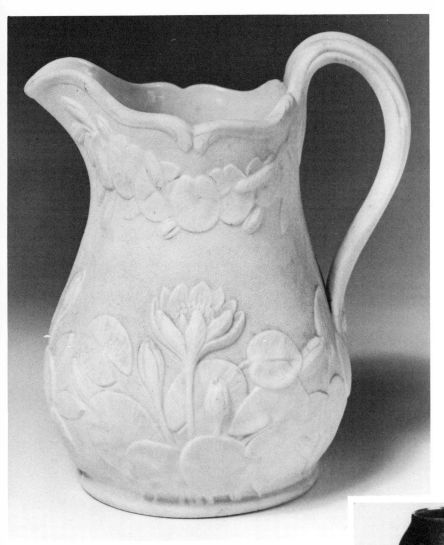

60

61 *62*

63

64

63. Mazie T. Ryan, Newcomb Pottery, New Orleans, Louisiana. *Vase,* 1905. Earthenware, H. 8″. Collection Michiko and Alfred Nobel. Photograph: Garth Clark/Lynne Wagner.

64. Sara B. Levy, Newcomb Pottery, New Orleans, Louisiana. *Vase,* before 1907. Glazed earthenware, H. 5″. Collection Michiko and Alfred Nobel. Photograph: Courtesy Art Gallery, California State University at Fullerton.

65. Arthur Eugene Baggs, Marblehead Pottery, Marblehead, Massachusetts. *Lidded Jar,* after 1908. Earthenware, gray mat glaze, H. 5¼″. Private collection. Photograph: Garth Clark/Lynne Wagner.

66. Arthur Eugene Baggs (executed by Hannah Tutt), Marblehead Pottery, Marblehead, Massachusetts. *Vase,* after 1908. Earthenware, decoration in light relief with mat glaze, H. 8¼″. Private collection. Photograph: Garth Clark/Lynne Wagner.

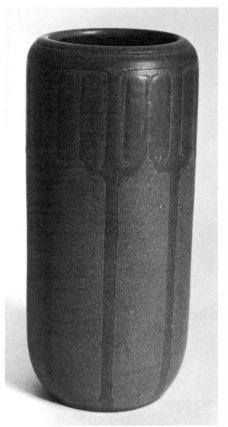

66

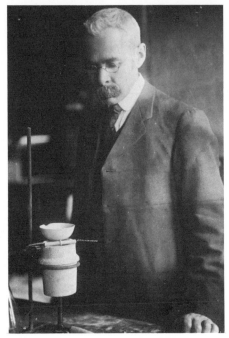

67

68

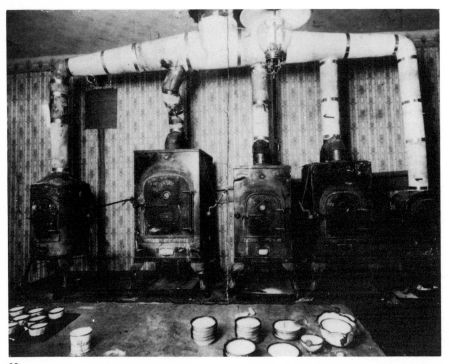

69

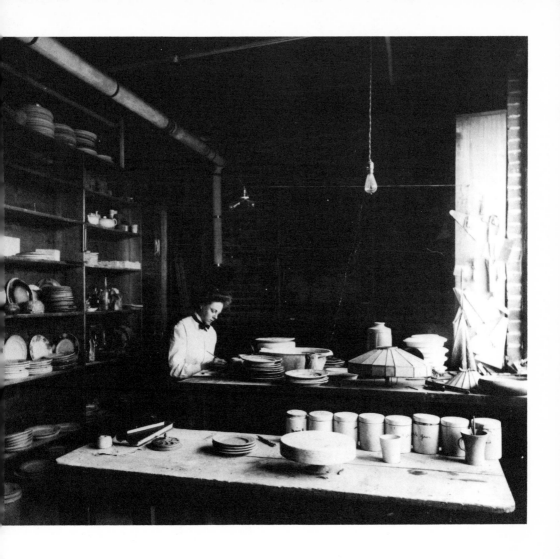

67. Charles Fergus Binns at New York College of Clay-working and Ceramics, Alfred, New York. 1906. Photograph: Courtesy American Ceramic Society.

68. Mary Chase Perry at the Pewabic Pottery, Detroit, Michigan. c. 1910. Photograph: Courtesy Michigan State University, East Lansing, Michigan; and Pewabic Pottery Museum, Detroit, Michigan.

69. The Revelation kilns at Pewabic Pottery, Detroit, Michigan, designed by Horace J. Caulkins and Mary Chase Perry. c. 1910. Photograph: Courtesy Michigan State University, East Lansing, Michigan; and Pewabic Pottery Museum, Detroit, Michigan.

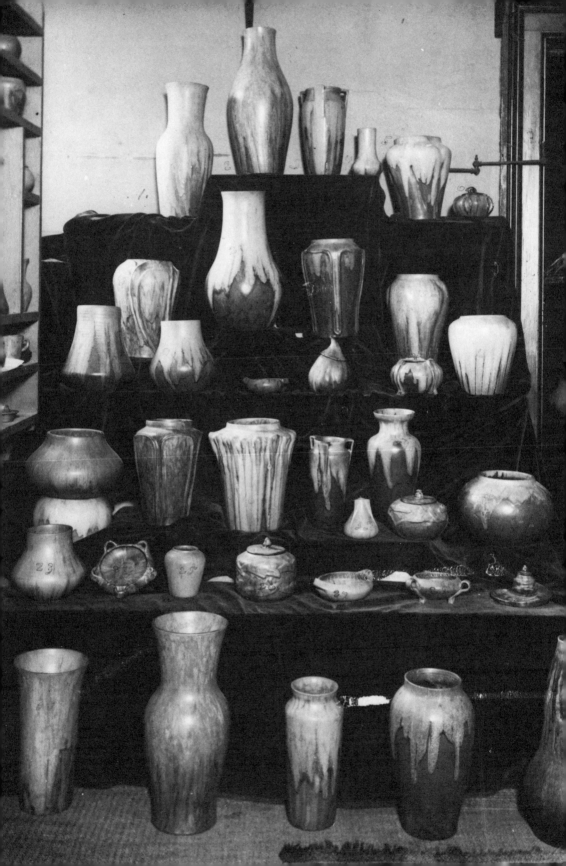

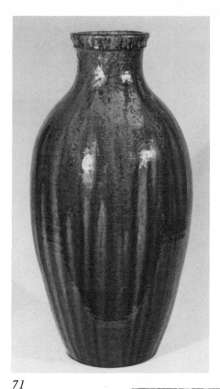

70. Mary Chase Perry's Pewabic pottery at the 1904 Louisiana Purchase International Exposition in St. Louis, Missouri. A comparison with the work by Delaherche reproduced in figure 36 shows Perry's debt to the French master. Photograph: Courtesy Michigan State University, East Lansing, Michigan; and Pewabic Pottery Museum, Detroit, Michigan.

71. Mary Chase Perry, Pewabic Pottery, Detroit, Michigan. *Vase,* 1909–1915. Earthenware, iridescent glaze, H. 21¼". Courtesy Marcia and William Goodman. Photograph: Taylor & Dull.

72. Pewabic Pottery tiles in the Church of the Most Holy Redeemer, Detroit, Michigan, 1920.

71

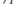

70

72

73

75

74

73. Henry Chapman Mercer. c. 1900. Courtesy Mercer Museum of the Bucks County Historical Society, Doylestown, Pennsylvania.

74. Moravian Tile Works, a reinforced-concrete building at Fonthill, Doylestown, Pennsylvania. c. 1912–1914.

75. Henry Chapman Mercer, Moravian Tile Works, Doylestown, Pennsylvania. *Tile,* c. 1910. Glazed earthenware, H. 5″. Collection Cleota Gabriel. Photograph: Jane Courtney Frisse.

76. China painted works by Adelaide Alsop Robineau, exhibited at the 1900 Paris Exposition Universelle and illustrated in *Keramik Studio.*

77. Adelaide Alsop Robineau at the wheel in her studio, Syracuse, New York. c. 1920. Photograph: Everson Museum of Art, Syracuse.

77

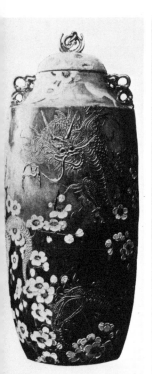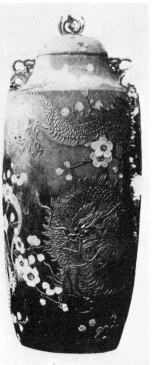

76

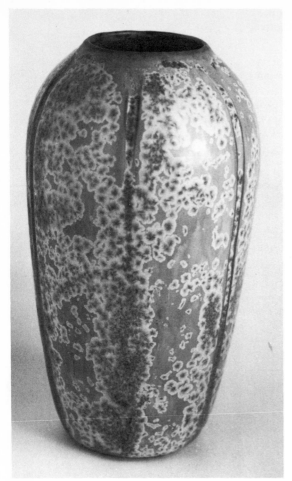
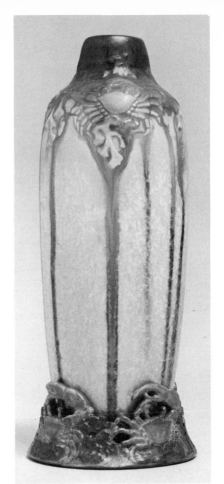

78 79

78. Adelaide Alsop Robineau, Syracuse, New York. *Vase,*
1905. Porcelain with blue/silver crystalline glaze, H. 7".
Collection Everson Museum of Art, Syracuse. Photograph:
Garth Clark/Lynne Wagner.

79. Adelaide Alsop Robineau, Syracuse, New York. *Crab
Vase,* 1908. Porcelain, incised decoration, mat glaze, H.
7⅜". Collection Everson Museum of Art, Syracuse. Photo-
graph: Robert Lorenz.

1910

By 1910 the foundations for the modern movement in ceramics had been laid. Ceramic art now had its own schools, active exhibiting societies, publications, and some artists of consequence. The preceding decade had greatly enlarged the technical vocabulary of ceramics, the secrets of high fire had become known, and more new glazes had been introduced during that time than during any other decade before or since. This knowledge was rapidly expanding as ceramics became more of an international pursuit. What the decade lacked, however, was aesthetic direction. Craftsmanship and decorating skills were advanced to a high level of proficiency, but no new vision emerged to give the medium momentum. The decade is distinguished by Robineau's successes in Europe and America, the founding of the University City Pottery, and a decline in the importance of the art pottery industry in favor of the studio potter.

In 1910 the School of Ceramic Art was opened at the People's University in University City, a suburb of St. Louis. The school was part of a project by Edward Gardner Lewis to create a center for culture in the Midwest. His empire was founded on the American Women's League, which he established in 1907, and the magazine publishing with which it was associated. League members were offered free education by correspondence through the People's University. The response was immediate and overwhelming: over 50,000 women registered for courses. The best of these were invited as honors students to study at the Fine Art Academy. Lewis had assembled a strong faculty, with the sculptor George Julian Zolnay at its head. For the ceramics school, he acquired the services of Taxile Doat as director. Doat brought with him from Europe the former foreman of a Paris pottery, Eugene Labarrière, and

Émile Diffloth, the art director from Boch Frères Pottery in Belgium. Robineau was appointed instructor of pottery, and Frederick Rhead, recently arrived from England, and a St. Louis china painter, Kathryn E. Cherry, completed the faculty. The venture was short-lived, for the Lewis empire foundered in 1911, but during the year and a half of its existence, the pottery had unlimited resources and freedom.

During this period, an atmosphere of creativity and experimentation was fostered. Unlimited funds seem to have been available to encourage investigation into every facet of ceramics. In the chemistry department, thousands of samples of American clayware were tested, and many were evaluated as being superior to European clays.[52]

The faculty departed in 1911, but the pottery continued under the indomitable Doat and in 1912 was reorganized on more spartan lines, continuing to produce exceptional porcelains until 1915, when Doat returned permanently to France.

Whatever its failings, the venture proved to be a significant one. It was through the American Women's League that Robineau assembled a group of fifty-five of her porcelains and submitted them to the Turin exposition in 1911.[53] The group that included the so-called *Scarab Vase* was given the Grand Prix, the highest award at the exposition, as well as a Diploma della Benemerenza, adjudging her porcelains the finest in the world. The award was a signal honor, achieved in the face of competition from Sèvres, Meissen, and other major porcelain factories in Europe. What they achieved through skilled teams of artisans and artists, Robineau, with the support of dutiful Samuel, had matched and surpassed. She exhibited the following year at both the Paris Salon and the Musée des Arts Décoratifs. While in Paris, she demonstrated her throwing skills at the Sèvres manufactory to prove that the forms were not cast and that porcelain could be used to throw with precision.[54]

Mention must be made of the *Scarab Vase*, one of the most famous pieces of American ceramic art. The vase was titled *Apotheosis of the Toiler* (1910), an appropriate title for a lidded jar that reputedly took 1,000 hours to carve. Literally and figuratively, it stands as a monument to the Protestant work ethic, depicting the beetle working upward toward the lid in search of the reward—food. It is difficult to understand the commitment that this vase represented without some knowledge of the technique employed by Robineau. Rhead was present during its making and recorded the detailed process involved:

> It is a definite fact that carving or excising is the most risky process of all. The carving cannot be well done until the piece is dry, and it is im-

possible to cut with the freedom possible in wood and ivory. The material is so short and brittle that any undue pressure will chip the surface. A line or excised surface of any depth must be extremely carefully scraped away bit by bit, gradually going deeper. A slight difference in the pressure of the tool, and considerable work, if not an entire piece can be ruined. I have seen the Scarab vase in all its stages of construction. Many times Mrs. Robineau would work all day, and on an otherwise clean floor there would be enough dry porcelain dust to cover a dollar piece and half an inch more carving on the vase.[55]

The *Scarab Vase* was the symbol of the aesthetic of the age, the search for perfection and control that was repeated in the work of the Binns school as well. For instance, Binns would throw his forms, even small vases, in three sections. He would then turn them on a lathe to the desired thinness and the exact shape he required and then reassemble them. An indication of his artistic credo can be gleaned from the following excerpt from an article titled "In Defense of Fire": "glazes must acknowledge the artistic restraint by which the whole work is controlled. Not an ear drop of molten glaze must pass the limit. At the bottom of every piece is a tiny rim of dead ground, a bisque line of demarcation. This far the fluid glaze can come, but no further." [56] This formalism, which both Robineau and Binns represented in different ways, continued to be an influence for many decades. The American potter, having obtained a tangible success in technical and design terms, was reluctant to leave the safety of these disciplines and take on the aesthetic of risk and invention. The decade ended prematurely in art terms at the 1915 Panama-Pacific International Exposition in San Francisco. From there on, the harsh reality of the war dominated ceramics, and the Arts and Crafts Movement became an irrelevant issue in the next four years. When the war ended, the ceramists and potters found that the energies that gave impetus to the Arts and Crafts Movement had been spent and much of the public support had been lost, and in their search for patronage, they drew closer to the educational establishment.

80

80. Taxile Doat working at the School of Ceramic Art, People's University, University City, St. Louis, Missouri, c. 1910.

81. Katherine E. Cherry, People's University, University City, St. Louis, Missouri. *Vase,* 1910–1911. Porcelain with gold- and copper-colored floral overglaze decoration, H. 9". Collection New Library, University City.

82. Taxile Doat, People's University, University City, St. Louis, Missouri. *Plate,* 1910. Porcelain, glazed, medallion decoration. Diam. 14½" Collection New Library, University City.

83. Taxile Doat, University City Pottery, St. Louis, Missouri. *Gourd Vase,* 1912. Mat-glazed porcelain, H. 9". Private collection. Photograph: Garth Clark/Lynne Wagner.

84. Frederick Hurten Rhead, People's University, University City, St. Louis, Missouri. *American Women's League Teapot,* 1910. Porcelain, glazed, H. 7". Collection New Library, University City.

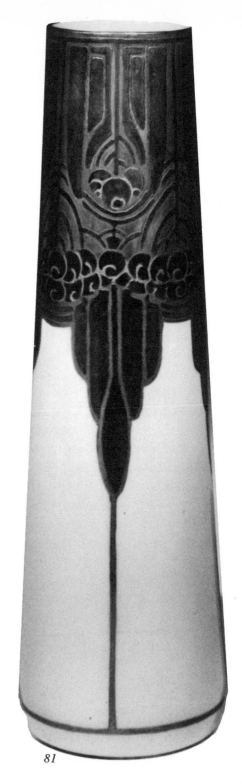

81

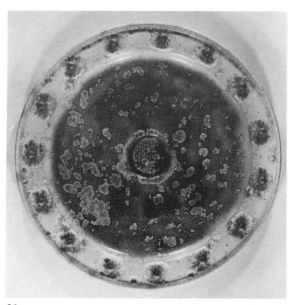

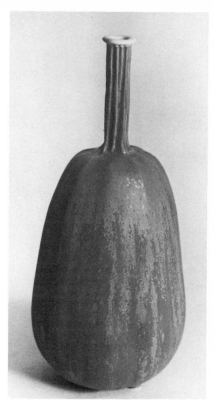

82

83

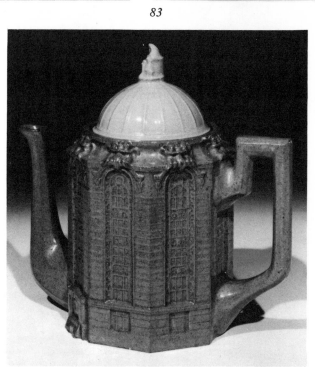

84

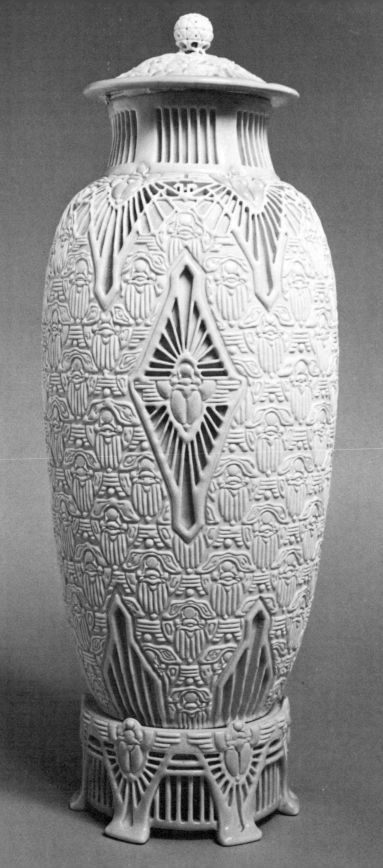

85. Adelaide Alsop Robineau, People's University, St. Louis, Missouri. *Scarab Vase*, 1910. Excised and carved glazed porcelain, H. 16⅝". Collection Everson Museum of Art, Syracuse.

86. Adelaide Alsop Robineau working on the *Scarab Vase* at the People's University, St. Louis, Missouri, 1910. When the vase was bisque-fired, it emerged with three big gaping cracks. It was carefully restored and glazed and reemerged in perfect condition.

87. Adelaide Alsop Robineau, Syracuse, New York. *Peruvian Serpent Bowl*, 1919. Porcelain, H. 2⅝". Collection The Metropolitan Museum of Art, New York.

86

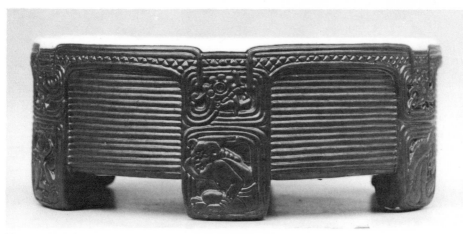

87

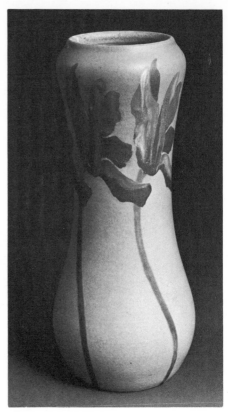

89

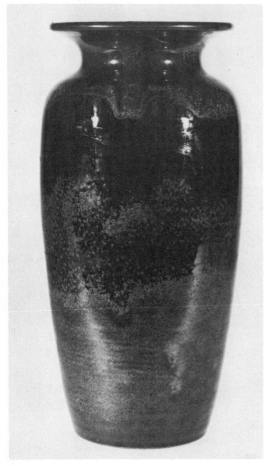

88

88. Charles Fergus Binns, Alfred, New York. *Vase*, 1916. Stoneware, H. 10¾". Collection The Detroit Institute of Arts, Detroit, Michigan; Gift of Mr. George G. Booth.

89. Albert R. Valentien, Valentien Pottery, San Diego, California. *Vase*, c. 1915. Mat-glazed earthenware, H. 11¾". Collection Michiko and Alfred Nobel. Photograph: Courtesy Art Gallery of California State University at Fullerton.

90. Fulper Pottery, Flemington, New Jersey. *Bottle*, c. 1912. Glazed ceramic, H. 9¾". Collection Jordan-Volpe Gallery, New York. Photograph: Taylor & Dull.

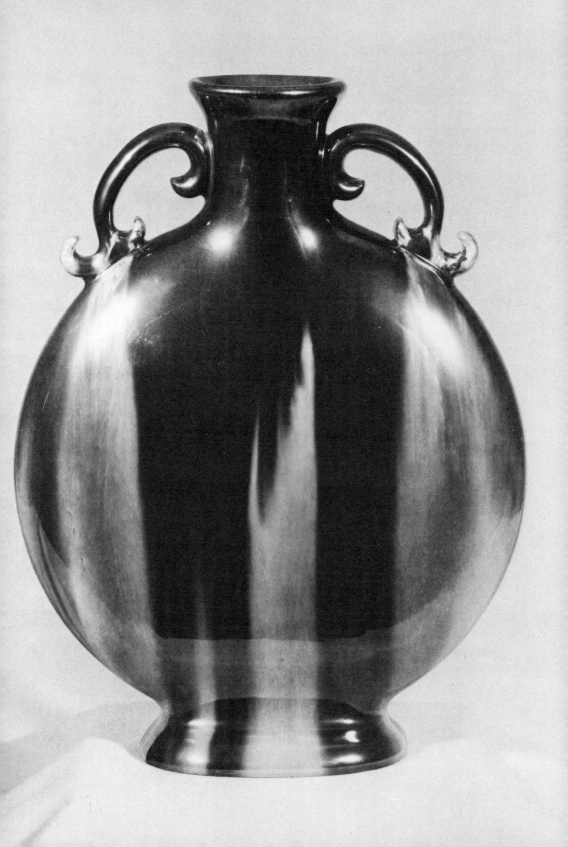

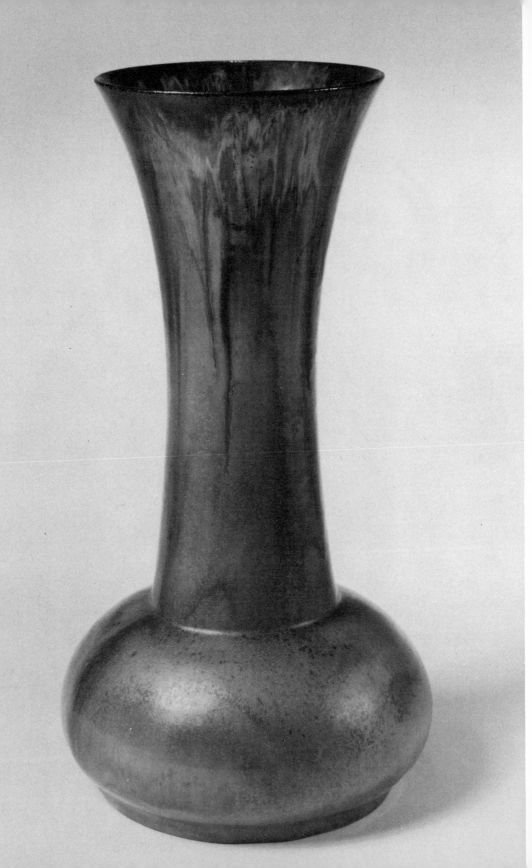

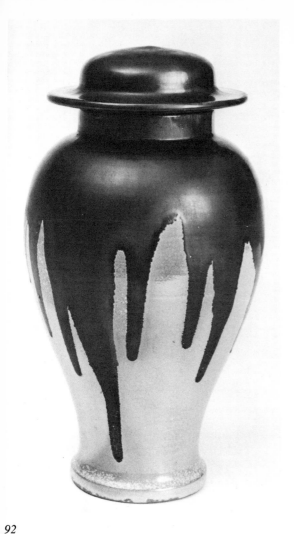

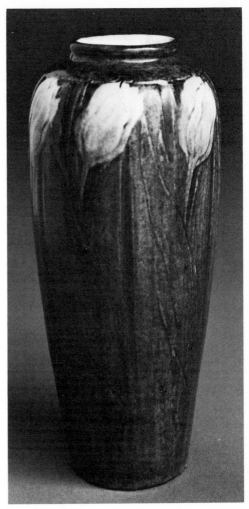

92

93

91. Fulper Pottery, Flemington, New Jersey. *Vase,* c. 1915. Glazed ceramic, H. 10″. Collection Philadelphia Museum of Art; Purchase: The Baugh-Barber Fund.

92. R. Guy Cowan, Cowan Pottery Studio, Cleveland, Ohio. *Ginger Jar,* 1917. Earthenware, orange luster with black drip glaze, H. 14″. Collection Cowan Pottery Museum, Rocky River Public Library, Ohio.

93. Anna Frances Simpson, Newcomb Pottery, New Orleans, Louisiana. *Vase,* 1910–1912. Earthenware, H. 8¼″. Collection Michiko and Alfred Nobel. Photograph: Mark Schwartz.

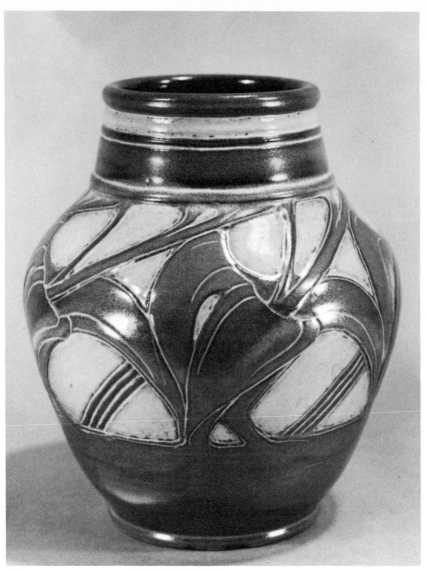

94

94. Sadie Irvine, Newcomb Pottery, New Orleans, Louisiana. *Vase,* c. 1910–1911. Glazed earthenware, H. 6⅞".
Collection Cincinnati Art Museum; Gift of Miss Mary G.
Sheerer.

1920

After the war, concerns of the art establishment turned against the romantic craftsmanship of the previous decade, as "modernism" became *de rigueur* in art and design. It was the decade that began the uneasy marriage between art and industry, never to be fully consummated, and that found its expression in the machine art exhibitions held annually at The Museum of Modern Art, New York. It was out of this involvement that the museum conceived its curious policy that functional ceramics made by industry could be art, whereas a vessel made by a potter with a wealth of intuition was craft and by implication of lesser importance.[57] Very little was produced in American ceramics that conformed to the cultist machine-age ethic. The small cadre of potters in America were in the process of discovering their past and were little concerned with the present, much less the future represented by the vanguardist art movements. The vessels produced during the 1920s were contemporary interpretations of the Tz'u-chou, Sung, and Tang, as well as the ancient works of Egypt and Persia. The strongest contemporary influence came from the Art Deco potters of France, themselves involved in a somewhat decadent rephrasing of past styles.

It is not surprising, therefore, that Frank Lloyd Wright wrote pessimistically of ceramics in the United States, for, to the uninvolved observer, the foundations that were being built for later achievement were not immediately apparent:

> We have little or nothing to say in the clay figure or pottery as a concrete expression of the ideal of beauty that is our own. No sense of form has developed among us that can be called creative—adapted to that material. And it may never come. The life that flowed into this channel in ancient times apparently now goes somewhere else.[58]

The decade has few but important highlights. In 1928 the American Federation of Arts organized the International Exhibition of Ceramic Art. It opened at The Metropolitan Museum of Art in New York and subsequently traveled to seven other museums, attracting considerable attention from the daily press and art magazines. The best American pottery of the time—painted earthenware by Henry Varnum Poor, Hunt Diederich, and Carl Walters and the spartan later works of Robineau—were arrayed alongside the objects of Europe's best ceramists and potters, Bernard Leach, Michael Cardew, William Staite Murray, Emile Decoeur, Emile Lenoble, Susi Singer, Vally Wieselthier, Hertha Bucher, and others. The comparison was instructive and showed that although the American potters could equal the technical achievement of their European counterparts, the genre as a whole lacked direction and was in a quandary how to employ its newfound skills. The naïveté of the American potters at that point can be gleaned from Arthur Baggs's delight in 1929 in discovering the plastic qualities "of the potter's thumbprint" after twenty-four years as a practicing potter.[59]

The lessons were being learned slowly as the potter tried to outgrow the bias of the Alfred school, which tended to treat vessel making as an area of solving design problems rather than approaching it as an art of expression.

The sterility of the pottery was compensated for by evident signs of growth in ceramic sculpture. Until the 1920s, the sculptural treatment of clay in America either had been confined to the pompous art porcelains of Trenton or else was incorporated into the vessel format as in the work of Anna Valentien, Van Briggle, and others. Two artists were to play a formative role in the development and acceptance of ceramics as an independent decorative sculptural genre: Carl Walters and R. Guy Cowan. Walters was the first artist of consequence to use the material, and Cowan set about orchestrating the institutions and instruments of power needed to establish the medium as a separate and valid art genre.

Walters was a successful painter when he decided to move to a new material. His first efforts in 1921 resulted in painted pottery, but from 1922 on, with the setting up of his kilns in Woodstock, New York, Walters began to produce a body of figurative work. His first showing was in 1924 at the Whitney Studio Club, and one of the pieces from this showing, *The Stallion,* was purchased by the museum. Walters dealt almost exclusively with animal subjects, although he did do a few human figures, one of the best being the circus fat lady *Ella* (1927) in the collection of The Museum of Modern Art,

a voluptuous figure that threatens to overwhelm the spidery, wrought-iron boudoir stool on which it is seated.

Stylistically Walters's work is difficult to place. It has associations with what has been termed *folk realism* in painting of the period. One also finds some of the whimsy in his pieces that later became a stamp of American ceramic sculpture, but it is presented without the sentimentality of the Austrian or Ohio schools. Walters was clearly American in his boldness, verve, and ingenuity of technique, yet as William Homer commented in his memorial tribute:

> It is difficult to associate him with a native style in ceramics. Because the United States depended heavily on European examples until the present century and because of our insistence on pottery as a utilitarian art, no unified American style had emerged when Walters appeared on the scene. He shared the general spirit of American work in this medium but his main sources were ancient Egypt, Persia and China. By turning to the masters of this art in the distant past, he recaptured the dignity of the medium—and in so doing restored glazed pottery as a sculptural material.[60]

Cowan had begun to campaign actively for the cause from 1925, the interest stemming from his production of limited-edition figurines at the Cowan Pottery Studio in Rocky River, a suburb of Cleveland. The aesthetic level of the early figures was uneven, and the term *ceramic sculpture,* so often used in descriptions of his work, can be applied only loosely. From 1927, however, his standards improved markedly. Several talented designers worked with Cowan, including Alexander Blazys and Waylande DeSantis Gregory. The group of Russian peasant figures made by Blazys were given the first prize to be awarded for ceramic sculpture as a separate category at the 1927 Annual Exhibition of Work by Cleveland Artists and Craftsmen—also known as the May Show.

This success was a double victory for Cowan, for not only was the prize-winning piece from his studio but the creation of the award was the direct result of his shrewd lobbying in Cleveland art circles. The director of the museum, William M. Milliken, became an enthusiastic patron of ceramics, and "all the prestige of the Cleveland Museum was thrown behind the ceramic artists so as to encourage the creative." [61] Milliken joined with the Cleveland School of Art and Cowan Pottery to encourage ceramic sculpture. Cowan taught at the school and employed the students at his pottery while Milliken provided a platform for their work at the May Shows. From 1928

on, an experimental laboratory in ceramic sculpture was run at the school by Cowan, Baggs (for a short period), and Mrs. A. R. Dyer. This initial class produced most of the future luminaries of the movement: Viktor Schreckengost, Thelma Frazier, Edward Winter, Paul Bogatay, Russell Aitken, and Edris Eckhardt. In 1930 Cowan Pottery Studio went into receivership, a victim of the Depression, and Cowan moved to Syracuse, New York. But he had been a successful catalyst, and the momentum that had been built up accelerated in the 1930s—still aided and abetted by Cowan, who played a central role in the growth of the Ceramic Nationals during the 1930s.

Finally, it is important to acknowledge the strong influence of Austrian ceramics on the direction that sculptural-figurative ceramics was to take in the coming years. The 1925 Paris Exposition Internationale des Arts Décoratifs de Industriels Modernes had reintroduced a strong European influence. The works in this exhibition were given saturation coverage in a series of ten articles written by Adelaide Robineau and published in *Design-Keramik Studio*. At first, the French Art Deco pottery attracted most interest, but gradually the Austrian artists working with the Wiener Werkstätte [62] in Vienna began to dominate. Their work excited much controversy at the highly publicized 1928 International Exhibition of Ceramic Art at The Metropolitan Museum of Art in New York. The critic Helen Appleton Read denounced their "careless technique and frivolity" [63] as being tired and vulgar. The factor that most critics missed was that the "modern style of sobriety and dignity of form" they demanded had already been explored by the Viennese ceramists at the turn of the century in the seminal *Sezessionstil* aesthetic. This cold architectonic use of clay was now being replaced with a witty, expressionist liberation of the material's potential for polychrome figurative imagery.

The *Wiener Werkstätte style,* as it was termed, had an immediate impact on the American ceramic arts despite its mixed critical reception. Several artists went to study in Vienna under Michael Powolny at the Kunstgewerbeschule, including Russell Aitken, Viktor Schreckengost, and Ruth Randall, and two of Vienna's most celebrated ceramists, Vally Wieselthier and Susi Singer, were to make the United States their home. Wieselthier arrived in New York in 1929 and joined the decorative arts group, Contempora, exhibiting at the Art Center in that year. Wieselthier proved to be a strong influence and an articulate spokesman for a particular school of decorative

sculpture. Writing soon after her arrival in the United States, she explained the raison d'être behind her work:

> There are arts which have no deep message to give the world save that of their own beauty and the artist's joy in making, intimate arts that make life gayer, and yet have all the seriousness of a thing that is felt intensely and worked out with the utmost care. Of these pottery is the chief. . . . Good pottery has the feeling of its purpose always in it; it expresses attitudes and moments of life which to the great poet or prophet may seem almost superficial but are, for the ordinary people, of the very stuff of life itself, the delight of the true "Lebenskünstler." [64]

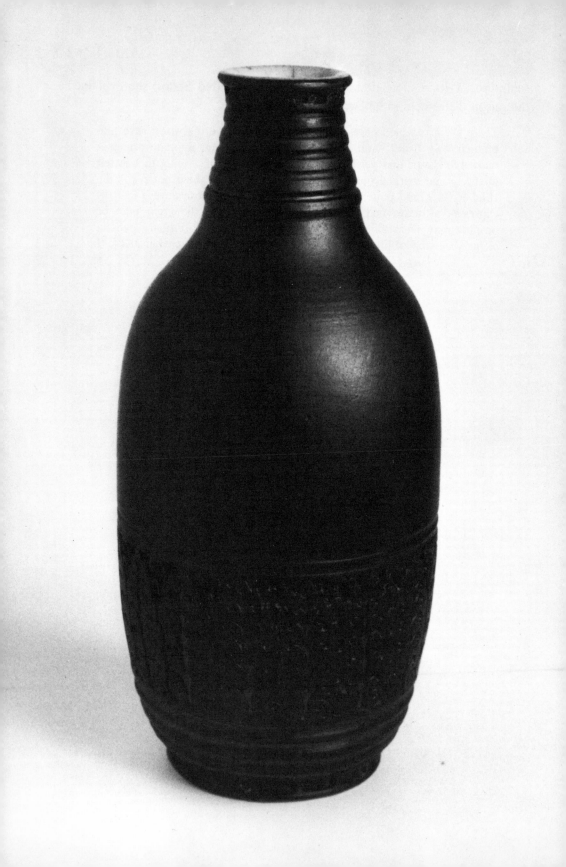

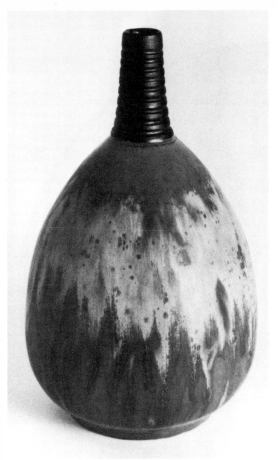

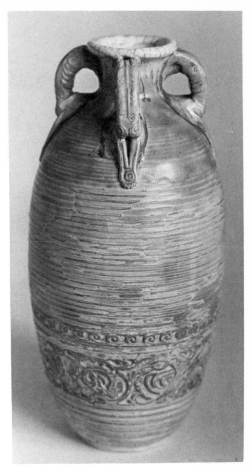

96 97

95. Adelaide Alsop Robineau, Syracuse, New York. *Vase,*
1928. Porcelain with black/bronze glaze, H. 7¾". Collec-
tion Everson Museum of Art, Syracuse. Photograph: Garth
Clark/Lynne Wagner.

96. Adelaide Alsop Robineau, Syracuse, New York.
Gourd Vase, 1926. Porcelain, H. 8½". Collection Everson
Museum of Art, Syracuse. Photograph: Garth Clark/
Lynne Wagner.

97. Adelaide Alsop Robineau, Syracuse, New York. *The
Sea,* 1927. Porcelain, glazed, carved decoration, H. 8⅝".
Collection Everson Museum of Art, Syracuse. Photograph:
Garth Clark/Lynne Wagner.

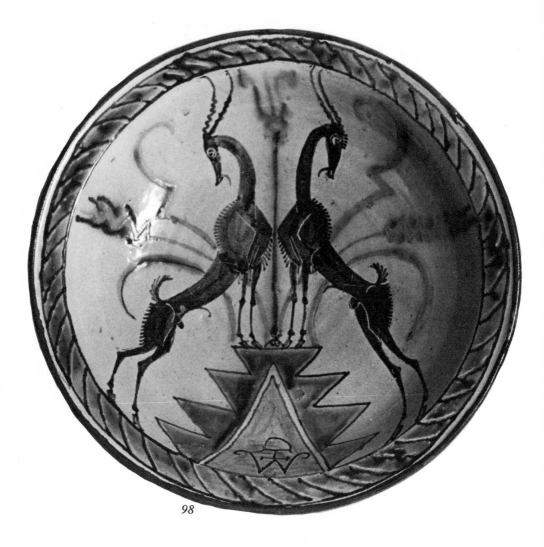

98

98. Hunt Diederich, New York. *Bowl,* 1926–1927. Under-glaze-painted earthenware, Diam. 15⅜″. Private collection. Photograph: Garth Clark/Lynne Wagner.

99. Charles Fergus Binns, Alfred, New York. *Bowl,* 1929. Stoneware, glazed, Diam. 7½″. Collection The Metropolitan Museum of Art; Gift of Henrietta M. Crawford.

100. Henry Varnum Poor, Pomona, Rockland County, New York. *Duck Plate,* 1928. Earthenware, underglaze painting, Diam. 11″. Collection The Metropolitan Museum of Art, New York.

101. Hunt Diederich, New York. *Cowboy Mounting Horse,* 1929. Glazed earthenware plate. Diam. 15″. Collection The Metropolitan Museum of Art, New York.

99

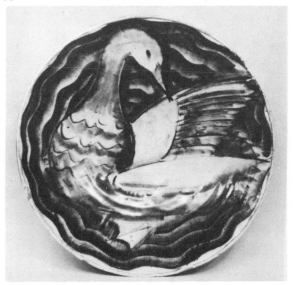

100

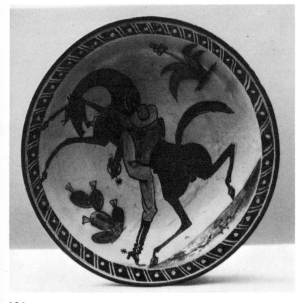

101

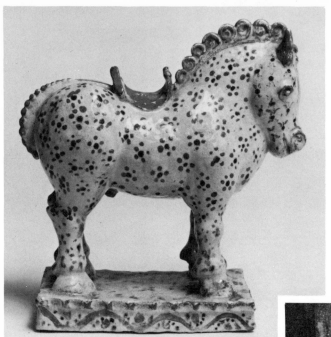

102

102. Carl Walters, Woodstock, New York. *The Stallion*, 1921. Glazed earthenware, H. 10½". Collection Whitney Museum of American Art, New York. Photograph: Geoffrey Clements.

103. Carl Walters in his studio in Woodstock, New York. c. 1949. The bull on the decorating stand is similar to a piece completed in 1927 and now in the collection of the Whitney Museum of American Art, New York.

104. Carl Walters, Woodstock, New York. *Figure of a Duck*, 1929. Earthenware, underglaze colors of mulberry, brick red, and yellow on cream ground, L. 11½". Collection The Metropolitan Museum of Art, New York.

103

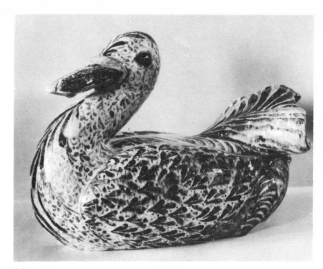

104

106

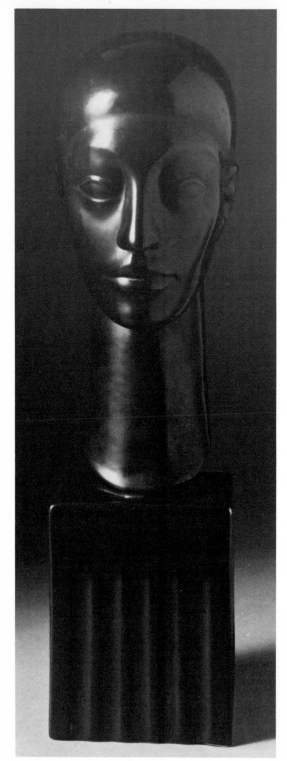

105

105. A. Drexler Jacobsen, Cowan Pottery Studio, Rocky River, Ohio. *Antinaeus,* 1928. Glazed porcelain, H. 13½″. Collection Everson Museum of Art, Syracuse. Photograph: Robert Lorenz.

106. R. Guy Cowan. c. 1930. Photograph courtesy Cowan Pottery Museum, Rocky River Public Library, Ohio.

107. Alexander Blazys, Cowan Pottery Studio, Rocky River, Ohio. *Russian Peasants,* 1927. Glazed porcelain, H. 10″. Collection Cowan Pottery Museum, Rocky River Public Library.

108. R. Guy Cowan, Cleveland, Ohio. *Madonna and Child,* 1927. Earthenware, molded, one of an edition of fifteen, H. 18⅝″. Exhibited 1928 at the Tenth Annual Cleveland Artist and Craftsman Exhibition. Awarded First Prize for Ceramic Sculpture. Collection The Cleveland Museum of Art; Purchase: Dudley P. Allen Fund.

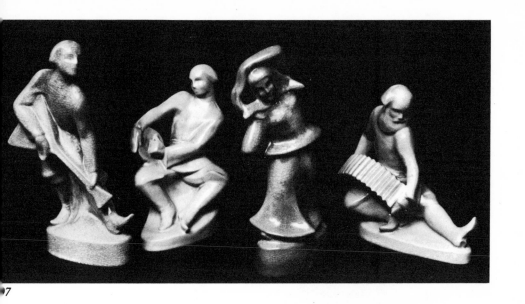

7

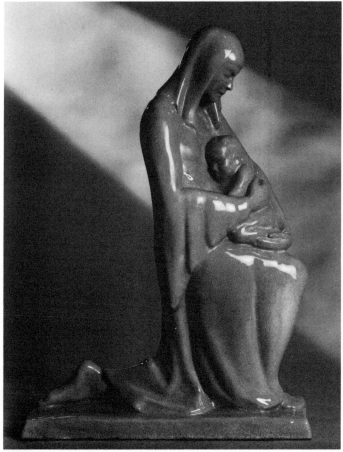

108

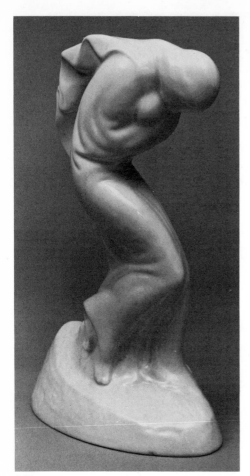

110

109

109. Waylande Gregory, Cowan Pottery Studio, Rocky River, Ohio. *Margarita*, 1929. Glazed porcelain, H. 16″. Collection Cowan Pottery Museum, Rocky River Public Library.

110. Waylande Gregory, Cowan Pottery Studio, Rocky River, Ohio. *Vase*, 1930. Glazed stoneware, H. 9″. Collection Cowan Pottery Museum, Rocky River Public Library.

111. Vally Wieselthier alongside one of her garden figures. c. 1929. Wieselthier, a leading European ceramist, immigrated to the United States in 1929.

111

92

1930

The 1930s produced a number of developments: the beginning of a challenging vessel aesthetic, the establishment of a decorative ceramic sculpture movement, and most significantly, the founding of the Ceramic Nationals in Syracuse—these annuals being the major platform for the ceramic arts for the next forty years. All this activity took place under the cloud of the Great Depression and its aftermath. The austerity of the decade had an indelible influence on the decorative arts. It promoted a sense of whimsy and humor as a visual antidote to the harsh realities of day-to-day life that ideally suited polychrome figurative sculpture. More subtly, it gave many of the ceramists and potters a sense of ideological mission. Recalling their reaction to the 1930s, Mary Chase Perry remembered how the flow of cheaply produced industrial bric-a-brac offended the craftsmen of the day:

> We had been given a flood of the commonplace, the crude and the unlovely. That is why it was important for the individual craftsman to keep working and to keep his place in the community, to train our eyes to recognise the fine things. That is one reason why hand-made pottery will always be needed and why the craftsman's studio will always have a place in the scheme of things.[65]

The view was somewhat simplistic but did provide a necessary purpose and idealism. In retrospect, only a few craftsmen provided the bulwark against ugliness; many created as much unlovely bric-a-brac as industry. In fact, some of the most superb examples of clay vessels during this period came from industry, notably the powerful, sleek forms of the so-called refrigerator-ware produced as giveaways and premium offers for the refrigerator manufacturers.

The Depression proved to be a double-edged sword for ceramics. On the one hand, it did staunch any experimental or avant-garde inclinations. What proved to be salable were classical vessels and jocular, amusing sculpture. But the austerity did give attention to and encourage the use of cheaper materials. This introduced several "visitors" to the medium, such as Alexander Archipenko, Reuben Nakian, Isamu Noguchi, and Elie Nadelman.[66] Until 1930 Nadelman had been working mainly on large, monumental figures, but with the decline of his fortunes, and the loss of his home and studio, he turned to experimenting with plaster, papier-mâché, and ceramics in the hope that "room-size statuary, mass produced in inexpensive materials could channel a residual interest in free standing figures." [67] His respect for the more common materials was an outgrowth of Nadelman's consuming interest in folk art. The figures he formed from clay and glazed simply in white, grays, yellows, and blacks have the directness of the objects he respected and collected, the toys of the Central European folk artists, and the baked clay figures of Tanagra and Taranto. The commanding elegance in these ceramics in 1934–1935 gave way to a fragmented and cursory modeling. Upon his death, hundreds of small plaster and ceramic figures were found in his studio and comprised his last body of work. The figures were bloated and disfigured and yet strangely compelling and erotic. Nadelman was happy with his works in clay and believed that he had "achieved what he wanted" [68] in these works. They remain some of the most enigmatic pieces of American sculpture and to a great extent defy categorization:

> These strange creatures, last objects from Nadelman's hands, are reminiscent of nearly everything from ancient cult figures, Kewpie dolls and Mae West to circus performers, burlesque queens and chorus girls. Despite numerous interpretations the figurines remain totally mystifying, the baffling culmination of a lifetime in sculpture.[69]

The Depression also resulted in the Welfare Art Program of the Works Progress Administration, which was the solution offered by Roosevelt's "New Deal" brain trust to maintaining the professional artist and so, the cultural momentum of the nation. The WAP/WPA invited artists to work on projects for a subsistence wage of around $97 a month. Because the program was biased toward populist forms of expression, ceramics fared well. Ceramic sculpture was produced in various parts of the country—some of the better works coming from Tony Rosenthal and Emmanuel Viviano in Chicago and Sargent Johnston in San Francisco. In addition, a Ceramic Sculpture Division was set up under the aegis of the WAP program at Cleveland—reinforcing the importance of Ohio as a ceramic arts center during the 1930s. The divi-

sion was directed by Edris Eckhardt, and under her pragmatic guidance, it undertook a number of projects: figures from children's literature were created for display in the libraries throughout the nation, murals and garden ornaments were produced for estates around Cleveland, and murals were painted for public buildings.[70]

The preference for public rather than private artworks through WAP/WPA patronage resulted in an ambitious approach to scale as ceramists sought to rival the monumental outdoor works produced in bronze. One of the most successful in this regard was Waylande DeSantis Gregory. In 1938 he completed his largest work, *The Fountain of Atoms,* arguably the largest single work in modern ceramic sculpture. Created for the World's Fair in New York in 1939–1940, it comprised twelve colossal earthenware figures, each weighing over a ton: *Fire, Earth, Air, Water,* and the eight *Electrons.* They were an extraordinary technical achievement. Gregory developed a honeycomb method of building up the pieces in the same manner as the wasp builds up its nest of mud: what he termed "inner modeling."[71] The work was returned to Gregory's New Jersey studio in 1941, and its present whereabouts is unknown. What remains is an enticing description of the sybarist works as seen by writer E. W. Watson in 1944:

> In the "water" a sculptured male swimmer of warm terra cotta descends through swirling, watery forms of green-blue glass, accompanied by maroon fish and lemon bubbles. The fire figure is covered in tongues of reddish glaze and reflected areas of faint blue and green. The colour tone being handled so as to give the sense of being viewed through fumes.[72]

The success enjoyed by Gregory and other ceramists in the 1930s was also the result of the attention drawn to the potential of the medium by the annual Ceramic Nationals [73] inaugurated as a memorial to Adelaide Robineau by Anna Olmsted, the director of the Syracuse Museum of Fine Arts in Syracuse, New York. In the first year, entries were restricted to artists from New York State, and no funds were available for either a catalogue or proper installation. The objects were set out on sateen-covered folding banquet tables borrowed from the YMCA. In 1933 the annual was declared "open to potters of the United States." Writing to Carlton Atherton, Professor of Art at Ohio State University, who had assisted in the first annual, Olmsted remarked that the city had again cut the museum budget and that the exhibition's allocation for the full year was now $419.00. "Perhaps it is rather mad to consider a *national* exhibition just now," she concluded, "but with no other

national exhibition devoted exclusively to ceramics in the country this might truly be the chance of a lifetime, and the museum ought to be put on the art map thereby." [74] They were prophetic words.

The second annual drew works from eleven states and 199 pieces representing seventy-two ceramists listed in a simple catalogue. There followed a period of hand-to-mouth improvisation, and the annual survived only as a result of Olmsted's indefatigable energy and optimism and later through R. Guy Cowan's efforts in obtaining corporate support. Among the many credits for assistance in the early years was a regular and curious entry, the Marcellus Casket Company. Olmsted had discovered that the casket manufacturer had a large stock of boxes in which the caskets were shipped. These, covered in sateen, lined the walls of the annual for several years, with smaller crates, used for infants' caskets, serving as pedestals. The installation for each annual began with the arrival of the Marcellus truck with its macabre cargo. This seemingly irrelevant "exposé" of the poverty of the museum rather amused the Rockefeller Foundation and was instrumental in obtaining financial assistance from the foundation for one of the annual's major achievements of the decade, the first exhibition of American ceramics to tour abroad.[75]

The exhibition of 133 pieces went to Helsinki; Göteborg, Sweden; and Copenhagen. On its return, it was engaged for an unscheduled showing at the Hanley Museum in Stoke-on-Trent before coming back in triumph to the Whitney Museum of American Art in New York. The tour and the exhibition at the Whitney received enthusiastic notices in the national press and art magazines. One of the most instructive was an article in *Fortune* magazine titled "Ceramics: The Art with the Inferiority Complex." In this special portfolio, with eight pages of color illustration, the anonymous writer remarked that America had yet to produce its Wedgwoods, Böttgers, or a Wiener Keramik and that, by comparison with Europe and the East, "has lacked even a high point from which to decline." For this reason, the writer concluded, the interest and growth in ceramics in the 1930s was more portentous than simply a passing fashionable fad and that the boisterous, mock-heroic figures of Russell Aitken, the speckled bulls of Carl Walters, and the terra-cotta horses of Waylande Gregory represented a breakthrough:

> The stodgier collectors of pottery, with one eye cocked on ancient China and the other on price, may damn such pieces as miniature giraffes and small shiny ruminating hippopotamuses as expensive bric-a-brac. But ceramic enthusiasts see them as signs of the vitality of a growing American art, and if they are true collectors, treasure them in the way that the homeowners of Rome probably treasured their collections of unterrify-

ing, homely, familiar little household gods. American ceramic art is beginning to show signs of life.[76]

The signs of life were not as evident in the vessel aesthetic—dressed in its less theatrical forms and glazes—but they were there nonetheless. The 1930s showed signs of strong maturity in the work of Charles Harder, Arthur Baggs, Glen Lukens, and others who exhibited regularly in the Ceramic Nationals. It was also a time when European artists began to play an influential role; the Swiss potter Paul Bonifas, Maija Grotell from Finland, Gertrud and Otto Natzler from Austria, and the Bauhaus-trained Marguerite Wildenhain. Each made important contributions. Bonifas taught at the University of Washington, Seattle, promoting a purist concept of pottery that had been developed in collaboration with his close friend, the French purist Ozenfant. Grotell and the Natzlers concentrated on decorative pottery, and Wildenhain introduced an aesthetic and ideology for the modern functional potter. The latter provided a welcome alternative to the often self-indulgent and arbitrary form of purely decorative pottery.

During this decade the work of the American potters was shown abroad at several exhibitions, with Charles Harder taking one of the Gold Medals at the 1937 Paris Exposition. Baggs showed new life with his salt-glazed wares, which realized his ambition, declared earlier, to direct his work toward "emphasizing clay's fundamental characteristics, plasticity and the beautiful qualities of surface." [77] In 1938 he produced one of the classics of the period, the "definitive" Cookie Jar, which won the pottery prize at the 1938 Ceramic National. However, despite the fact that both Harder's and Baggs's work had improved enormously, neither was able to exorcise fully the "designerly" approach that Binns had inbred during their early education.

The same error was evident in the ceramic education of the times. Ceramics was not taught as a discipline in itself but very much as a convenient tool of art education. Clay was a simple, plastic, and above all, cheap material with which trainee teachers could learn about surface, texture, color, and form. Although the interest in ceramic education grew and the medium was popularized as a result, it was at high cost. The "art education" approach did not acknowledge that the material had its own specific and long-standing tradition as an art form. Literature proliferated, but it was of the simplistic "twenty ways to make a clay horse" variety—a bandwagon that later attracted even the usually discerning Museum of Modern Art. The entire emphasis was now placed on the "how-to" aspect of the art. Both Baggs

at Ohio State and Harder at Alfred did advocate a more progressive view, but it was Glen Lukens who most impressively was the man of his time.

The course that Lukens taught at the University of California at Los Angeles from 1934 onward was established initially with structured art-education purposes. Lukens succeeded in introducing a sensitivity to the materials and a respect for its traditions. He achieved this by advocating a gentle monistic view of creativity that anticipated the attitude that Bernard Leach was to propose in 1940 in his classic, *A Potter's Book.* Lukens had at first been taught to believe, as had most of his contemporaries, that in art cleverness was the aim. Through a close friend, he discovered that this approach simply externalized the creative process and that to escape this self-consciousness, the potter must sublimate his ego to the material and explore a more inward experience:

> There in New Mexico among the priceless remains of a magnificent pre-Civilization, I was taught to study the self expression of a race of people who for more than a thousand years trained the mechanism of the consciousness so that what they now do takes place independently of the conscious intelligence. The only approach to a sound philosophy of life. The one sure approach to creativity in art.[78]

Lukens was an influence because his works matched his rhetoric. He succeeded in the difficult task of making an almost primitive statement without seeming to be what the French term *faux naïf.* His forms went beyond simplicity and can best be termed *primal shapes,* with their thick viscous glazes developed from local raw materials. These glazes in strong yellows, turquoises, and greens were, in the words of R. G. Cowan, "as luscious as ripe fruit." Lukens was an inspiration to his fellow artists on the West Coast and instrumental in getting the ceramics movement underway there when in 1938 the first all-California Ceramic Art Exhibition was held. The positive reviews that the event received confirmed his success in trying to raise standards. "This exhibition," he announced, "means that the Pacific Coast ceramic child is able to walk alone." [79] Lukens lived into the 1960s and was able to see the fruits of that first step as California began to play the central role in the growth of the ceramic arts.

112. Viktor Schreckengost, Cowan Pottery Studio, Rocky River, Ohio. *Punch Bowl,* 1931. Porcelain with sgraffito decoration, H. 11½". Collection Cowan Pottery Museum, Rocky River Public Library.

113. Alexander Archipenko, New York. *Walking Woman,* 1937. Earthenware, H. 25½". Courtesy Perls Galleries, New York.

113

112

114. Reuben Nakian, New York. *The Lap Dog,* 1927. Terra-cotta, H. 6½". Collection Whitney Museum of American Art. Photograph: Geoffrey Clements.

115. Isamu Noguchi. *The Queen,* 1931. Terra-cotta, H. 45½". Collection Whitney Museum of American Art. Photograph: Geoffrey Clements.

114

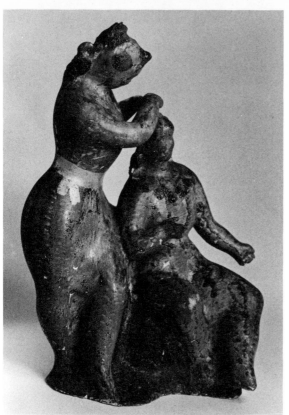

116

116. Elie Nadelman, New York. *One Woman Doing Another's Hair,* 1934–1935. Gray glazed earthenware, H. 14". Collection Jan Nadelman. Photograph: Garth Clark/Lynne Wagner.

117. Elie Nadelman, New York. *Seated Nude,* 1933–1935. Glazed earthenware and wood, H. 7". Collection Jan Nadelman. Photograph: Garth Clark/Lynne Wagner.

118. Elie Nadelman, New York. *Two Acrobats,* 1934. Glazed earthenware, H. 10¾". Collection Hirshhorn Museum and Sculpture Garden, Smithsonian Institution, Washington, D.C.

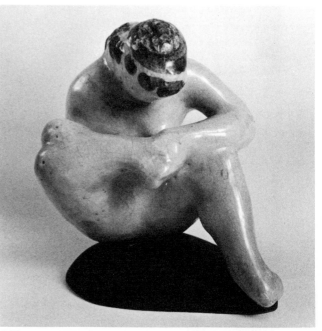

117

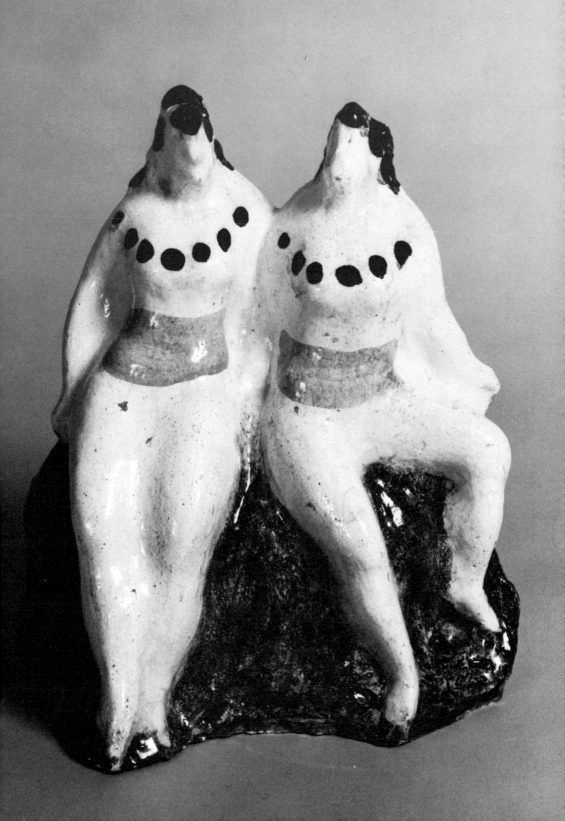

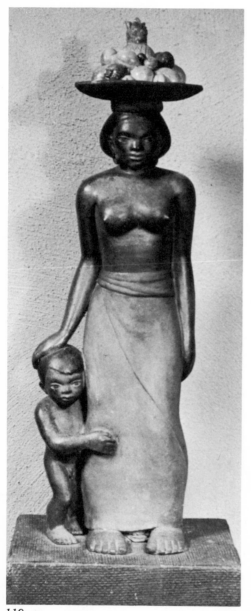

119

120

121

119. Paul Bogatay, Columbus, Ohio. *Javanese Mother and Child,* c. 1935. Earthenware, H. 22″. Photograph: Todd Bogatay.

120. Edris Eckhardt working on *Huckleberry Finn,* a sculpture commission by Eleanor Roosevelt, Cleveland, Ohio, 1939. Present whereabouts unknown.

121. Ruth Randall, Syracuse, New York. *Madame Queen,* 1935. Glazed earthenware, H. 11½″. Collection Everson Museum of Art, Syracuse.

122. Waylande Gregory photographed in his studio at Bound Brook, New Jersey, c. 1938, alongside *Sea* and *Fire,* two of twelve figures for the *Fountain of Atoms,* which was completed in 1938 and exhibited at the 1939 World's Fair in New York.

123. Edris Eckhardt, WAP/WPA Program, Cleveland, Ohio. *Alice in Wonderland Series,* 1935–1936. One of four pieces, earthenware, glazed, H. 5″. Collection The Cleveland Public Library.

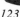

123

105

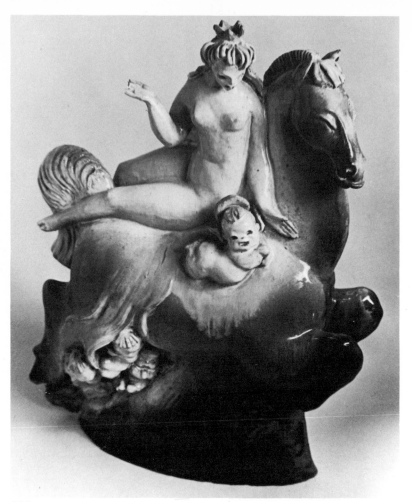

124

124. Thelma Winter Frazier, Cleveland, Ohio. *Night with Young Moon,* 1938. Glazed earthenware, H. 16½". Collection Everson Museum of Art, Syracuse, New York. Photograph: Garth Clark/Lynne Wagner.

125. Waylande Gregory, Metuchen, New Jersey. *Europa,* 1938. Unglazed earthenware, H. 23¼". Collection Everson Museum of Art, Syracuse. Photograph: Robert Lorenz.

126. Viktor Schreckengost, Cleveland, Ohio. *Spring,* 1939. Terra-cotta, L. 20". Collection Everson Museum of Art, Syracuse. Photograph: Jane Courtney Frisse.

127. Carl Walters, Woodstock, New York. *Cat,* 1938. Glazed earthenware, L. 23". Courtesy Zabriskie Gallery, New York. Photograph: Jane Courtney Frisse.

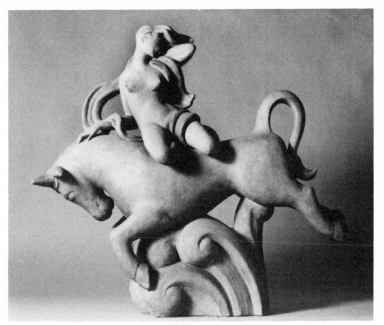

125

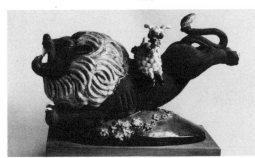

126

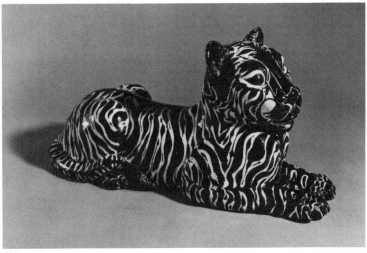

127

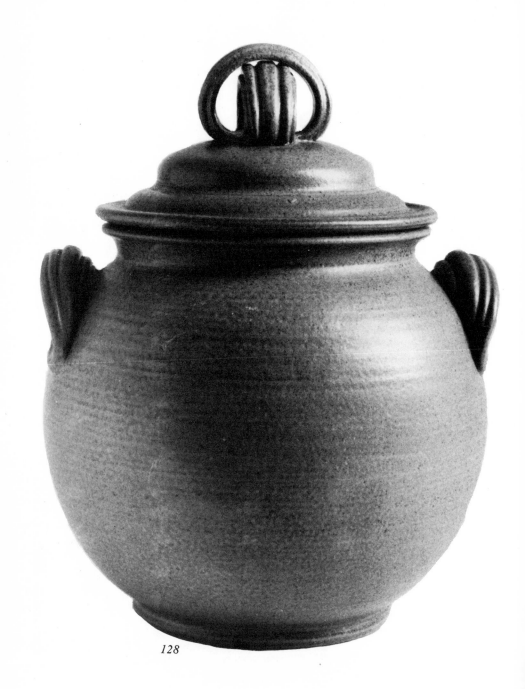

128

128. Arthur E. Baggs, Columbus, Ohio. *Cookie Jar,* 1939. Salt-glazed stoneware, H. 11¾". Collection Everson Museum of Art, Syracuse. Exhibited 1938 at the Seventh Ceramic National, Syracuse. Awarded First Prize for Pottery.

129. Arthur E. Baggs at Ohio State University, Columbus, Ohio. c. 1930.

130. Dorothea Warren O'Hara, Darien, Connecticut. *Bowl,* 1939. Earthenware, glazed inside, relief decoration, Diam. 10¼". Collection Everson Museum of Art, Syracuse. Photograph: Robert Lorenz.

129

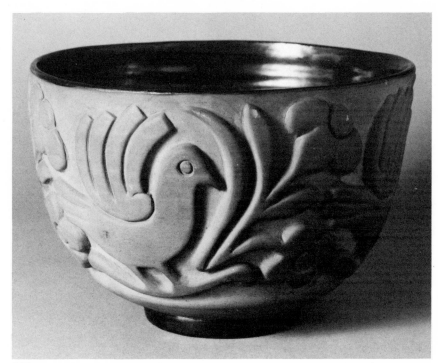

130

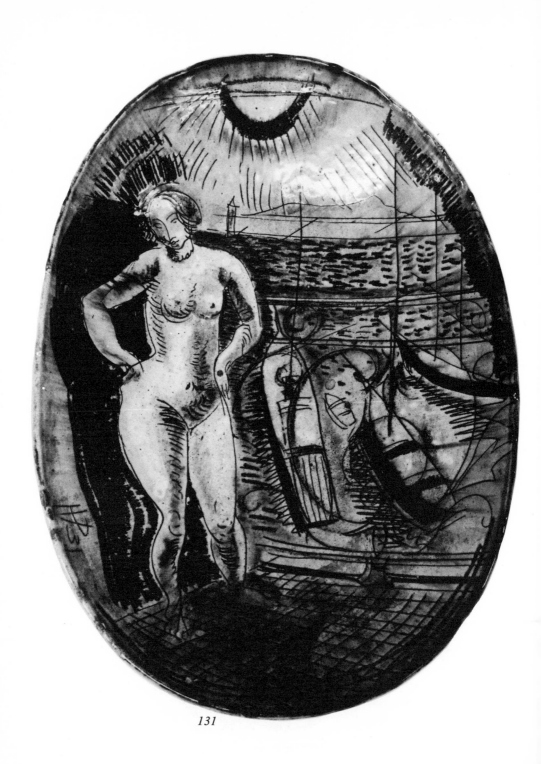

131

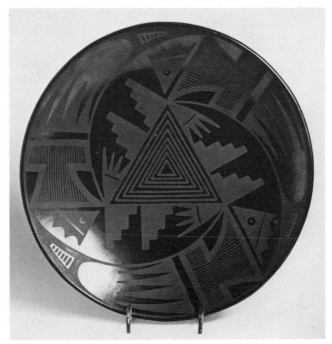

132

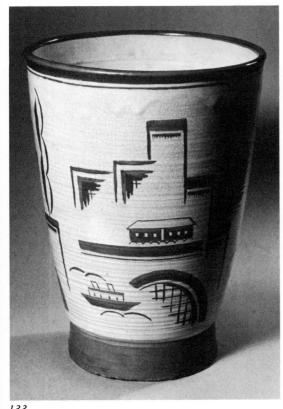

131. Henry Varnum Poor, New York. *Nude,* 1938. Earthenware platter, underglaze painting, L. 17¾". Collection Everson Museum of Art, Syracuse.

132. Maria Martinez, New Mexico. *Plate,* c. 1939. Burnished, low-fired earthenware, Diam. 10". Collection Everson Museum of Art, Syracuse. Photograph: Garth Clark/Lynne Wagner.

133. Maija Grotell, New York. *The City,* 1935. Earthenware, glazed, H. 10⅝". Collection Cranbrook Academy of Art Museum, Bloomfield Hills, Michigan.

133

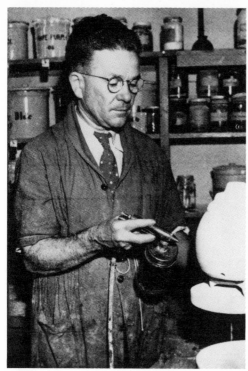

134. Glen Lukens at the University of California, Los Angeles. c. 1948.

135. Glen Lukens, Los Angeles. *Yellow Bowl,* 1936. Earthenware, alkaline glaze, Diam. 11⅝". Collection Everson Museum of Art, Syracuse. Exhibited 1936, Fifth Ceramic National, Syracuse. Awarded First Prize for Pottery.

134

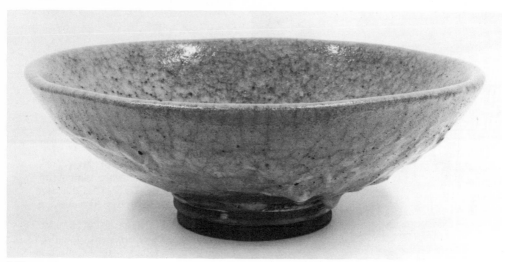

135

1940

The 1940s saw new concerns emerging in sculpture as exemplified by the work of David Smith, Alexander Calder, and Joseph Cornell. These artists pointed to the direction that sculpture was to follow for the next three decades, as found objects, assemblage, and the fabrication of metal replaced the traditional craft of the sculptor and his skills of modeling and carving. Sculptors now sought a different "sculptural unity" that allowed the use of totally disparate and discordant elements. This constructivist tendency had a strong impact on the way in which the sculptor—and the fine artists in general—began to view materials and processes:

> To create sculpture by assembling parts that had been fabricated originally for quite a different context did not necessarily involve new technology. But it did mean a change in sculptural practice, for it raised the possibility that making sculpture might involve more a conceptual than a physical transformation of the material from which it is composed.[80]

This thinking was the death knell of the first ceramic sculpture movement in the United States. The sculptors working in the medium had, with a few exceptions, based their aesthetic upon the ideals of middle-class connoisseurship and an intimate artist–material relationship in which the subtle nuances of the firing and glazes were all-important. The ceramic sculptors also found that public interest in figurative sculpture was on the wane and that a nation facing the specter of world conflict for the second time in less than twenty-five years was not in a mood for supercilious ceramic humor.

The Ohio school declined rapidly, unable to outgrow the cloying whimsy of the early work. The work of Viktor Schreckengost during this time is an

exception, however. Schreckengost retained his playful style of clay handling and the brash comic-book palette of colors, but the content of his works changed markedly. In the 1930s he reflected the influence of the Viennese school, dealing with elegant visual puns such as *Spring* (1938). In the 1940s he turned to political satire, which, surprisingly, well suited his style. In 1939 he completed *The Dictator,* one of the masterworks from the Ohio school, which comprises a corpulent Roman emperor with four cherubic figures representing Stalin, Hitler, Mussolini, and Hirohito gamboling in his robes. A starker quality can be seen in *Apocalypse* (1942), wherein three of the leaders are mounted on a frenzied horse—a work that strikes a disturbing balance between humor and horror.[81]

Although the momentum was lost in ceramic sculpture during this decade, there was some activity of note apart from the accomplishments of Schreckengost. Louise Nevelson worked successfully in terra-cotta, creating a constructivist work *Moving—Static—Moving Figures* (1945) that comprised a group of fifteen assembled clay forms with brusque drawing on the surfaces. Work of a different character was the series of ash-glazed horse sculptures produced by the Kansan sculptor Bernard Frazier. Two of these, *Prairie Combat* (1941) and *Untamed* (1948), are in the collection of the Everson Museum of Art, having been acquired at the Tenth and Thirteenth Ceramic Nationals. The style was distinctive and fully employed the plasticity of the material. Frazier massed and distorted elements of the forms so as to direct the viewer's eye and create an almost brutal and explosive sense of strength.

However, these high points were few, as the focus of the medium began to return to the vessel aesthetic. The potters prospered despite the inclement climate in the fine arts because, unlike the sculptors, they had little need of the patronage of museums and major galleries. Pottery was a popular and intimate art form that because of its low price could reach a wide public. For two decades, the pottery had existed outside the mainstream of fine art and had built up an independent structure of patronage and exhibiting platforms. Far from attempting to match developments in painting and sculpture, the potters in many cases consciously saw themselves as providing an alternative—retaining the traditions of craftsmanship against the onslaughts of postmodernism.

The decade saw a strong group of potters emerge in the United States, many having come to the country in the 1920s and 1930s as already-established artists. Although they shared certain characteristics and a common volumetric discipline, the potters were a diverse group philosophically and intellectually. Some, such as Wildenhain, adhered to a stern functionalist

view. These attitudes based on repetition and production ware were in turn an anathema to Beatrice Wood, Maija Grotell, and others who worked with the same intent as painters or sculptors. Between the two poles of thought were the potters who took a vocational view of the art based on a romantic, traditionalist conception of pottery. This view was reflected in the number of potteries run by husband-and-wife teams such as Gertrud and Otto Natzler, Edwin and Mary Scheier, and Vivika and Otto Heino.

Of the potters of this decade, Maija Grotell, both as a teacher and as an artist, was the most outstanding influence. Grotell arrived in New York from Helsinki in 1927 and worked first at a settlement house and then at Rutgers University. Her early style with painted Art Deco motifs on simple ovoid or cylindrical forms was popular and won awards at the 1929 Barcelona and 1937 Paris expositions. But this style was eclipsed by her work of the 1940s and early 1950s, produced at the Cranbrook Academy of Art in Bloomfield Hills,[82] where from 1938 she headed the ceramic department. The later works began to assume a monumental quality, although this quality had little to do with the scale of the pieces, which ranged from shallow bowls to four-foot-high thrown vases. The presence of the work derived from the strength and simplicity of her forms. For most of her career, Grotell concentrated on only two types of forms and had come to understand most thoroughly the dynamics of enclosing space.

Grotell developed a palette of direct colors—deep turquoises, reds, and burnt oranges—with which she would draw on her forms emphatic motifs that showed a carefully considered relationship to the thrust, lines, and proportions of the host vessel. Later she became known for her distinctive craterous glazes, which she obtained by painting Albany slip under a clear Bristol glaze. The results were uneven, and Grotell's works vary from a vivacious use of color to florid excesses—Grotell was never content to play safely within accessible decorative limits. She was constantly experimenting, saying, "discovering new ways of doing interests me most . . . once I have mastered a form, a glaze, an idea, I lose interest and move onto something else . . . this helps as a teacher but not as an exhibitor." [83]

Grotell was also an unorthodox teacher. She rejected the structured, doctrinaire methods employed by Myrtle French, Arthur Baggs, and others and instead taught by example of spirit rather than example of work. She disliked imitation of her pots and encouraged self-reliance among her students, assisting them in discovering their most truthful responses to the medium. As a result, Cranbrook Academy of Art rapidly became one of the

most important institutions in ceramic education, and several of her postwar students are included in this study: Toshiko Takaezu, Richard DeVore, John Glick, and Suzanne and John Stephenson. The legacy that she left through her students and in her vessels was an aesthetic for the genre that was not based on conventional objet d'art virtues of beauty. Instead of pleasing in the simplistic sense, Grotell's work challenged and confronted the viewer.

The same striving to extend the vocabulary of the medium can be seen in the work of one of the major catalysts of the decade, Thomas Samuel (Sam) Haile. Haile's indelible influence on American pottery was surprising considering his short stay in the country. He came to the United States in 1939, shortly after having graduated from the Royal College of Art, where he studied under one of Europe's finest artist-potters, William Staite Murray. Haile was first and foremost a painter, who stumbled upon ceramics through force of circumstance. Although he brought to the medium certain painterly qualities—as well as his strong Surrealist affinities—Haile never lost the perspective that ceramics was a separate discipline requiring an approach altogether different from that of paint and canvas. Upon his arrival in New York, he did odd jobs and exhibited extensively until invited by Charles Harder to study and teach at Alfred University. At Alfred, he found glazes being compounded from ten and more separate ingredients. Haile challenged this practice, insisting that "all that craft separated the artist from his instincts and visions." [84] and instead advocated simple glazes, compounded from two or three materials, and a creative use of the kiln in obtaining variations of color. This refreshing view found a sympathetic ear among the young potters of the time, who had grown weary of Alfred's pedantic use of materials. Harder had plans to groom Haile as his successor, but Haile's restless spirit was not easily tamed, and he moved instead to Ann Arbor, where he taught at the University of Michigan until his induction into the U.S. Army in 1944 and his subsequent return to England.

Haile's work, although figurative, showed many of the same instincts that were to resurface in the so-called Abstract Expressionist ceramics of the mid-1950s. One of the most distinctive qualities was the manner in which Haile dealt with the vessel as format. Unlike many of the potters of the day who decorated passively within this frame, Haile assaulted the regimen of the defining line on his vessels. His carefully conceived but freely executed painting would give depth and purpose to the form, sometimes by confirming the qualities of form, as in *Orpheus* (1941). In other pieces, the strong movement of line around the form would break down the outer edge of his bowls,

vases, or pitchers so that form and painting became a complex, inseparable whole. One of the finest examples of the latter technique, *Cern Abbas Giant* (1938), has unfortunately been lost, but other masterworks, such as the *Chichén Itzá Vase* (1942) and *Cretan Feast* (1939), found their way into American public collections.

Haile died in a motorcar accident in 1948 in England. As a tribute to to an artist who had contributed richly to a more progressive view of the vessel as an art form in America, the Institute of Contemporary Art, Washington, D.C., held a well-publicized memorial exhibition of his works in the United States. The director of the institute, Robert Richman, praised the work for demonstrating "belief in the principle that art is a way of thinking, meeting art and function at their foundations, by making for use yet transcending it." [85] Speaking more specifically of his influence in this country, Richman added:

> To Americans conditioned to ceramic trivia—fish, gazelles and earrings —the work of Haile is a fresh wind. Here is pottery that is not only perfection in form, and glazes controlled miraculously, but with decorations like those on Etruscan and Greek pots. And always a simple statement: this is a pot, this is a dish, this is a jug. Haile could throw stoneware to the absolute limit of its yield point, achieving thereby a rhythmic tension quite of the same essence as sculpture.[86]

136

137

138

136. Viktor Schreckengost, Cleveland, Ohio. *The Dictator,* 1939. Glazed earthenware, H. 14″. Collection of the artist.

137. Louise Nevelson, New York. *Moving-Static-Moving Figures,* 1945. Terracotta. Partial installation view, Whitney Museum of American Art, New York. Photograph: Geoffrey Clements.

138. Bernard Frazier, Lawrence, Kansas. *Untamed,* 1947. Ash-glazed stoneware, L. 36½″. Collection Everson Museum of Art, Syracuse. Awarded $500 prize for ceramic sculpture at Thirteenth Ceramic National, Syracuse, 1948. Photograph: Jane Courtney Frisse.

139. Vally Wieselthier, New York. *Taming the Unicorn,* 1946. Stoneware, H. 21″. Collection Everson Museum of Art, Syracuse; Gift of IBM. Photograph: Jane Courtney Frisse.

139

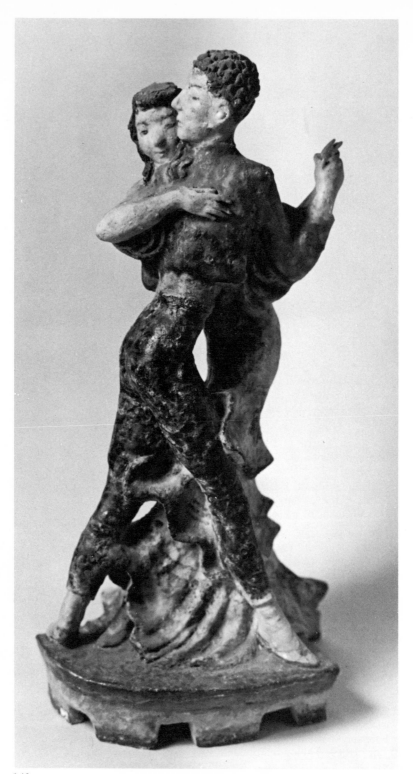

140

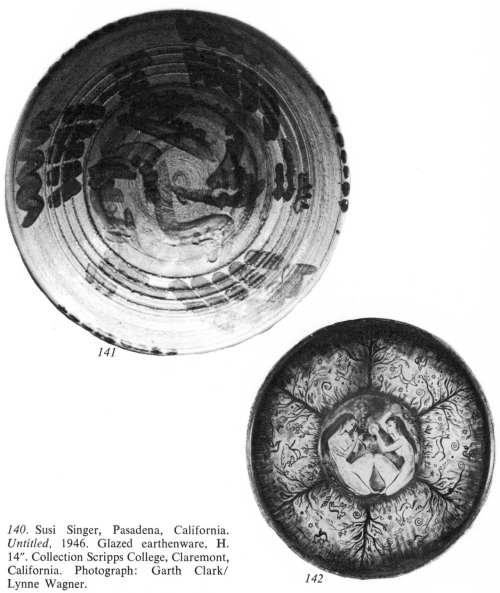

140. Susi Singer, Pasadena, California. *Untitled,* 1946. Glazed earthenware, H. 14″. Collection Scripps College, Claremont, California. Photograph: Garth Clark/ Lynne Wagner.

141. Marion Lawrence Fosdick, Alfred, New York. *Bowl,* 1940. Stoneware, Diam. 17″. Collection The Metropolitan Museum of Art, New York.

142. Carlton and Kathryn Ball, Mills College, Oakland, California. *Incantation Plate,* 1941. Stoneware, Diam. 16″. Collection Everson Museum of Art, Syracuse. Photograph: Jane Courtney Frisse.

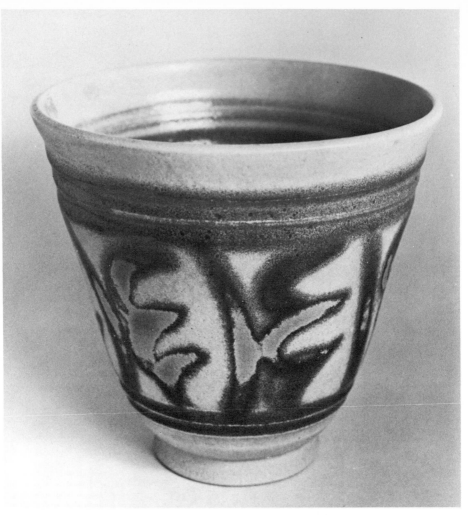

143

143. Edgar Littlefield, Columbus, Ohio. *Vase,* 1941. Stoneware, mat glaze, H. 8″. Collection Everson Museum of Art, Syracuse. Photograph: Garth Clark/Lynne Wagner.

144. Gertrud and Otto Natzler, Los Angeles, California. *Bowl,* 1946. Earthenware, gray celadon reduction glaze with melt crackle, Diam. 6½″. Collection Everson Museum of Art, Syracuse. Photograph: Julius Shulman.

145. Harold E. Riegger, Alfred, New York. *Vase,* 1944. Stoneware, glazed, H. 8½″. Collection The Metropolitan Museum of Art, New York.

146. Louis Benjamin Raynor, Alfred, New York. *Pitcher,* 1946. Stoneware, iron oxide decoration on gray glaze, H. 8⅜″. Collection The Metropolitan Museum of Art, New York.

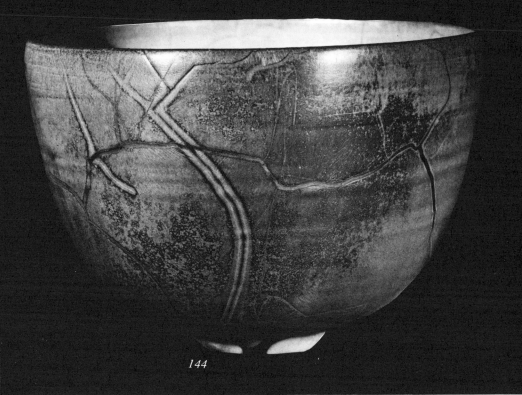

144

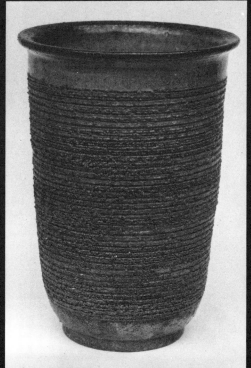

145

146

147

148

149

147. Antonio Prieto, Oakland, California. *Plate*, 1946. Stoneware, Diam. 13". Collection Everson Museum of Art, Syracuse. Photograph: Garth Clark/Lynne Wagner. Exhibited 1946, Eleventh Ceramic National, Syracuse. Richard B. Gump Award.

148. Marguerite Wildenhain, Guerneville, California. *Teapot*, 1945. Glazed stoneware; H. of pot 5". Collection Everson Museum of Art, Syracuse. Photograph: Garth Clark/Lynne Wagner. Exhibited 1946, Eleventh Ceramic National, Syracuse. Richard B. Gump Award for best ceramic suitable for mass production.

149. Laura Andreson, Los Angeles, California. *Cookie Jar,* 1946. Earthenware, mat glaze with narrow copper luster rings, H. 9". Collection Everson Museum of Art, Syracuse. Photograph: Garth Clark/Lynne Wagner.

150. Edwin and Mary Scheier, New Hampshire. *Coffee Set,* 1947. Glazed stoneware, H. of cups 2"; H. of pot 8". Collection Everson Museum of Art, Syracuse. Exhibited 1947, Twelfth Ceramic National, Syracuse. Richard B. Gump Award for best ceramic suitable for mass production.

150

151

152

153

151. Maija Grotell, Bloomfield Hills, Michigan. *Vase,* 1940. Glazed earthenware, H. 15½". Collection The Metropolitan Museum of Art, New York.

152. Maija Grotell, Bloomfield Hills, Michigan. *Vase,* 1945. Stoneware vase with white slip decoration, H. 17". Collection Everson Museum of Art, Syracuse. Exhibited 1946, Eleventh Ceramic National, Syracuse. Awarded Encyclopaedia Britannica Prize for Pottery. Photograph: Jane Courtney Frisse.

153. Maija Grotell, Bloomfield Hills, Michigan. *Vase,* 1949. Stoneware, glazed, H. 12½". Collection Everson Museum of Art, Syracuse. Photograph: Robert Lorenz.

154. Maija Grotell at Cranbrook Academy of Art, Bloomfield Hills, Michigan. c. 1950. Photograph: Courtesy Cranbrook Academy of Art Museum.

154

155. Sam Haile, Ann Arbor, Michigan. *Vase*, 1942. Stoneware, glazed, H. 7″. Collection The University of Michigan Museum of Art, Ann Arbor. Photograph: Garth Clark/Lynne Wagner.

156. Sam Haile, Ann Arbor, Michigan. *Plate*, 1942. Glazed, slip-trailed earthenware, Diam. 11″. Collection The University of Michigan Museum of Art, Ann Arbor. Photograph: Garth Clark/Lynne Wagner.

155

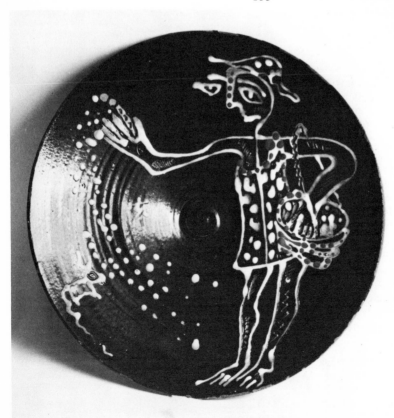

156

1950

The 1950s were the decade of liberation. It was during this period that the American potter finally cut loose the shackles that had for so long bound him to the manners and values of European art and design. That is not to say that Europe ceased to be an influence. On the contrary, the input of Constructivism and the example of artists who worked in ceramics during the early 1950s, such as Miró and Picasso, were crucial to the development that took place. But the influences were interpreted, digested, and applied objectively.

The beginnings of the decade were inauspicious, however, with little indication of the revolution to come. Henry Varnum Poor viewed the activities of the day cynically, pronouncing that "hygienic hotelware" was the true American ceramic aesthetic. At the time, ceramics was experiencing a surge of interest together with the other craft media. Popular magazines exhorted housewives to take to macrame, pottery, and weaving in search of the cultural opiate, self-expression. Yet others, early members of the counterculture movement and ex-GIs, came to the crafts in search of a gentle, romantic life-style.

Out of this interest grew a number of dedicated artists who set aside the romantic traditions of the material and began establishing a contemporary vocabulary—in particular those artists who gathered around Peter Voulkos at the Otis Art Institute (formerly the Los Angeles County Art Institute) in the mid-1950s. In looking at the Otis experiment, it is necessary to examine the major influences that contributed to this breakthrough in the vessel aesthetic. Many influences can be cited, the growing appreciation of jazz, the beat poets, the breakthroughs in American art, and most broadly, the general climate of urgency and release that followed the war. But in purely visual

terms, three influences dominated: the Zen pottery of Japan, the surface energies of Abstract Expressionist painting, and the form freedoms of Constructivism.

The dominant influence was the impact of Japanese pottery and the Zen Buddhist theories that accompanied it. On the West Coast in particular, the artists were sympathetic to Oriental philosophy, and a popular interest in Zen was growing under the leadership of scholars such as Alan Watts in San Francisco. The Zen concepts of beauty appealed to the American potter for a number of reasons. In the wares of the tea ceremony, they saw new forms of expression in the subtle asymmetry, the simplicity, and the often random, abstract decoration. The earlier works of Japan inspired as well, particularly prehistoric Jomon pottery with its architectonic structure, curiously weighted proportions, and tension between surface and form.

Japanese pottery offered the potter a set of aesthetic values different from those of the West.[87] Above all, Zen was the key to breaking with the formalist regime of European objecthood that demanded perfectionist craftsmanship. Through Japanese pottery, the California potters glimpsed a new value based on risk and expression. The following comment from Daisetz Suzuki's study on Zen in Japanese culture explains part of the Oriental concept of beauty:

> Evidently beauty does not necessarily spell perfection of form. This has been one of the favorite tricks of Japanese artists—to embody beauty in a form of imperfection or even ugliness. When this beauty of imperfection is accompanied by antiquity or primitive uncouthness, we have a glimpse of *sabi,* so prized by Japanese connoisseurs. Antiquity and primitiveness may not be an actuality. If an object of art suggests even superficially the feeling of historical period there is *sabi* in it. *Sabi* consists in rustic unpretentiousness, apparent simplicity of effortlessness in execution, and, lastly it contains inexplicable elements that raise the object in question to a rank of artistic production.[88]

The first contact with Oriental philosophy came through Bernard Leach. In 1940 this English potter wrote *A Potter's Book,* one of the classics of ceramic literature. In the opening chapter, "Towards a Standard," Leach proposed a meeting of East and West that he was later to define as "Bauhaus over Sung." This interest in the bridging of cultures had been a popular crusade among artists and intellectuals during the 1930s and 1940s, and Leach had been part of one of the more influential groups that had gathered at Dartington Hall in Devon and included Mark Tobey, Ravi Shankar, Aldous Huxley, and Pearl Buck.

In 1950 Leach visited the United States and toured from coast to coast,

drawing large and appreciative audiences. He was awarded the Binns Medal of the American Ceramic Society and left a strong impact. However, he slightly sullied his reception by pointing out that American ceramics was without a taproot—and by implication without any sense of direction.[89] Yet it is ironical that this society that Leach had declared to be rootless was the first to achieve his ideal. Earlier Leach had emphasized that "because a potter belongs to our time and aspires to the position of creative artist he is divided in his allegiance between the contemporary movements in our own art and his challenge from the classic periods of the East." [90] The answer, he felt, lay in balance and integration. These qualities were not achieved in Leach's work, nor in that of his contemporaries in England, who remained staunchly traditionalist. The fusion of East and West was to occur in the following years in the United States.

Leach returned to America in 1953. This time he brought with him two close friends, the potter Shoji Hamada and Soetsu Yanagi, the founder of the Mingei craft movement and director of the National Folk Museum of Japan. They had just come from the first International Conference of Potters and Weavers at Dartington Hall and toured the country speaking on the issues and concerns raised at that conference. The trio drew great attention wherever they spoke, and in Los Angeles more than a thousand people packed a hall to hear them speak and hundreds were turned away. Leach spoke persuasively of what the Orient had to offer the West, Yanagi explained the mystical principles of Zen Buddhist aesthetics, and Hamada demonstrated. For those who participated in the various seminars, lectures, and symposiums, the tour proved to be a rich and challenging event. The seminars at the Archie Bray Foundation and Black Mountain College in North Carolina proved to be particularly far-reaching.

Other visitors gave a different view of Japanese ceramics. In 1954 the perspicacious Rosanjin toured the country, exhibiting and lecturing, followed by the Bizen master Toyo Kaneshige. Kaneshige gave extraordinary demonstrations. He would swiftly pummel his thrown form and after a moment's contemplation declare it good or bad and so consign it to either the kiln or the soak bin. But in retrospect, Rosanjin was one of the most important ambassadors of the Oriental aesthetic. At one time, he had been the most respected gourmet restaurateur in Japan. When he required certain pottery for his restaurant and was unable to find it from practicing potters, he began to work himself. His approach was audacious. Sidney Cardozo affectionately termed him "the supreme amateur and dilettante," [91] for he imitated and paraphrased all the great periods, styles, and masters in Japanese ceramics.

The results nonetheless were distinctly the works of Rosanjin, and his brush-work—so brusque and economical—spoke of his years of study of calligraphy.

To Western eyes at least, Rosanjin was the embodiment of *sabi,* a mixture of sophistry and savagery. His mercurial temper was legend, and his progress through the United States was peppered with incidents. While in the Bay Area, he had his exhibition removed from Mills College after only twenty-four hours following an exchange with Antonio Prieto, head of the college's ceramic department. Rosanjin had told Prieto that he did not think that his fat, bulbous forms with miniature necks and spouts were the last word in elegance. Prieto responded by calling Rosanjin's pottery turds and kiln shelves. The pottery was taken to the ceramic department at the California College of Arts and Crafts, where students, including Manuel Neri, Viola Frey, and others, had free access to the pieces for several months.

While in San Francisco, Rosanjin gave a memorable lecture. In contrast to the paternalism of Leach, he spoke enthusiastically of American ceramics and prophesied that the nation would make a great and unique contribution to the ceramic arts in the coming years. In his address, he also dealt with the more spiritual concerns of the potter, insisting that pottery was not an art of technical expertise—machines and soulless craftsmanship he said were "reckless tools"—but that ceramics was an art of the mind, "dependent solely upon the beauty of the mind":

> I am learning by trying to produce pottery as fine art, in accordance with art for art's sake principles. Work done by machines is after all, work *by* machines. A work is of no value unless it moves the human mind and the human spirit. As for pottery of daily use, which should of necessity be of moderate price, I think there is nothing wrong with manufacturing it by mechanized methods. *But* once a man wishes to become an artist with the determination to dedicate his mind to the creation of first class art he must disregard the advantages of the machine. In other words, the fine arts are all activities of the intuitive mind and are not affected by the development or advancement of our knowledge, intelligence, or reason alone.[92]

The first reaction to the heady influences from Japan was imitation. Potters made their pilgrimage to Japan to learn how to copy Japanese wares, and the less purist simply copied from examples in books and museums. Quasi-Oriental wares proliferated, and potters working outside this tradition found difficulty in being shown at fairs and exhibitions. An archaeologist of

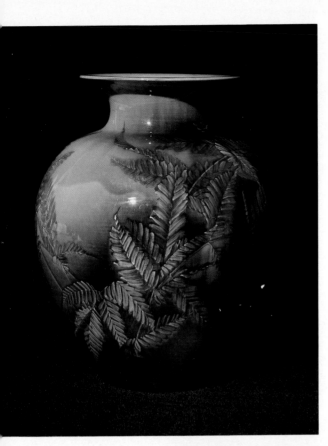

Plate 1. Kataro Shirayamadani, Rookwood Pottery, Cincinnati, Ohio. *Fern Vase*, 1890. Earthenware, underglaze slip painting, H. 10½". Collection Everson Museum of Art, Syracuse, New York. Photograph: Robert Lorenz.

Plate 2. Mary Louise McLaughlin, Cincinnati, Ohio. *Losanti,* 1898–1902. Glazed, carved porcelain, H. 5". Collection Alfred and Michiko Nobel. Photograph: Garth Clark/Lynne Wagner.

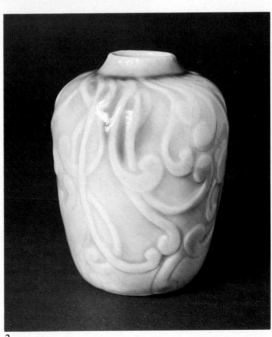

Plate 3. George E. Ohr, Biloxi Art Pottery, Biloxi, Mississippi. *Vase,* after 1900. Glazed earthenware, H. 12″. Collection Martin and Estelle Shack. Courtesy Mississippi State Historical Museum, Jackson.

Plate 4. George E. Ohr, Biloxi Art Pottery, Biloxi, Mississippi. *Handled Vase,* after 1900. Bright polychrome glazed earthenware, H. 11½″. Collection Martin and Estelle Shack. Photograph courtesy Mississippi State Historical Museum, Jackson.

Plate 5. Jacques Sicard, Weller Pottery, Zanesville, Ohio. *Vase,* c. 1903. Iridescent glazed earthenware, H. 6⅜″. Collection Philadelphia Museum of Art; Gift of Samuel A. Weller.

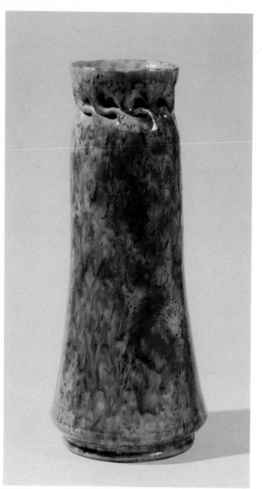

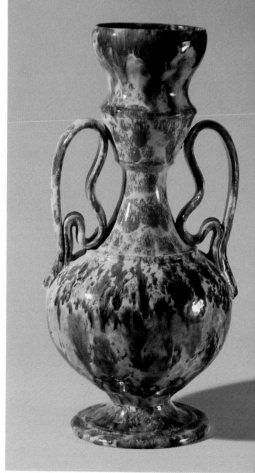

3

4

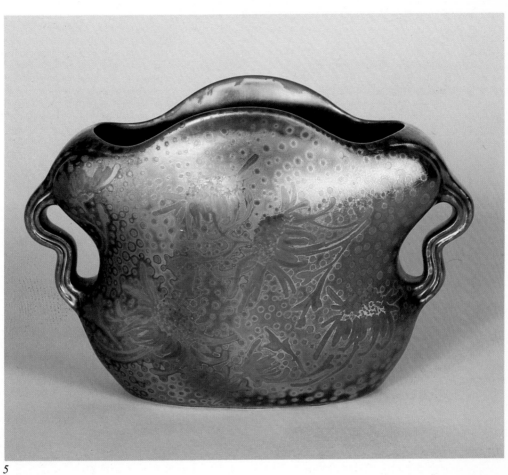

5

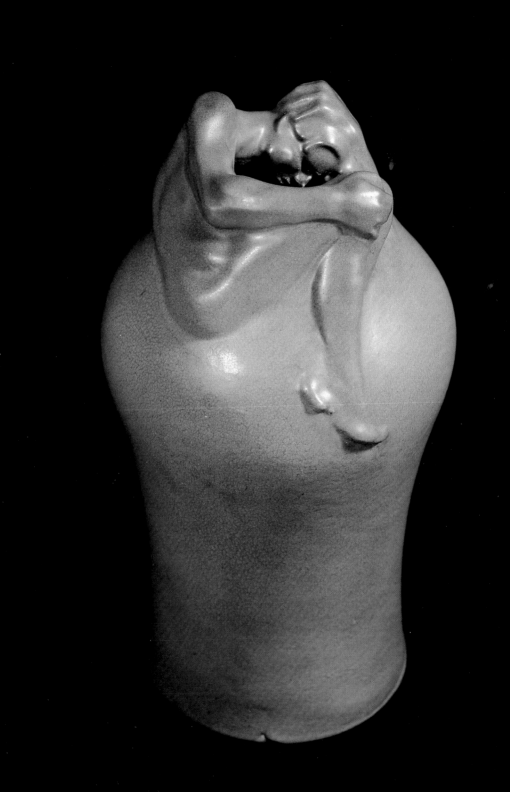

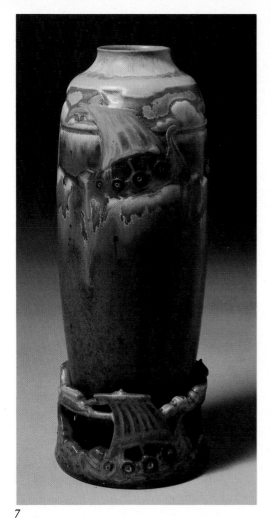

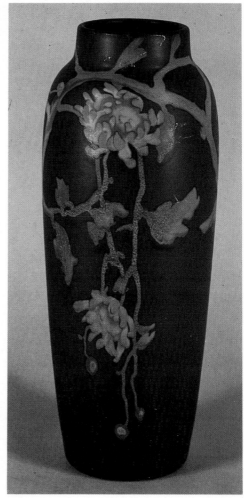

7

8

Plate 6. Artus Van Briggle, Van Briggle Pottery Company, Colorado Springs, Colorado. *Despondency,* 1905 (designed 1902). Glazed earthenware, H. 12¾″. Private collection. Photograph: Taylor & Dull, Inc.

Plate 7. Adelaide Alsop Robineau, Syracuse, New York. *Viking Vase,* 1905. Porcelain, mat glazes, H. 7¼″. Collection Everson Museum of Art, Syracuse. Photograph: Robert Lorenz.

Plate 8. Harriet Elizabeth Wilcox, Rookwood Pottery, Cincinnati, Ohio. *Vase,* 1906. Earthenware with mauve, lavender, and blue-gray glaze, H. 13¾″. Collection Cincinnati Art Museum, Cincinnati. Photograph: Cincinnati Art Museum.

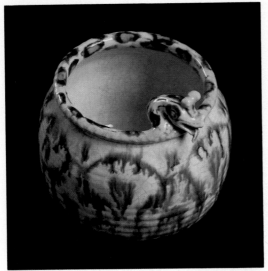

9

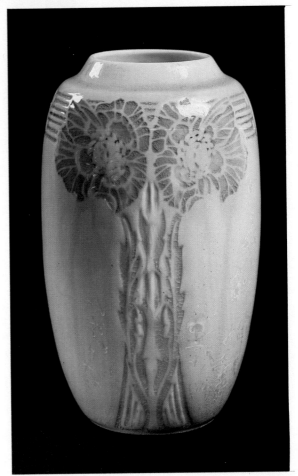

10

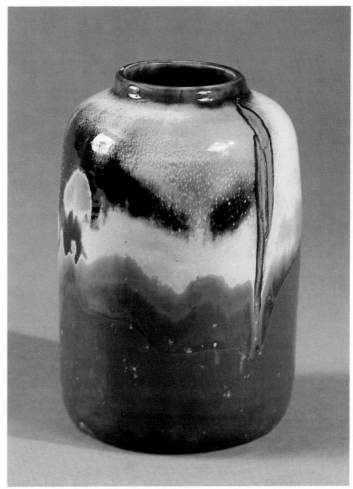

11

Plate 9. Adelaide Alsop Robineau, Syracuse, New York. *Snake Vase,* 1919. Porcelain, H. 3½″. Collection Everson Museum of Art, Syracuse. Photograph: Robert Lorenz.

Plate 10. Adelaide Alsop Robineau, Syracuse, New York. *Poppy Vase,* 1910. Porcelain, inlaid poppy decoration, H. 6¼″. Collection Everson Museum of Art, Syracuse. Photograph: Robert Lorenz.

Plate 11. Mary Chase Perry, Pewabic Pottery, Detroit, Michigan. *Jar,* c. 1929. Reduction luster, earthenware, H. 9½″. Collection Cranbrook Academy of Art Museum, Bloomfield Hills, Michigan. Photograph: Jack Kausch.

12

13

14

Plate 12. Carl Walters, Woodstock, New York. *Ella,* 1927. Glazed earthenware, H. 16¾". Collection The Museum of Modern Art, New York.

Plate 13. Russell Aitken, Cleveland, Ohio. *Student Singers,* 1934. Earthenware, bright lead glazes, H. 11¾". Collection Everson Museum of Art, Syracuse. Photograph: Robert Lorenz.

Plate 14. Viktor Schreckengost, Cleveland, Ohio. *Apocalypse '42,* 1942. Modeled earthenware with blackbird engobe and brilliant opaque colored glazes, H. 15". Collection of the artist. Courtesy Cleveland Museum of Art.

Plate 15. Glen Lukens, Los Angeles. *Death Valley Plate*, 1940. Earthenware with alkaline glaze, Diam. 18¾". Collection Everson Museum of Art, Syracuse. Photograph: Robert Lorenz.

Plate 16. Maija Grotell, Bloomfield Hills, Michigan. *Bowl*, 1956. Earthenware, mat brown and turquoise glaze, H. 8¾". Syracuse University Art Collections, New York. Photograph: Robert Lorenz.

Plate 17. Sam Haile, Alfred, New York. *Orpheus*, 1941. Glazed stoneware, H. 19½". Collection Everson Museum of Art, Syracuse; Gift of IBM. Photograph: Robert Lorenz.

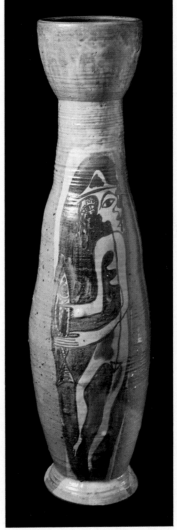

17

16

Plate 18. Peter Voulkos, Los Angeles. *Plate,* 1957. Glazed stoneware, Diam. 12″. Collection Quay Gallery, San Francisco, California. Photograph: Richard Sargent.

Plate 19. John Mason, Los Angeles. *Vase,* 1958. Stoneware, low-fire overglaze, H. 23¾″. Marer Collection, Scripps College, Claremont, California. Photograph: Paul Soldner.

Plate 20. Ron Nagle, San Francisco, California. *Bottle with Stopper,* 1960. Low-fire clay, glaze and china paint, H. 23¾″. Marer Collection, Scripps College, Claremont, California. Photograph: Paul Soldner.

19

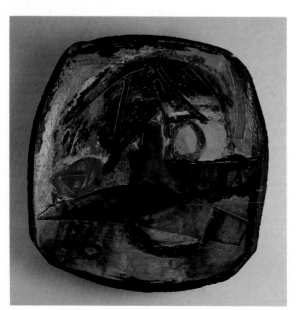

18

20

21

22

Plate 21. Toshiko Takaezu. *Shallow Painted Bowl,* 1962. Japanese stoneware clay, multiple glazes: ash, copper, black, and pink. Diam. 13½". Collection Everson Museum of Art, Syracuse. Photograph: Robert Lorenz.

Plate 22. Jerry Rothman, Los Angeles. *Pot*, 1966. Stoneware, H. 22". Collection Everson Museum of Art, Syracuse. Photograph: Robert Lorenz.

Plate 23. Rudy Autio, Missoula, Montana. *Covered Vessel,* 1965. Stoneware, H. 18½". Collection Everson Museum of Art, Syracuse. Photograph: Robert Lorenz.

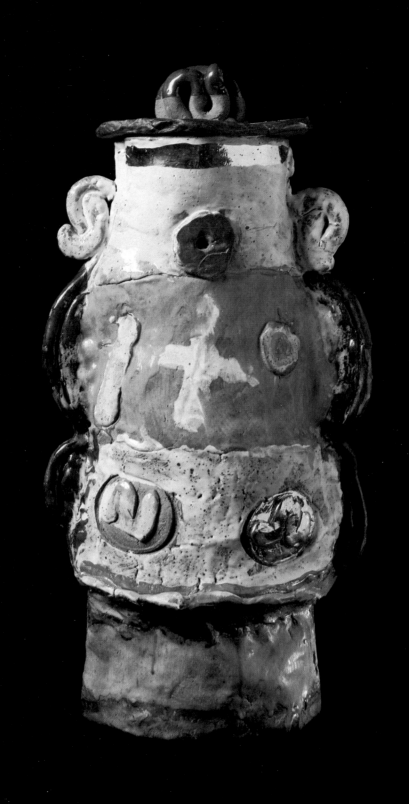

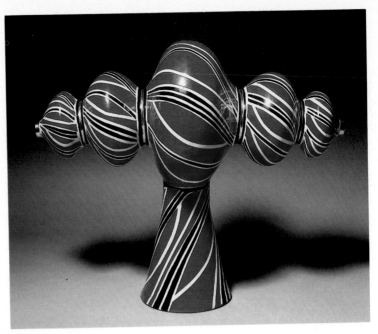

24

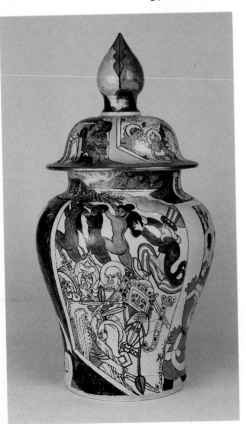

25

Plate 24. Ka-Kwong Hui, New York. *Ceramic Form,* 1967. Stoneware, thrown and glazed form, H. 22". Collection Everson Museum of Art, Syracuse. Photograph: Robert Lorenz.

Plate 25. Michael Frimkess, Los Angeles. *Covered Jar,* 1968. Tin-glazed earthenware with on-glaze painting, H. 23¾". Marer Collection, Scripps College, Claremont, California. Photograph: Paul Soldner.

Plate 26. Jack Earl, Toledo, Ohio. *Dog with Pink Shoes,* 1969. Cast porcelain, acrylic paint, H. 18½". Collection Robert and Jean Pfannebecker. Photograph: Robert H. Lowing, Lancaster, Pennsylvania.

Plate 27. Fred Bauer, Seattle, Washington. *Formal Dinner,* 1968. Stoneware, low-fire glazes, luster, Diam. 16½". Collection Robert and Jean Pfannebecker. Photograph: Robert H. Lowing, Lancaster, Pennsylvania.

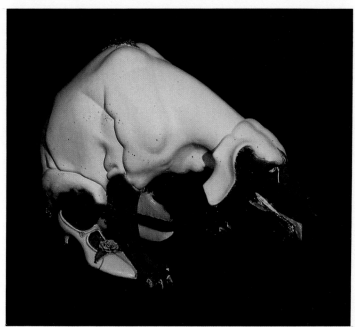

26

27

28

Plate 28. Rudolf Staffel, Philadelphia, Pennsylvania. *Vase*, 1972. Porcelain, hand-built, H. 11″. Collection Dr. and Mrs. Parry Ottenberg, Philadelphia. Photograph: Robert Lorenz.

Plate 29. Robert Arneson, Davis, California. *A Hollow Jesture,* 1971. Earthenware, glazes, china paint, H. 19⅞″. Collection Professor and Mrs. R. Joseph Monsen. Courtesy San Francisco Museum of Modern Art.

Plate 30. Beatrice Wood, Ojai, California. *Teapot,* 1975. Lustered earthenware, H 12″. Private collection. Photograph: Robert Lorenz.

Plate 31. Robert Turner, Alfred, New York. *Jar,* 1976. Stoneware, glazed, H. 10″. Private collection. Photograph: Courtesy Yaw Gallery, Ann Arbor, Michigan.

29

30

31

Plate 32. Mark Burns, Philadelphia, Pennsylvania. *Rattlesnake Teapot,* 1967. Earthenware, stains, glazes, L. 14″. Collection Robert and Jean Pfannebecker. Photograph: Garth Clark/Lynne Wagner.

Plate 33. John Glick, Plum Tree Pottery, Farmington, Michigan. *Bowl,* 1977. Stoneware, Diam. 18⅝″. Collection Everson Museum of Art, Syracuse; Gift of Mr. and Mrs. Robert Eddy. Photograph: Robert Lorenz.

Plate 34. Richard DeVore, Bloomfield Hills, Michigan. *Pot,* 1977. Stoneware, glazed, multifired, H. 15″. Collection Mack L. Graham. Photograph: Don Carstens.

Plate 35. Viola Frey, Oakland, California. *Bricoleuse,* 1976. White low-fire clay, glazed. H. 68″. Collection of the artist. Photograph: Lee Fatherree.

33

34

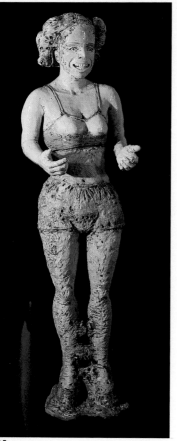

35

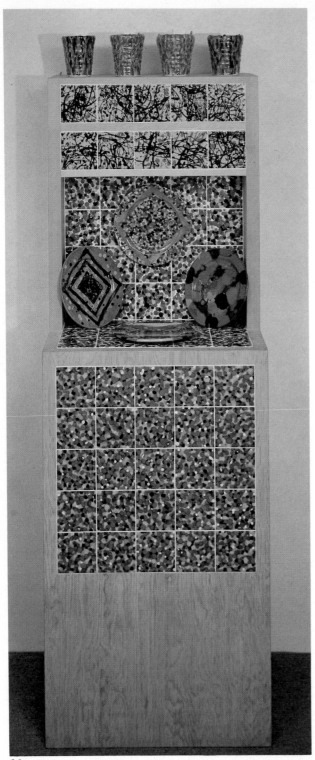

36

37

Plate 36. Kenneth Price, Taos, New Mexico. *Tile Unit*, 1972–1977. Glazed earthenware and wood, H. 69¾″. Private collection. Photograph: Courtesy James Corcoran Gallery, Los Angeles.

Plate 37. Margie Hughto, Syracuse, New York. *Fan 5*, 1978. Colored stoneware clays, H. 25″. Collection of the artist. Photograph: Robert Lorenz.

Plate 38. Betty Woodman, Boulder, Colorado. *Letter Rack*, 1977. Earthenware, glazed, L. 20″. Private collection. Photograph: George Woodman.

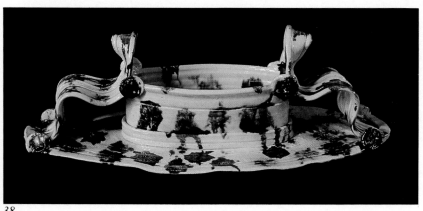

38

Plate 39. Ron Nagle, San Francisco, California. *Solaryama,* 1978. Low-fired, glazed, overglazed, china-painted, H. 4″. Courtesy Braunstein/Quay Gallery, San Francisco. Photograph: Schopplein Studios.

Plate 40. Kenneth Noland, Syracuse, New York. *Ceramic Relief #3,* 1978. Stoneware with porcelain slip, L. 27″. Collection of the artist. Photograph: Robert Lorenz.

39

40

the future, digging through the shard piles of the mid-1950s, can be excused if he deduces that during this time the United States was overrun by an army of fourth-rate potters from China, Korea, and Japan. But as more and more Oriental pottery of quality became available and was shown in public collections, a greater understanding of the nature of the objects and their beauty began to emerge.

An artist who had carefully followed and digested the various inputs from the East was Peter Voulkos. Voulkos was studying to be a painter but changed his major to ceramics, and received his M.F.A. in 1952 at the California College of Arts and Crafts in Oakland. In a short time, Voulkos had established himself as a nationally known potter. Before leaving graduate school, he had taken several of the prizes in the Ceramic Nationals at Syracuse and began to win prizes in international shows as well. At the time, he was producing strong, full-formed but perfectly conventional vessels. He was obsessed with the wheel while taking his B.F.A., only when threatened with the withholding of his degree did he consent to work with hand-building techniques.

After receiving his M.F.A., he went on to work at the Archie Bray Foundation[93] with Rudy Autio. Autio is one of the unsung heroes in this decade of change and redefinition. He has been left out of the survey exhibitions of the decade, and yet his work was among the best of the period and patently one of the formative influences on the Otis group. Although he used his clay and surface decoration as loosely as his contemporaries, there is a greater accuracy about Autio's work. Over the years the work has grown in stature, continuing his theme of anthropomorphic form and decoration, and Autio has remained one of the most consistently inventive potters of the postwar period.

In 1954 Voulkos moved to Los Angeles, taking on the job of setting up the ceramics faculty at the Otis Art Institute. He ran the department together with Harrison McIntosh, and for the first few months, there was little sign of revolution. Voulkos was himself concentrating on functional wares at the time. But slowly the pace began to develop: the students challenged his work; Voulkos experienced something of a revelation through a period of studying music;[94] and the ceramic work of European artists Miró, Chagall, Léger, Fontana, and Picasso began to inspire and excite. The tempo of experiment built up, and soon Otis was producing the most radical ceramics in the country. The word got around Venice, the art community of Los Angeles, that

"something was happening at Otis," and artists drifted in and joined the department, Paul Soldner, Kenneth Price, John Mason, Billy Al Bengston, Henry Takemoto, Malcolm McClain, and Jerry Rothman. Artists from other media became interested in the energies being generated, and Robert Irwin and Craig Kauffman each titled a painting *Black Raku* in recognition of the ceramists' achievements.

There was no common style or ideology—other than the tacit agreement not to have any common style or ideology. The group was freely, almost purposefully, eclectic. They drew from myriad sources: Haniwa terra-cottas, Wotruba's sculpture, Jackson Pollock's paintings, music, poetry, and the brash, inelegant Los Angeles environment. But books were the major "museum" of the group. Voulkos in particular was a ravenous browser of ceramic literature. The photographs were marvelously abstracting, and in one case Soldner recalls Voulkos's being inspired to imitate what he saw as the gigantic scale of one illustrated pot, which he discovered much later to be a mere five inches in height.

The environment celebrated the individual, but there were common qualities that linked an otherwise diverse group of artists. The manner in which they handled the clay was looser and more informal than ever before, and generally there was a unifying sense of incompleteness in the seemingly cursory finish of the works. What was taking place was a broad-ranging experiment taking craft to the point that the critic Harold Rosenberg proposed as the ideal in contemporary art, an unfocused play with materials.

In explaining the motivations of the group, John Coplans was later to write that "they were totally uninterested in exhibiting. What they needed was time to mature as artists, to seek their own path free from external pressures. The pot they felt was no more than an idiom." They were keenly aware of what was taking place in the art world, particularly in San Francisco and New York, but no one in the art world (apart from Rose Slivka, editor of *Craft Horizons*, and Fred Marer, who had from the outset collected their work) was aware of what was taking place, and "this suited their purposes at the time." [95]

The central figure in the decade was undoubtedly Voulkos. But he was not solely responsible for the breakthrough in American ceramics, as recent attempts at deification have attempted to suggest. He was involved in a dynamic relationship with his students, and the victory of Otis was really the victory of a highly competitive environment where the participants functioned as "independent contestants." [96] Jim Melchert, who worked with

Voulkos from 1958, wrote that working with him gave one the feeling of being onto something big and real:

> At the same time it was unforgettably disturbing. To build confidence in your own authority you had to keep surpassing your preconceptions and expectations. Having Voulkos for a teacher was the most demanding situation that I had encountered. To him a person's notion of existing limitations was largely imaginary. He constantly cautioned against underestimating the artist. If the persons working with him broke with the standard conceptions of formal structure they also managed to get around technical obstacles.[97]

Voulkos set an intimidating example, producing fifteen pots to everyone else's one. Frequently he and the students would work seven days a week, sometimes through the night, firing hundreds of pots a week. Voulkos influenced students by example, and if he had any message or doctrine, it was that the artist must trust intuition:

> When you are experimenting on the wheel there are a lot of things you cannot explain. You just say to yourself, "the form will find its way"— it always does. That's what makes it exciting. The minute you begin to feel you understand what you are doing it loses that searching quality. You reach a point where you are no longer concerned with keeping this blob of clay centered on the wheel and up in the air. Your emotions take over and what happens just happens. Pottery has to be more than an exercise in facility—the human element, expression, is usually badly neglected.[98]

In the work of Voulkos at Otis, three developments emerged. First, by imitating the ceramics of Picasso, he came to the same realization as the master painter, that the overall painting of the pot surface destroys three-dimensionality.[99] At the same time, it allows the artist to rebuild the form using line and color and so to distribute the climactic aspects of the form. Second, Voulkos began to assemble his vessels from separate elements. Instead of a fluid, compositional unity, the pots became fragmented as one part competed for attention with the others. Third, in his treatment of form, Voulkos began to deal less and less with the pot as volume—a contained space—and more with the pot as mass. The forms were made from almost solid pieces of clay, and although the traditional components—foot, main form, and neck—remained, the vessel had now become a sculptural body of indeterminate shape. But the claim that Voulkos "turned ceramics into sculpture" is a misconception. For no matter how sculptural his works became,

they remained patently part of the tradition of pottery rather than sculpture.

Voulkos did also begin to produce a body of clay sculptures toward the end of the Otis period and his move in 1958 to Berkeley and the University of California. Some of these forms have a brooding presence, but generally speaking, this was Voulkos's most uneven and unsuccessful period of work, and he finally turned in 1962 to metal as his major medium.

Around 1957 the Otis students began to show a more assertive independence, their exploration of the medium in many cases taking them in a direction different from that of Voulkos. Kenneth Price concentrated on two aspects that have been a continuing theme in his work: the play of line and color, deemphasizing mass and even volume as he satirically dealt with the counterpoints of two- and three-dimensionality. John Mason and Malcolm McClain were more intellectually involved in the medium. Their works are patently Constructivist, usually produced out of carefully placed and even modules. There was one phase of Abstract Expressionist work in Mason's output, however, when he created huge wall pieces by trailing long slabs of clay, one over another, in a random manner But his interests became more and more geometrically formal as he progressed toward Minimalism and Conceptualism.

Henry Takemoto dealt largely with the pot as a canvas, covering his plates and fecund pot forms with energetic calligraphic drawing. Billy Al Bengston also concentrated on surface, finally leaving ceramics to become a successful painter. Paul Soldner remained a functional potter; Michael Frimkess dealt with the material in an iconographic manner, and Jerry Rothman, the maverick of the group, flirted at first with Constructivism, creating twelve-foot-high clay and metal sculptures for the Ferus Gallery in 1958. He moved on to more expressionist works thereafter, as in his serenely sensual *Sky Pots.*

What took place at Otis was by any standard a major event. The students in that group have gone on to become the leading artists, teachers, and designers in ceramics today. But the momentum did not stop at Otis. In Berkeley a new group assembled around Voulkos: Ron Nagle, Jim Melchert, Stephen De Staebler, and others, giving rise to a body of strong sculpture in the 1960s and some interesting refinements of the vessel aesthetic. The activities attracted visitors, notably Manuel Neri, who had been working sporadically in clay since 1954 and his contact with Voulkos at Archie Bray, and Harold Paris, who worked on mammoth ceramic walls. The peak of the so-called Abstract Expressionist developments came between 1957 and 1960. Later

developments were to lead away from abstract concerns to figurative imagery, but the effect of the early years of the experiment, as Coplans has noted, has been "to totally revolutionize the approach to ceramics. . . . What was done in those days is now mainstream ceramics." [100]

On the East Coast and in the Midwest, a quieter revolution was taking place. The seeds planted there in the 1950s took a longer time to grow. But the achievements of this time should not be discounted. Alfred University was for the first time producing students with an adventurous approach to their material. Most remained respectful to the functional disciplines of the art but thrived within its limitations, producing a generation of strong potters: Bob Turner, Karen Karnes, Val Cushing, Ken Ferguson. Other students were more experimental. David Weinrib began to produce structured, slab pots before moving into a successful career as an internationally known sculptor. Daniel Rhodes developed techniques of combining fiber glass and clay to allow for sculptural forms that were previously technically impossible. Rhodes was also to be one of the most influential educators of the postwar period through his series of books on clays, glazes, kilns, and recently, potter's form.

Black Mountain College, near Asheville, North Carolina, a progressive community that included at various times such diverse figures as Josef Albers, Clement Greenberg, and Robert Rauschenberg, was a magnet for the Alfred artists. Robert Turner worked there in 1952, building an immaculate and imaginative pottery. When he left, he was replaced by Karen Karnes and her husband, David Weinrib. Their reception was hostile. The dominant radical element in the school looked upon "the crafts" as being insupportably bourgeois. Weinrib was at least experimental, but the down-to-earth functional ware of Karnes was adjudged "not real or grubby enough," and above all she committed the cardinal sin of "actually selling in commercial outlets." [101] On one occasion, the students demonstrated their dislike of the pottery by piling scraps from their dinner on Karnes's pots. After the ten-day International Ceramics Symposium in 1953, with Bernard Leach, Shoji Hamada, Soetsu Yanagi, and host Marguerite Wildenhain, the community began to reassess the pottery. The embattled resident potters were actually given official billing on the symposium held in the following year with Rhodes and Warren MacKenzie, one of the most influential of Leach's American apprentices. Weinrib recalled that the community finally saw the pottery as a "measurable" achievement and that the more conservative members began

to question the depth of students who became "too instantly hip" on reading Rimbaud and Proust, welcoming the potters' contrasting practicality as a counter to the overly libertine elements of the school.[102]

What took place at Black Mountain was a dramatization of what was happening throughout the country. A popular interest in the medium was resulting in the introduction of ceramics programs in art schools, colleges, and universities. The medium, however, was not accepted by the influential post-modernists, who were beginning to take over the academic art institutions and devalue the importance of both craft and object. Furthermore ceramics still carried its aura of being a tool of art education, and critics and media found difficulty in treating ceramics as a serious medium. Those in the Otis group, for instance, found that once they attempted to engage an audience with their work they were arbitrarily consigned "to what they considered to be a twilight world, that of the crafts which caused considerable misgivings, even anguish." [103] In the decade that followed, the most determined assault yet on the boundaries of fine arts took place, during which the American ceramist was finally to establish an artistic beachhead for the medium.

157

158

157. Reuben Nakian, New York.
Nymph, 1951. Terra-cotta, H. 9¾".
Collection Hirshhorn Museum and
Sculpture Garden, Smithsonian Insti-
tution, Washington, D.C.

158. Maija Grotell, Bloomfield Hills,
Michigan. *Bowl,* c. 1950. Stoneware,
H. 9¼". Collection Cranbrook
Academy of Art Museum, Bloom-
field Hills.

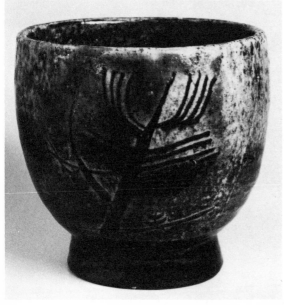

159

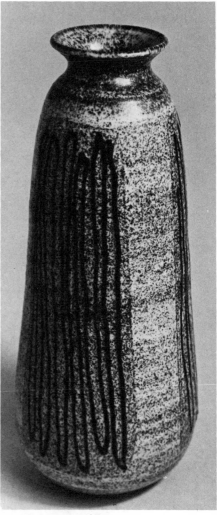

160

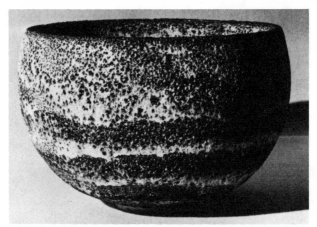

161

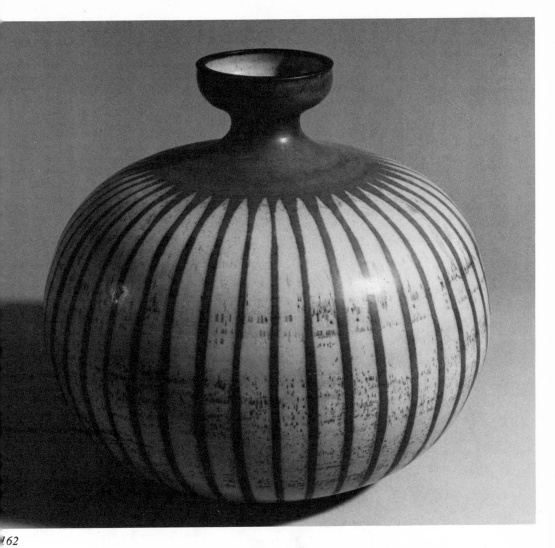

159. Henry Varnum Poor, New York. *Footed Bowl*, 1954. Stoneware, glaze with underglaze decoration, H. 5¾". Collection Everson Museum of Art, Syracuse. Photograph: Garth Clark/Lynne Wagner.

160. Antonio Prieto, Oakland, California. *Vase*, 1950. Stoneware, H. 13¾". Collection Everson Museum of Art, Syracuse. Photograph: Garth Clark/Lynne Wagner.

161. Gertrud and Otto Natzler, Los Angeles, California. *Earth Crater Bowl*, 1956. Earthenware, green-gray glaze, Diam. 12". Collection Everson Museum of Art, Syracuse. Photograph: Robert Lorenz.

162. Harrison McIntosh, Claremont, California. *Vase*, 1959. Stoneware, mat glaze, H. 13½". Collection Everson Museum of Art, Syracuse. Photograph: Jane Courtney Frisse.

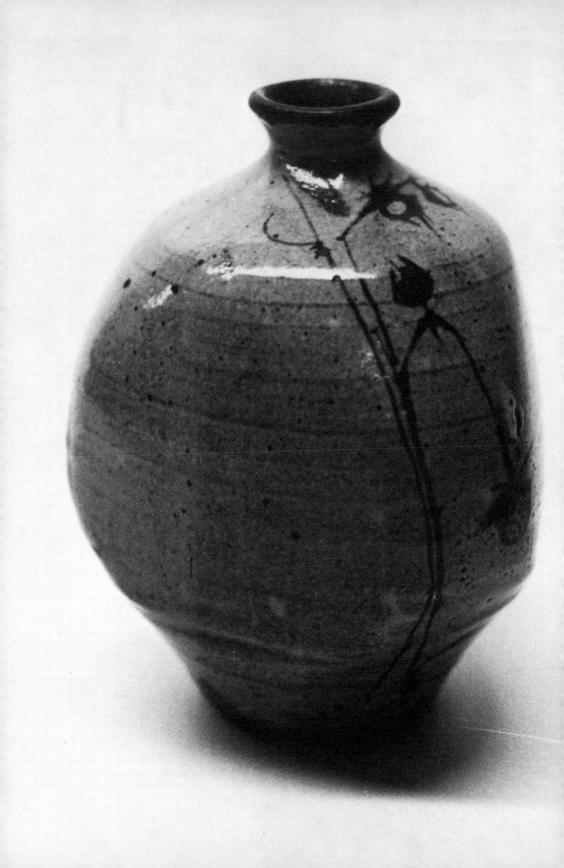

164

165

163. Warren and Alix MacKenzie, Stillwater, Minnesota. *Bottle Vase*, 1957. Stoneware, glazed with iron oxide brushwork, H. 9″. Courtesy the artist.

164. (*left to right*) Soetsu Yanagi, Bernard Leach, Archie Bray, Peter Voulkos, and Shoji Hamada at the Archie Bray Foundation, Helena, Montana. 1953.

165. Shoji Hamada with John Stephenson at the University of Michigan, Ann Arbor. 1966.

163

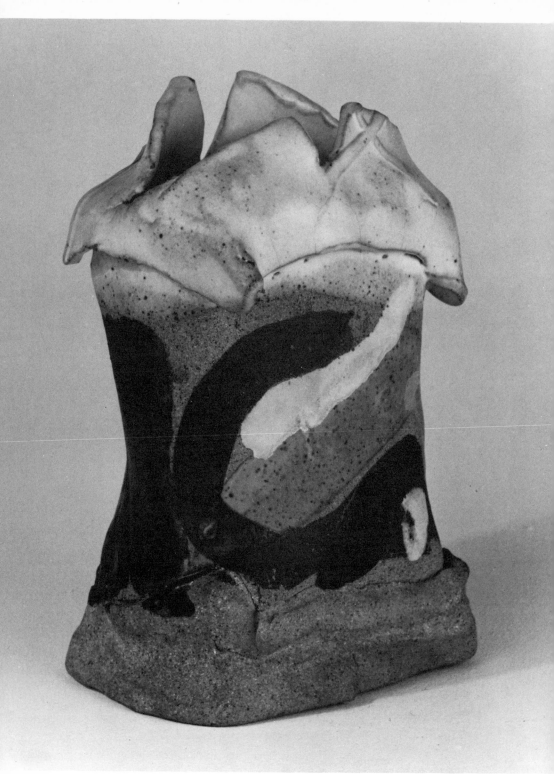

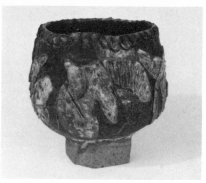

167

166. Rudy Autio, Helena, Montana. *Vase,* 1958–1959. Stoneware, H. 10″. Marer Collection, Scripps College, Claremont, California. Photograph: Paul Soldner.

167. Robert Arneson, Oakland, California. *Footed Bowl,* 1955. Stoneware, H. 6¾″. Marer Collection, Scripps College, Claremont, California. Photograph: Paul Soldner.

168. Rudy Autio, Helena, Montana. *Vase,* 1959. Stoneware, H. 14½″. Marer Collection, Scripps College, Claremont, California. Photograph: Paul Soldner.

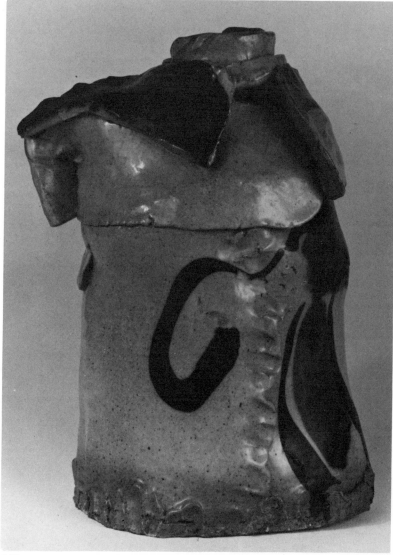

168

145

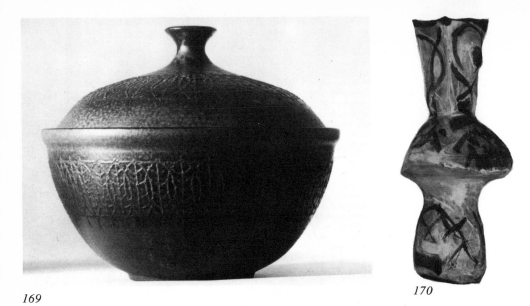

169

170

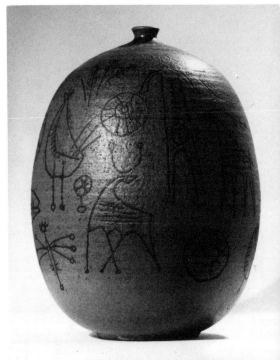

169. Peter Voulkos, Archie Bray Foundation, Helena, Montana. *Covered Bowl,* 1950. Glazed earthenware, H. 11¼″. Collection Everson Museum of Art, Syracuse. Photograph: Robert Lorenz.

170. Peter Voulkos, Los Angeles. *Vase,* 1958. Stoneware, H. 20½″. Marer Collection, Scripps College, Claremont, California. Photograph: Paul Soldner.

171. Peter Voulkos, Archie Bray Foundation, Helena, Montana. *Rice Bottle,* 1951. Glazed wax-resist decoration, H. 13½″. Collection Everson Museum of Art, Syracuse. Photograph: Robert Lorenz.

171

172. Peter Voulkos, Los Angeles, California. *Jar,* 1956. Stoneware, H. 25½″. Collection Everson Museum of Art, Syracuse.

146

172

173

174

175

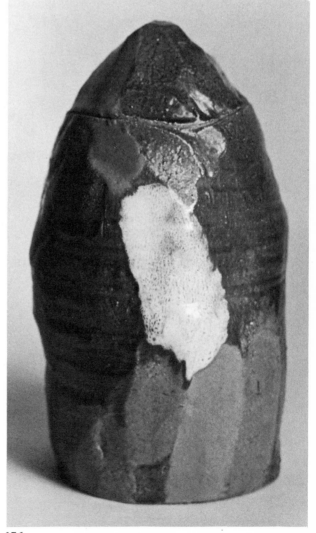

176

173. Peter Voulkos (*center*), Jerry Rothman, and Henry Takemoto at Otis Art Institute, San Francisco, California, 1957.

174. Peter Voulkos, Los Angeles. *Pot,* 1957. Green, gray, and brown glazed stoneware, H. 11½". Marer Collection, Scripps College, Claremont, California. Photograph: Paul Soldner.

175. Kenneth Price, Los Angeles. *Vase,* 1956. Stoneware, H. 18¼". Marer Collection, Scripps College, Claremont, California. Photograph: Paul Soldner.

176. Kenneth Price, Los Angeles. *Lidded Jar,* 1957. Stoneware, glazed, H. 9". Collection Irving Blum. Photograph: Garth Clark/Lynne Wagner.

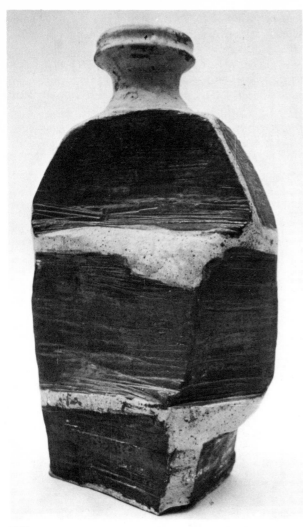

177. Malcolm McClain, Los Angeles. *Vase,* 1957. Stoneware, glazed, H. 15". Marer Collection, Scripps College, Claremont, California. Photograph: Sharon Hare.

178. John Mason, Los Angeles. *Vase,* 1958. Glazed stoneware, H. 10¾". Marer Collection, Scripps College, Claremont, California. Photograph: Paul Soldner.

179. Billy Al Bengston, Los Angeles. *Platter,* 1956. Stoneware, Diam. 12". Marer Collection, Scripps College, Claremont, California. Photograph: Paul Soldner.

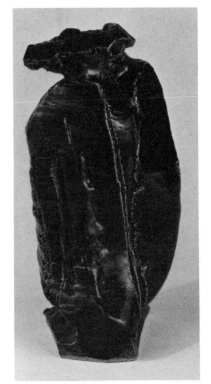

177

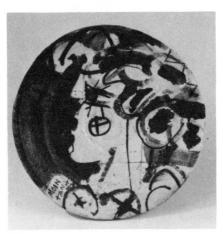

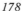

178

179

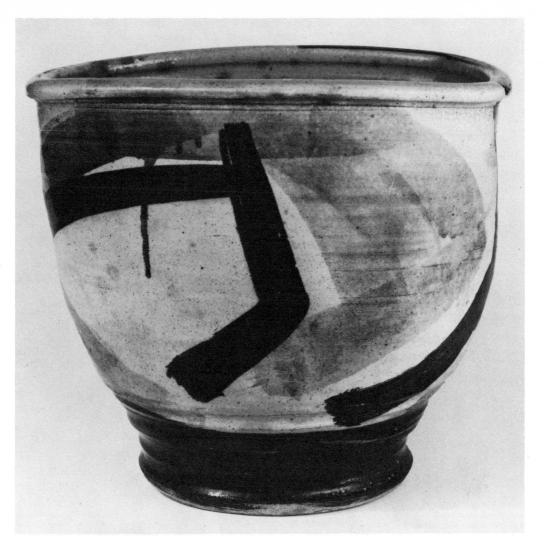

180

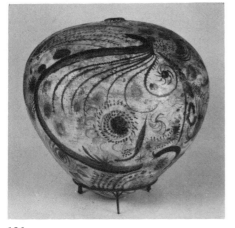

181

180. John Mason, Los Angeles. *Bowl,* c. 1957. Stoneware, glazed, H. 14½″. Marer Collection, Scripps College, Claremont, California. Photograph: Paul Soldner.

181. Henry T. Takemoto, Los Angeles. *First Kumu,* 1959. Stoneware, H. 21¾″. Marer Collection, Scripps College, Claremont, California. Photograph: Paul Soldner.

151

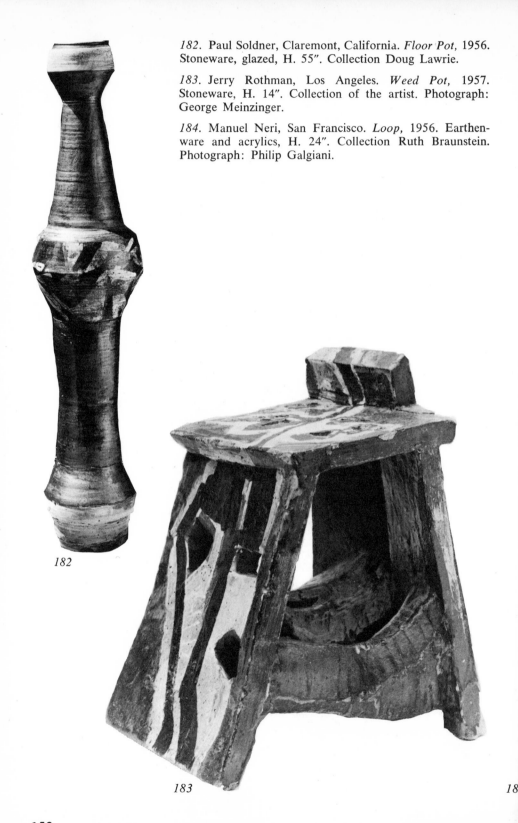

182. Paul Soldner, Claremont, California. *Floor Pot,* 1956. Stoneware, glazed, H. 55". Collection Doug Lawrie.

183. Jerry Rothman, Los Angeles. *Weed Pot,* 1957. Stoneware, H. 14". Collection of the artist. Photograph: George Meinzinger.

184. Manuel Neri, San Francisco. *Loop,* 1956. Earthenware and acrylics, H. 24". Collection Ruth Braunstein. Photograph: Philip Galgiani.

182

183

18

186

185. Robert C. Turner, Black Mountain College, near Asheville, North Carolina. *Bottle*, 1951. Stoneware with reduction glaze, H. 9¼". Collection Everson Museum of Art, Syracuse. Photograph: Garth Clark/Lynne Wagner.

186. David Weinrib and Karen Karnes at the Pottery, Black Mountain College, near Asheville, North Carolina. Early 1950s.

187. David Weinrib, New York. *Slab Pots*, 1956. Stoneware, metal, H. 8¾" and 10½". Collection Everson Museum of Art, Syracuse.

187

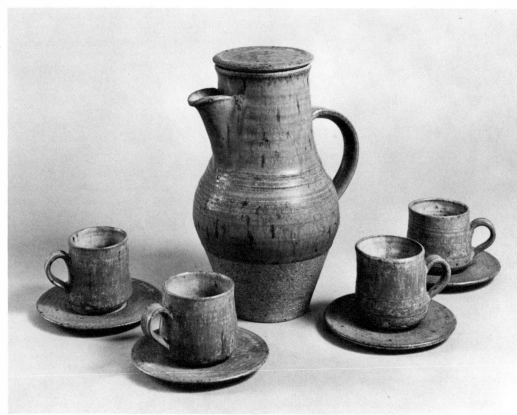

188

188. Karen Karnes, Stony Point, New York. *Demitasse
Set*, 1957. Stoneware, orange glaze, H. of cups 2½"; H.
of pot 8¼". Collection Everson Museum of Art, Syracuse.
Photograph: Jane Courtney Frisse.

1960

Although the 1950s had been a busy, innovative period, there was in 1960 little national sense of direction. Potters and ceramists were vaguely aware that new developments were underway. Voulkos consistently won prizes at the Ceramic Nationals, and other artists began to exhibit: Mason, Rothman, Soldner, Melchert, and Frimkess. In fact, Europe, where the United States was winning the major prizes (including the Grand Prix des Nations at the 1959 Ostend International Ceramics Exhibition), was probably more aware of and excited by the revolution that was taking place. It was Rose Slivka's article in the July–August 1961 *Craft Horizons,* titled "The New Ceramic Presence," that brought the new aesthetic into the national forum.

Slivka had been in contact with Voulkos and the group around him since 1958 and had in turn introduced Voulkos to her friends in New York, such as Willem de Kooning and others in the New York school. She completed the article in 1960 and published it the following year. Despite taking great pains to be nonpartisan and present the works of Voulkos, Mason, Takemoto, Rothman, and a young potter who was later to lead sculptural developments in the decade, Robert Arneson, as being simply one approach to the medium, her article caused a furor. The largely conservative membership of the magazine's parent, the American Crafts Council, were confused, angered, and threatened. A debate opened as letters poured in, and it continued for some years. The reaction proved to be a healthy one in the long run, as the ceramics community began to question and reject its own entrenched criteria.

However, there were elements of the article that tended toward paternalism. Slivka wrote the article from a painterly rather than a ceramic viewpoint. Although giving an acknowledgment to Japanese pottery, she did not

explore the depth of this involvement. The pouring of colored pigments one over another, gestural painting, a random use of color, and pure abstraction —developments new to painting—had been consciously explored for centuries in a highly sophisticated manner by Japanese potters. It was a recognition of the complexity of the Japanese ceramic aesthetic that was the primary experience for the potter of the 1950s. Abstract Expressionism modified that experience and gave it contemporary context.[104]

One of the most insightful comments in the article had nothing to do with painting and was Slivka's linking of the new ceramics with jazz, which implied giving greater importance to the performance of making than to the object itself. Until the 1950s, potters had tended to observe the European approach that viewed process simply as means. In jazz, means and end become one:

> Spontaneity, as the creative manifestation of this intimate knowledge of tools and their use on materials in the pursuit of art, has been dramatically an American identity in the art of jazz, the one medium that was born here. Always seeking to break through unexpected patterns, the jazzman makes it while he is playing it. With superb mastery of his instrument and intimate identification with it, the instrumentalist creates at the same time as he performs; the entire process is there for the listener to hear—he witnesses the acts of creation at the time when they are happening and shares with the performer the elation of the creative act.[105]

A second appraisal of the work of the 1950s came in 1966, when John Coplans organized "Abstract Expressionist Ceramics," an exhibition that was shown at the University of California in Irvine's art gallery, and in 1967 at the San Francisco Museum of Art. The exhibition was, despite the dubious accuracy of the title, one of the most important single events in American ceramic history. For numerous ceramists working today, it was a turning point in their careers and their sensitivities toward the medium. It showed many of the best works of a loose genre that was for the first time identifiably American. The exhibition catalogue was in great demand and ran to three printings. Coplans's catalogue essay is one of the more important statements in contemporary American ceramics but also has the bias of seeing the work as an experiment in painting—"the most ingenious regional adaptation of . . . Abstract Expressionism . . . yet" [106]—rather than as an independent achievement of a distinct and different discipline: ceramics. Furthermore the links with Abstract Expressionism were hardly strong enough to justify the

title, as Constructivism was patently a more central influence for many works in the exhibition.

But the denial of any European influence was a necessary deceit at a time when the American ceramist needed to have confidence in his own roots, and chauvinism proved for once to be healthy. Furthermore a debt must be acknowledged to Coplans. Long before the exhibition, he had become one of the most energetic supporters of the clay movement. His articles in *Artforum, Art in America,* and other journals from 1963 onward contributed most strongly toward a growing acceptance of ceramics as an art genre.

Yet another exhibition, held at the University of California in Berkeley in 1967 and titled "Funk Art," pinpointed a new energy and direction. Organized by Peter Selz, the exhibition contained objects in every medium, although it was the clay objects that seemed closest to the aesthetic Selz suggested in his essay. In fact, the exhibition proved to be far less a definition of Funk (the cool egg forms of Kenneth Price and clean polychrome metal sculptures of Robert Hudson clearly did not belong to the title) than a survey exhibition of West Coast art that was without a genre. However, it did draw attention to broad Funk concerns in art and was a showcase for some of the ceramic talents in this area, David Gilhooly and Robert Arneson.

Harold Paris, in an article titled "Sweet Land of Funk," had earlier pinpointed the context out of which the "style" had grown. It was less an identifiably visual expression than an attitude. Each artist interpreted it in a different manner, but when Bay Area artists spoke of Funk, each knew what the other meant. Funk was in a sense protest (unspecific) coming out of a feeling (equally unspecific) of being betrayed by traditional forms and ideas in society:

> Artists of the current generation have turned inward. Rejecting collective ideas and moral judgment they are hypersensitive to their own elemental feelings and processes. What is felt is real and tangible; what is thought to be is distrusted. Intuitive perception is desirable. The residue, or the by product is more interesting and provocative than the intellectual process that creates it. In essence, "It's a groove to stick your finger down your throat and see what comes up," this is funk.[107]

The early Funk art on the West Coast had its roots in Dada and Surrealism. It is beyond the limitations of this study to go into the relative inputs of each, apart from their obvious insouciance, poetic juxtaposition of found or common objects, and rejection of establishment values in the fine arts. More

important to acknowledge is that the Dada and Surrealist objects proposed a new type of art object. Marcel Duchamp's readymade *The Fountain* (1917), a urinal signed R. Mutt; Man Ray's iron with nails attached to the flat surface, *Gift* (1921); and later, Meret Oppenheim's fur-lined teacup and Salvador Dali's lobster telephone coming from the exposition "Objets Surréaliste" at Galerie Charles Ratton in Paris in 1936—all have one thing in common. Unlike sculpture, which is concerned primarily with form, these objects, although three-dimensional, do not attempt to deal with form at all. Even the participants in the Dada-Surrealist movement agreed that their objects were "Objects of Symbolic function. . . . They depend solely upon our amorous imagination and are extra plastic." [108]

The objects were therefore purely contextual. It did not matter whether they were good form or bad form. The only issue was the reaction evoked between the object or objects and the viewer's preconceived notion of art. They were designed in many cases to affront and offend and so challenge the tasteful tours de force of mainstream modern art. Their distance from sculpture was also increased through a growing involvement with concepts of collage, where as a result "the very conditions of the activity forced the artist to make decisions of a purely pictorial order." [109] In summary, therefore, the Funk ceramics that dominated this decade came out of a nonsculptural tradition where qualities and relevance of form and craft were less important than the contextual response evoked.

Funk objects on the West Coast did not begin with ceramics. The roots were in the Rat Bastard Protective Association, a group of artists who in 1951 mounted an exhibition, "Common Art Accumulations," at the Place Bar in San Francisco. Bruce Conner, Joan Brown, and others put together ephemeral conglomerations combining all kinds of uncombinable things, called them "Funk and didn't care what happened to them." [110] The title "Funk" was taken from the term *bagless funk,* describing a free, improvised, earthy street jazz and also used in Cajun patois to describe the musk smell of a woman's groin. The loose style based on ingredients that Suzanne Foley isolated as being "expressionist, surrealist and offensive," [111] continued as an underground movement through the 1950s in visual art, music, and poetry. It surfaced strongly in the early 1960s at the University of California at Davis,[112] where, under the leadership of Robert Arneson, a group of students began to explore Funk as alternative to both the cool, mannered Pop art and the so-called Abstract Expressionist ceramics that were now being derogatorily referred to as "the blood-and-guts school."

Arneson's involvement began around 1962, when he placed a ceramic

cap on a "handsomely thrown" bottle and marked it *no return*.[113] Until then, Arneson had been a potter, making vessels and winning prizes at decorative art shows such as the Wichita Annual. By 1966 something of a new style had emerged, coming, much like that of Otis, out of student–teacher interaction and a loose, unstructured teaching–learning situation. In that year, an important exhibition took place in the fall at the San Francisco gallery of the American Crafts Council.[114] Arneson exhibited alongside seven of his undergraduates, Margaret Dodd, David Gilhooly, Stephen Kaltenbach, Richard Shaw, Peter Vandenberge, Chris Unterseher, and Gerald Walburg. Kaltenbach's later work as a conceptualist had an influence on a period of Arneson's work, and Gilhooly and Shaw emerged as two of the most prominent ceramists of that decade. But it is Arneson who has dominated the past fifteen years as the leading object-maker–sculptor in ceramics.

Arneson's work from the mid-1960s can be seen in two periods. In the first stage he was, in the words of Dennis Adrian, "a fringe Pop Gangster." His early objects from the mid-1960s have become classics but are not the most important of his works. These pieces—such as the group of eight Seven-Up bottles; *Toasties* (1965); *Typewriter* (1966), with the red-lacquered fingernails replacing the keys; and the visual puns in *Call Girl* (1967), a telephone with breasts—are crowd pleasers. Although less significant in terms of Arneson's total oeuvre, they are important historically. They show the manner in which the early ceramic Funk artists were working out of a Dadaesque inversion of Pop art. The icons were common to both—typewriters, toilets, canned foods. The difference between the two lay in a difference of degree rather than kind, which Peter Plagens succinctly defined as the dirty and the clean. Pop reflected cool, lobotomized images, as in Claes Oldenburg's soft toilets. Arneson's *John* series made the toilets out of genitals and left them splendidly unflushed.

From 1967–1968 onward, a new phase of Arneson's work began to show. The pieces existed less within the definition of the art object à la Dada and became more sculptural. His seminal work *Alice House Wall* (1967), made up of modules, was particularly important in Arneson's growth as a sculptor. This allowed him to work on a large scale and recently culminated in major works such as *Fragments of Western Civilization* (1972) and *Swimming Pool* (1977).

The growth of the verbal-visual in Arneson's work became more complex and less a form of sight gag. The wordplay with objects began early in Arneson's work, and among students, such as Gilhooly, it has continued into

non-Funk activities and has become one of the identifying characteristics in contemporary object-making in American ceramics. The pun in Arneson's work results in a complex response from the viewer. In a penetrating study of Arneson's work, Dennis Adrian emphasizes this aspect:

> The catch is of course that to an English/speaking/thinking audience, the pun is usually interpreted as simplistically humorous on a fairly low level, so statements of double meaning in art—as elsewhere—tend to elicit giggles, and not much more. Yet as any scholar of Joyce or Japanese poetry will wearily insist, the primary function of any kind of pun is the expansion of meaning, within discrete form, into at least two simultaneous modes of thought. This is the key to a large area of art which concerns itself seriously with the truly comic; but, because of the fluky nature of the pun in English, interpretation in that language frequently thrusts aside or misconstrues such art as ignoble.[115]

Apart from a distinguishing use of titles among the Funk artists, there is also a common use of the material. When Alfred Frankenstein said that Arneson had gone one better than Dada, he had produced the "ready-made home-made," [116] he touched the essence of the Funk aesthetic. The sloppy use of the material was carefully sustained, linking the objects with the hobby-craft aesthetic of thick, oozing, and virulently colored glazes over complacent whiteware. So whereas Pop art drew its aesthetic from a commercial craft form of poster-advertising art, the Funk art drew from what might be termed *consumer craft*. Arneson's realization of this quality in the work is substantiated by his bumper sticker "Ceramics is the world's most fascinating hobby" and the works that play on simplistic pottery making, such as *Pottery Lessons* (1967) and *How to Make the Big Dish Plate* (1967).

Lastly the Funk artists shared a massive appetite for eclecticism. Arneson played on various influences, one of the most direct being his *Art Works* series. Stephen Kaltenbach had begun to demarcate various places as being "Art Works" by affixing a bronze plaque with that title. Arneson took the plaque and turned *it* into the artwork in porcelain with celadon glazes, so adding the additional pun of the treasure-house association of Chinese Sung pottery.

The same eclecticism is evident in Gilhooly's frogworld mythanthropy. Gilhooly began by producing facetious animal-related objects such as the *Elephant Ottoman* (1966) but, influenced by Maija Peeples, turned to frogs. Gilhooly's invented culture has allowed him a platform from which to playfully satirize all society and particularly its art.

Last of the Funk artists is Clayton Bailey. Bailey is ceramic's most in-

sistent raconteur. His aesthetic credo can be summed up simply from a statement he once made about his work: "anyone can do things in poor taste —it takes an artist to be truly gross." [117] Certainly the critics agree that Bailey is beyond poor taste. *Art and Artists* (David Zack, "California Myth Makers," 4, March 1970, p. 56) called his work "as gross and phallic as a draught horse's mating equipment." It is a measure of his anarchistic approach that Bailey most treasures reviews that denigrate his work. One of his favorite and most-quoted came from Cynthia Barlow, the reviewer at the *St. Louis Globe Democrat*, who denounced his exhibition at the Craft Alliance Gallery:

> A show that is tasteless, obscene and barely above the level of bathroom humor. Dismembered and disfigured fingers, lips and other portions of the human anatomy make up a large part of the objects presented. Even the titles are unpleasant—*Nite Pot, Kissing Pot*. The pieces are crudely done, carefully painted to the point of lewdity.[118]

These works by Bailey, Arneson's penis-teapots and genital trophies, Gilhooly's frogs fornicating with vegetables and—outside the Bay Area school —the phallic cameras of Fred Bauer comprise the second exorcism for American ceramics. More irreverent than the Otis group's assault on the vessel, they dealt with the preciousness of the figurative ceramic objects that had until then been associated with the conceited and refined court figurines from Europe, the sentimental figurines of Royal Copenhagen, the highly priced limited-edition porcelains of Boehm, Cybis Porcelains, and by contrast the vulgar mass-produced ornaments of the gift shops with their gilding and lace draping. This style broke completely with the role of the ceramist as the producer of tasteful, overly crafted bric-a-brac for middle-class sideboards and mantelpieces.

The impact was enormous, fashionably but superficially seen as the ceramic hippiedom; it was linked with the youth protest movement that had emerged at the same time in the Bay Area. Ceramics students misunderstood the complex cultural statement that was developing, and most saw Funk simplistically as a means of nihilist protest. The work was imitated mindlessly throughout the United States and abroad in Scandinavia and in England (particularly the Wolverhampton Polytechnic, which became the center for the peculiarly English style of "gentlemanly Funk"). *Funk* became the ceramic buzzword. It seemed that overnight everything was Funk: colors, glazes, images, attitudes. But because the images of the style were applied without even a modicum of understanding, the Funk movement fizzled out in the early 1970s, leaving only a handful of credible exponents: the master

(Arneson), Gilhooly, Vandenberge, Bailey (alias Dr. Gladstone), and a few others. Today Funk as a style no longer exists, and the word has the same tired datedness as *hippie*. The protest was over early in the 1970s, and the participants, with the possible exception of Bailey, have moved on to other concerns. But it served its purpose as a purgative for the art, flushing out the last vestiges of formalism in ceramics and adding the second American mainstream to ceramic art within a decade.

One last comment must be made about this complex, ambiguous expression. It grew very much out of regional energies and concerns. It is less than incidental that those who succeeded in applying the style lived within the Bay Area. In his description of Funk, the artist Harold Paris emphasizes this regionalism:

> The casual insincere, irreverent Californian atmosphere with its absurd elements—weather, clothes, skinny-dipping, hobby craft, sun drenched mentality, Doggie Diner, perfumed toilet tissue, do-it-yourself—all this drives the artist's vision inward. This is the land of Funk.[119]

In contrast to the "dirty" aspect of Funk, the art of the clean was growing apace. It came in many forms, the first expression being Kenneth Price's sensual egg forms from the early 1960s. They were immaculately crafted with a purist use of form, line, and acid colors. "Like the geometric redness of the Black Widow's belly or the burning rings of the Coral snake" Henry Hopkins wrote, "these objects proclaim their intent to survive." [120] Gradually a taste began to grow on the West Coast for finely crafted, or "fetish finish" objects, as they became known, as a counter to both the rawness of Funk and the macho casualness of the Abstract Expressionists. Ron Nagle was one of the central figures in this development. Strongly influenced by Price he began to explore new directions. His mother's involvement with china painting suggested one direction to follow; photo-decal decoration was another. In 1962 Nagle and Jim Melchert were responsible for the change from stoneware to whitewares at the San Francisco Art Institute, allowing a wider range of surface treatments and doing away with the expressionist exuberance of stoneware glazes and bodies.

A number of key exhibitions followed, for example, "Works in Clay by Six Artists" (Melchert, Manuel Neri, Anne Stockton, Ricardo Gomez, and Stephen De Staebler), at the San Francisco Art Institute in 1963, where Nagle exhibited china-painted cups and photo-decal decoration.[121] In 1964 Melchert held a one-man show at the HansenFuller Gallery titled "Ghost-wares," having changed from stoneware and abstract form to molded, figu-

rative, china-painted whitewares. The use of these materials became increasingly refined, culminating in his *a Series* and *Games* series. Michael Frimkess also changed materials and content, painting with china paints on classic forms: amphora, ginger jars, and Greek urns.

The Museum of Contemporary Crafts' "New Ceramic Forms" exhibition in New York in September 1965 finally acknowledged the new thrust that was taking place, and all the objects exhibited came from the whiteware, china-painted tradition. At first, the polarities of the "school" were indistinct, and the division of dirty and clean was less apparent. But from 1966 on, a new finesse was established as a group of artists sought for pristine, immaculate craftsmanship.[122] An early masterwork in this genre was Richard Shaw's *Ocean Liner Sinking into a Sofa* (1966) and the subsequent *Sofa* series. This high-craft approach, belonging to what I term the "Super Object" tradition in ceramics, now began to grow rapidly, using a Surrealist base for its imagery. The Bay Area dominated for some time, but many were working in this style: Jack Earl in Toledo, Ohio; Victor Spinski and Ka-Kwong Hui in New York. Although Hui worked with abstract form, the accent on refinement and surface was nonetheless in harmony with the Super Object aesthetic.

The year 1966 proved to be one of the most important for the Super Object aesthetic. In that year Hui collaborated with Pop artist Roy Lichtenstein, and a body of work—piles of cups, teapots, and molded heads—was assembled and exhibited at the Leo Castelli Gallery in New York. These works, much like the Super Objects that developed elsewhere, were consciously dealing with interaction between the reality of the three-dimensional form and the illusion of painting; Lichtenstein was interested "in putting two dimensional symbols on a three dimensional object." [123] More broadly, Lichtenstein's aesthetic credo is very much a summary of that of the Super-Object makers:

> Lichtenstein conceals the process from an object to art . . . disguising the genuine aesthetic concern in apparent anti-sensibility and his painstaking craftsmanship in the appearance of mass-production.[124]

The use of evident mass-production techniques was not as frequent a ploy of the ceramists, who preferred to use assemblages of trivia, flip throwaway visual gags, and nose-thumbing satire to deflate the craft input. But the end result was the same, preventing the craft from appearing pompous and dominant.

At the same time that Lichtenstein was showing his assembled cup sculptures and Ben-day-dot–decorated mannequin heads, another exhibition,

"The Object Transformed," was taking place at The Museum of Modern Art. The show emphasized the growing interest in the art object as an alternative to either painting or sculpture, which was welcomed as "the new still life of the Twentieth century" by its organizer, Mildred Constantine. In a review of the exhibition, Alice Adams wrote that unlike the still life of Cézanne, Picasso, and Braque, where the object becomes universalized through successive analysis, the transformed object is unique and personal in concept:

> Objects from the environment, things that were made for specific use, have now entered a realm of artists' media. Along with the altering of images through collage has come the actual dis-assemblage, shrouding, melting down or otherwise altering ordinary objects so that they resolidify into another form. Usually retaining a ghost of the original, their transformation forces a parallel change in the observer's preconceived notion of what he knows. The world of dreams and fantasies congeals before his eyes, and he must deal with it as reality.[125]

The opportunity for the ceramist—dealing as he had with cups, teapots, and objects and their utilitarian associations—was implicit, allowing him to retain the traditional formats of his art and through the input of collage, assemblage, Surrealism, and trompe l'oeil convert them into contextual art statements.

A second school of ceramists working with these aspirations began to develop in Seattle at the University of Washington, with leadership coming from Howard Kottler, Fred Bauer, and Patti Warashina. Kottler turned from making lumpish stoneware weed pots to collages made up from store-bought decals that he fired onto commercial porcelain blanks. As the supreme irony, he would then encase his plates in luxurious custom-made containers, lavishing more attention on the wrappings than on the "art objects" they contained. Bauer worked on the cusp of the Funk–Super Object border. His imagery was frequently close to that of the Funk artist (cameras with penis lenses), but he defused the potential vulgarity of the concept with elegance of craftsmanship, carefully modeling and glazing with slick lustered surfaces.

Apart from the two areas discussed, there are also those artists in the 1960s who attempted to apply the medium to more public and sculptural concerns. John Mason worked on a series of monoliths that were up to six feet in height. The first and most successful of these, produced in 1962–1963, have a strong sense of heroism. Later he tried to work in a Minimal format, building up geometric, hard-edged forms with what were intended

to be flat, monochrome-glazed surfaces. Elaborate systems of drying the large forms were devised, but despite the care, the forms warped and cracked, and colors flowed into a rich and busy surface. The large works of this period that succeeded unreservedly were the series of walls that Mason created— again revealing the formal modularity that was to take him inevitably into brick sculpture.

Jerry Rothman worked at the same time to enlarge the scope of the material and overcome the limitations of ceramics that made it unsuitable for the sculptural objectives of the time. His Minimalist work *In-Pugmill Art* (1967), installed at the University of Iowa, did manage to overcome limitations of scale. However, in neither the work of Mason nor that of Rothman does the large-scale use of the material appear to have a logic beyond the need to solve and overcome an immediate limitation of the material. In the work of Stephen De Staebler, where the clay is used for its own sake and because the emotions expressed in his work flow so easily from the clay's ready expressionist qualities, there is no ambivalence. De Staebler's use of clay as a passionate, figurative medium in the 1960s has matured in the 1970s, whereas the more contrived expansions of the medium have failed to make any headway. This can be read in two ways: either the public has been unable to appreciate ceramics outside the known and accepted qualities of the material, or overinvolvement in technical sophistication can hamper rather than expand an artist's scope.

189

189. Michael Frimkess, Los Angeles. *Platter,* 1960. Stoneware, Diam. 18¾″. Marer Collection, Scripps College, Claremont, California. Photograph: Paul Soldner.

190. Win Ng, San Francisco. *Directions,* 1960. Stoneware, H. 35⁷⁄₁₆″. Collection Everson Museum of Art, Syracuse.

191. Daniel Rhodes, Alfred, New York. *Form,* 1962. Stoneware, H. 47″. Collection Everson Museum of Art, Syracuse. Photograph: Jane Courtney Frisse.

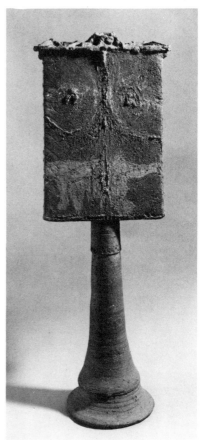

191

190

192. John Mason working on ceramic wall, Los Angeles. 1960.

193. Installation view of "Abstract Expressionist Ceramics" exhibit at University of California at Irvine, 1966.

194. Peter Voulkos, Berkeley, California. *Bottle,* 1961. Stoneware, glazed, H. 17". Marer Collection, Scripps College, Claremont, California. Photograph: Paul Soldner.

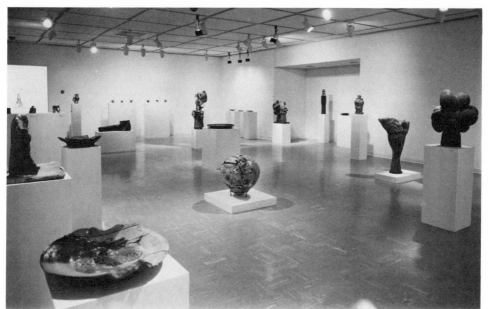

193

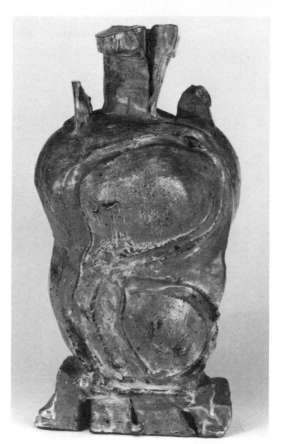

194

171

195. James Melchert, Berkeley. *Legpot I,* 1962. Stoneware with lead and cloth inlay, slab and thrown forms combined, L. 32″. Collection Museum of Contemporary Crafts, New York.

196. Installation view of sculptures by John Mason at Los Angeles County Museum of Art, 1966.

197. William Wyman, Massachusetts. *Untitled,* 1962. Stoneware, H. 25½″. Collection Everson Museum of Art, Syracuse. Photograph: Jane Courtney Frisse.

198. Peter Voulkos, Berkeley. *Platter,* 1963. Tan, white, and blue glazed stoneware, L. 14¾″. Marer Collection, Scripps College, Claremont, California. Photograph: Sharon Hare/Doug Humble.

195

196

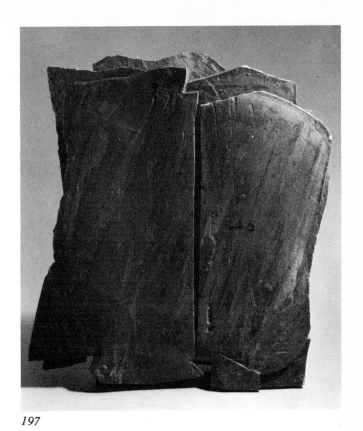

197

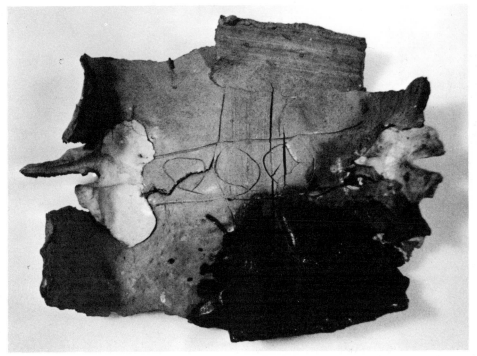

198

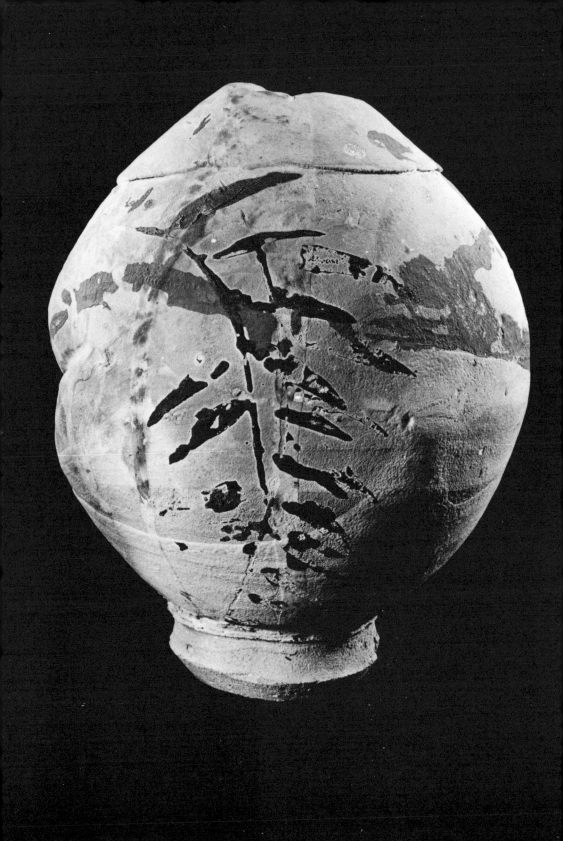

200

199. Paul Soldner, Claremont, California. *Bottle,* 1964. Raku-fired, wheel-thrown, and altered, H. 9″. Collection Everson Museum of Art, Syracuse. Photograph: Jane Courtney Frisse.

200. David Smith, Bennington, Vermont. *Untitled,* 1964. Stoneware and blue slips, H. 8¾″. Collection David Gil. Photograph: Robert Lorenz.

201. Rudy Autio, Missoula, Montana. *Double Lady Vessel,* 1964. Stoneware, black and white slips, H. 28¼″. Collection Everson Museum of Art, Syracuse. Photograph: Jane Courtney Frisse.

201

202. Jun Kaneko, Berkeley, California. *Tegata,* c. 1966. Stoneware, H. 20". Collection Everson Museum of Art, Syracuse.

203. Peter Voulkos, Berkeley. *Vase,* 1966. Stoneware, H. 27½". Marer Collection, Scripps College, Claremont, California. Photograph: Paul Soldner.

204. Paul Soldner, Claremont, California. *Platter,* 1968. Raku-fired earthenware, Diam. 22". Syracuse University Art Collections, New York. Photograph: Garth Clark/ Lynne Wagner.

205. John Mason, Los Angeles. *Untitled,* 1969. Stoneware, H. 41½". Marer Collection, Scripps College, Claremont, California.

203

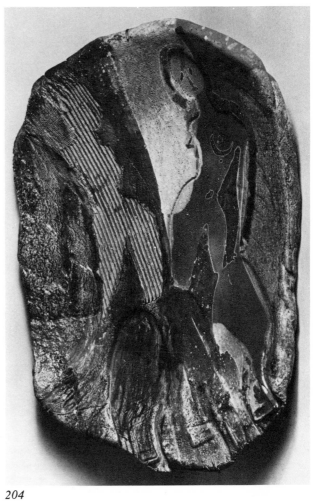

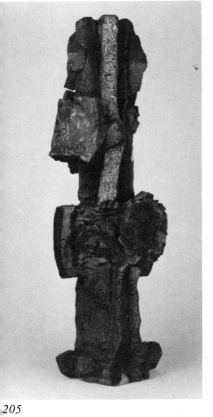
205

204

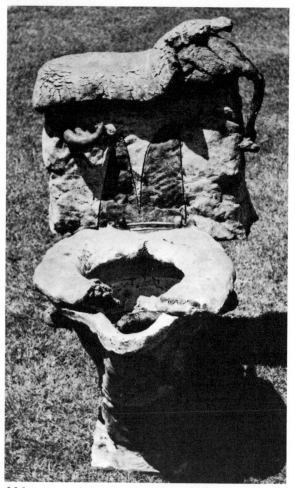

206

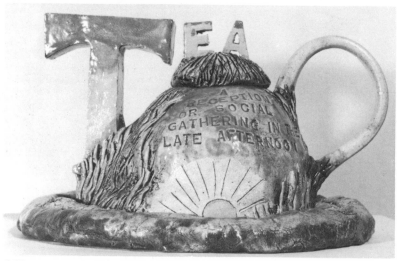

207

178

206. Robert Arneson, Davis, California. *Funk John,* 1963. Glazed ceramic, H. 36″. Collection Mr. and Mrs. Robert Kelly. Photograph: Courtesy Hansen Fuller Gallery, San Francisco.

207. Robert Arneson, Davis, California. *T Pot,* 1969. Earthenware, glazed, H. 12″. Collection Allan Stone Gallery, New York.

208. Robert Arneson, Davis, California. *Alice House Wall,* 1967. W. 96″. Johnson Collection, Spring Green, Wisconsin. Photograph: Courtesy Hansen Fuller Gallery, San Francisco.

209. Robert Arneson, Davis, California. *Toasties,* 1965. Glazed ceramic, H. 9″. Private collection. Photograph: Courtesy Hansen Fuller Gallery, San Francisco.

208

209

210. Stephen Kaltenbach, *First Sidewalk Plaque*, 1968. See figure 211 for Robert Arneson's interpretation.

211. Robert Arneson, Davis, California. *Cocks Fighting over Art*, 1970. Glazed porcelain, L. 6". Courtesy Hansen Fuller Gallery, San Francisco.

212. David Gilhooly, Davis, California. *Elephant Ottoman #2*, 1966. Glazed earthenware, vinyl, plywood, D. 21". Collection of Professor and Mrs. R. Joseph Monsen, Seattle, Washington. Courtesy San Francisco Museum of Modern Art, San Francisco. Photograph: Schopplein Studios.

213. Clayton Bailey, San Francisco. *Caterpillar with Flying Buttresses*, 1963. Stoneware, L. 30". Courtesy the artist.

210

211

213

212

214

214. Fred Bauer, Seattle, Washington. *Black Camera,* 1968. Porcelain, glaze, luster, L. 13″. Collection Robert and Jean Pfannebecker. Photograph: Garth Clark/Lynne Wagner.

215. Fred Bauer, Ann Arbor, Michigan. *Sarcophagus on Stand,* 1966. Slab-built, stoneware, acrylic paint, H. 58″. Collection Robert and Jean Pfannebecker. Photograph: Garth Clark/Lynne Wagner.

216. Margaret Dodd, Davis, California. *Buick,* 1966. Glazed earthenware, L. 14″. Private collection.

217. James Melchert, San Francisco. *Man with Mickey Mouse Ears,* 1964. Glazed earthenware plate, Diam. 14″. Private collection. Photograph: Hawken, Berkeley, California.

215

216

217

218

218. Kenneth Price, Los Angeles. *Form,* 1967. Glazed earthenware, wood, H. 6½". Courtesy James Corcoran Gallery, Los Angeles.

219. Ron Nagle, San Francisco. *Cup,* 1968. Multifired earthenware with wood and plastic box, H. 3". Collection Museum of Contemporary Crafts, New York.

220. Richard Shaw, San Francisco. *Couch and Chair with Landscape and Cows,* 1967. Earthenware, H. 8½". Collection Museum of Contemporary Crafts, New York.

219

221

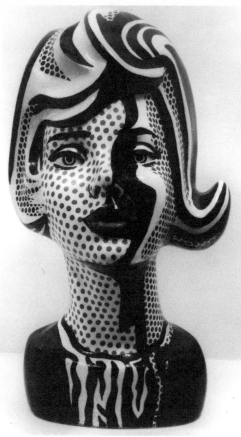

221. Roy Lichtenstein, New York. *Ceramic Sculpture 12*, 1965. Glazed earthenware, overglaze decoration, H. 9″. Collection Mr. and Mrs. John Powers. Photograph: Courtesy Leo Castelli Gallery, New York.

222. Roy Lichtenstein, New York. *Head with Black Shadow*, 1965. Glazed earthenware with overglaze imagery, H. 15″. Collection Mr. and Mrs. Leo Castelli. Photograph: Eric Pollitzer.

223. Howard Kottler, Seattle, Washington. *Playmate Pot*, 1969. Stoneware, glaze, luster, H. 23½″. Collection Robert and Jean Pfannebecker. Photograph: Garth Clark/Lynne Wagner.

224. Ralph Bacerra, Los Angeles. *Red Form*, 1968. Earthenware, luster, H. 12″. Syracuse University Art Collections, New York. Photograph: Jane Courtney Frisse.

222

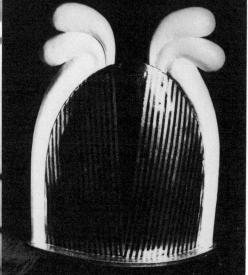

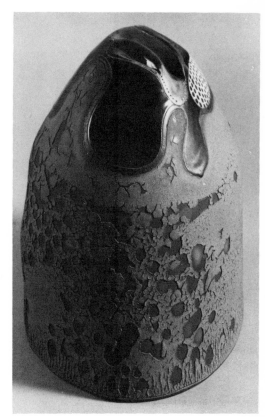

223

224

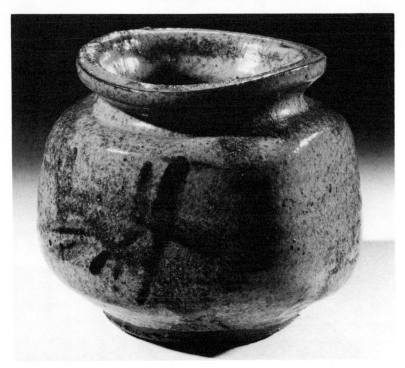

225

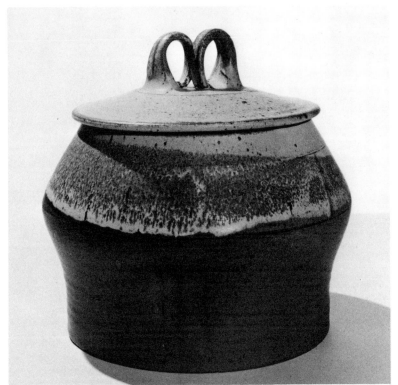

226

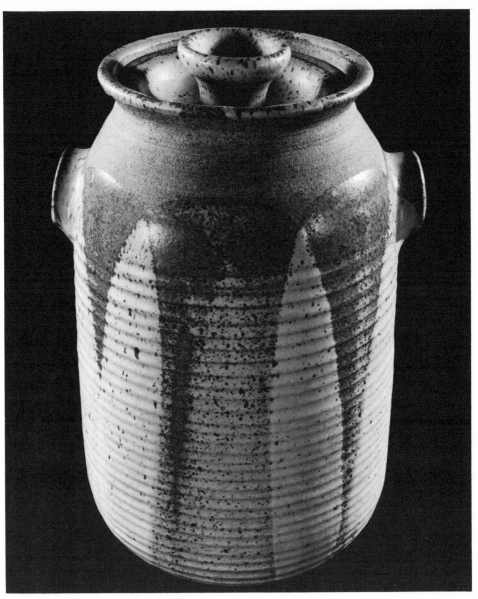

227

225. Warren MacKenzie, Stillwater, Minnesota. *Vase,* 1961. Stoneware, glazed, H. 5″. Collection of the artist. Photograph: Eric Sutherland.

226. Robert C. Turner, Alfred Station, New York. *Storage Jar,* 1965. Stoneware, H. 11″. Collection Everson Museum of Art, Syracuse.

227. Kenneth Ferguson, Helena, Montana. *Storage Jar,* 1962. Stoneware, glazed, H. 15″. Collection Everson Museum of Art, Syracuse. Photograph: Jane Courtney Frisse.

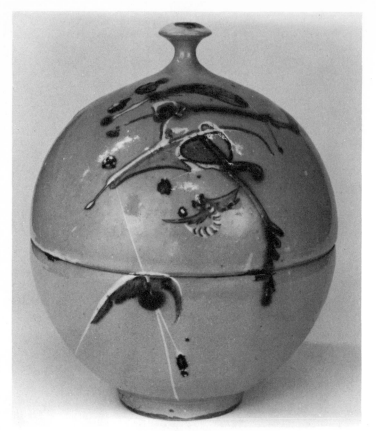

228

229

228. Patti Warashina, Ann Arbor, Michigan. *Covered Jar,* 1964. Stoneware, glazed, H. 12¾". Marer Collection, Scripps College, Claremont, California. Photograph: Paul Soldner.

229. David Shaner, Helena, Montana. *Garden Slab,* 1966. Stoneware, hand-built, brown and gray glaze, white slip, Diam. 14". Collection Everson Museum of Art, Syracuse. Photograph: Jane Courtney Frisse.

230. Betty and George Woodman, Boulder, Colorado. *Urn,* 1966. Stoneware with slips, H. 14". Courtesy the artists. Photograph: George Woodman.

231. Toshiko Takaezu. *Form,* 1967. Stoneware, mat glazes, H. 11½". Collection Everson Museum of Art, Syracuse. Photograph: Jane Courtney Frisse.

231

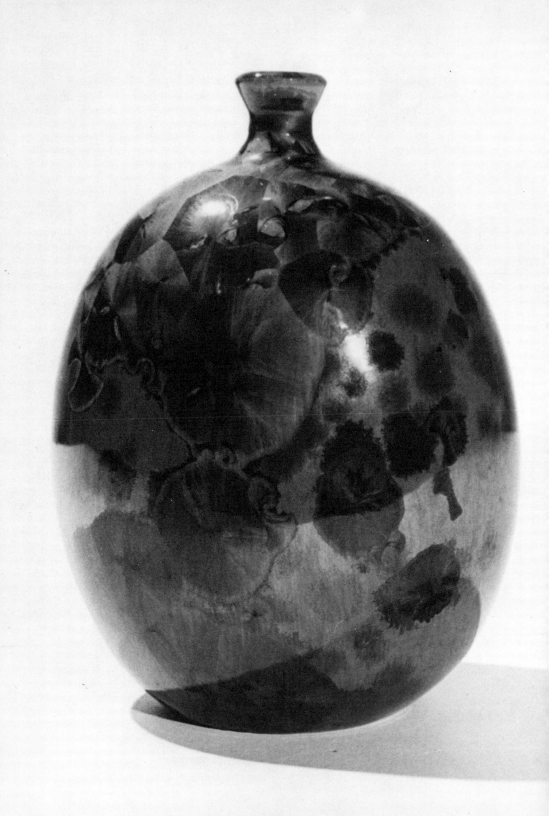

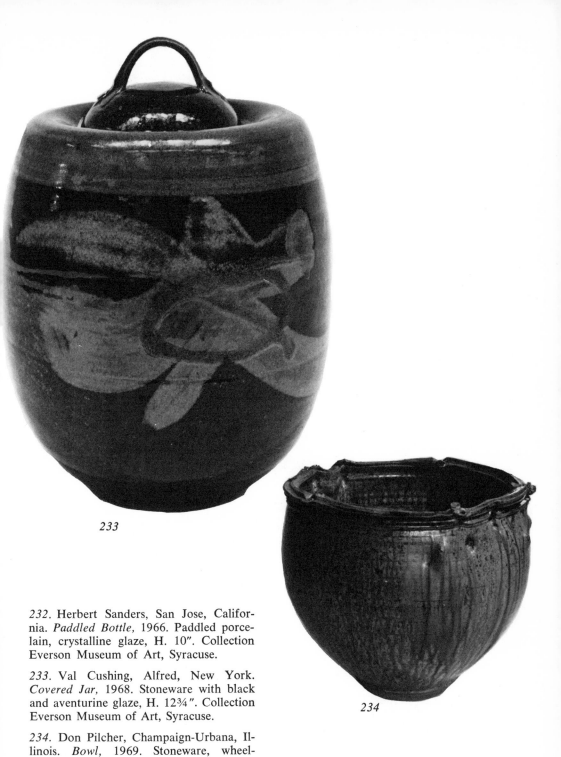

233

234

232. Herbert Sanders, San Jose, California. *Paddled Bottle*, 1966. Paddled porcelain, crystalline glaze, H. 10″. Collection Everson Museum of Art, Syracuse.

233. Val Cushing, Alfred, New York. *Covered Jar*, 1968. Stoneware with black and aventurine glaze, H. 12¾″. Collection Everson Museum of Art, Syracuse.

234. Don Pilcher, Champaign-Urbana, Illinois. *Bowl*, 1969. Stoneware, wheelthrown and altered, tan and ocher glaze, H. 18″. Collection Everson Museum of Art, Syracuse.

235. Beatrice Wood, Ojai, California. *Lidded Jar*, 1969. Luster and volcanic glaze on earthenware, H. 14". Collection of the artist. Photograph: Garth Clark/Lynne Wagner.

236. Frans Wildenhain, Rochester, New York. *Mushroom Pot,* 1969. Stoneware, H. 14". Collection Everson Museum of Art, Syracuse. Photograph: Jane Courtney Frisse.

235

236

1970

The 1970s are the years of least perspective. Comments made about the past eight years are as a result critical without the benefit of historical distance. Nonetheless certain developments and polarizations are evident as the distinction between sculptor, object maker, and vessel maker has become more defined. In terms of dominant influences on style—and drawing most attention from the media—the Super Object emerges as the dominant concern, much as Funk and Abstract Expressionist ceramics had led stylistic thinking in the previous two decades. Challenging the dominant position of the Super Object most strongly is a return of energy and pride in vessel making. Still very much "the art with the inferiority complex" the pottery in the 1970s is making contributions that may, once the charm of more flamboyant expression is past, be the most enduring ceramic expression of the decade. The statement is made not to devalue the achievements of the Super Object but as a caution not to disregard the subtle art of the potter, which tends to be underplayed rather than enhanced in illustration and exhibition.

The major event of this decade, or more strictly the major nonevent, was the Twenty-seventh and last Ceramic National at the Everson Museum of Art in Syracuse, New York. It is necessary to examine its closure before we return to the categories of ceramic artists and review the progress of a decade. By 1972 the Ceramic National had been held regularly over a period of forty years, with the break of the World War II years and a few internationals and biannuals. Its importance in providing a platform for the ceramic artist in the United States was considerable. The touring of the Ceramic Nationals over the years had taken the exhibitions to over fifty museums, from the Whitney Museum of American Art in New York to small-town museums

in dozens of states. More than five hundred articles, reviews, and comments of one kind and another had appeared in the art and craft magazines covering the Nationals.

By 1972 the Ceramic National had grown to unmanageable proportions, and more than 4,500 slide entries were received despite recent criticism of uneven quality and lack of direction in the past few shows. The museum director, James Harithas, declared that the Ceramic National would now become "a basis for reevaluation of what ceramics is . . . a starting point for the presentation of a new aesthetic." [126] But the jurors, Peter Voulkos, Robert Turner, and Jeff Schlanger, decided that the new aesthetic was not present, and surprised entrants received a letter stating that the Ceramic National would not take place because the jurors found slides to be an unsuitable means of review. In the exhibition's place was a mishmash two-part invitational. The first part was an almost all-male section (except for Toshiko Takaezu) of fourteen contemporary and predictable "names." The second part was a group of old-school stalwarts from the Ceramic Nationals selected by Anna Olmsted. With this group was combined a slide showing of the better slide entries and a Robineau exhibition. It was a compromised and inglorious end to the medium's most faithful institution.

Donna Nicholas recorded the diverse reaction to this announcement in her detailed investigation into the controversial decision:

> There was excitement, alright. Incomprehension. Lots of unanswered questions. Mutterings heard from amongst the clay bags. Many felt the jurors' action to be some sort of Olympian hoax, perpetrated by larger-than-life ceramic figures pointing a collective finger and causing a whole show to disappear. A giant power trip? A gesture of courage? Despair? Indifference? Hope? [127]

In retrospect the action seems indefensibly cavalier as ceramics has so few supportive institutions. Selection by slide is, of course, a compromise, but even then the cost of a national machine to judge the works physically was patently exorbitant and slide selection inevitable. Today the jurors involved happily send slides of their own work for exhibition selection. On the other hand, it is argued that the timing was perfect and that the Ceramic Nationals would only have declined further and in so doing diminish the esteem of the medium. It is arguable that significant exhibitions that followed at the Everson Museum, such as Margie Hughto's "New Works in Clay by Contemporary Painters and Sculptors" and indeed the exhibition that accompanies this study, might not have taken place but for their courage.

Certainly a new format was necessary. Too many entries were coming in, and the Ceramic National was using the erroneous premise of a common material to combine everything from the unfired process works to functional soup bowls. What was needed was a new format that emphasized that ceramics was now a multipolarized medium that required specific intent and selection to replace the "come one, come all" approach. The Ceramic Nationals could have each year invited the submission of works of a specific nature— functionalists, nonvessel orientation, and so on.

What was nonetheless important was to retain a *juried* show to break away from the cliques that dominate selection and in particular to give young artists their first public exposure. Whether the departure of this grand old lady of ceramics will prove to be beneficial or an arrogant disservice to the field will be known only in the years to come. But she is still remembered and missed. The Ceramic National and Anna Olmsted, who worked at keeping them alive for four decades, had made an immeasurable contribution.

The "Young Americans" showing of the American Crafts Council has to some extent filled the void, but the Everson still remains very much the central focus. Other museums have proved to be good friends of the ceramic arts as well, notably the San Francisco Museum of Modern Art through curator Suzanne Foley, the Los Angeles County Museum of Art, and others. The Whitney Museum of American Art touched on the fringes with Richard Marshall's exhibition "Clay" in 1975, but the problem of achieving a platform of national importance remains a major stumbling block for all the spheres of the ceramic arts. The matter becomes more urgent now in the face of diminishing support from the university, the major patron of ceramics over the last eighty years, and the need for the ceramists to command prices commensurate with those of professional artists in other fields.

In looking first at sculpture, one finds that the decade has produced great diversity but no indication of producing a genre or having specific direction. What has taken place is a number of highly personal explorations linked only by the common material. Early in the decade, it seemed that ceramics could be seen in a sufficiently liberal manner to do away with the kiln, and for some time, a "mud 'n' dust" school dominated. In terms of creative exercises, the use of unfired clay was liberating. The first event of importance was the 1970 "Unfired Clay" exhibition at Southern Illinois University, which included object makers Gilhooly, Arneson, and Victor Cikansky as well as those more conceptually inclined, such as Jim Melchert.

Commenting on the pertinence of the event, Evert Johnson suggested that the whole concept of making objects that were left outdoors to return to the earth had merits above the concepts of more traditional exhibitions:

> There is something spiritually appropriate in the implication of the pot returning to the earth, of artists participating physically in the installation of their own exhibit, and of creative man being, for a short time at least, really at one with his work, the earth from which it was made and elements that besiege both. The whole idea was a joyful denial of the notion that art is a precious commodity. . . . It was instead a positive affirmation that the most important element in art is man.[128]

In 1972 Melchert produced his last "claywork," a videotape event titled *Changes* wherein the participants dunked their heads in slip and were seated in a room that was cool at one end and hot at the other. The camera recorded the uneven return of the slip to its dry state and at the same time, and more subtly, the altering interpersonal reactions of the participants. In Los Angeles in 1973 and 1974, Sharon Hare, Doug Humble, Joe Soldate, and others formed a small avant-garde group of ceramists. Humble covered his entire home, even the car in the driveway, in slip. Hare set up installation shows in the deserts outside Los Angeles. Soldate went on to dealing with wet and dry clay in structural, installation situations. These energies came to a head in 1974 with an exhibition, "Clay Images," at the University of California at Los Angeles organized by Ed Ford and Soldate.

At the same time in Colorado, Mark Boulding set up his "Forest Firing," a tongue in cheek event where through careful scientific analysis of the forest-fire risk in the state, a site was selected that was theoretically the highest fire risk area in the state. Twenty clay spheroids were placed there awaiting, according to statistics, a wood-firing within the next 200 years. The final event of this phase was "Clayworks in Progress" in 1975 at the Los Angeles Institute of Contemporary Art. It was described as "an exhibition of five artists whose work concerns the natural effect of time on clay; forces not at rest or in equilibrium." [129] Although some good work was produced, notably the "accidental" event of Roger Sweet and Tom Colgrove's sandwiches of glass and clay, the exhibition seemed finally to exhaust the play with unfired clay. The concerns were continued to a limited extent in the clay and latex works of Bill Farrell and his students at The Art Institute of Chicago, but the issues raised by the refusal to make clay permanent through fire seem no longer to be relevant. Except as a personal learning process, one could argue that this work, with a few exceptions such as Melchert, was never pertinent to art at large, coming years after the main thrust of conceptual sculpture. At best,

the period can be seen as a time of soft-core Conceptualism, which one hopes had the effect of liberalizing the ceramist's conceptions even if it did not produce great works or innovation.

In 1976 the opposite pole of thought was presented at the Everson Museum of Art's "New Works in Clay by Contemporary Painters and Sculptors." Curated by Margie Hughto, the exhibition brought together ten mainstream artists over a period of time. In collaboration with Hughto and her artist friends and students from Syracuse University, the painters and sculptors worked in clay and produced a body of fired clay sculptures. The project involved Billy Al Bengston, Stanley Boxer, Anthony Caro, Friedel Dzubas, Helen Frankenthaler, Michael Hall, Dorothy Hood, Jules Olitski, Larry Poons, Michael Steiner. In addition, the ceramics of David Smith were exhibited posthumously alongside these new works. The exhibition caused the ceramic establishment to seethe with controversy and discontent. They argued that there would never be an exhibition of "paintings by potters" and that this project was a waste of resources that could otherwise be applied to the specialists in the medium.

They missed the point that the titles *painter* or *potter* were irrelevant. What was taking place was simply that a group of active, professional *artists* were being invited to work in a material that was not their day-to-day medium in order to bring a different perspective and, it was hoped, a fresh view to the sculptural use of clay. The "New Works in Clay" had great impact on those who saw the impressive installation. The clay was used without artifice. The qualities of the material, which many ceramists try to suppress with elaborate craft, were given free reign, and the artists worked expansively with scale. The massive exhibition was understandably uneven, but the high points more than justified Hughto's risk and determination. It dramatized that many of the ceramists had lost the ideal that it is what one does *with* and not *to* the material that divides art from craft.[130]

Lastly, in a review of the sculpture of the decade, there are four artists whose works have focused attention on the potential of ceramic sculpture: Mary Frank, Robert Arneson, Viola Frey, and Stephen De Staebler. Writing of Frank in *The New York Times,* Hilton Kramer acknowledged that she was a magnificent anomaly among sculptors:

> While so many expend their energies on making sculpture a language of cerebration, securely quarantined against direct expressions of feeling, Frank insists on making it a language of passion. The result is an oeuvre unlike any other on the current scene—an oeuvre in which imagery of

great inwardness and intimacy is combined with an earthy articulation of emotion.[131]

Although speaking specifically of Frank, Kramer was also suggesting an aesthetic niche for clay. Emphasis on the cerebral had proved in the 1960s to be a poor bedfellow for the ceramic medium and, outside the vessel tradition, so too had abstraction. Again praising the figurative mode, Kramer commented in a later review on the works of Robert Arneson that were on show at the Allan Frumkin Gallery in New York. The review was titled "Sculpture—From the Boring to the Brilliant": the boring contributed by Carl Andre, and the brilliant, a series of large-scale portraits by Arneson. Kramer praised the "stunning mastery of characterization" in Arneson's work and welcomed the use of color in sculpture. Arneson's work, he pointed out, "reminds us that there is something of a revival of polychrome ceramic sculpture . . . in recent years that New York has never quite caught up on. Perhaps the time has come for some museum to bring us up to date on this interesting and unexpected development." [132]

One of ceramics' most extraordinary talents is the Californian sculptor Viola Frey. Frey has in the last five years emerged from a period of washing through the inevitable influences of pottery from temmoku glazes and quasi-Oriental stonewares to funky overpainted objects. Her recent works have a commanding power. Working both small and large, she is able to imbue her almost naïve figurative pieces with an undercurrent of menace and disquiet. Something of the potter remains, a tendency to deal with volume and to convert her self-portraits into vessels—even if abstractly so. But this does not inhibit her expression and only makes more iconographic the assemblages of personal, tall, brooding portraits, and the personalized animals. The accent in her work is "on the element of play." [133] This play takes several forms and is most direct in the manner in which her painting on the sculptures teases and reconstructs the play of light and shade. More complex is the play of images:

> Clues in the sculpture will lead eventually to a variety of meanings. Hats, shoes and wheels, masks, geese to mention a few are all clues. They are used as contemporary symbols that are instantly recognized for what they are by their form, but may have many different meanings depending upon their inflection, size, distortion and association. My completed works are three dimensional puzzles where parts fit together.[134]

Whereas sculpture remains the most enigmatic, indefinable aspect of ceramics in this decade, the Super Object has become more consolidated. The genre (using the word in its most liberal sense) is expressed in two

styles. One is abstract, as in Ron Nagle's multifired cups and the immaculate Constructivist cups between 1972 and 1974 by Kenneth Price. The other school deals with collage and the making and assembly of identifiable objects. Both are characterized by their unbounded preciousness, by carefully considered execution, and by a meticulous craftsmanship that denies any expressionist use of the materials. Those working in the collage style are also denied the speed and freedom of composition usual in that school. Instead their work has the careful, considered, and mannered approach that identifies Pop art and superrealism, the art forms to which it is most closely related. In ceramic terms, the production of Super Objects has a long-standing tradition. Works of the collage–trompe-l'oeil school today are particularly closely related to works in that style in both Europe and China during the eighteenth century. In France and Germany, it was the vogue to create massive dinner services painted to look like wood with the illusion of etchings and posters peeling off the surface. In China, the Yi-hsing wares included realistic peanuts, gnarled pieces of wood, and bamboo shoots being eaten away by worms. Later this led to the imitation of ivory, metal, and other materials in clay under the rule of Ch'ien-lung (1736–1795).

The artists of this persuasion are well represented by the illustrations in this study, and their numbers reflect its popularity. It is not possible to deal individually with their work, but it is necessary to deal with some of the high points in the style. In 1972 at the "Sharp-Focus Realism" exhibition at the Sidney Janis Gallery in New York, the work of ceramist Marilyn Levine was included. Levine produced stoneware that faithfully echoed leather objects: suitcases, leather jackets, and boots. Harold Rosenberg called her works "translations of objects into a different substance without altering the appearance." Although Levine produced objects, Rosenberg pointed out that this "was essentially a conceptual art, that brings to the eye nothing not present in nature but instructs the spectators that things may not be what they seem." [135]

Spurred on by the example of Levine and earlier leaders such as Richard Shaw, trompe-l'oeil rapidly became—and has remained—one of the most obsessive odysseys of the American ceramists. It has seemed to provide an area where the ceramist could indulge technical involvement without the craft's overpowering content. After all, in this case the craft *is* the message. As critic Kim Levin noted, "old time illusionistic art has collided with the future becoming as literal as minimal forms . . . form has re-dissolved into content—Pygmalion is back in business." [136]

In 1976 an attempt to define a genre for these works was attempted

at the Laguna Beach Museum and given the indigestible title of "Illusionist Realism as Defined in Contemporary Ceramic Sculpture." In the catalogue essay,[137] Lukman Glasgow grasped at everything from Surrealism to Gestalt in order to impose fine-art respectability. What is of interest is that nowhere does he mention the fact that this use of technique and content has a well-established precedent in ceramic tradition, and nowhere does he deal with the immediate question, "Why ceramic?" The exhibition was an attempt to herd a group of artists into a single stylistic kraal. The only artist who suited the title without conflict, Marilyn Levine, was inexplicably absent. For the rest, the hard, brash definition limited and underestimated the perceptions of the artist.

A more flexible means of understanding the more evolved and symbolic end of the Super Object school came from Rose Slivka's "The Object as Poet" exhibition at the Renwick Gallery in Washington, D.C., in 1976. The exhibition suggested a union of spirit and intent that linked Levine's bags, Shaw's assemblages, and Lucian Octavius Pompili's fragile multimedia works. Their use of material, their selection of images, and indeed their elegance of composition were used to create visual poetry—with all the freedom and depth of personal expression that that idea implies:

> The reality of the object—poem and material thing—suggests other re-
> alities. Other metaphors in the form of things and poems that interact
> in the old root way before specialization divided us from ourselves and
> each other. The power of these objects to take us into their orbit and
> beget energy is endless. This is the magic. The Shamanist vision yields
> multiple mnemonic clues to the enigma of life through intuitive forms
> invented or found ready made in the touch of each individual maker.[138]

In essence, Slivka's comment is a plea for pure objecthood. Whether utilitarian or not, the concept of the identification of the object maker as a visual poet removes the circular debate on the boundaries of art and craft as a consideration. The viewer is thus able to confront the collage, fetish, or assemblage works that have come out of the contemporary crafts movement and deal with them beyond their more obvious virtues of craftsmanship. Slivka's view suggests a different language of appreciation, seeking out the rhythms of composition and the syntax of the materials. Some objects immediately express their intent, and the rhythm's structures are formal and strict; in others, the artist deals with material as a stream-of-consciousness exploration.

This concept certainly gives a new means of enjoying the work of Richard Shaw. Shaw's works, although they appear to employ collage and

assemblage technique, neither compete with nor belong within the urgent collage world of the Futurists or of artists such as Kurt Schwitters. The assemblages are carefully conceived and painstakingly executed idealized images. They lack the contextual bite of Dada and Surrealism, and their relationships, harmonies, and counterpoints can be related only to a gentler poetic association speaking of materials, ambiguities, and deceptions. Recent works such as *Whiplash* (1978) and *Blue Goose* (1978) show the extent to which Shaw has been able to outgrow a romantic involvement in trompe-l'oeil surfaces, drawing the viewer's eye through a series of comments and retorts based on material, color, and image. One feels that, in common with his earlier *Couch* works, the artist and not the craft is again in control.

Another development that distinguishes the 1970s is a new direction in the relationship between ceramics and painting. Much of the energy has come from Margie Hughto, her students, and the visiting artists who work with her at Syracuse University's Clay Institute in downtown Syracuse, New York. Hughto's early work showed the conflict and compromise so frequent among those who come out of both a painting and a ceramics background, the push–pull pressure to turn a plate into a pure canvas and the canvas back into a plate. But later series such as the *Spinners* began to deemphasize pottery and to emphasize painting and drawing without treating clay as paint. Following the two-way flow of influences from the first "New Works in Clay" project, a greater clarity has emerged. Hughto builds her large slab paintings out of colored clay and in addition paints on the surface with slip. The pieces explore the multiplicity of depth and color in a unique manner and above all give an importance to the outer frame with its fissures, cracks, and lack of uniformity. These objects do not plagiarize known painting so much as they break new ground and simultaneously extend the painter's and the ceramist's vocabulary. The work of Kenneth Noland in colored clays, produced with Hughto at the Syracuse Clay Institute, deals effectively with these concerns as well. These works are neither pottery, pure sculpture, nor contextual objects, and they open up a new area of exploration.

A more ambiguous relationship between painting and pottery comes from the body of works by Kenneth Price produced between 1972 and 1978, titled *Happy's Curios*. The works were installed at the Los Angeles County Museum of Art, and they have proved to be one of the most popular ceramics exhibitions of the decade, the showing being extended three times. The exhibition has generated both healthy debate and some of the most

flaccid critical writing. Few critics dealt with the works of Price in analytical terms, and most followed the style of Suzanne Muchnic's long, gossipy review in the *Los Angeles Times*, which, through loose praise, trivialized the work as cartoons based on New Mexico folk and tourist art.[139]

In fact, Price's exhibition, as a total environment, had almost nothing to say of specific racial culture. The statement was about hierarchy in art—any art. It was a formidable treatment of the "decorative" in art—the element that so disturbs the intellectual establishment. Price was taking pottery as a low art at its most debased level—the curio shop—and painting the clichéd images and forms with such skill and dash that the viewer has to respect, and so revalue, what is seen. The overwhelming impact of the show furthermore had to do with color and not form. Indeed many of the forms were flaccid and less than successful. There was also no "homage to Mexican pottery," as critics have sentimentally suggested. It was a homage to decorative painting, its vitality, and its pertinence today—a message made all the more effective by the use of ceramics, both because of its second-class citizenship in the arts and because of the decorative exuberance of its materials. The racial-cultural play was the least significant element. It suggested a theme, but it is interesting that *Tile Unit* (1972–1977), the major work of the exhibition, was without any literal or literary Mexican association.

The use of the vessel in as liberal a format as that of Price is one end of a scale. At the other are those artists who deal with the vessel traditionally. They explore the limitations of the form through careful development and refinement of a limited and evolving range of forms and surfaces. Their central dynamic is volume, the enclosure of space, around which all other input revolves. The term *traditional* is a difficult one, for it has acquired overtones of romantic anachronism. The potters, although fully respecting their past and the elemental qualities of pottery, are nonetheless contemporary artists. The works of Robert Turner, Richard DeVore, Betty Woodman, John Glick, and many others show a strong affinity with the ceramics of the past and yet instruct the viewer in many ways that they could not come out of any other century but our own.

These traditionalists have achieved a quiet revolution in the 1970s, which has proceeded apace without being acknowledged. Yet at no other point in modern American ceramic history has the vessel been employed more expressively, more coherently, and with such credence to its claim as a legitimate medium for creative expression. The potters have both removed the conscious "design-problem solving" cul-de-sac of the 1930s and the

tendency toward a theatrical radicalism that followed the 1950s. Gone too is the confusion "Am I a Sculpture, Am I a Pot?" The works illustrated here indicate that the makers acknowledge that theirs is an art of limitations, limitations that can be assaulted only through the deepest understanding of the fundamentals of their art form. In this sense, pottery is closest to music, which also preserves and repeats the compositions of the past, places emphasis upon performance, and recognizes that without thorough craft, pursued to the point where it becomes almost unconscious, original creative work is impossible. But what is most optimistic about this 6,000-year tradition of pottery is that the developments of the decade seem to be only the groundswell. The pot, far from being a redundant relic of the past, is reestablishing itself in ceramics as the format of the future.

There have been several exhibitions in the last eight years that have attempted to present the sophistication that has taken place, but scholarship in the area of the contemporary pot is woefully low. Except for a few progressive galleries—notably Quay in San Francisco, Drutt Gallery in Philadelphia, Yaw in Birmingham, Michigan, and Exhibit A in Evanston, Illinois—pots are still shown in craft shops alongside shelves of shabbily made tablewares. The galleries mentioned have done much over the years to improve exhibition standards and build up an audience. But their impact in real terms has been minimal. Only the lifting of the embargo that excludes the contemporary vessel from The Museum of Modern Art, the Whitney, the Guggenheim, and other institutions of influence can alter the status quo of the potter. But it is also to be considered whether the embrace of the establishment is indeed beneficial. Possibly the very fact that pottery lives outside the fine arts paradoxically nourishes expression and encourages strong independence and an accent on personal rather than stylistic values.

The medium is more free than any other of the -isms of art. The traditional vessel is both timeless and styleless, despite tendencies toward specific historical references. It is a form of expression that cannot be valued by criteria in other contemporary art. The failure to recognize this fact and the resultant lack of a critical language have perhaps been the major reason for the slow uptake in the artistic world of the achievements of America's potters. Writing of the contemporary vessel aesthetic in *New Arts Examiner,* Andy Nasisse points out that in intellectually dissecting and evaluating the vessel's various units, one is dealing with a singular aesthetic:

> In this extensive analysis of a pot's form one becomes aware that many
> of the aesthetic conclusions are unique to the idea of the vessel, and the
> vessel itself has the potential for becoming a major metaphor, with

complex, sensuous analogies. One also becomes aware of the fallibility of a language which is intrinsically tied to logic . . . to describe these vessels' imponderable tendency towards the infinite. So in the final analysis, *feelings*—both emotional and tactile—become the final message.[140]

As visual art appears to come to the end of the cerebral age, as intellectual, nonvisual visual art is becoming undermined, it is possible that the potter's multisensuous medium will have a prouder place in the art of the 1980s. One hopes it will overcome the "tactile castration" [141] that Philip Rawson accuses our society of having suffered, and that function, if only in a ritualistic form, will return to the dynamics of the art. Certainly there has never before been so strong a cadre of potters to bring respect to the medium that Herbert Read defined as "the most abstract of all the arts." [142] The return to intimacy in art will do more than simply encourage the vessel maker; it will provide greater acceptance of the medium in its broadest sense.

After two and a half decades of world leadership in ceramics, the United States still faces no challenge to its vanguardist role. Its position in the fine arts is far less secure. In ceramic sculpture, a few have succeeded —Kenneth Price, Robert Arneson, and Mary Frank in particular—in achieving legitimacy. But despite the hopeful prognostications of the 1960s, ceramics has not emerged as a convincing sculptural genre. The ceramist still lacks a platform for contemporary appreciation at depth. In short, the challenges remain—as inviting and urgent as before.

The coming decade, the 1980s, could bring a culmination of a century's energies and strivings. It can also lessen the schizophrenia of the past decades, give honesty and respect to the title of craftsman, and dictate a higher standard of achievement to those we rightly or wrongly designate artists. In looking at the future, Rawson contemplates another revolution in art that may demand work that is addressed to the whole multisensuous man, hands and all, and that will "awaken those important and intensely valuable regions of feeling and sensuous order which purely visual-abstract work ignores or even affronts . . . a complete re-evaluation of the meaning of ceramics could play as vital a part as did the discovery of African sculpture." [143] The signs of this drift already seem apparent. The demand of the future is explicit: ceramics, so long an art of evolution, needs to find a revolutionary voice. As we examine the work of the past one hundred years and the culminating decade, the medium has never been more equal to the challenge.

237

237. Jim Melchert (*second from left*) during *Changes*
videoperformance in Amsterdam, August 22, 1972, at the
studio of ceramist-conceptualist, Hetty Huisman. Photo-
graph: Mieke H. Hille.

238

239

240

238. Bill Farrell, Chicago. *Stack,* 1977. Plastic, clay, latex, H. 48″. Collection of the artist.

239. Roger Sweet, Los Angeles. "Clay Works in Progress." Installation at Los Angeles Institute of Contemporary Art, August 6, 1975.

240. Joe Soldate, Los Angeles. *Clay Gravity Piece,* 1977. Wood, one ton of clay in process, H. 120″. Photograph: Courtesy Ceramic Arts Library, Claremont, California.

241. Roger Sweet, Albuquerque, New Mexico. *Atomic Glaze . . . Applied,* 1976. Tile from Nagasaki, plastic, L. 5″. Collection of the artist.

209

242

243

242. Margie Hughto (*left*) with Helen Frankenthaler (*right*), Clay Institute, Syracuse, New York. 1975. Photograph: Stuart Lisson.

243. Michael Steiner, Syracuse, New York. *Chenango,* 1975. Stoneware, L. 47¼″. Collection of the artist. Photograph: Stuart Lisson.

244. Jules Olitski, Syracuse, New York. *Brown Slab Two,* 1975. Stoneware with colored slips, H. 30″. Private collection. Photograph: Stuart Lisson.

244

245. Billy Al Bengston, Syracuse, New York. *Dinner Plate,* 1975. Commercial flintware, L. 13". Collection Everson Museum of Art, Syracuse. Photograph: Robert Lorenz.

246. Helen Frankenthaler, Syracuse, New York. *Mattress I,* 1975. Stoneware, L. 62". Collection Everson Museum of Art, Syracuse. Photograph: Stuart Lisson.

247. Friedel Dzubas, Syracuse, New York. *Pink Pile-Up,* 1975. Stoneware with low-fire glaze, L. 37½". Collection Everson Museum of Art, Syracuse. Photograph: Stuart Lisson.

248. Anthony Caro, Syracuse, New York. *Con-Can Tablet,* 1976. Stoneware, H. 18". Private collection. Photograph: Robert Lorenz.

245

246

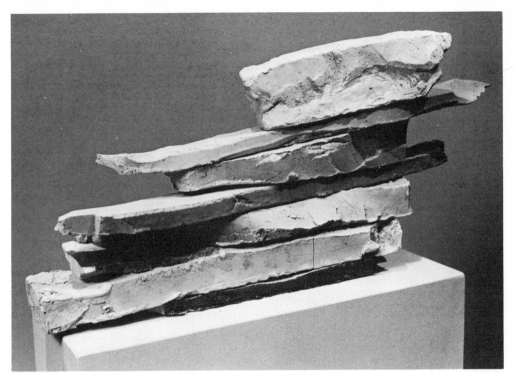

247

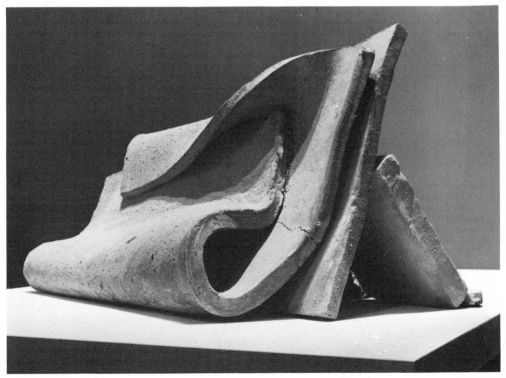

248

213

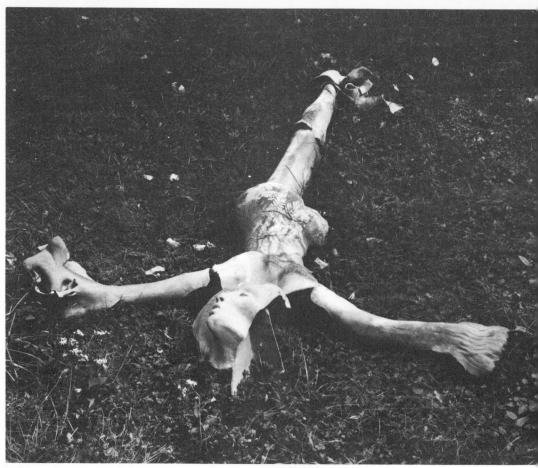

249

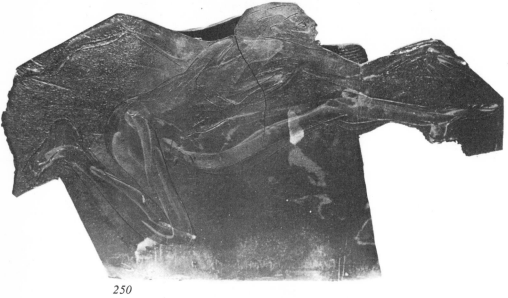

250

214

249. Mary Frank, New York. *Woman with Outstretched Arms,* 1975. Unglazed stoneware, L. 91″. Collection of the artist. Photograph: Jerry L. Thompson, New York. Courtesy Zabriskie Gallery, New York.

250. Mary Frank, Syracuse, New York. *Leaping Man,* 1978. Stoneware, L. 36″. Collection of the artist.

251. Mary Frank, New York. *Leafhead,* 1972. Stoneware, H. 25½″. Collection Mr. and Mrs. Talcott Stanley. Photograph: John A. Ferrari. Courtesy Zabriskie Gallery, New York.

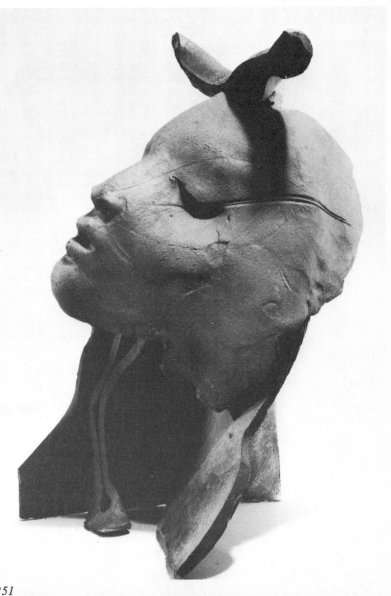

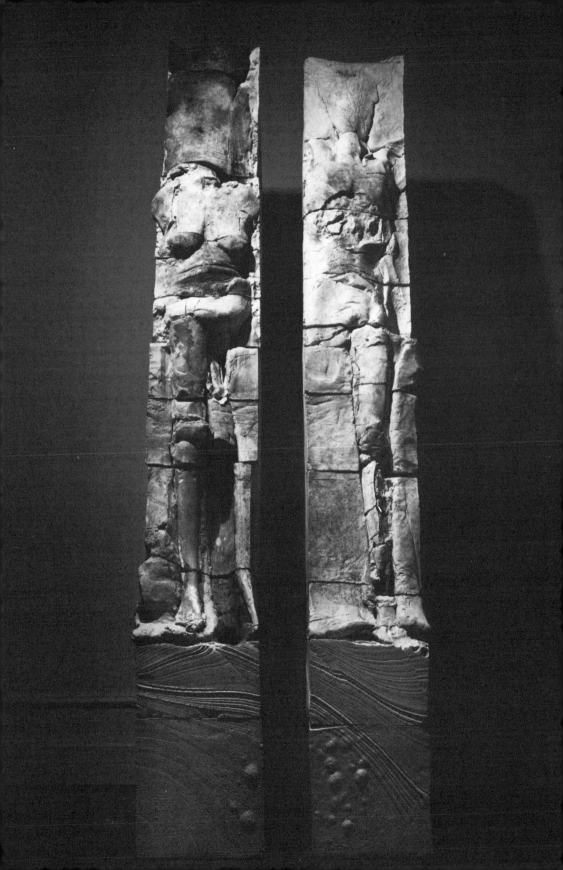

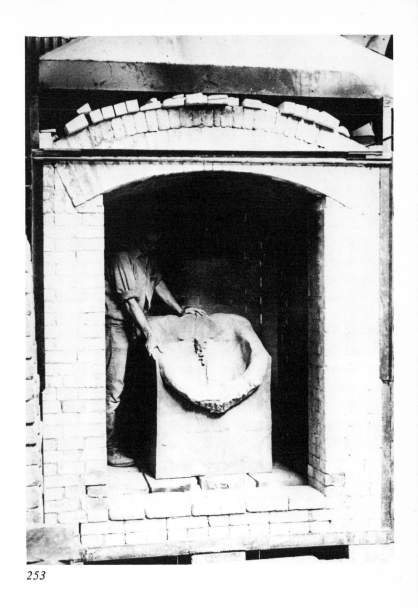

253

252. Stephen De Staebler, Berkeley, California. *Standing Man and Woman*, 1975. Stoneware, H. 96″. Collection of the artist. Photograph: Susan Felter.

253. Stephen De Staebler in his kiln after loading *Lavender Throne*, Berkeley, California. April 1978. Photograph: Charlotte Speight.

254

255

256

254. Robert Arneson in his studio, Benicia, California. 1978.

255. Robert Arneson, Davis, California. *Smorgy Bob, The Cook,* 1971. White, glazed earthenware, 72″ x 72″ x 72″. San Francisco Museum of Art, California.

256. Robert Arneson, Davis, California. *Fragments of Western Civilization,* 1972. Earthenware. Installation view. Courtesy Hansen Fuller Gallery, San Francisco.

257

257. Robert Arneson, Davis, California. *Whistling in the Dark*, 1976. Terra-cotta and glazed ceramic, H. 36¼". Collection Whitney Museum of American Art, New York. Photograph: Jerry L. Thompson.

258. Robert Arneson, Davis, California. *Pool with Splash*, 1977. Glazed earthenware, L. 145". Courtesy Hansen Fuller Gallery, San Francisco.

259. Viola Frey, Oakland, California. *1955 Chevy*, 1972. Stoneware, H. 14". Collection Martin and Judith Schwartz. Photograph: Judith Schwartz.

258

259

260. Peter Vandenberge, Sacramento, California. *The Sheriff*, 1977. Stoneware, H. 67¼". Collection Martin and Judith Schwartz. Photograph: Judith Schwartz.

261. David Gilhooly, Davis, California. *Breadfrog and Pigeons*, 1977. Glazed earthenware, L. 20". Courtesy Alan Frumkin Gallery, New York. Photograph: Garth Clark/ Lynne Wagner.

262. David Gilhooly, Davis, California. *Mao Tse Toad*, 1976. Glazed earthenware, H. 31". Courtesy Hansen Fuller Gallery, San Francisco.

263. Clayton Bailey, Porta Costa, California. *Creates Life Out of Mud*, 1975. Glazed earthenware, installation, L. 50". Collection of the artist.

260

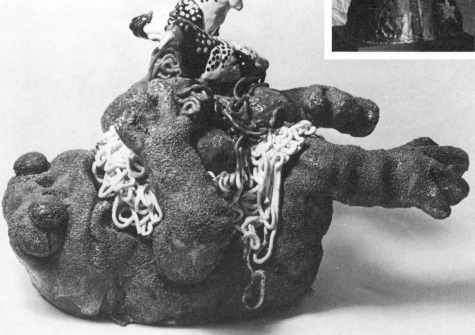

261

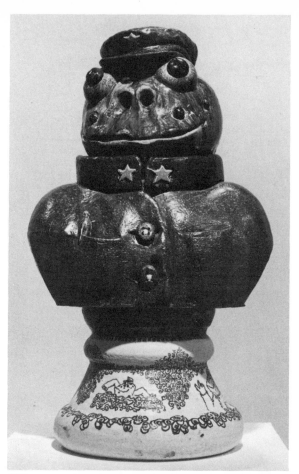

262

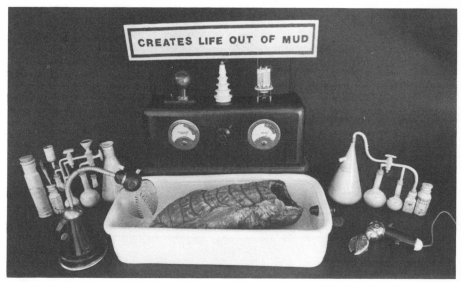

CREATES LIFE OUT OF MUD

263

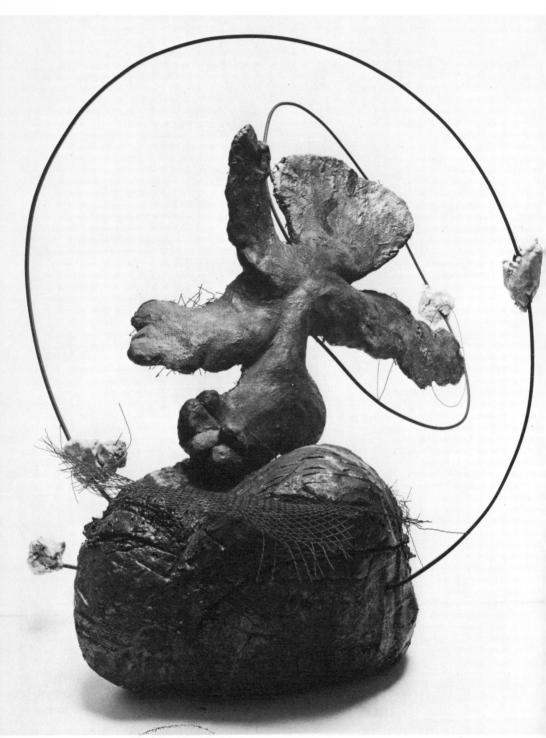

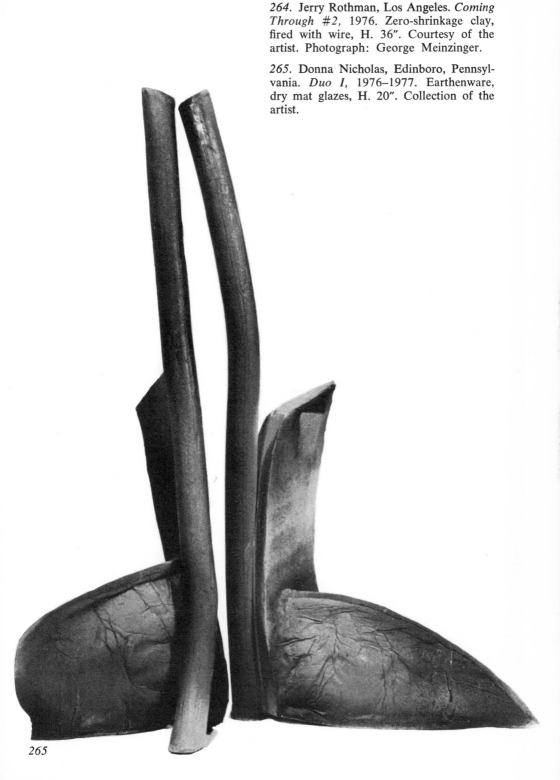

264. Jerry Rothman, Los Angeles. *Coming Through #2,* 1976. Zero-shrinkage clay, fired with wire, H. 36″. Courtesy of the artist. Photograph: George Meinzinger.

265. Donna Nicholas, Edinboro, Pennsylvania. *Duo I,* 1976–1977. Earthenware, dry mat glazes, H. 20″. Collection of the artist.

265

266

267

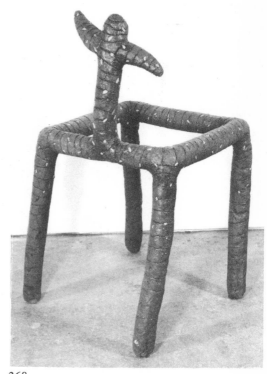

266. John H. Stephenson, Ann Arbor, Michigan. *Ligature*, 1978. Pit-fired clay bound with baling wire on acrylic-painted wooden grid, H. 50″. Collection of the artist.

267. Tony Costanzo, San Francisco. *Strawberries*, 1976. Ceramic and glaze, H. 30″. Courtesy Braunstein/Quay Gallery, San Francisco.

268. Ken D. Little, Missoula, Montana. *Untitled*, 1977. Stoneware, 46″. Collection of the artist.

268

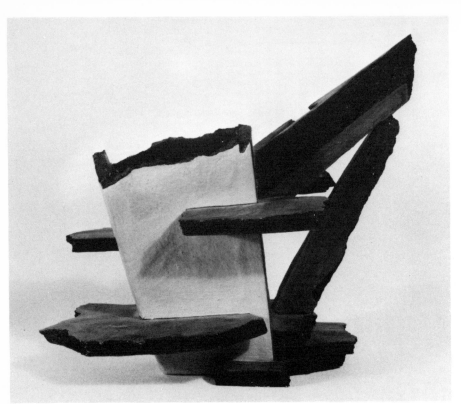

269

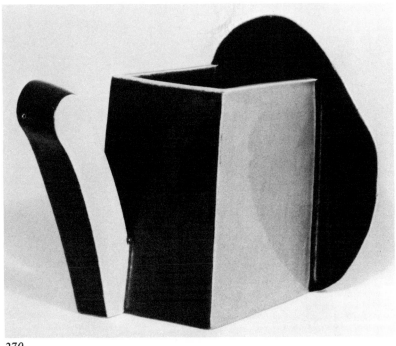

270

228

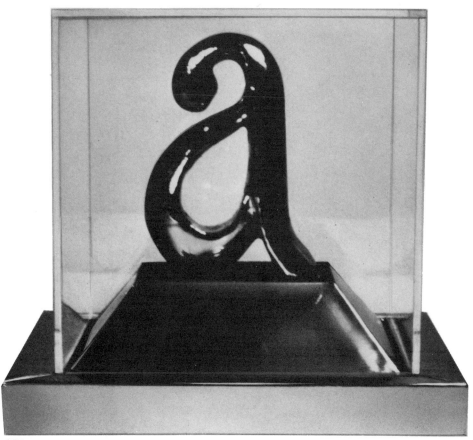

271

269. Kenneth Price, Taos, New Mexico. *Slate Cup,* 1972–1974. Porcelain, glazed, W. 5½". Courtesy James Corcoran Gallery, Los Angeles.

270. Kenneth Price, Taos, New Mexico. *Cup,* 1972–1974. Porcelain, glazed, W. 4¾". Courtesy James Corcoran Gallery, Los Angeles.

271. Jim Melchert, Oakland, California. *Precious a,* 1970. Earthenware, glazes, W. 8". Collection Mr. and Mrs. Stephen D. Paine.

272

273

272. Robert Rauschenberg, Tampa, Florida. *Tampa Clay Piece I*, 1972. Earthenware, L. 15½". Courtesy Graphic Studio, University of South Florida, Tampa.

273. Marilyn Levine, San Francisco. *Maki's Shoulder Bag*, 1975. Stoneware, H. 7". Courtesy Hansen Fuller Gallery, San Francisco.

274. Marilyn Levine, San Francisco. *Hanging Bag with Rope Strap*, 1975. Ceramic, wood, metal, rope, H. 32". Courtesy Hansen Fuller Gallery, San Francisco.

274

275

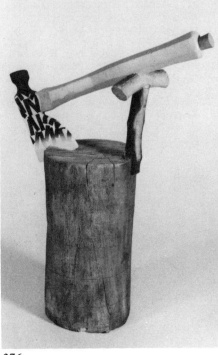

276

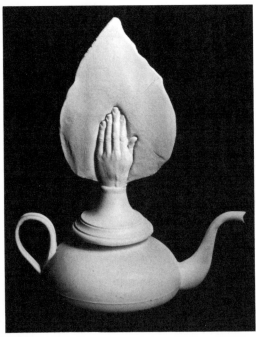

277

275. Robert Hudson, Stinson Beach, California. *Ceramic #29*, 1973. Glazed and painted porcelain with luster, H. 9″. Courtesy Hansen Fuller Gallery, San Francisco.

276. Richard Shaw, San Francisco. *Ax in a Stump Bottle,* 1974. Porcelain, H. 17″. Courtesy Braunstein/Quay Gallery, San Francisco.

277. Lucian Octavius Pompili, *Hand and Teapot,* 1974. Porcelain, molded, H. 8″. Collection Robert and Jean Pfannebecker. Photograph: Garth Clark/Lynne Wagner.

278. Robert Hudson. Stinson Beach, California. *Untitled Ceramic #21*, 1973. Painted porcelain, H. 15½″. Courtesy Hansen Fuller Gallery, San Francisco.

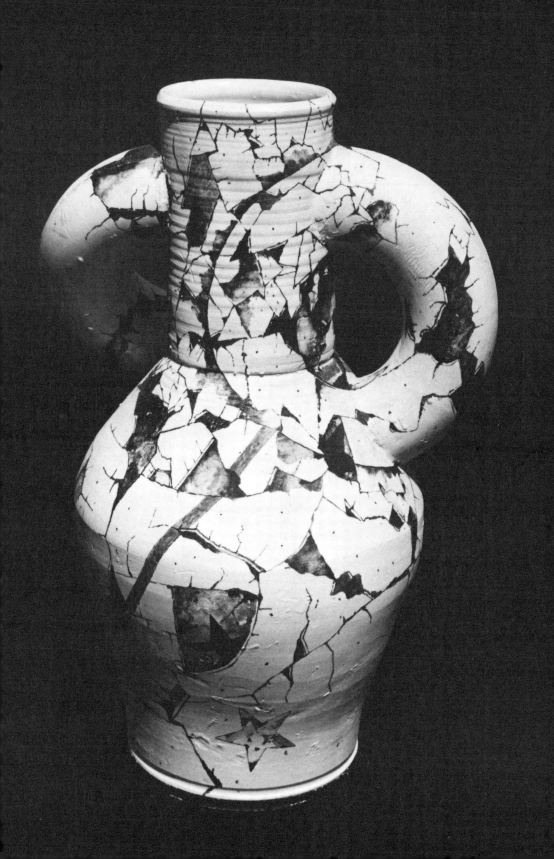

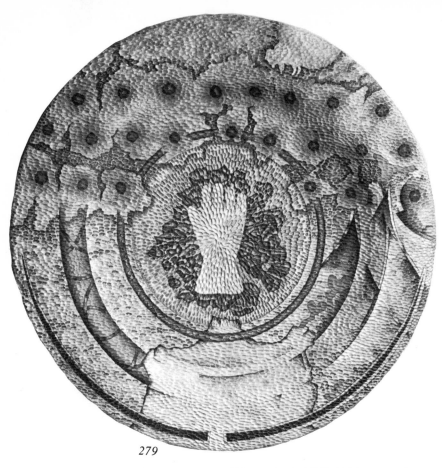

279

279. Ed Blackburn, San Francisco. *Lone Moon Buffler,* 1974. Earthenware and underglazes, Diam. 19½". Collection Robert and Jean Pfannebecker. Photograph: Garth Clark/ Lynne Wagner.

280. Jack Earl, Toledo, Ohio. *Dog,* 1974. Cast porcelain, glaze, H. 17½". Collection Robert and Jean Pfannebecker. Photograph: Garth Clark/ Lynne Wagner.

280

281

281. Patti Warashina, Seattle, Washington. *After the Catch,* 1974. Earthenware and low-fire glazes, Diam. 21". Collection Robert and Jean Pfannebecker. Photograph: Garth Clark/ Lynne Wagner.

282. Vernon Patrick, Chico, California. *Middle America, Post and Lintel,* 1975. Earthenware, glazed, H. 24". Collection of the artist.

235

283

284

283. Karen Breschi, San Francisco. *Man Disguised as Dog,* 1972. Earthenware, acrylic, H. 28″. Private collection.

284. Lucian Octavius Pompili, Providence, Rhode Island. *Hand with Rose,* 1977. Raku-fired earthenware, oxides, H. 14″. Collection Robert and Jean Pfannebecker. Photograph: Garth Clark/Lynne Wagner.

285. Howard Kottler, Seattle, Washington. *The Old Bag Next Door Is Nuts,* 1977. Earthenware, glazes, and plexiglass, H. 13″. Collection Judith and Martin Schwartz.

286

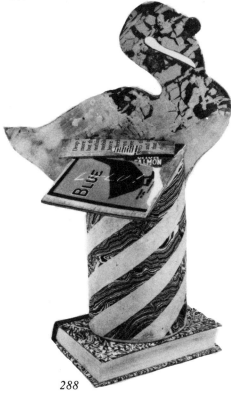

286. David Middlebrook, San Jose, California. *The Journey*, 1977. Glazed earthenware, H. 68″. Courtesy Quay Ceramics Gallery, San Francisco.

287. Margie Hughto, Syracuse, New York. *Fan 9*, 1978. Stoneware, colored clays, H. 28″. Collection of the artist. Photograph: Robert Lorenz.

288. Richard Shaw, San Francisco. *Blue Goose*, 1978. Porcelain, H. 24″. Collection of the artist. Photograph: Richard Sargent. Courtesy Braunstein/Quay Gallery, San Francisco.

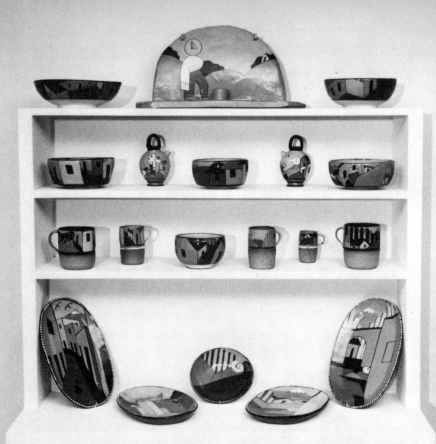

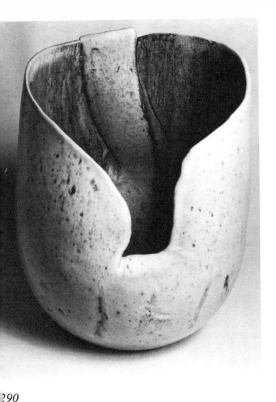

289. Kenneth Price, Taos, New Mexico. *Town Unit 2,* 1972–1977. Ceramic, wood, H. 70". Courtesy James Corcoran Gallery, Los Angeles.

290. Richard DeVore, Bloomfield Hills, Michigan. *Pot,* 1970. Stoneware, glazes, H. 13". Collection Robert and Jean Pfanne-becker. Photograph: Garth Clark/Lynne Wagner.

291. Thom Bohnert, Bloomfield Hills, Michigan. *Untitled,* 1970. Ceramic and metal, H. 10". Private collection. Photograph: Steven Klindt.

292. George Timock, Bloomfield Hills, Michigan. *Lidded Vessel,* 1970. Glazed raku, H. 51½". Collection Robert and Jean Pfannebecker.

290

292

291

293

294

242

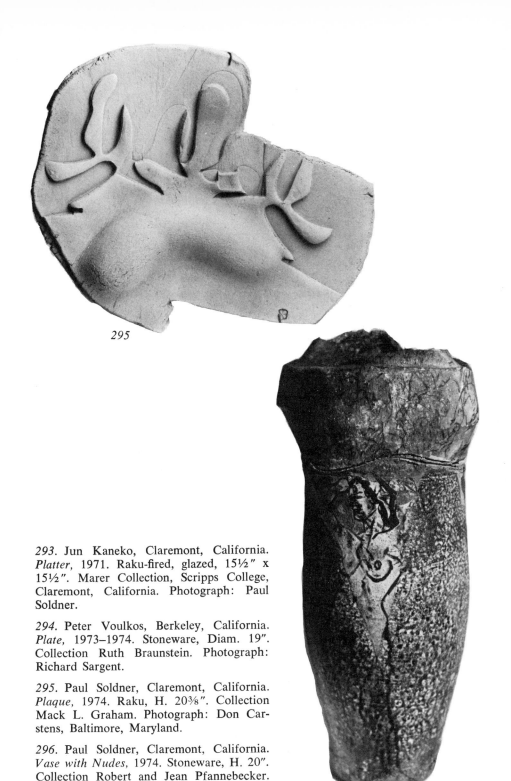

295

293. Jun Kaneko, Claremont, California. *Platter*, 1971. Raku-fired, glazed, 15½″ x 15½″. Marer Collection, Scripps College, Claremont, California. Photograph: Paul Soldner.

294. Peter Voulkos, Berkeley, California. *Plate*, 1973–1974. Stoneware, Diam. 19″. Collection Ruth Braunstein. Photograph: Richard Sargent.

295. Paul Soldner, Claremont, California. *Plaque*, 1974. Raku, H. 20⅜″. Collection Mack L. Graham. Photograph: Don Carstens, Baltimore, Maryland.

296. Paul Soldner, Claremont, California. *Vase with Nudes*, 1974. Stoneware, H. 20″. Collection Robert and Jean Pfannebecker. Photograph: Garth Clark/Lynne Wagner.

296

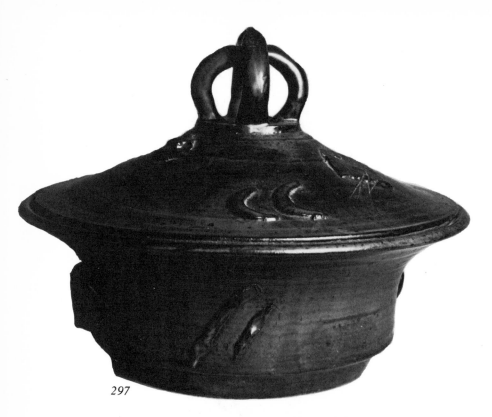

297

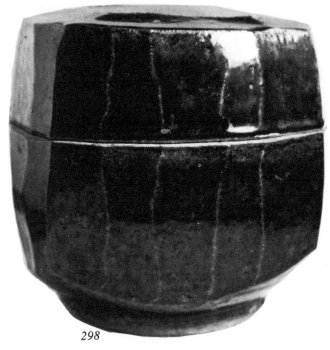

298

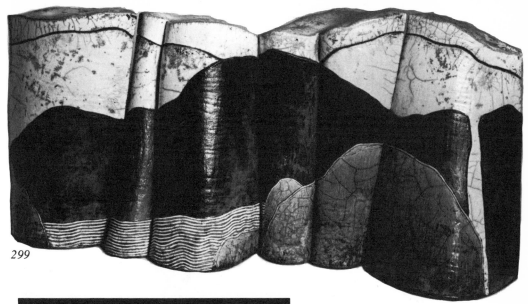

299

297. Robert Turner, Alfred, New York. *Niger #1*, 1974. Glazed stoneware, Diam. 16¾". Collection Robert and Jean Pfannebecker. Photograph: Garth Clark/Lynne Wagner.

298. Warren MacKenzie, Stillwater, Minnesota. *Tureen*, 1975. Stoneware, thrown, cut, and formed, brown glaze, H. 9". Collection Helen Drutt. Photograph: Garth Clark/Lynne Wagner.

299. Wayne Higby, Alfred, New York. *Yellow Rock Falls*, 1975. Raku-fired earthenware, glazed, H. 14". Collection Robert and Jean Pfannebecker. Photograph: Garth Clark/Lynne Wagner.

300. Betty Woodman, Boulder, Colorado. *Vase*, 1975. Salt-glazed porcelain, H. 27". Collection Jerry Kunkle. Photograph: George Woodman.

300

301

301. William Daley, Philadelphia, Pennsylvania. *Floor Pot,* 1976. Stoneware, slab construction, H. 27". Collection Mr. and Mrs. Robert Jaffee. Photograph: Peter Lullemann.

302. Rudy Autio, Missoula, Montana. *Big Ellie,* 1973. Stoneware covered vessel, H. 32". Collection The Lannan Foundation, Palm Beach, Florida.

303. Don Reitz, Spring Green, Wisconsin. *Soup Tureen,* 1976. Salt-glazed stoneware, H. 8". Collection Robert and Jean Pfannebecker. Photograph: Garth Clark/Lynne Wagner.

304. Rudolf Staffel, Philadelphia, Pennsylvania. *Vessel,* 1976–1977. Wrapped blue and white porcelain, H. 4¼". Collection Dr. and Mrs. Parry Ottenberg. Photograph: Garth Clark/Lynne Wagner.

302

303

304

247

305. John Glick, Plum Tree Pottery, Farmington, Michigan. *Plate,* 1977. Stoneware, glazed, reduction-fired, Diam. 18″. Collection of the artist. Photograph: Jane Courtney Frisse.

306. Richard DeVore, Bloomfield Hills, Michigan. *Untitled,* 1975. Stoneware, multifired, Diam. 12½″. Collection Mr. and Mrs. James Yaw.

305

306

307. Adrian Saxe, Los Angeles. *Untitled,* 1976. Colored porcelain, H. 17″. Collection Jeffrey Klawans.

308. Robert Turner, Alfred, New York. *Jar,* 1977. Glazed stoneware, H. 10″. Collection of the artist. Photograph: Lester Mertz.

309. Wayne Higby, Alfred, New York. *Grey Sand Basin,* 1977. Raku, H. 12¾″. Collection Mack L. Graham. Photograph: Don Carstens.

07

308

309

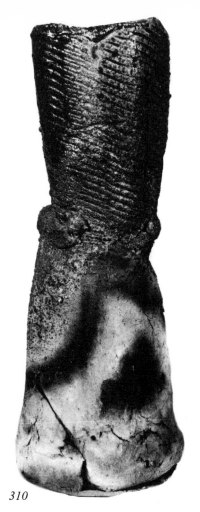

311

310

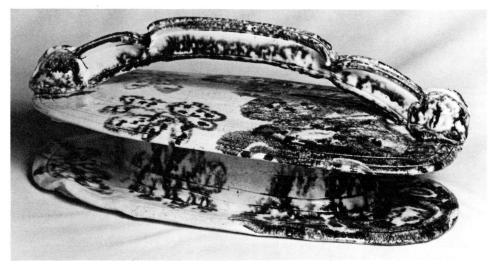

312

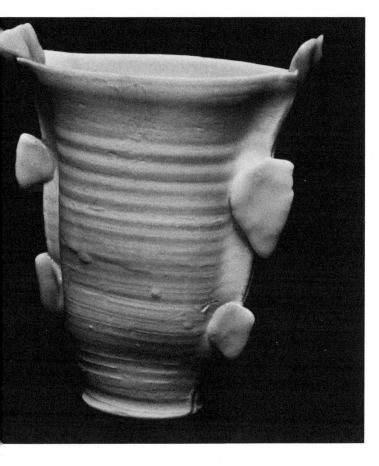

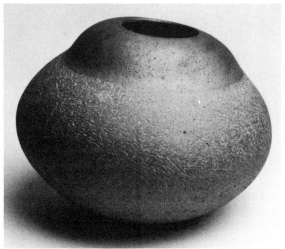

310. Charles Hindes, Iowa City, Iowa. *Vessel*, 1977. Stoneware, trash glaze, sagger-fired, H. 15″. Collection Garth Clark/Lynne Wagner. Photograph: Courtesy of the artist.

311. Rudolf Staffel, Philadelphia, Pennsylvania. *Vessels*, 1977. Porcelain, handbuilt, H. 4″ and 6″. Collection Dr. and Mrs. Parry Ottenberg. Photograph: Garth Clark/Lynne Wagner.

312. Betty Woodman, Boulder, Colorado. *Tureen*, 1977. Earthenware, lead glaze, oxides, W. 17″. Collection Robert and Jean Pfannebecker. Photograph: Garth Clark/Lynne Wagner.

313. David Shaner, Big Fork, Montana. *Jar*, 1977. Stoneware, H. 10¼″. Collection Mack L. Graham. Photograph: Don Carstens.

313

251

314

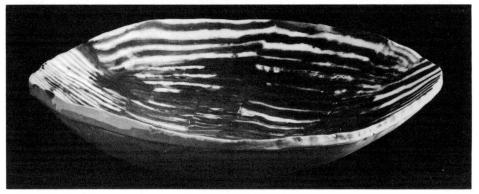

315

316

314. Victor Spinski, New York. *Gun Shot Garbage Pail,* 1976. Low-fire clay with luster, H. 13", Diam. 12¹³⁄₃₂". Private collection. Photograph: Portnoy Gallery, New York.

315. Ruth Duckworth, Alfred, New York. *Shallow Bowl,* 1978. Porcelain, Diam. 24". Collection Helen Drutt. Photograph: Peter Lullemann.

316. Ruth Duckworth, Chicago. *Form,* 1978. Porcelain, H. 4". Collection Helen Drutt. Photograph: Garth Clark/Lynne Wagner.

317. Ken Ferguson, Kansas City, Missouri. *Basket,* 1978. Stoneware, wood-fired, H. 13". Collection of the artist.

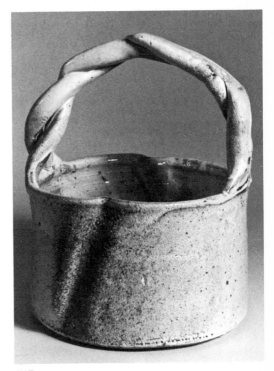

317

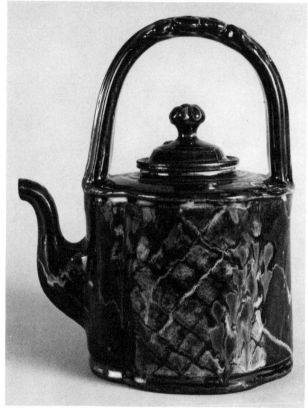

318

318. John Glick, Plum Tree Pottery, Farmington, Michigan. *Teapot*, 1975. Stoneware, glazed, reduction-fired, H. 10″. Collection of the artist. Photograph: Jane Courtney Frisse.

319. Vivika and Otto Heino, Ojai, California. *Bottle*, 1978. Stoneware, ash and iron glaze, H. 16⅜″. Collection Mack L. Graham. Photograph: Don Carstens.

320. Karen Karnes, Stony Point, New York. *Vessel*, 1978. Salt-glazed, thrown stoneware, H. 13″. Collection Stanley and Evelyn Shapiro. Photograph: Garth Clark/Lynne Wagner.

321. Roberta Marks, Miami, Florida. *Vessel*, 1977. Pit-fired earthenware, H. 12″. Collection of the artist.

319

320

321

322

322. Don Pilcher, Champaign-Urbana, Illinois. *Bottle,* 1978. Porcelain, salt-fired, glazed, H. 11″. Collection of the artist.

323. Peter Voulkos, Berkeley, California. *Plate A,* 1978. Stoneware, glazed, Diam. 23″. Courtesy Braunstein/Quay Gallery, San Francisco.

324. Suzanne G. Stephenson, Ann Arbor, Michigan. *Covered Jar,* 1978. Extruded handle, porcelain with black, yellow, and brown slips, H. 18″. Collection of the artist.

323

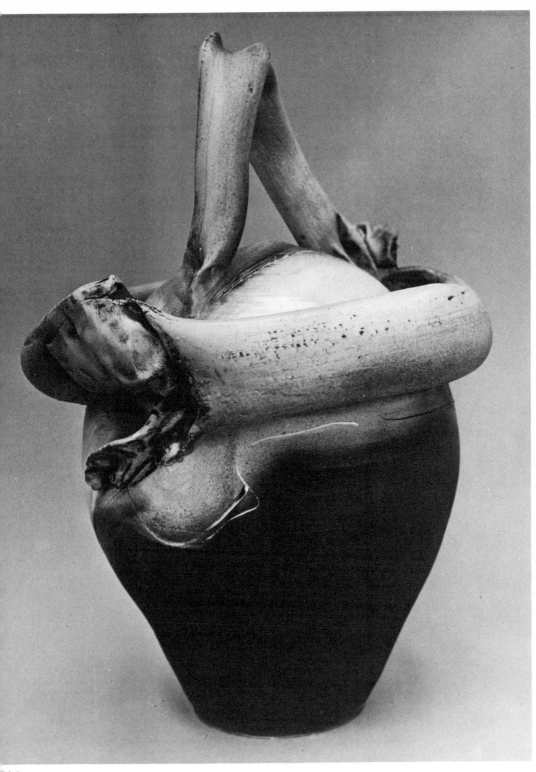

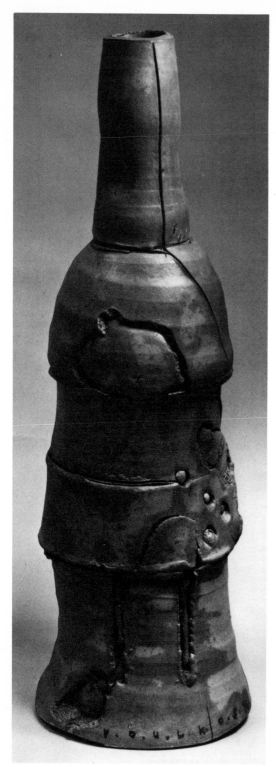

326

325. Peter Voulkos, Berkeley, California. *Gash,* 1978. Stoneware and glaze, H. 38″. Courtesy Braunstein/Quay Gallery, San Francisco.

326. Peter Voulkos at work, Berkeley, California, 1977.

325

NOTES

1. Herbert Read in *The Meaning of Art* (London: Faber and Faber, 1931), pp. 41, 42. See also *Ceramic Art: Comment and Review 1882–1977* (New York: Dutton Paperbacks, 1978), by the author for a discussion of Read's writings on ceramics.

2. Bernard Leach, "American Impressions," *Craft Horizons* (Winter 1950), pp. 18–20.

3. Isaac Clarke, *Art and Industry* (Washington, D.C., 1885), p. ccxvii.

4. Among the students in the class were Mrs. William Dodd, Mrs. George Dominick, Miss Alice B. Holabird, Mrs. Charles Kebler, Mrs. Harriet Leonard, Mrs. A. B. Merriam, Miss Clara Chapman Newton, and Miss Julie Rice. These artists remained involved in china painting after the class was disbanded and formed the nucleus for the formation of the Cincinnati Pottery Club. See Mary Louise McLaughlin, "Miss McLaughlin Tells Her Own Story," *The Bulletin of The American Ceramic Society* (May 1938), p. 218. The article is an extract from a paper read at the meeting of the Porcelain League, Cincinnati, Ohio, April 25, 1914.

5. The technique of *procès barbotine*, painting under a clear glaze with a liquid mixture of clay and oxides (pigments), was revived by the pioneer artist-potter Ernest Chaplet (1835–1909) while working for the *maître faïencier* Laurin of Bourg-la-Reine, France, during the 1860s. A chance meeting with the artist Felix Bracquemond during the siege of Paris in 1872 led to Chaplet's being invited to join the Haviland Auteuil studio in Paris some years later. The studio, under the artistic direction of Bracquemond, provided an open, creative environment for various artists, painters, sculptors, and ceramists to work on the production of unique artwares. Chaplet introduced his *procès barbotine* to the studio, later succeeding Bracquemond as director. The works became known by the misnomer of *Limoges faïence* because of the sponsorship of the studio by Haviland of Limoges. See Jean d'Albis, "La Céramique impressioniste à l'atelier de Paris-Auteuil (1873–1885)," *Cahiers de la Céramique,* 41 (1968), pp. 32–44, and *Ernest Chaplet* (Paris: La Presse de la Connaissance, 1976).

6. See R. H. Soden Smith, *Reports on the Philadelphia International Exhibition of 1816* (London, 1877), p. 464. Smith was one of the few who reported favorably on American ceramics, commenting that "the self reliance which is so marked a characteristic of the American, has strikingly come out in the progress of this industry." Further information on works shown at the exposition can be found in J. G. Stradling, "American Ceramics and the Philadelphia Centennial," *Antiques* (July 1976), pp. 146–158.

7. See McLaughlin, 1938, p. 219.

8. *Ibid.* McLaughlin records that the publicity was due in part to a misunder-

standing. The press took the term *Limoges faïence* to mean "Limoges enamel." The production of the latter had been discontinued, and examples of this technique were rare and highly sought after. McLaughlin was therefore credited with having been the first to rediscover a long-lost process. Intrigued, many wished to produce the wares, and so Coultry offered classes taught by a group of young men who were to be the nucleus of decorators for Rookwood Pottery: John Rettig, Albert Valentine (Valentien), and Matt Daly.

9. *Ibid.*

10. *Ibid.* See Cincinnati Museum of Art, *The Ladies, God Bless 'Em* (Cincinnati, 1976), p. 34, for an illustration of the wares described.

11. *Ibid.*

12. See Clara Chapman Newton, "The Porcelain League of Cincinnati," paper read at the Porcelain League Breakfast in honor of its twentieth birthday, January 10, 1914. The manuscript is lodged with the Historical and Philosophical Society of Ohio, Cincinnati. Extracts published in *The Bulletin of The American Ceramic Society* (November 1939), p. 445.

13. See "War Among Potters, T. J. Wheatley Secures a Patent on American Limoges," *Cincinnati Daily Gazette,* October 7, 1880. Nichols added that Wheatley "might as well get a patent for wood carving and that I might with better reason get out a patent on drawing dragons on vases." However, in 1893 the Nichols/McLaughlin rivalry flared up over an entry in the catalogue to the Cincinnati Room of the Woman's Building at the World's Columbian Exposition. The introduction credited McLaughlin with discovering the technique on which the Rookwood wares were based, and William Watts Taylor, the manager of Rookwood, demanded that the reference be removed. McLaughlin wrote to Nichols asking for clarification. Nichols replied, denying Rookwood's indebtedness to McLaughlin, a petty but not uncharacteristic move on Nichols's part that caused McLaughlin some anguish. In her Porcelain League address in 1914 McLaughlin bemoaned the fact that she had been "credited with having done what I had never claimed to do [initiating the

pottery-decorating craze] while the acknowledgment of what I had done was withheld." See *The Ladies, God Bless 'Em,* p. 64, and McLaughlin, p. 219.

14. See Clara Chapman Newton, "The Early Days of Rookwood," manuscript, Cincinnati, Historical and Philosophical Society of Ohio.

15. See Clara Chapman Newton, *The Bulletin of The American Ceramic Society* (1939), p. 445. The comment refers to the siting of the first pottery alongside the Ohio River. Nichols had chosen the site because she thought it feasible that clay could be brought in economically by barge. In fact, only one such delivery was arranged, and ironically the barge arrived when the water had fallen so low that the pottery was left high and dry. The cost of hauling the clay across the riverbed was as much as it would have been from the railway station. The siting, alongside a railway, was appallingly dirty and unsuitable for a pottery. In 1892, Rookwood moved to spacious new premises on Mount Adams. The building still stands but has been converted into a discotheque with the bottle kilns serving as cubicles for a hamburger restaurant.

16. Japanese art played a strong role in Nichols's artistic motivations. Her introduction came through the gift in 1875 of "some little Japanese books of design" that were almost certainly Katsushika Hokusai's *Manga,* and these prepared her for the beauty of the Japanese pottery exhibit at the Centennial. It was there, Nichols wrote, that she "first felt a desire to have a place of my own where things could be made." In 1877 in New York her husband, George Ward Nichols, an early enthusiast of the Orient, published *Pottery, How It Is Made, Its Shape and Decoration, Instructions for Painting on Porcelain and All Kinds of Pottery with Vitrifiable and Common Oil Colours.* The book includes six illustrations of suggested pottery designs by his wife, taken almost directly from the *Manga.* These remained the central reference source for Nichols's pottery creations. Her intensely personal art expression had a strong influence on the early decorators at Rookwood, in particular Albert R. Valentien, creating a

climate of acceptance for Oriental aesthetic ideals in the pottery. See Kenneth Trapp, "Japanese Influence in Early Rookwood Pottery," *Antiques* (January 1973), pp. 193–197, and "Maria Longworth Storer: A Study of Her Bronze Objets d'Art in the Cincinnati Art Museum" (Master's thesis, University of Cincinnati, 1973).

17. Fry adapted a mouth atomizer to apply slips, allowing greater freedom to the decorator and resulting in the development of *Standard* Rookwood. Taylor was later to regret his advice that Fry patent the technique. She was granted her patent in 1889. Later, while on the staff of Lonhuda Pottery in Steubenville, Ohio, she made an attempt to deny Rookwood the use of the technique. The court ruled against Fry in 1898 on the grounds that it was simply the new application of an old tool. See Kenneth E. Smith, "Laura Anne Fry: Originator of Atomizing Process for Application of Underglaze Colour," *The Bulletin of The American Ceramic Society,* 17 (1938), pp. 368–372.

18. See William Walton, "Charles Volkmar, Potter," *The International Studio* (January 1909), pp. LXXV–LXXX, and Mary G. Humphries, "Charles Volkmar," *The Art Amateur* (January 1883), pp. 42–43.

19. See Cincinnati Art Museum (1976), p. 7. The Englishman referred to was Benn Pitman, and the "new method of communication" was the shorthand system developed by his brother, Sir Isaac Pitman. Pitman came to the United States to promote his brother's invention and stayed to become the major influence in the early days of the Cincinnati School of Design, inspiring a generation of lady woodcarvers, metalworkers, and china painters.

20. The influence of Dutch ceramics has been little explored, but the American ceramists were aware of the prophetic work taking place at Rozenburg Den Haag. As early as 1900, J. B. Owens was producing wares apparently modeled on the lines of the Rozenburg Art Nouveau and given the inappropriate title of *Henri Deux.* The title was from the French Orion ware, with which the work had no technical or stylistic relationship and was probably selected as a red herring to detract from the real source of the plagiarism. See Marion John Nelson, "Art Nouveau in American Ceramics," *Art Quarterly,* 26 (1963), p. 454; and Frederick Rhead, "Some Dutch Pottery," *The Artist,* 24 (1899), pp. 34–40, 64–73.

21. See Newton (1939), p. 446.

22. Frackelton's involvement with ceramics began in 1883, when she established the Frackelton China and Decorating Works in Milwaukee, Wisconsin, where her trained decorators produced from 1,500 to 2,000 pieces a week. She turned to stoneware to take advantage of local clays. The use of salt-glazed decorative stoneware was rare during the Arts and Crafts period, and the only other pottery producing these kinds of wares was Graham Pottery in Brooklyn, New York. See Paul Evans, *Art Pottery in the United States* (New York: Scribner's, 1974), pp. 105–108, 114–115. The work of Frackelton on the exposition is extensively reported by Richard G. Frackelton in *The Clay-Worker,* 21 (April 1894), pp. 437–438.

23. Newcomb grew, much as had Rookwood, indirectly out of a local ceramic enterprise, the New Orleans Art Pottery, a small pottery catering to the needs of the local art league and run by Joseph Meyer and George E. Ohr. William and Ellsworth Woodward, two artist-teachers, became associated with the venture, which was later taken over by the Art League Pottery Club. From this involvement, Edward Woodward developed his interest in vocational training for women and formed the Newcomb Pottery, with Ellsworth as its supervisor.

24. The pottery won medals at the Exposition Universelle in Paris in 1900, at Buffalo in 1901, Charleston in 1902, St. Louis in 1904, Portland in 1905, Jamestown in 1907, Knoxville in 1913, and San Francisco in 1915. See Evans (1974), p. 185.

25. One of the noteworthy private collections was that of the Detroit connoisseur Charles Freer, who assembled one of the finest collections of Oriental ceramics in the West, which is now housed in the Freer Gallery, Washington, D.C. The William Rockhill Nelson Collection

in Kansas City, Missouri, was another exceptional collection.

26. The concept for the Dedham wares was not created by Robertson. He devised the gray/white cracquelle glaze, but the inspiration for the stenciled decoration came from the *Rabbit* plate designed for Dedham Pottery in 1891 by Joseph Lindon Smith, the director of the Boston Museum of Fine Arts, and his wife, Alice.

27. There is some misunderstanding about the starting date of Grueby Faience Company, which is generally given as 1897. This was the year of incorporation; in fact, the pottery commenced production of architectural faïence in 1894. In 1899 Grueby started to use the name Grueby Pottery to differentiate the artware production. See Martin Eidelberg, "The Ceramic Art of William H. Grueby," *The American Connoisseur* (September 1973), pp. 47–54.

28. See Gabriel Mourey, "The Potter's Art: With Especial Reference to the Work of Auguste Delaherche," *The Studio,* 12 (1898), pp. 112–118. Mary Chase Perry gives an account of Grueby's contact with Delaherche in "Grueby Potteries," *Keramik Studio* (1902), pp. 250–253. Grueby wrote to Delaherche about purchasing some of his work and received a letter in reply with some ink sketches of pots that Grueby found a trifle too expensive for his tastes. "Yet," claimed Perry, "[Grueby] is no more in Delaherche's debt than are all of us to one who has produced works of beauty which continue to be a stimulus and inspiration." They proved to be a particular inspiration to Perry, as can be seen by a comparison of the Delaherche photographs reproduced here with the display of her work at the 1904 Louisiana Purchase International Exposition in St. Louis illustrated in figure 70.

29. Adelaide Alsop Robineau, "Mary Chase Perry," *Keramik Studio,* 10 (1905), p. 217.

30. See Mary Louise McLaughlin, "Losantiware," *The Craftsman* (December 1902), p. 187.

31. See George E. Ohr, "Some Facts in the History of a Unique Personality," *Crockery and Glass Journal* (December 1901), pp. 123–125.

32. For a fuller statement on Ohr's aesthetic importance, see "George E. Ohr —Clay Prophet," *Craft Horizons* (October 1978), by the author.

33. From a critical lecture on the Arts and Crafts Exhibition reported in the Buffalo *Express,* April 21, 1900. Ohr's response can be found in *Crockery and Glass,* 53 (1901).

34. See Herbert Peck, "Rookwood Pottery and Foreign Museum Collections," *The Connoisseur,* 172 (September 1969), pp. 43–49; and Art Journal, "Some New Design and Methods in Rookwood and Grueby Faience" in *The Paris Exposition Universelle* (London: Virtue, 1901), p. 60.

35. See Oscar Lovell Triggs, *Chapters in the History of the Arts and Crafts Movement* (Chicago, 1902), p. 161.

36. A review of the Paris exhibition can be found in *Glass and Pottery World,* 11 (June 1903), p. 43. The Louisiana Purchase International Exposition is discussed in *Keramik Studio* (May 1905), p. 8.

37. Quoted in Barbara M. Arnest, "Van Briggle, Several Perspectives," *Van Briggle: The Early Years* (Colorado Springs: Fine Arts Center, 1975), p. 13.

38. See Martin Eidelberg, "Tiffany Favrile Pottery: A New Study of a Few Known Facts," *The Connoisseur* (September 1968), pp. 57–61.

39. In his study "Art Nouveau in American Ceramics," Marion John Nelson highlighted the prophecy of the Bennington parianwares, although concluding that the pieces, produced around 1850, were "too early" to be considered proto– Art Nouveau. This seems to be an unduly rigid manner of looking at the work, for the wares, particularly in the "cornfield" designs illustrated here, anticipate Art Nouveau to an extraordinary degree and are closer to the grammar of the style than the much-vaunted earthenwares by Grainger and Company and the porcelains of the Royal Porcelain Works of Munich—the latter exhibited in the 1851 Great Exhibition at the Crystal Palace in London and used by several historians as

examples of the first stirrings of the Art Nouveau style. The latter wares are illustrated and discussed in S. Tschudi Madsen, *Sources of Art Nouveau* (Oslo: Aschehoug, 1956) and Hugh Wakefield's "Ceramics" in Hans Jurgen Hansen, ed., *Late Nineteenth-Century Art: The Art, Architecture, and Applied Art of Pompon's Age* (New York: McGraw-Hill, 1972).

40. See Kirsten Keen, *American Art Pottery* (Wilmington: Delaware Art Museum, 1978), pp. 31–32. Keen describes the style as being "essentially structural with the decoration rising in low relief" as opposed to European Art Nouveau, which is simplistically described as comprising "exuberant whiplash designs." The French—and to an extent the Belgian and Dutch—forms of Art Nouveau did employ the distinctive linear energy in their work. But the structural qualities that Keen identifies as American were as popular in Europe, particularly in the German *Jugendstil* and Austrian *Sezessionstil* variants of the style. In addition, the first style of Art Nouveau, the Franco-Belgian abstract-organic style of Hector Guimard and Henry van de Velde, was also primarily concerned with structural or constructive elements. Explorations in these areas occurred many years before their development in the United States.

41. The recommendation of Alfred, New York, as the site of a ceramic school was suggested by Charles T. Harris, lessee of the local Celadon Terra Cotta Company. A bill founding the school was passed early in 1900 and was signed into law by Governor Theodore Roosevelt on April 12, 1900, providing $15,000 for the building and equipment and $5,000 for the first year's maintenance and operation. In June, when the cornerstone was laid, the newly appointed director, Binns, ventured the following prediction: "I see the school thronging with busy workers . . . I hear the roar of kilns . . . see those who dream of graceful form and glowing colours realising, by the work of the hands, the creations of the brain. I see technical and training schools arise . . . and their professors are men from Alfred." See

John Nelson Norwood's *Fifty Years of Ceramic Education* (Alfred: New York College of Ceramics, 1950), p. 7.

42. The first school in the country was that of the Ohio State University in Columbus, which was begun in 1894 under the direction of Edward Orton, Jr. A third was established at Rutgers University, New Brunswick, New Jersey, under C. W. Parmelee in 1902. Thereafter ceramic education expanded rapidly.

43. Quoted in Roger Ault, "Mary Chase Perry Stratton and Her Pewabic Pottery," *Great Lakes Informant,* ser. 1, no. 4, n.d., p. 6.

44. For a description of Perry's achievements in this area, see both the biography and the excellent essay by Thom Brunk, "Pewabic Pottery," *Arts and Crafts in Detroit, 1876–1976* (Detroit: The Detroit Institute of Arts, 1976), pp. 141–153.

45. Mercer gave his estate, Fonthill, to the Bucks County Historical Society. The estate included three concrete buildings: his home, the museum that housed his Tools of the Nationmakers collection of over 6,000 hand tools, and the tileworks, which is operated as a living museum today. In addition Mercer left a vast number of papers, which have yet to be catalogued and assessed. Some pioneering work has been done by the historian Cleota Gabriel Reed under grants from the Philosophical Society and the New York State Council on the Arts. Her study, *The Arts and Crafts Ideal* (Syracuse, N.Y.: The Institute for Development of Evolutionary Architecture, 1978), traces the collaboration between architect and artist, involving Mercer, glassmaker Keck, and architect Ward Wellington Ward.

46. See Frederick Rhead, "Adelaide Alsop Robineau—Maker of Porcelains," *The Potter* (February 1917), p. 88. Rhead saw this work during a visit to the Robineaus in 1909.

47. See Adelaide Alsop Robineau, "Editorial," *Keramik Studio,* 1, no. 1 (1899), p. 1.

48. Robineau, quoted from autobiographical notes prepared for the Boston Society of Arts and Crafts in 1906.

49. See Samuel Robineau, "Adelaide Alsop Robineau," *Design* (April 1929), pp. 202–203.

50. *Ibid.*, p. 204.

51. Quoted in Rhead, "Adelaide Alsop Robineau—Maker of Porcelains," p. 87.

52. See Lois Kohlenberger, "Ceramics at the People's University," *Ceramics Monthly* (November 1976), p. 34. For a broader study of University City and its short, troubled history, see Sidney Morse, *The Siege of University City: The Dreyfus Case in America* (St. Louis: University City Publishing, 1912).

53. See La Ligue Américaine de la Femme, *Catalogue des Porcelaines Robineau* (St. Louis: University City Publishing, 1911). The catalogue accompanied Robineau's work to Turin and then in the following year to the showings in Paris.

54. See Anna W. Olmsted, "The Memorial Collection of Robineau Porcelains," *Design* (December 1931), p. 153.

55. See Rhead, "Adelaide Alsop Robineau—Maker of Porcelains," pp. 86–87.

56. See Charles Fergus Binns, "In Defense of Fire," *Craftsman* (March 1903), pp. 369–372.

57. See John Coplans, *Abstract Expressionist Ceramics* (Irvine: University of California, 1966), p. 18, n. 6.

58. See Frank Lloyd Wright, "In the Cause of Architecture: The Meaning of Materials—The Kiln," *Architectural Record* (June 1928), p. 561.

59. See Arthur E. Baggs, "The Story of a Potter," *The Handicrafter*, 1 (April–May 1929).

60. See William I. Homer, "Carl Walters, Ceramic Sculptor," *Art in America*, 44 (Fall 1956), pp. 42–43.

61. See William M. Milliken, "Ohio Ceramics," *Design* (November 1937), p. 17.

62. The Wiener Werkstätte was a design workshop founded in Vienna in 1903 by the architect Josef Hoffmann and painter-designer Koloman Moser. It rapidly became one of the most significant forces in modern design in Europe. At first, its pottery was produced by Wiener Keramik, a firm founded in 1905 by Michael Powolny and Bertholdt Löffler. Later the Wiener Werkstätte began to employ its own ceramists, and during the 1920s some of the finest ceramists in Austria worked with or designed for the firm: Gudrun Baudisch, Hertha Bucher, Matilde Flögel, Erna Kopriva, Dina Kuhn, Kitty Rix, Susi Singer, and Vally Wieselthier.

63. See Helen Appleton Read, "Metropolitan Museum Opens Current Art Season with Fine Display of Ceramics," *Brooklyn Daily Eagle*, October 14, 1928. The review was later included in American Federation of Arts, *Critical Comments on the International Exhibitions of Ceramic Art* (New York, 1928).

64. See Vally Wieselthier, "Ceramics," *Design* (November 1929), p. 101.

65. Quoted in Ault, "Mary Chase Perry Stratton and Her Pewabic Pottery," p. 6.

66. The interest in clay as a final material was the result of a growing purism in sculpture concerning the aesthetic of materials, where the greatest sin was to "mix manners" and to conceive a work in clay and then point it up into a large carved piece. This insistence upon a truth to materials—as well as the austerity of the times—encouraged artists to look upon fired clay as a final material for certain works. For a study of the sculptural aesthetic of this time, see Daniel Robbins, "Statues to Sculpture: From the Nineties to the Thirties," Whitney Museum of American Art, *200 Years of American Sculpture*, ed. Tom Armstrong *et al.* (New York: Godine, 1976), pp. 113–159.

67. See Lincoln Kirstein, *Figures and Figurines by Elie Nadelman* (New York: Hewitt Gallery, 1958), unpaged.

68. See David Bourdon, "The Sleek, Witty and Elegant Art of Elie Nadelman," *Smithsonian* (February 1975), p. 90.

69. *Ibid.*

70. See Karal Ann Marling, "New Deal Ceramics: The Cleveland Workshop," *Ceramics Monthly* (June 1977), pp. 25–31.

71. See E. W. Watson, "Waylande Gregory's Ceramic Art," *American Artist* (September 1944), p. 14.

72. *Ibid.*, p. 12.

73. The nomenclature of the annual changed over the years. It was inaugurated as the National Robineau Memorial Ceramic Exhibition and was held under this title until 1936, when it was titled the

National Ceramic Exhibition, later becoming known as the Ceramic National. In addition, the name of the Syracuse Museum of Fine Arts was changed in 1968 to the Everson Museum of Art when the new I. M. Pei building was opened.

74. Anna Wetherill Olmsted, "The Ceramic National Founded in Memory of Adelaide Alsop Robineau," manuscript, Syracuse, N.Y., Everson Museum of Art, n.d.

75. Although there had been no exhibition abroad specifically of ceramics, several potters had already had exposure through exhibitions such as the 1930 Exhibition of American Industrial Arts at the Röhsska Museum in Göteborg, Sweden, where five potters were featured. For comments on the reception of the American work, see extract of a letter from Gustav Munthe in Olmsted, "The Ceramic National."

76. See "Ceramics: The Art with the Inferiority Complex," *Fortune* (December 1937), p. 114. The article was not signed but appears to be by arts editor Eleanor Treacy.

77. See Baggs, "The Story of a Potter," p. 6.

78. See Glen Lukens, "The New Craftsman," *Design* (November 1937), p. 39.

79. See Roger Hollenbeck, "Review," *The Bulletin of The American Ceramic Society* (April 1938), p. 194. The exhibition took place at the Los Angeles County Museum of Art and was arranged by Reginald Poland of the Fine Arts Gallery in San Diego, with Lukens as one of the judges. For additional comments see "California Ceramics," *Art Digest* (March 15, 1938), p. 16.

80. See Rosalind E. Krauss, "Magician's Game: Decades of Transformation 1930–1950," *200 Years of American Sculpture*, p. 162.

81. For an appreciation of Schreckengost's work, see James Stubblebine and Martin Eidelberg, "Viktor Schreckengost and the Cleveland School," *Craft Horizons* (June 1975), pp. 34–35, 52–53.

82. Cranbrook Academy of Art was part of a complex of small private schools established by the newspaper publisher and art connoisseur George C. Booth.

The project began in 1904, when he purchased one hundred acres of rolling Michigan farmland. At first, his interest in the arts and crafts was restricted to purchases of objects for his home and as gifts for The Detroit Institute of Arts. In the 1920s Booth began to conceive of an ideal artists' community where practicing artists could live, work, and teach in a stimulating, pedagogical environment. He found an active supporter of these ideas in Eliel Saarinen, who designed a complex of buildings for the schools and the academy and also enlisted artists for the faculty. The setting was superb, with large sculptures in manicured gardens, custom-designed furnishings and fabrics, and the very best in Art Deco lamps and accessories. Grotell replaced Waylande Gregory, joining an all-Scandinavian faculty: Eliel and Loja Saarinen, weaver Marianne Strengel, and Swedish sculptor Carl Milles.

83. Quoted in Elaine Levin's, "Pioneers of Contemporary American Ceramics: Maija Grotell, Herbert Sanders," *Ceramics Monthly* (November 1976), p. 50.

84. From interview with Haile's widow, Marianne de Trey, Dartington Hall, Devon, England, summer 1976.

85. See "The Arts of Living," *Architectural Forum* (March 1949), p. 177.

86. *Ibid.*

87. In writing about the Zen aesthetic, Alan Watts writes that André Malraux speaks always of the artist's conquering his material, "as our explorers and scientists also speak of conquering mountains or conquering space. To Chinese or Japanese ears these are grotesque expressions. For when you climb it is as much the mountain as your own legs which lifts you upwards, and when you paint it is the brush, ink and paper which determine the result as much as your own hand." See Alan Watts, *The Way of Zen* (London: Thames & Hudson, 1957), pp. 174–175. This dualistic attitude that divides spirit from nature and materials is what separates Western aesthetic concepts from those of the East.

88. See Daisetz Suzuki, *Zen and Japanese Culture* (New York: Pantheon Books, 1959), pp. 23–24.

89. See Bernard Leach, "American Im-

pressions," *Craft Horizons* (Fall 1950). In response to Leach's comment that the American ceramist was without a taproot, Marguerite Wildenhain responded in "An Open Letter to Bernard Leach from Marguerite Wildenhain" (*Craft Horizons,* 13, May–June 1953), saying that, "It ought to be clear that American potters cannot possibly grow roots by implanting Sung pottery or by copying the way of life of the rural population of Japan. Conscious copying of the works of a culture unrelated to the mind and soul of our generation would only produce dubious makeshifts and turn our struggling potters into either dilettantes or pure fakes. As creative craftsmen, we reject the tendency to force our generation into a mold that does not belong to it."

90. See Bernard Leach, *Belief and Hope* (St. Ives, Cornwall: St. Ives Council, 1968), p. 4.

91. See Sidney Cardozo, "Rosanjin," *Craft Horizons* (April 1972), p. 65. Rosanjin isolated himself from the rest of the "folk" potters in several ways. When designated by that eminent ceramic authority Koyama Fujio to receive the *ningen kokuho* award, Rosanjin flatly refused to accept it, thereby reinforcing his aloofness from the ceramic mainstream.

92. From transcript of lecture given April 1954 at Mills College, Oakland, California, translated by Noriko Yamamoto. I express my thanks to Viola Frey and Charles Fiske for access to this document.

93. The Archie Bray Foundation was established as a creative workshop by Mr. Bray (1886–1953), owner of a brick and pipe works, Helena's Western Clay Manufacturing Works, who wished to leave as a memorial "a fine place to work for all who are sincerely and seriously interested in any branch of creative ceramics." Under the leadership of various directors who succeeded Autio, including Ken Ferguson and David Shaner, the foundation has continued to be just that for over twenty-seven years. For a brief history, see Dave Depew, "The Archie Bray Foundation," *Ceramics Monthly* (May 1972), pp. 18–23.

94. A discussion of the short but im-

portant role of music in the development of a new aesthetic credo in the work of Voulkos was given in his keynote address at the National Council for Education in the Ceramic Arts Conference in Philadelphia, 1975.

95. See Coplans, *Abstract Expressionist Ceramics,* p. 8.

96. *Ibid.,* p. 7.

97. See Jim Melchert, "Origins of the Collection," *The Fred and Mary Marer Collection* (Claremont, Calif.: Scripps College, 1974), unpaged.

98. See Conrad Brown, "Peter Voulkos," *Craft Horizons* (October 1956), p. 12.

99. See Daniel-Henry Kahnweiler, *Picasso's Ceramic* (Hannover: Fackelträger, 1957), p. 17. Kahnweiler repeats a conversation in his office between Picasso and Henri Laurens wherein Picasso commented, "You ought to go into ceramics. It is amazing. I made a head. . . . Well you look at it from all angles and it is flat. Of course it is the painting that makes it flat." Picasso went on to muse about the strangeness that painting a canvas gives depth and painting ceramics robs the object of depth.

100. See Coplans, *Abstract Expressionist Ceramics,* p. 16.

101. See Martin Duberman, *Black Mountain: An Exploration in Community* (New York: E.P. Dutton, 1972), p. 344.

102. *Ibid.* For further insights into Black Mountain, see Mary Caroline Richards, "Black Mountain College, a Golden Seed," *Craft Horizons* (June 1977), pp. 20–22, 70. Richards was one of the handful of students at Black Mountain who worked intently in ceramics.

103. See Coplans, *Abstract Expressionist Ceramics,* p. 8.

104. Fred Marer, who was involved as friend and collector with the Otis group from the start, feels that the Abstract Expressionist element has been overromanticized. Apart from other considerations, there was an underlying element of figurative expression that constantly emerged. In a letter to the author in January 1977, he commented, "I watched Voulkos making his six–seven feet high sculptures fighting desperately to subdue the figurative

formations that seemed to creep out."

105. See Rose Slivka, "The New Ceramic Presence," *Craft Horizons* (July–August 1961), p. 36.

106. See Coplans, *Abstract Expressionist Ceramics,* p. 7.

107. See Harold Paris, "Sweet Land of Funk," *Art in America* (March–April 1967), p. 95.

108. See Salvador Dali, "Objets Surréalistes," *La Surréalisme au Service de la Révolution* (Paris, December 1931), p. 16.

109. See William Rubin, *Dada and Surrealist Art* (London: Thames & Hudson, 1969), p. 9.

110. See Peter Selz, *Funk Art* (Berkeley: University of California, 1967), p. 5.

111. See Suzanne Foley, *A Decade of Ceramic Art 1962–1972; From the Collection of Professor and Mrs. R. Joseph Monsen* (San Francisco: San Francisco Museum of Art, 1972), unpaged.

112. The Davis faculty attracted individualists, and in addition to Arneson, Wayne Thiebaud, William T. Wiley, Manuel Neri, and Roy De Forest taught there. The art department was established in the early 1960s, and so there was in the words of Arneson, "no academic hierarchy . . . no worshipful old-timers whose word was law. There was no academic infighting. Above all, there was no one to say this is the right way, that is the wrong way, and everybody could work as they saw fit." Quoted in Alfred Frankenstein, "The Ceramic Sculpture of Robert Arneson," *ARTnews* (January 1976), p. 48.

113. A letter from Arneson to Paul J. Smith of the Museum of Contemporary Crafts dealing with this event is reprinted in *Clayworks: Twenty Americans* (New York: Museum of Contemporary Crafts, 1971).

114. For a review of the exhibition, see Joseph Pugliese, "Ceramics from Davis," *Craft Horizons* (November–December 1966).

115. See Dennis Adrian, "Robert Arneson's Feats of Clay," *Art in America* (September 1974), p. 80.

116. See Alfred Frankenstein, "Of Bricks, Pop Bottles and a Better Mousetrap," *San Francisco Sunday Examiner*

and Chronicle, October 6, 1974, p. 37.

117. Comment to author, interview at Porta Costa, California, March 1976.

118. See Cynthia Barlow, "Arts Review," *St. Louis Globe Democrat,* September 19, 1965.

119. See Paris, "Sweet Land of Funk," p. 98.

120. Henry Hopkins, "Kenneth Price, Untitled Ceramic," *Artforum* (August 1963), p. 41.

121. See John Coplans, "Out of Clay; West Coast Ceramic Sculpture Emerges as a Strong Regional Trend," *Art in America* (December 1963), p. 40.

122. For an investigation of the role of china painting in this new aesthetic, see Richard Shaw, "Beyond the Barriers of Tradition," *Overglaze Imagery* (Fullerton: Art Gallery, California State University, 1977), pp. 157–160.

123. See John Coplans, ed., *Roy Lichtenstein: Documentary Monograph in Modern Art* (New York: Praeger, 1972), p. 91.

124. See Ellen H. Johnson, "The Lichtenstein Paradox," *Art and Artists* (January 1968), p. 15.

125. See Alice Adams, "Exhibitions," *Craft Horizons* (September–October 1966), p. 42.

126. See Donna Nicholas, "The Ceramic Nationals at Syracuse," *Craft Horizons* (December 1972), p. 33.

127. *Ibid.,* p. 31.

128. See Evert Johnson, "Two Happenings at Southern Illinois University: 1) Clay Unfired," *Craft Horizons* (October 1970), p. 39.

129. See Tobi Smith, "Clay Works in Progress," *Journal* (November–December 1975), pp. 38–47. In addition to Sweet and Colgrove, the event, curated by Tobi Smith, included George Geyer, Tom McMillan, and Larry Shep.

130. See Everson Museum of Art, *New Works in Clay by Contemporary Painters and Sculptors* (Syracuse, N.Y., 1976). This event was the second one of its kind in American ceramic art. The first took place in 1963 at the instigation of *Art in America* where twelve artists, directed by painter Cleve Gray and with the technical assistance of David Gil of Bennington

Potters, Vermont, produced a body of limited-edition ceramics. Those involved in the project were Louise Nevelson, Cleve Gray, Alexander Liberman, Milton Avery, Helen Frankenthaler, David Smith, James Metcalf, Ben Shahn, Jack Youngerman, Leonard Baskin, Seymour Lipton, Richard Anuszkiewicz. See "Ceramics by Twelve Artists," *Art in America,* 52 (December 1964), pp. 27–41, and Richard Lafean, "Ceramics by Twelve Artists," *Craft Horizons,* 25–26 (January 1965), pp. 30–33, 48–49. In addition, the Clay Works studio workshop in New York, established by Susan Peterson for nonclay artists to explore clay with ceramists during three-week work sessions, was established as a pilot project in 1973. It was inspired by the collaborative format of June Wayne, Tamarind Lithography Workshop, with the original inspiration coming from the editor of *Craft Horizons,* Rose Slivka, who took the concept of a collaborative workshop in clay to the NEA in 1971 and helped guide its inception.

131. See Hilton Kramer, "Art: Sensual, Serene Sculpture," *The New York Times,* January 25, 1975.

132. See Hilton Kramer, "Sculpture—From the Boring to the Brilliant," *The New York Times,* May 15, 1977.

133. Viola Frey, "Artist's Statement" in *Viewpoints: Ceramics 1977* (El Cajón, Calif.: Grossmont College Art Gallery, 1977).

134. *Ibid.*

135. Harold Rosenberg, "Reality Again," *Super Realism: A Critical Anthology,* ed. Gregory Battcock (New York: Dutton Paperbacks, 1975), pp. 139–140. The essay was first published in *The New Yorker* (February 5, 1972).

136. See Kim Levin, "The Ersatz Object," *Arts Magazine* (February 1974).

137. See Laguna Beach Museum of Art, *Illusionistic Realism as Defined in Contemporary Ceramic Sculpture* (Laguna Beach, Calif., 1977).

138. Rose Slivka, *The Object as Poet* (Washington, D.C.: Renwick Gallery, 1977), p. 12.

139. See Suzanne Muchnic, "Curios from the Home Folk," *Los Angeles Times,* April 16, 1978, p. 96.

140. See Andy Nasisse, "The Ceramic Vessel as Metaphor," *New Art Examiner* (January 1976). The title was later taken for an exhibition at the Evanston Art Center in 1977.

141. See Philip Rawson, *Ceramics: The Appreciation of the Arts* (London: Oxford University Press, 1971), p. 240.

142. See Read, *The Meaning of Art,* p. 41.

143. See Rawson, *Ceramics: The Appreciation of the Arts,* p. 286.

BIOGRAPHIES

In order to keep the biographical entries as compact as possible, a simplified form of notation has been used to ascribe the source of comments and facts. Reference has been made in some entries to the Everson Museum of Art or Syracuse Museum of Art, which do not have supporting entries in the bibliography. These refer to the catalogues published in conjunction with the Ceramic Nationals from 1932 to 1972. Special international exhibition or anniversary Ceramic National catalogues have been included in the Bibliography, however. Where a reference to a Ceramic National catalogue appears in the reference sources, it indicates that the work of that artist either was included in a special survey exhibition or was a prize winner for that particular year. Although every effort has been made to make the biographical information as complete as possible, a few artists have been omitted where it was not possible to verify available information in time for publication.

AITKEN, RUSSELL (1910–). Graduated from the Cleveland School of Art in 1931 and in 1932–1933 studied under Professor Michael Powolny at the Wiener Kunstgewerbeschule. Aitken was one of the youngest of the group of ceramists to graduate from the Cleveland School of Art's ceramic program set up by R. Guy Cowan. He soon achieved acknowledgment and success and was a consistent prize winner in pottery and ceramic sculpture in the annual May Shows at the Cleveland Museum during the 1930s, also receiving several awards at the Ceramic Nationals. In addition, he exhibited at the Sloane Galleries, Ferargill Galleries, and the Brownell-Lamberton Galleries in New York City, as well as at the Neue Gallerie, Vienna. In a discussion of the aritst's work,

Geoffrey Archbold described Aitken: "an incurable romantic given to numerous boyish extravagant and exotic ventures, he turns out a surprisingly large quantity of excellent work" (Archbold, 1934). The sculptural work deals largely with western and animal imagery, a result of Aitken's great admiration for the works of Frederic Remington.

(See Bibliography: Aitken, 1936; Archbold, 1934; "Art with the Inferiority Complex," 1937; Syracuse Museum, 1937, 1938)

ANDRESON, LAURA (1902–). Born in San Bernardino, California, and studied at the University of California, Los Angeles, where she received her B.A. in 1932. In the following year she began teaching

every summer at UCLA, while also taking her M.A. in painting at Columbia University, New York, where she was graduated in 1936. Andreson established one of the pioneering pottery courses on the West Coast at a time when little information was available. When she heard that Carlton Ball had developed a wheel and excellent throwing skills, she sent a student to study with Ball, who, on her return, repeated these lessons to Andreson. An accidental reduction firing of her kiln in 1948, together with the discovery of stoneware clay deposits in northern California during the same year, led Andreson away from low-fire, gloss-glazed earthenware. She concentrated on developing a range of stoneware glazes and bodies and then from 1957 began to work in porcelain as well. In 1970, Andreson retired from UCLA, although remaining a force in the studio as a professor emeritus. Andreson contends that her retirement from teaching marks the truly creative phase of her work and since then she has participated in over sixty-eight invitational and one-woman exhibitions. She works with clean, simplified forms in the Scandinavian tradition and blends this with the sensitivity for color found in the pottery of Japan. Her selection of color and its vibrancy is drawn from many areas including Andreson's still clear memories of her youth in San Bernardino, "surrounded by orange orchards and the alpine glow of the mountains."

(See Bibliography: Kester, 1970; Levin, May, 1976; Scripps College, 1974)

ARCHIPENKO, ALEXANDER (1887–1964). Born in Kiev, Russia, studying painting and sculpture at the Kiev Art School from 1902 to 1905. He later moved to Paris, where in 1908 he attended the École des Beaux-Arts. Two years later he exhibited with Cubists at the Salon des Artistes Indépendants and in 1911 at the Salon d'Automne. He emigrated to the United States in 1923, founding an art school in New York City. Archipenko played an active part in American art, both as a teacher and through his own exhibitions, which included more than 118 one-man shows in his lifetime and a major touring posthumous retrospective in 1967 organized by the UCLA Art Gallery. Archipenko worked frequently in polychrome terra-cotta, occasionally exhibiting at the Ceramic Nationals. In some pieces, he used the clay as a cheap alternative to bronze, but in other works, notably *Walking Woman* (1937), he exploited qualities of modeling, texture, and color that emphasized the material.

(See Bibliography: Hirshhorn Collection, 1975; Syracuse Museum, 1937; University of California, 1967)

ARNESON, ROBERT (1930–). Born in Benicia, California, and studied at the College of Marin, Kentfield, California, from 1949 to 1951; the California College of Arts and Crafts, Oakland, where he received his B.A. in 1954; and Mills College, Oakland, where he was awarded an M.F.A. in 1958. He taught at several schools thereafter, working as an assistant to Tony Prieto at Mills College, Oakland, from 1960 to 1962, and as head of the ceramics department at the University of California, Davis, from 1962 to the present. Arneson has had numerous one-man exhibitions, including a major retrospective at the Museum of Contemporary Art, Chicago, and the San Francisco Museum of Modern Art in 1974. His work is included in several collections, including the San Francisco Museum of Modern Art; The Oakland

Laura Andreson. Photograph: Ellen Silk.

Museum; University Art Museum, University of California, Berkeley; Whitney Museum of American Art, New York; Guggenheim Museum, New York; Philadelphia Museum of Art, Pennsylvania; Stedelijk Museum, Amsterdam, Holland; and the Hirshhorn Museum and Sculpture Garden, Smithsonian Institution, Washington, D.C. Although Arneson had studied ceramics while at the California College of Arts and Crafts, he says that it was during his period of teaching high school students and showing them how to throw and handle clay that his real interest in the medium began to develop. In 1958 he had made sufficient progress to join Prieto as a graduate student, making what he terms "slick bottles in the Mills tradition" (Museum of Contemporary Crafts, 1972), and he won second prize at the 1958 Wichita Ceramic National Exhibition. At this stage, he began to be influenced by the work of Peter Voulkos and produced a body of more-or-less Abstract Expressionist ceramics that Elena Natherby christened his "Mastodon dropping." Arneson began to move from the contrived works to a more personal statement when in 1961, while demonstrating pottery techniques at the California State Fair alongside Tony Prieto and Wayne Taylor, he threw "a handsome, sturdy bottle about a quart size and then carefully sealed it with a clay bottlecap and then stamped it *No Return.* That's what it's really about, isn't it?" (Museum of Contemporary Crafts, 1972). The piece was first exhibited in 1962 at an exhibition at the M. H. de Young Memorial Museum, where the object stood alongside a group of conventional vessels. "As for the *No Deposit Bottle,*" sniffed a writer for *Craft Horizons,* "if the purpose of including this in the exhibition was to irritate the reviewers, it did" (Meisel, 1962). But with this insouciant gesture, Arneson was beginning a development that was to do more than simply irritate. In the years that followed, he profoundly offended, dismayed, and delighted both the sculptural world and that of the ceramic arts. From 1963 onward, he began to work on a series of explorations, the extreme of which was his *John* series. This was the beginning of a dialogue on ceramics that in subsequent

years dealt with a wide range of themes, from throwing lessons to the treasure-house associations of ninth-century Sung celadons. Arneson described the toilet as the "ultimate ceramic" and, above all, an object within the ceramic tradition that had no art heritage. The shock aspect of these pieces—which include penis handles, red clitoral drains, generous amounts of ceramic excrement, and various oozes and pustules—represented the ceramic equivalent of Duchamp's exhibition of a urinal, *The Fountain,* in 1917. In ceramics, however, the shock value was greater, as the material had been for so long identified with the timid decorative-art format, and these objects created a major furor. The works of the mid-1960s have less bite and deal with more comic themes, such as *Toasties* (1965), with a hand emerging from the appliance's innards; *Typewriter* (1965–1966), with its red, lacquered fingernails substituting for keys; and food series such as *Crisco* (1966). Soon after this body of work, Arneson began to work on his seminal *Alice Street* series, which dealt with his suburban home environment. This series is less dramatic than the early works of Arneson and attracted little critical attention. But these works with their modular format have developed into one of Arneson's richest areas of investigation. They freed him from the preciousness of an object-making tradition and brought his works fully into the realms of sculpture, allowing him to work in a monumental, mock-heroic style. Among the major works that have evolved from this method of construction are *Mountain and Lake* (1975) and more recently *Pool with Splash* (1977). This was also explored in some of his portraits, notably *Smorgy Bob* (1972) and *Fragments of Western Civilization* (1975). His self-portraits and portraits of friends have developed into the most masterful of his many series of explorations. In *Classical Exposure* (1972), the seditious, Dadaesque quality of his early works remains, and although the pun has continued to be the basis of his statement, since then the aesthetic has become more subtle and now relies upon more fundamental and universal concerns, employing pure color and texture and force-

ful modeling. Arneson's work represents one of the most extraordinary contributions to American ceramics—a contribution that can be likened only to that of the Della Robbias of the Renaissance in Italy and Bernard Palissy, the French mannerist. In common with these ceramic masters of the past, Arneson's work exhibits considerable skill, formal accomplishment, and a unique and commanding personal vision. He is also a true maverick, and his work, while cognizant of mainstream art movements and at times freely satirizing and commenting on these developments, is nonetheless outside any of the identifiable genres or schools of contemporary art today. Commenting on the works of Arneson at his retrospective in 1974, Dennis Adrian remarked that the work had taken on an increasingly visionary, complex, and even profound character: "His probing of the various implication of puns, both visual and verbal, and, more broadly, of metamorphosis, has brought Arneson into the area of metaphysical statement about the conditions and varieties of artistic processes and forms . . . the true foci of Arneson's interests are not easy gags or Funk conceits, but the consistently varied investigations of ambiguities in the materials, processes and rationales of artistic activity itself" (Adrian, 1974).

(See Bibliography: Albright, 1976; Adrian, 1974; Ball, 1974; Campbell Museum, 1976; "Ceramics," 1968, "Ceramics: Double Issue," 1958; Clark, 1978; Davis, D., 1971; Derfner, 1975; Foley and Foley, 1974; Frankenstein, 1976; Hepburn, 1970; Johnson, 1970; Judd, 1965; Kalamazoo, 1977; Kramer, 1977; Laguna Beach, 1977; Museum of Contemporary Art, 1974; New York Reviews, 1975; Nordness, 1970; Nordstrom, 1978; Paris, 1967; Plagens, 1974; Pugliese, 1966; Renwick, 1977; Richardson, 1969; San Francisco Art Institute, 1971; San Francisco Museum of Art, 1972; Scripps College, 1974; Selz, 1967; Slivka, 1971; Stone, 1965; Tarshis, 1974; William Hayes Ackland, 1977; Zack, 1970, 1971)

AUTIO, RUDY (1926–). Born in Butte, Montana. He was educated at the Butte public schools; Aviation Machinist's Mate

Rudy Autio.

School, U.S. Navy (1943–1944); and at the Montana State University, Bozeman, where he took his B.S. in 1950. In 1952 he received his M.F.A. from Washington State University, Pullman. Autio was resident artist at the Archie Bray Foundation, Helena, Montana, from 1952 to 1956. During that period, he produced a number of architectural commissions, including a ten foot by thirty foot ceramic wall relief depicting *The Sermon on the Mount* at the First Methodist Church in Great Falls, Montana. In 1957 he became assistant curator of the Montana Museum, Missoula, and after a short stay moved to the University of Montana, Missoula, where he became a professor of ceramics and sculpture, remaining there from 1957 to 1971. Autio's interest gradually moved away from ceramics to metal, which is now his major medium. The strength of Autio's ceramics and his original use of anthropomorphic form and decoration have made him an inspiration to a generation of ceramic artists in the United States, beginning with the early Abstract Expressionist group at the Otis Art Institute.

(See Bibliography: Depew, 1972; The Evanston Art Center, 1977; Everson, 24th Ceramic National Exhibition, 1966–1968; Kalamazoo, 1977; San Francisco Museum

of Art, 1972; Scripps College, 1974; Victoria and Albert Museum, 1972)

BACERRA, RALPH (1938–). Born in Orange County, California, and studied at the Chouinard Art School, Los Angeles, where he received his B.F.A. in 1961. He later became chairman of the ceramics department at the Chouinard Art Institute, where he was a strong influence on students. Bacerra's work is distinguished by an almost intimidating standard of craftsmanship. He is a skilled decorator, employing a number of techniques from incising into the clay body to overglaze painting. Some of his finest work is produced in porcelain, which emphasizes the richness and preciousness of his work. Bacerra now works from his studio in the Los Angeles area and is also a consultant to the ceramics industry.

(See Bibliography: Kalamazoo, 1967; Kester and Peterson, 1967; Levin, 1977; San Francisco Museum of Art, 1972)

Arthur Eugene Baggs. Photograph: Clifford Norton.

Ralph Bacerra. Photograph: Ellen Silk.

BAGGS, ARTHUR EUGENE (1886–1947). Baggs was living in Alfred, New York, when New York State established the School of Ceramics in 1900. He was interested in drawing and design, and the best instruction in these disciplines was to be had from the School of Ceramics. He entered the school without any thought of becoming a potter, and "in the general course of things I made a few pots and got the bug which has been spreading its infection through my system ever since" (Baggs, 1929). At the end of his sophomore year, Professor Charles Fergus Binns sent Baggs to Marblehead, Massachusetts, on a vacation job. There he assisted Dr. Herbert J. Hall in setting up a pottery department for occupational therapy at his sanitarium. By 1908 Marblehead Pottery had developed into an independent commercial venture with a weekly output of 200 pieces, most designed by Baggs, with subtle conventionalized decoration and mat glazes. For six years, Baggs taught elementary pottery, provided technical assistance for the Ethical Culture School of New York City, and studied at the Art

Students League. In 1915 he purchased the pottery from Dr. Hall. From 1925 to 1928, he worked as glaze chemist for the Cowan Art Pottery Studio and taught at the Cleveland School of Art. In 1928 Baggs became professor of ceramic arts at the Ohio State University, Columbus. During his summers, he worked at Marblehead Pottery, a working arrangement he maintained until the closing of the pottery in 1936. The work of Baggs shows an obsession with glaze chemistry, ranging from his superbly bland mat glazes for Marblehead to his Egyptian blue and Persian green for Cowan. In the 1930s he became interested in reviving interest in the salt-glaze process, which apart from isolated work such as that of Susan Frackelton in the 1890s had been neglected as a decorative medium. During his career, he won many awards, including the Ogden Armour Prize at the Chicago Exhibition of Applied Art (1915); the medal of the Boston Society of Arts and Crafts (1925); the Charles F. Binns Medal at the American Ceramic Society (1928); First Prize for Pottery at the May Show, Cleveland (1928). He was an active exhibitor at the Ceramic Nationals, winning First Prizes in 1933 and 1938 and a Second Prize in 1935. His *Cookie Jar* (1938), which won the First Prize at the Ceramic National of that year, is considered his masterwork and one of the major pieces of the decade.

(See Bibliography: Baggs, 1929; Eidelberg, 1972; Emerson, 1916; Evans, 1974; Hall, 1908; Henzke, 1970; Keen, 1978; Kovel and Kovel, 1974; Levin, 1976; MacSwiggan, 1972; Syracuse Museum, 1935, 1937, 1938)

BAILEY, CLAYTON (1939–). Born in Antigo, Wisconsin, and received his M.A. at the University of Wisconsin in 1962, having studied under Harvey Littleton, Clyde Bert, and Toshiko Takaezu. After graduation, he taught at various Midwestern universities and became instructor of ceramics at the University of Wisconsin, Whitewater. After two semesters as a guest artist at the University of California in Davis, working alongside painters Roy De Forest and Wayne Thiebaud and ceramist Robert Arneson, he returned to

Clayton Bailey. Photograph: Carl Byoir & Associates.

settle in California, teaching at the California State College, Hayward. By the time of his move to California, Bailey had already established a reputation as an unconventional artist, exhibiting four-foot-long inflatable rubber grubs and "nose-pots" that were covered in tacky layers of latex "glaze." He had already received major one-man shows, including one at the Museum of Contemporary Crafts, New York, in 1964 and one at the Milwaukee Art Center in 1967. In the 1970s Bailey has dealt with a series of themes in his work, ranging from pornography, the medical establishment, and primitive man of the "kaolithian" period to his now famous workshops and staged events, which have exploited so masterfully the ceramic arts

tendency toward a craft hypochondria—a neurotic search for new glazes and craft skills to cure imagined creative ills. Bailey's work is the most truly Funk of the Bay Area artists and one of the few whose work still patently belongs to this genre. In 1976 he installed his works in a "penny arcade" installation in Porta Costa. Viewers paid a nominal entrance fee to see the Wonders of the World Museum, where Bailey maintained that his public could enjoy his works without the alienation of a museum or art gallery environment. The museum has now been transferred to his home.

(See Bibliography: Albright, 1973, 1975; Art Gallery, 1972; Breckenridge, 1965; Bower, 1968; California State University, 1977; Campbell Museum, 1976; Clark, 1978; Davis, D., 1971; Earley, 1976; Grossmont College, 1977; Nordness, 1970; Pyron, "From Pottery to Amateur Science," n.d.; San Francisco Museum of Art, 1972; Selz, 1967; Slivka, 1971; Stewart, 1975; Wenger, 1975; Zack, 1970, 1971, 1973)

BALL, F. CARLTON (1911–). Born in Sutter Creek, California, and studied at the University of Southern California from 1932 to 1935, teaching at the California College of Arts and Crafts (1935–1938); Mills College, Oakland (1939–1949); the University of Wisconsin (1950–1951); Southern Illinois University (1951–1956); the University of Southern California (1956–1968), and the University of Puget Sound, Washington, from 1968 until his retirement. Carlton Ball is known for the size of his pots and for their surface texture. He has been shown in over 500 exhibitions in the United States since 1940 and has contributed strongly to education in the ceramic arts with several books and articles on the techniques and aesthetics of potting.

(See Bibliography: Ball, 1965, 1967; "Ceramics: Double Issue," 1958; Lovoos, 1965; Syracuse Museum, 1958)

BAUER, FRED (1937–). Born in Memphis, Tennessee, and studied at the Memphis Academy of Art, taking his B.F.A. in 1962, and at the University of Washington, where he received an M.F.A. in 1964. In 1966 he was the recipient of a

Louis Comfort Tiffany Foundation grant and worked at the Archie Bray Foundation in Helena, Montana, in 1964. He taught at University of Wisconsin, Madison (1964–1965); Aztec Mountain School of Craft, Liberty, Maine (1967); the University of Michigan, Ann Arbor (1965–1968); and the University of Washington, Seattle, until 1971. The mercurial Bauer achieved early notoriety as a ceramic artist in the Funk/Super-Object vein. Bauer's style, irreverence, and evident talent made him a romantic hero to the young ceramic artists of his day. Eventually the pressures and compromise of the role of artist-performer-guru that he found himself undertaking became too destructive, and Bauer left ceramics in 1972, seeking seclusion as a farmer in northern California. Despite the short period of his involvement, Bauer was a prolific producer, developing from a skilled, functional potter to an imaginative sculptor. His oeuvre of the latter part of the 1960s is the most interesting period,

Fred Bauer. Photograph: Jane Eddy.

with its milieu of phallic cameras, plates with pyramids of lustered peas, and six-foot-high Funk pumps.

(See Bibliography: Bauer, 1965; Pugliese, 1975; San Francisco Museum of Art, 1972; Syracuse Museum, 1958)

BENGSTON, BILLY AL (1934–). Born in Dodge City, Kansas, moving at an early age to California, where he attended the Manual Arts High School in Los Angeles. It was there that he first became involved in ceramics, and after leaving school, he studied at the Los Angeles City College from 1953 to 1956 and at the Otis Art Institute in Los Angeles in 1956–1957. Bengston was part of the group of experimental artists around Peter Voulkos. After leaving Otis, Bengston turned from pottery to painting. Two influences from Japanese ceramics—raku and oribe, with their rich, spontaneous surfaces—remained a strong influence in his painting. He returned to ceramics in June 1975, when he was invited to participate in the "New Works in Clay by Contemporary Painters and Sculptors" show at the Everson Museum of Art. His works were produced with the assistance of the Syracuse China Corporation from designs (wax models and drawings) that he submitted for execution. These required several modifications before the final plaster molds were prepared by Don Foley to be produced in flintware. In this body of work, Bengston employed the iris motif that he terms "Dracula," created by spraying glazes over template. The motif is a central concern in Bengston's work and appears in many of his paintings as well.

(See Bibliography: Coplans, 1966; Everson Museum, 1976; "Museum Clay," 1976; Scripps College, 1974)

BINNS, CHARLES FERGUS (1857–1934). Born in Worcester, England, the son of Richard William Binns, director of the Royal Worcester Porcelain Works. As a child he attended the Cathedral King School and at the age of fourteen was apprenticed at the porcelain works under the supervision of his father. He studied chemistry in Birmingham, and upon his return a ceramics laboratory was established at

the plant and efforts were made to bring the production at the factory under more scientific control. In 1897 he came to the United States to become principal of the Technical School of Sciences and Art at Trenton, New Jersey. In 1900 he was invited to become the first director of the New York College of Clayworking and Ceramics in Alfred. A year after joining Alfred University, he was given an honorary degree of master of science by the university in recognition of his work, and in 1925 he was given the degree of doctor of science. He was one of the charter members of the American Ceramic Society, which was founded in 1899, with Binns being elected trustee at the first meeting. The following year he was made vice-president and in 1901 became president of the society. In 1918, when Professor Edward Orton resigned as secretary, he accepted that office and acted as secretary of the society for four years. He was also a member of the English Ceramics Society and various art organizations as well as a fellow of the Boston Society of Arts and Crafts. Binns was a man of strong convictions. These were evident both in the standards he set for his work as an artist

Charles Fergus Binns.

and in his dedication to the church. In 1923 Binns was ordained as a priest in the Protestant Episcopal Church. He was the author of numerous papers that were published in *Craftsman, Keramik Studio,* and *Transactions* and *Journal of the American Ceramic Society,* as well as other publications. He wrote many monographs and three books: *The Story of the Potter, The Potter's Craft,* and *Ceramic Technology.* Although Binns received some renown in his day for his superbly glazed stonewares, a memorial exhibition of which was held after his death in 1935 at The Metropolitan Museum of Art in New York, his greatest contribution came in the field of ceramic education. Under his guidance, a generation of significant ceramic teachers emerged, including Arthur Baggs, Harold Nash, Myrtle French, Paul Cox, R. Guy Cowan, Ruth Canfield, and Charles Harder.

(See Bibliography: American Federation of Arts, 1928; Avery, 1935; Barber, 1909; Binns, 1894, 1898, 1900, 1916, 1922; Detroit Institute, 1976; Henzke, 1970; Jervis, 1902; Keen, 1978; Kovel and Kovel, 1974; Levine, 1975; Norwood, 1950; "Professor Charles F. Binns," 1935; "Stoneware . . . ," 1935)

BLACKBURN, ED (1947–). Born in New York City and studied at the Humboldt State University, Arcata, California, taking his B.A. and his M.F.A. at the San Francisco Art Institute. He has taught at the University of Washington (1974–1975) and since 1975 at the California State University, Chico. Blackburn has had several one-man exhibitions, and he has been included in numerous group shows. Speaking of his work, he comments, "A specific direction in my current work involves the use of underglazes, lustre glazes and china paints on earthenware. Forms I am working with take shape through a combination of forming processes—primarily: handbuilding, moldmaking, and slip casting. In conjunction with these techniques my emphasis is towards integrating the image painted on the surface of the clay and glazes with the form itself. The surface is developed by building up successive layers of color utilizing a process of multiple firings at various temperatures"

Ed Blackburn.

(California State University, Fullerton, 1976).

(See Bibliography: California State University, Fullerton, 1976; Campbell Museum, 1976)

BOGATAY, PAUL (1905–1972). Born in Ada, Ohio, and studied at the Cleveland School of Art under R. Guy Cowan and,

Paul Bogatay.

briefly, Arthur Baggs. He later became a graduate student of Baggs at Ohio State University, Columbus, which he joined as a ceramics instructor in the early 1930s, remaining there until 1971. Bogatay received two First Prizes for his sculptural works at the Ceramic Nationals and a $100 purchase prize in 1946, was the recipient of a Tiffany fellowship, and for three years was a fellow of the Rockefeller Foundation. Apart from his interest in clay as a sculptural material, Bogatay was also strongly involved in industrial concerns and was an active member and officer of the American Ceramic Society.

(See Bibliography: Bogatay, 1931, 1948; Scripps College, 1947; Syracuse Museum, 1937, 1938; Syracuse Museum, 17th Ceramic National, 1953)

BOHNERT, THOM R. (1948–). Studied at Southern Illinois University, Edwardsville, Illinois, from 1965 to 1969, taking his B.A. there, and at the Cranbrook Academy of Art, Bloomfield Hills, Michigan, where he was awarded his M.F.A. in 1971, majoring in ceramics, with minors in printmaking and metalsmithing. Bohnert has evolved a unique method of dealing with both volume and space, creating polychrome assemblage vessels with wire and ceramics. He has exhibited extensively since 1966 and has received numerous scholarships and awards, including the National Endowment for the Arts, Craftsman Fellowship, in 1978.

(See Bibliography: "Cranbrook 12," 1976; The Evanston Art Center, 1977; Slusser Gallery, 1977)

BRESCHI, KAREN (1941–). Born in Oakland, California, and studied at the California College of Arts and Crafts, Oakland, where she received her B.F.A. in 1963, and the San Francisco State College until 1965. From 1968 to 1971, she studied at the San Francisco Art Institute. After graduating, she taught at the San Francisco Art Institute. Breschi works on figurative fired-clay sculptures that she later paints and occasionally embellishes with other materials and found objects. These works involve macabre dream imagery that

Karen Breschi.

chiefly represents animals dressed and in human situations. Later work has involved a series of self-portraits and figures such as *False Fronted Man* (1973), which extended Breschi's investigation of the mask, a theme that has been explored extensively in her work.

(See Bibliography: Brown, 1978; Hepburn, 1976; Laguna Beach, 1977; Pomeroy, 1973)

BURNS, MARK A. (1950–). Received his B.F.A. from the College of the Dayton Art Institute, Dayton, Ohio, in 1972 with ceramics as his major. He took his M.F.A. at the University of Washington, Seattle, in 1974 under Howard Kottler and Patti Warashina. He has taught at the College of the Dayton Art Institute; the University of Washington; The Factory of Visual Arts, Seattle; and at the State University of New York, Oswego. In 1975, he joined the Philadelphia College of Art where he is

Anthony Caro. Photograph: Stuart Lisson.

currently employed. Labeling Burns's work as Punk Art is to oversimplify what are in fact intensely personal statements of the artist's search for identity and the ambivalence-alienation of the creative act. Burns employs bizarre, exotic, and sadomasochistic imagery in his immaculately crafted works. In 1977 he held a one-man exhibition of his works at the Drutt Gallery, Philadelphia, which incorporated a total, painted environment.

(See Bibliography: Campbell Museum, 1976)

CARO, ANTHONY (1924–). Born in England and studied at Cambridge as well as at the Royal Academy School, London, and from 1951 to 1953 was one of Henry Moore's helpers. From 1953 he experimented with sculptured clay in an "automatic" fashion: "dropping it on a table or floor, or puncturing it in order to 'force' his inspirations. This activity suggested

shapes that were not in mind when the work began which could be developed as it progressed" (Hughto, 1976). In 1959 the character of his work changed from figurative clay cast in bronze to abstract sculpture in found steel. When invited to participate in the Everson Museum's "New Works in Clay" in 1975, he had coincidentally just begun to experiment with clay again. Caro was one of the most enthusiastic of the ten artists invited to participate, and he wanted to explore a whole range of ceramic forms without becoming embroiled in vessel concerns. Some of his pieces exploited the plasticity of the material, allowing it to set off form as best suited the slab forms that he was working on. Another development was what became known as the "piece pit," a conglomeration of different elements that could be assembled in the same manner as his metal sculptures. Writing later to Margie Hughto of his rediscovery of the material, he commented, "I began to get a picture of the way clay asserts its needs, how it likes to turn in on itself, how it requires to be cradled when damp, as well as being drawn into handles or thrown on the wheel. I wanted to see which way the clay would lead me, to start without preconceptions" (Hughto, 1976). Caro has returned to the Clay Institute in Syracuse several times since the completion of the Everson project and has produced over 100 clay sculptures.

(See Bibliography: Clark, 1978; Everson Museum, 1976; Hughto, 1976; "Museum Clay," 1976; Nordstrom, 1978)

COSTANZO, TONY (1948–). Born in Schenectady, New York. He attended Alfred University, Alfred, New York, briefly, taking his B.F.A. in 1971 at the San Francisco Art Institute and his M.F.A. in 1973 at Mills College, Oakland, California. Costanzo taught in the Oakland public schools from 1974 to 1976 and has taught at Humboldt State University, Arcata, California, since 1976. Costanzo uses the ceramic medium as a unique canvas, extending the field of pattern painting into the ceramic medium. He has had three one-man exhibitions at the Quay Gallery, San Francisco, and one in 1977 at the Nuage Gallery, Los Angeles, as well as being included in nu-

Tony Costanzo.

merous group exhibitions.
(See Bibliography: California State University, 1976)

COWAN, R. GUY (1884–1957). Born in East Liverpool, Ohio, to a family who had been in the pottery industry for generations. Cowan was one of the first graduates from the New York College of Clayworking and Ceramics, where he studied under Charles Fergus Binns. In 1913 he opened his own pottery in Cleveland, scoring his first public success in 1917, when he was awarded the First Prize for Pottery at The Art Institute of Chicago. After the war, Cowan moved to Rocky River, a suburb of Cleveland, and there he began to concentrate on molded, limited-edition ceramics, winning many awards including the Logan Medal for Beauty in Design in Chicago in 1924. The company name was changed from the Cleveland Tile and Pottery Company to the Cowan Pottery Studio. There he began to work with a white porcelain clay, designing most of the figurative and vessel pieces himself until 1927, when Paul Manship, Waylande Gregory, A. Drexler Jacobsen, and Thelma Frazier began to design limited-edition works for the pottery. By then Cowan's glazes had improved in variety and quality with the addition of Arthur Eugene Baggs to the staff from 1925 to 1928. Although Cowan's ceramics, par-

ticularly the figurines, were popular and the company was reincorporated with $100,000 capital, the studio was unable to survive the Depression, and in 1931 the pottery went into receivership. Cowan moved to Syracuse and became the art director of the Onondaga Pottery Company, producers of Syracuse china. In Syracuse he became one of the guiding figures in the Ceramic Nationals. A fitting memorial to his achievement now exists in the Cowan Pottery Museum at the Rocky River Public Library, which has a collection of over 800 works and comprehensive archives of catalogues and correspondence. The collection is based mainly on the John Brodbeck collection, which the library purchased in December 1976.
(See Bibliography: Brodbeck, 1973; Calkins, D. H., 1977, 1978; Clark, E. M., 1975; Cowan, 1937; Cowan Pottery Museum, 1978; Davis, E. B., 1928; Evans, 1974; Hoffman, Driscole, and Zahler, 1977; Norwood, 1950; Robbins, C., 1929; Syracuse Museum of Fine Arts, 1937)

CUSHING, VAL MURAT (1931–). Born in Rochester, New York, and received his education at the New York College of Ceramics at Alfred University, Alfred, New York, taking his B.F.A. in 1952 and his M.F.A. in 1956. After leaving college he taught at the University of Illinois, Urbana, and became director of the Alfred University summer school course in pottery from 1957 to 1965. He is now a professor of pottery at Alfred University and has been an active member in the ceramic arts. Cushing was chairman of the standards committee of the New York State Craftsmen and chairman of the technical committee of the National Council for Education in the Ceramic Arts from 1962 to 1966. His work has been extensively exhibited in major group and one-man shows, and he was recently awarded the Binns Medal of the American Ceramic Society.
(See Bibliography: Campbell Museum, 1976; Ceramics East Coast, 1966; Everson, Ceramic Nationals, 1968–1970; New Gallery [Iowa], 1963; Nordness, 1970)

DALEY, WILLIAM (1925–). Born in Hastings-on-Hudson, New York. He

Val Murat Cushing.

William Daley.

studied at the Massachusetts College of Art in Boston and Columbia University Teachers College, New York City, receiving his M.Ed. in 1951. From 1951 he taught in Iowa, New York, New Mexico, and at the Philadelphia College of Art, where he has been since 1966. Daley has developed an architectonic form, creating large, press-molded stoneware vessels. In addition, he has considerable experience of architectural ceramics and has received commissions for murals, both in bronze and ceramic, from

the Atlantic Richfield Corporation, the South African Airlines Office in New York, and a work titled *Symbolic Screen* for the IBM Pavilion at the Seattle Century 21 Exposition in 1962.

(See Bibliography: Campbell Museum, 1976; Cochran, M., 1976; The Evanston Art Center, 1977; Schlanger, J., 1969; Syracuse Museum, 1968)

DALY, MATTHEW A. (1860–1937). Born in Cincinnati, Ohio. Among his boy-

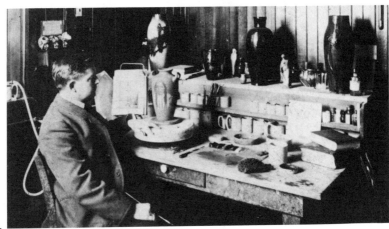

Matthew Daly.

hood companions were Artus Van Briggle and Ernst Blumenshein, the magazine illustrator. Daly was one of the first decorators to join Rookwood Pottery, and he remained there for twenty years. He left Rookwood to become the art director of the United States Playing Card Company and held this post for thirty years. Daly was a member of the Cincinnati Art Club, of which he was both a charter member and president, and also of the American Artists' Professional League.

(See Bibliography: Peck, 1968; Ripley, 1933)

Stephen De Staebler.

DE STAEBLER, STEPHEN (1933–). Born in St. Louis, Missouri, and studied with Ben Shahn and Robert Motherwell at Black Mountain College in 1951, subsequently traveling to Europe, where he concentrated on making stained-glass windows. In 1954 he received his B.A. degree in religion with high honors from Princeton University. From 1954 to 1955, he served in the United States Army in Germany. In 1957 he worked at Union Settlement, East Harlem, New York, and studied ceramics with Ka-Kwong Hui at The Brooklyn Museum School, later moving to California, where he taught history and art at the Chadwick School of Rolling Hills. In 1958 he studied at the University of California, Berkeley, where he worked with Peter Voulkos as well as taking his M.A. in art history. Since 1967 he has been associate professor of sculpture at San Francisco State University. He is an active sculptor, exhibiting at major group shows since 1962 and creating commissions for the Newman Center Chapel, the University Art Museum, and the Bay Area Rapid Transit Station at Concord as well as for private residences. In 1974 he had a major one-man show at The Oakland Museum. De Staebler works on a large scale (his free-standing sculptures are eight to nine feet in height) and draws his inspiration from the terrain and landscapes, particularly of the West. Insofar as there is direct symbolism in his work, he draws strongly from the gestation of earth and rock. Nature, not cultural references, is the major inspiration in his works. Writing about De Staebler in the catalogue of his one-man exhibition at The Oakland Museum, Harvey L. Jones remarked that the power and appeal of De Staebler's sculpture derives in large part from his attitude toward the clay: "He has learned by long experience to recognize the intrinsic character and beauty of the medium and, more important, to respect its natural limitations. De Staebler responds to the peculiar qualities which clay possesses: its plasticity when wet, its fragility when dry, its tendency to warp, crack, and slump during the drying and firing processes. He equates the obvious but frequently overlooked fact that clay is earth. He has developed a vocabulary of earth forces: gravity and pressure, erupture and erosion, shearing and breaking. By yielding to clay and discovering what it wants to do, he has evolved a unique art form" (The Oakland Museum, 1974).

(See Bibliography: Ashton, 1967; Coplans, 1963; Dillenberger and Dillenberger, 1977; Meisel, 1975; Nordness, 1970; Oakland Museum, 1974; Richardson, 1969; University Art Galleries, 1976; William Hayes Ackland, 1977)

DEVORE, RICHARD E. (1933–). Born in Toledo, Ohio, and educated at the University of Toledo, where he received his B.Ed. in 1955, and at the Cranbrook Academy of Art, Bloomfield Hills, Michigan, where he received an M.F.A. in 1957, studying under Maija Grotell. In 1966 Grotell chose DeVore as her successor, and he became the head of the ceramics department, a position he held until 1978, having now joined the faculty of the University of Colorado at Boulder. During the 1960s DeVore's work explored a range of interests, from brightly colored vessels to lustered, figurative sculpture, preciously contained in framed glass boxes. From 1970 onward, this eclecticism was replaced with an intense, passionate, and sharply focused investigation of the vessel format. The last nine years have seen a virtuoso handling of the dynamics of the potter's aesthetic, presenting a refined and tensely controlled treatment of line, volume, entrapped and displaced space, tactilism, and color. This process of distillation to achieve the essence of these qualities is understandably a highly conscious and intellectual pursuit. While the cerebral quality of DeVore's work is certainly evident— and is a potent quality in its power and attraction—the vessels never lapse into an academic format. DeVore has been a significant force in restoring credibility to the potter's art as a serious, contemporary form of expression after nearly two decades that have stressed the importance of ceramic sculpture over that of the vessel. First of all, DeVore has rejected the gift-shop pricing mentality so rife in the medium and has insisted that his work receive prices commensurate with those of other serious artworks. Second, he has rejected all attempts to define his work as ceramic sculpture, insisting that it be termed simply *pottery*. DeVore's work is that of a traditionalist in the most progressive sense of the word; without apology or compromise, he has built a reputation as a serious artist based on the foundations of an art medium that stretches back through civilization for over 6,000 years. One of the dominant features of DeVore's vessels is the lip or rim area, which as the final act of making, establishes and orders the compositional priorities in the eye of the viewer. Although the forms seem primarily biomorphic, the rims, frequently offset by points or protuberances, allude to a geometric logic that is the foundation of DeVore's compositional style. In writing of these works, Andy Nasisse refers to DeVore's pots as androgynous, with their combination of the male or dark principle and a contractive, light-giving female principle: "The open bowl form is receptive, which embodies the female principle. The various heights allow a versatility of presentation, some related more to the male principle. . . . The female quality of light as opposed to male darkness is inherent in DeVore's use of color. Often the interior surface has a mottled use of color which appears to give off its own light. The surface is always matt but never flat. Even in pieces seemingly all black there is a subtle combination of deep hued color which appears gradually. DeVore's particular genius and paradox is his ability to create an object of almost seductive beauty and serenity, which at the same time is invested with an extremely turbulent level of spatial reality" (Nasisse, 1976).

(See Bibliography: Artner, 1976; Campbell Museum, 1976; Clark, 1978; Cochran, 1976; Colby, 1978; DeVore, 1978; Donohoe, 1976; The Evanston Art Center, 1977; Jones, 1977; Kalamazoo, 1977; Kline, 1978; Mehring, 1977–1978; Miro, 1978;

Richard E. DeVore.

Nasisse, 1976; Nordness, 1970; "A Potter Called DeVore," 1972; Victoria and Albert Museum, 1972)

DIEDERICH, HUNT (1884–1953). Born in Hungary. He studied in Paris, in Rome, and at the Pennsylvania Academy of Fine Arts in Philadelphia. Diederich worked primarily in bronze, specializing in animals and figures for monuments and fountains and winning several awards, including the Gold Medal from the Architectural League. He produced his ceramics in the mid-1920s, painting individual pieces as well as designing for mass production. His works were included in the International Exhibition of Ceramic Art at The Metropolitan Museum of Art in 1928. Diederich's ceramics, although produced for a limited period, exhibit both superb draftsmanship and an ability to employ the translucency of his glazes to achieve a sense of depth.

(See Bibliography: American Federation of Arts, 1928; The Detroit Institute of Arts, 1977)

DOAT, TAXILE (1851–1939). Studied at the École des Arts Décoratifs, Limoges, and at the École des Beaux-Arts and with the sculptor Augustin Dumont. In 1887 he joined the Sèvres Manufactory as a sculptor, modeler, and decorator. He soon became a specialist in *pâte-sur-pâte,* a technique of painting porcelain slips in light relief against contrasting ground, using the translucency to give qualities of light and shade. Doat soon established himself as one of the leading ceramists in France, winning gold medals for his porcelains at Antwerp in 1885, Barcelona in 1888, and Paris in 1889 at the Exposition Universelle. In 1898 he established his own studio in Sèvres at the Rue Brancas 47. In 1903 he had contact with the publisher of *Keramik Studio* in the United States, Samuel Robineau, and his wife, Adelaide. They first published a series of his articles on high-fire ceramics, which in 1905 were published as a book, *Grand Feu Ceramics,* by *Keramik Studio.* It was the first handbook of its kind to be published in English, and Doat followed up

the impact that this book had made in the United States by coming to the country in 1909 at the invitation of Edward G. Lewis, founder of the American Women's League and the People's University at University City in St. Louis, Missouri. The purpose of the trip was to have a "conference with the League's architects in order that the erection of one of the most perfectly designed and equipped art potteries in the world might be immediately begun." Doat had been appointed director of the University City Pottery, and he assembled a distinguished faculty, which included Adelaide Robineau, Frederick Rhead, Katherine E. Cherry (a local china painter), and two of his European associates: Eugene Labarriere, foreman of a pottery in the suburbs of Paris, and Emile Diffloth, former art director of the Boch Frères, La Louvière, Belgium. The first firing of the kiln took place in April 1910, and although the American Women's League foundered in 1911, Doat reorganized the pottery and continued it until early 1915, when he returned permanently to France. While in the United States, Doat had sold his collection of almost 200 pieces to The St. Louis Art Museum. It was a meticulous selection of his works, showing each and every change in his style and technique. In 1945 the collection was deaccessioned by the museum, and only eighteen pieces retained.

(See Bibliography: Belot, 1909; Doat, 1905; Eidelberg, 1972; Evans, 1971, 1974; Jervis, 1902; Kohlenberger, 1976; Sargent, 1906; Verneuil, 1904)

DODD, MARGARET (1941–). Born in South Australia and took her diploma in art teaching at the South Australian School of Arts. In 1968 she received her B.A. at the University of California at Davis, where she was one of the group of Funk artists that gathered around their mentor and teacher, Robert Arneson. While in the United States, her work was included in several exhibitions, including "Ceramics from Davis," Museum West, San Francisco, 1966; "Color Pot, the Experience" at Purdue University, Lafayette, Indiana, 1967, and a one-woman show at the Memorial Union Gallery,

University of California at Davis, 1968. Dodd developed the automobile as her theme, creating small, evocative, personal interpretations in clay. She has retained this as a central concern in her works since her return in 1969 to Australia.

(See Bibliography: Pugliese, 1966)

DUCKWORTH, RUTH (1919–). Born in Hamburg, Germany, leaving to live in England in 1936. While in Germany, she was not allowed, as a Jew, to enter any art school. Not long after World War II, she filed for a "loss of education" claim from the German government and with the money received bought her first kiln. In England she studied at the Liverpool School of Art from 1936 to 1940, the Hammersmith School of Art in 1955, and the Central School of Arts and Crafts in London from 1956 to 1958. Duckworth worked as a sculptor, learning to carve stone, and even earned a living for a while carving tombstones. Around 1956 she began to do some simple clay sculpture and returned to school to learn about glazing at the suggestion of potter Lucie Rie. After a short period at the Hammersmith School of Art, which she found too doctrinaire, she moved to the Central School of Arts and Crafts in London. It was there that her work began to develop, and by 1960 she was teaching at the Central School. Duckworth's early work ranged from small, delicate, highly secretive porcelain forms of an organic nature to large, roughly textured weed pots in stoneware. In 1964 she came to Chicago to teach at the University of Chicago, accepting the offer because she was "curious to see the United States and Mexico, and to find out why people made those ugly pots I saw so often in *Craft Horizons*" (Duckworth, 1977). She is now a permanent resident in Chicago, where she has established her studio. Her involvement with ceramics now covers a wide spectrum: massive stoneware murals, free-standing sculptural forms, vessels, and delicate porcelain forms reminiscent of her earlier work. Duckworth has been one of the strongest influences in the liberalization of ceramics in the United Kingdom and has been a successful teacher and artist in the United States. Duckworth

has been included in several one-woman and group exhibitions and has produced several architectural commissions, including *Clouds over Lake Michigan,* a 240-square-foot mural for the Dresner Bank in the Chicago Board of Trade building.

(See Bibliography: Cooper, 1974; Duckworth, 1977; The Evanston Art Center, 1977; Kalamazoo, 1977; Westphal, 1977)

DZUBAS, FRIEDEL (1915–). Born in Berlin, graduating from the Berlin Gymnasium in 1931 and studying at the Prussian Academy of Fine Arts in the Kunstgewerbeschule between 1931 and 1933. His style was rooted in the aggressive forms of northern Expressionism and the traditional principles of "guild-like purity of craftsmanship." Dzubas left Germany in 1939, arriving in the United States via England. In the United States, his work changed to an abstract format with the focus on strong areas of colors. He has been artist-in-residence at Dartmouth College, Hanover, New Hampshire; the University of South Florida, Tampa; the University of Pennsylvania, Philadelphia; and most recently at Cornell University, Ithaca, New York. His work produced at the Everson Museum's "New Works in Clay by Contemporary Painters and Sculptors" was his first contact with clay. The project was an awakening experience for Dzubas, who referred to the experience of a painter dealing with physical matter in volume and arriving at a three-dimensional image as "truly profound": "I received great pleasure from the very act of getting my hands into physical matter, pushing it around into the shapes I desired and immediately placing these shapes in relation with each other. The instantaneous possibilities that were offered to me seemed endless. It is possible that the whole process of realizing an image almost in the same moment that it is visualized could have an effect on the way I look at painting from now on. I have just scratched the surface of something that is very new to me . . . I am thinking of the 'problematic' of sculpture encountering color. I am curious to know how I would handle paint (which also means glazes) on clay. Shall the color just be a skin on the form

and emphasized as such or should it become an integral part of the form" (Hughto, 1976). Dzubas completed nineteen sculptures for the Everson Museum exhibition and since has returned several times to the Clay Institute, creating a second group of works.

(See Bibliography: Everson Museum, 1976; Hughto, "Museum Clay," 1976; Nordstrom, 1978)

EARL, JACK (1934–). Born in Uniopolis, Ohio. He took his B.A. at Blufton College, Ohio, in 1956, returning to school in 1964 to take an M.A. at Ohio State University in Columbus. He taught at The Toledo Museum of Art, Ohio, from 1963 to 1972, where the magnificent collection of ceramics, early Meissen figures, Kandler dinner services, the faïence sculptures of the Della Robbia family, and other works had a strong impact on his work and his perfectionist craftsmanship. He now teaches at Virginia Commonwealth University, Richmond.

(See Bibliography: Campbell Museum, 1976; Cochran, 1976; Everson Museum of Art, *Ceramic Nationals*, 1968–1970; "Fantasy at Kohler," 1974; Museum of Contemporary Crafts, 1971; Nordness, 1970; San Francisco Museum of Art, 1972; Slivka, 1971; Victoria and Albert Museum, 1972)

ECKHARDT, EDRIS (1907–). Born in Cleveland, Ohio, and studied at the Cleveland Institute of Art, where she was awarded a scholarship and remained for five years, graduating in 1932. In her last year at the school, she participated in a collaborative ceramics program created by three institutions: the Cleveland Art School, the Cleveland Museum of Art, and the Cowan Pottery. After leaving the school, she set up her own studio and began to involve herself in glaze chemistry. In 1933–1934 Eckhardt was involved in a pilot program of the Public Works of Art Project (PWAP), which operated for five months and provided a number of specific assignments for individual artists. It was through this program that she conceived the idea of producing small-scale sculptures for use in children's library pro-

grams based on the Mother Goose series, *Alice in Wonderland,* and W. H. Hudson's *Green Mansions,* then popular with adolescent readers. Her *Alice in Wonderland* series was particularly successful, and a piece from this series was acquired by Her Majesty, Queen Elizabeth II, for her private collection. In 1935 she was made director of the Cleveland department of ceramic sculpture when the WPA-FAP began local operation. She held this position until the program, which later passed into state control, was finally discontinued in 1941. Eckhardt continued to work in the ceramic medium, producing one of her major pieces, *Painted Mask,* in 1947. It was exhibited in the May Show in Cleveland of that year. In 1953 she began to work in glass and rediscovered the technique of fusing gold leaf between sheets of glass— producing the first known examples of gold glass in almost 2,000 years. The original technique had been perfected by the Egyptians, who used it in glass vessels and and jewelry. Eckhardt has since developed her technique into multiple laminations of sheet glass, using layers of enamels, foils, and other materials to add depth to the surfaces. Eckhardt has been the recipient of several awards for her researches and was a Guggenheim fellow in 1956 and again in 1959. She is also the recipient of a Louis Comfort Tiffany fellowship for her work in stained glass. Eckhardt is an active exhibitor in both one-woman and group shows throughout the country and is recognized as one of the pioneering artists in the glass medium.

(See Bibliography: Barrie, 1978; Eckhardt, 1976; Hoffman and Hoffman, 1977; Marling, 1977; Syracuse Museum, 1937)

FARRELL, WILLIAM (1936–). Born in Philipsburg, Pennsylvania, and studied at the Indiana State University, Terre Haute, where he received his B.S. in 1958, and at the Pennsylvania State University, University Park, receiving his M.Ed. in 1961. He currently teaches at the School of The Art Institute of Chicago. Farrell's earliest work showed an involvement with Abstract Expressionism, but in the late 1960s his affinities were closer to Pop art and Minimalism, with his arched

William Farrell. Photograph: Ceramic Arts Library.

"Popeye" forms and their bold, flat color. This exploration of the arch form has been an ongoing theme in Farrell's work, moving from the cool, bright color of his early work to expressionist works in the last two years that speak of the process and nature of the material. Running parallel to this development has been Farrell's interest in the more abstract elements of the ceramic process. Under his guidance, The Art Institute of Chicago has become the center for Conceptualist clay in the United States, with Farrell taking the lead in his exploration of plastic unfired clay and latex. By covering unfired, wet, plastic forms with latex, he is able to create a semipermanent object, symbolically glaze it with the latex surface, and yet retain the plasticity of the clay in its original state. Farrell has exhibited extensively throughout the United States and was a founding member of the National Council for Education in the Ceramic Arts.
(See Bibliography: Kalamazoo, 1977; Nordness, 1970)

FERGUSON, KENNETH (1928–). Born in Elwood, Indiana, and studied at the American Academy of Art (summer school), Chicago, and the Carnegie Institute of Technology, Pittsburgh, where he received his B.F.A., 1952, and Alfred University, Alfred, New York, where he was awarded an M.F.A., 1954. He has taught at various institutions, including the Carnegie Institute; Alfred University; and the Archie Bray Foundation, Helena, Montana; and in the early 1960s, he joined the Kansas City Art Institute, Missouri, heading its ceramic department, where he now teaches and works. Ken Ferguson has been a strong influence as a functional potter, his work distinguished by a sensuality of form and surface. In summing up his personal view of his art, Ferguson comments, "I enjoy the versatility. For this reason I work with functional and nonfunctional forms—stoneware, salt firing, raku, porcelain and low temperature, thrown forms and handbuilding, and castware. I reflect the fine arts traditional craft and the need to make things. I try to be honest with myself and honest with clay" (Nordness, 1970).
(See Bibliography: Campbell Museum, 1976; Everson, 21st Ceramic National, 1962; New Gallery [Iowa], 1963; Sewalt, 1978)

FOSDICK, MARION LAWRENCE (1888–1973). Born in Fitchburg, Massachusetts, and studied at the school of the Museum of Fine Arts, Boston, from 1900 to 1912 and at the Kunstgewerbeschule, Berlin, in 1912–1913, returning to do special work in the art museum school in Boston in 1914–1915. She joined Alfred University, Alfred, New York, as a professor of drawing and design in 1915, and from 1920 on she was professor of pottery and sculpture. During the late 1930s and the 1940s, she exhibited her pottery extensively and won First Prize in 1941 at the Ceramic National for a bowl that was later purchased by The Metropolitan Museum of Art in New York. In

Marion Lawrence Fosdick.

1947 she won the Homer Laughlin Company Prize at the Ceramic National. She has received the Binns Medal and was a medalist of the Boston Society of Arts and Crafts.
(See Bibliography: Fosdick, 1926; Norwood, 1950; Syracuse Museum, 1937; Syracuse Museum, 12th Ceramic National, 1948)

FRACKELTON, SUSAN STUART GOODRICH (1848–1932). The daughter of a brickmaker, Frackelton established the Frackelton China and Decorating Works in Milwaukee, Wisconsin, in 1883. She employed decorators, and within a short time the weekly production of objects ranged from 1,500 to 2,000 pieces. In 1892 she organized the National League of Mineral Painters, whose membership included Adelaide Robineau and Mary Chase Perry. In 1893 she exhibited salt-glazed wares at the World's Columbian Exposition in Chicago. Her famed *Olive Jar* was purchased for $500 by Edwin Atlee Barber for the collection of the Pennsylvania Museum. She later moved

on to what were termed Delftwares, blue, underglaze-decorated wares, which were exhibited at the 1900 Exposition Universelle in Paris. Frackelton ceased potting at the beginning of the twentieth century and moved to Chicago, where she became an active lecturer until her death in 1932. The major collection of her work is in the State Historical Society, Madison, Wisconsin, most of it contributed through a gift from her daughter, Susan Frackelton.
(See Bibliography: Barber, 1909; Frackelton, 1886, 1905, 1906; Henzke, 1970; Jervis, 1902; Kovel and Kovel, 1974; Stover, 1954)

FRANK, MARY (1933–). Born in London, England, the only child of Eleonor Lockspeiser, a painter, and Edward Lockspeiser, a musicologist and critic. She emigrated to the United States in 1940. At the age of seventeen, she worked for a short period in the studio of sculptor Alfred van Loen and studied modern dance with Martha Graham. Following her marriage to Swiss photographer Robert Frank, she studied drawing with painter Max Beckmann at the American Art School in Holland and after 1951 studied drawing with Hans Hofmann at his Eighth Street School in New York. Although she never formally studied sculpture, Frank was attracted to this medium, and her early works were small, wooden figures influenced by Giacometti, Egyptian art, and the work of Henry Moore. Inspired by Reuben Nakian's ceramic wall plaques and Margaret Israel's ceramic sculpture, Frank began to work in wet clay, and since 1969 most of her works have been produced in stoneware. The first major exhibition of these works took place at Zabriskie Gallery, New York, receiving an enthusiastic notice from Hilton Kramer, who called her works "marvels of poetic invention . . . the very process of the ceramic medium seems to have released the requisite spontaneity" (Kramer, 1970). Three years later, Frank produced her first larger-than-life figures, demonstrating maturity in the handling of her material and great originality, the works showing only a slight debt to the strong, early inspiration of Nakian. Since then, the

Mary Frank.

work has grown rapidly in stature, is charged with erotic energy, and is consistently exploring myth and metamorphosis. The guest curator of Frank's one-woman exhibition at the Neuberger Museum, State University of New York, Purchase, in 1978, Hayden Herrera, wrote evocatively of the artist's having "created a strange, Arcadian world populated by nudes, earth goddesses, forest spirits, Nereids and winged nymphs in flowing gowns. In this world the human figure is at home in nature. There is no hint of the romantic artist's insatiable yearning to connect with nature; figures *are* nature, embodying all time. All this without a glimmer of romantic nostalgia; although her sculpture is full of poetic whimsy, it is too urgent and earthy ever to be sentimental or sweet" (Herrera, 1978).

(See Bibliography: Clark, 1978; Henry, 1971; Herrera, 1978; Hirshhorn Collection, 1975; Kramer, 1970, 1975; Mellow, 1973, 1975; Nordstrom, 1978; Sawin, 1977)

FRANKENTHALER, HELEN (1928–). Born in New York City and received her art education at Bennington College, Vermont. Her work has been widely exhibited, including a one-woman retrospective at the Whitney Museum of American Art in 1969. Her paintings, acrylic on canvas, are clear, simple forms in irregular boundaries that avoid the familiar and the geometric. She is known for her technique of stain painting, in which she washes colors onto unprimed canvas. Frankenthaler participated in the *Art in America* project in 1964, producing a limited number of plates that echoed the transparency of color on her canvases. In November 1975 she worked at the Clay Institute in Syracuse on the Everson Museum of Art's "New Works in Clay by Contemporary Painters and Sculptors" project. Frankenthaler approached the project with caution and afterward wrote: "The idea of working in clay has never really appealed to me; in all ways it seemed too fragile and my fantasy-scale of what I wanted to do sculpturally seemed to go way beyond the possibilities of wet earth. But the project called me—much in the same way I had made metal sculpture, a ceramic tile wall and a series of 71 ceramic tiles" (Hughto, 1976). In working on her pieces, Frankenthaler was not interested in using drawings, models, or running tests but wished to stress the immediacy of her contact with the medium: "From the beginning I wanted nothing to resemble arts-and-crafts, ashtrays, abstract lamp bases, etc. The point was sculpture out of clay in my terms."

(See Bibliography: Everson Museum, 1976; Hughto, 1976; Lafean, 1965; "Museum Clay," 1976; Nordstrom, 1978)

FRAZIER, BERNARD ("Poco") (1906– 1976). Born on a cattle ranch near Athol, Kansas. Frazier received his first artistic training at the Kansas Wesleyan University in Salina in 1924. He then enrolled in the newly created school of design at the University of Kansas, Lawrence. Upon graduation in 1929, he traveled to Chicago to work as an apprentice to sculptors Lorado Taft and Fred Torrey, studying intermittently at the National Academy

of Art, the Chicago School of Sculpture, and The Art Institute, of Chicago, as well as briefly at Moholy-Nagy's New School, an offshoot of the Bauhaus. Returning to Kansas in the mid-1930s, he was awarded a grant in 1938 by the Andrew Carnegie Foundation to serve as sculptor-in-residence at the University of Kansas, remaining there to establish the first regular department of sculpture. During the next three decades, his local reputation grew, and he was continually involved in the fulfillment of important commissions. Two of his major ceramic works—*Untamed* (1948) and *Prairie Combat* (1940)—are in the permanent collection of the Everson Museum of Art, Syracuse, New York.
(See Bibliography: Weiss, 1978)

FREY, VIOLA (1933–). Born in Lodi, California, and studied at the California College of Arts and Crafts, Oakland, taking her B.F.A. in 1956 and her M.F.A. in 1958 at Tulane University, New Orleans, Louisiana. From 1970 to the present she has taught at the California College of Arts and Crafts. Her early work was involved with the fashioinable interest in Japanese ceramics in the Bay Area during the 1950s. But in the 1960s her work began to become more iconographic, and an interest in overglaze painting grew out of a period of color-light studies. Frey sees this involvement in two phases, the first trying to match effects achieved in painting—spray effects for clouds and modulating of colors to add activity in depth to the surface of the object. The second phase grew out of these interests, and she used china painting to manipulate the surface of forms. By painting light and shadow, she was able to establish auxiliary forms upon the base structure. Her method of working is to deal concurrently with several issues, many of which evolve out of an interest in ceramic and plastic figurines, cheap throwaways, working on both a small and a large scale. Frey comments that they "have a frozen presence far beyond their value. They become images from childhood, memories enlarged and scary. Amongst these artifacts are little animals—dogs, cats, roosters, birds— and their attendant human. I decided to make them big—take them out of the crib and off the coffee tables, make them myths of childhood. I altered their poster colors using overglazes to give them alertness and vividness, and to unfreeze them" (California State University, 1977).
(See California State University, 1977; Clark, 1978; Grossmont College, 1977; Wenger, 1975)

FRIMKESS, MICHAEL (1937–). Born in Los Angeles and at the age of fifteen admitted as one of the youngest students at the Otis Art Institute, where he studied sculpture. He was one of the last students to join the ceramics course under Peter Voulkos and was inspired to take that step after a peyote trip, when he had the vision of throwing a pot. After art school he worked at a Pennsylvania commercial pottery and there replaced an Italian potter who had been using a technique of throwing using a hard clay without water. Frimkess learned this technique and began studying the ancient Greek ceramics in New York's Metropolitan Museum of Art, deciding that they had probably been thrown by this method. Since then, this form of throwing has become the central focus in the work of Frimkess, who chooses forms that have distinct cultural references such as the amphora shape and the Chinese ginger jar. These he decorates with bright overglaze decorations, some purely decorative motifs and others employing complex comic-book illustrations that deal with his experiences of being a member of "the last Jewish family left in Boyle Heights," where he grew up with Japanese, Chicano, and black children. The objects he has created have become what he sees symbolically as ethnic melting pots wherein all racial difference and discrimination can be dissolved. These works represent a major departure in style from his earlier pieces, which deal with iconographic assemblages in mixed media and bronze television-set sculptures such as *Hooker* (1962). The vessel remains the main Frimkess format: "Today's pottery continues as ever, an art form. Wheel throwers remain philosophers, humanitarians and men of conscience, aware of their time's mission, ever on a par with the

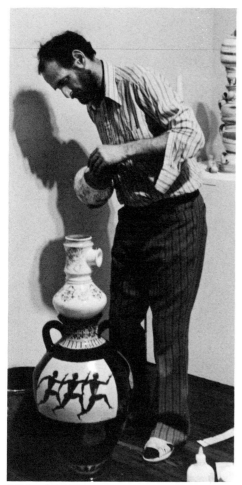

Michael Frimkess.

painting, sculpture, and drawing at the Cincinnati School of Design from 1872 to 1876 and continued her studies in Trenton, New Jersey (the American equivalent of Stoke-on-Trent), and then in France and England. In 1881 she joined the decorating team at Rookwood Pottery, where she worked in the style of Doulton's *Lambeth* Art Studio's artist, Hannah Barlow, incising decoration and rubbing in cobalt oxide. In July 1883 Fry introduced the application of slips to greenware with an atomizer—the first use of the "spray gun" in American ceramics. In 1889 she was granted patent of the technique. In 1891 Fry became the Professor of Industrial Art at Purdue University, Lafayette, Indiana. A year later she returned to Ohio, joining Lonhuda Pottery in Steubenville. There she attempted to restrain Rookwood from using her atomizer technique, but the courts ruled against her in a judgment delivered by Judge William Howard Taft in 1898. She returned to her teaching post at Purdue after finding the public interest in the women's decorative art movement to be sharply on the wane, and she remained there until 1922. Fry was one of the leading figures in the Cincinnati women's art movement, and her innovation in pottery decoration was directly responsible for the *Standard* Rookwood style. Upset by the failure of her patent claim, Fry refused to give any of her works to the Cincinnati Art Museum and instead donated a substantial collection of her wares to The St. Louis Art Museum in 1911.

(See Bibliography: Barber, 1909; Cincinnati Art Museum, 1976; Eidelberg, 1972; Henzke, 1970; Jervis, *Encyclopedia of Ceramics,* 1902; Keen, 1978; Kovel and Kovel, 1974; Peck, H., "Amateur Antecedents of Rookwood Pottery," 1968; Perry, 1881; Smith, K. E., "Laura Anne Fry," 1938; Trapp, 1973)

greatest sculptors, perfectionist painters, writers and musicians. Due to throwing's freedom-giving limitations, it is still one of the finest roads towards self improvement" (Frimkess, 1966).

(See Bibliography: Coplans, 1963, 1966; Frimkess, 1966; Giambruni, 1966; Kalamazoo, 1977; McChesney, 1973; Nordness, 1970; Scripps College, 1974; University Art Galleries, 1976; Victoria and Albert Museum, 1972)

FRY, LAURA ANNE (1857–1943). Born in Indiana, Fry was the daughter of a noted wood-carver, William Henry Fry. She studied wood carving, china

FULPER, WILLIAM H. (1872–1928). Born in New Jersey into a potting family. The pottery operated by the Fulpers had been in production since 1805, but its importance in the production of artwares was slight until late in 1909, when the Fulper Pottery Company first introduced the *Vasekraft* line. The body used in these

wares was of a natural New Jersey clay and was fired at a high temperature alongside the pottery's production of commercial ware. The superb range of luster, crystalline, mat, and high-gloss glazes attracted considerable attention—but the most prestigious glaze was the so-called famille rose developed by Fulper, and these pieces were sold for as high as $100 a piece. Fulper was one of the few "regenerative" art potteries of the post-1910 period and richly deserved their awards at the San Francisco Panama-Pacific International Exposition in 1915. After William Fulper's death in 1928, a new plant was established in Trenton, New Jersey. The pottery continued after 1930, when it was acquired by J. Martin Stangl. In 1955 the corporate title was formally changed to the Stangl Pottery Company. A collection of major works of Fulper artware was given to the Philadelphia Museum of Art in 1911, and other important collections are at The Newark Museum and at the New Jersey State Museum in Trenton.

(See Bibliography: Blasberg, 1973; Evans, 1974; Henzke, 1970; Keen, 1978; Kovel and Kovel, 1974; Volpe, 1978)

GILHOOLY, DAVID (1943–). Born in Auburn, California. He took his B.A. at the University of California, Davis, in 1965 and his M.A. in 1967. He taught at the San Jose State University, California (1967–1969); the University of Saskatchewan, Regina, Canada (1969–1971); York University, Toronto (1971–1975, 1976–1977); and the University of California, Davis (1975–1976). Gilhooly's early work was based on a satirical play on animal scenes, such as his *Elephant Ottoman* (1966) in the Monsen Collection, Seattle. But since 1968, Gilhooly has been working prolifically on a body of work that is almost without parallel in the ceramic arts. Each year sees the production of several hundred frog objects of one kind or another. In a detailed discussion of "the Gilhooly mythology," Dale McConathy remarked, "These pieces, dispersed almost as soon as they are made and never shown in the full context of their creation, comprise a sort of archeology in reverse—the

David Gilhooly.

random deposits of the artifacts of Gilhooly's frog world. . . . A vast, disturbing, deeply dark *speculum mundi* . . . the depth of that mirror further clouded by an uneasiness about just what the correspondences are—the sort of troubled ambivalence found in lists that mark off the boundaries of what is human and nonhuman" (McConathy, 1975). In common with other Funk artists of the ceramic genre, Gilhooly gives his work titles that add significance beyond identification: they are clues to the artist's intent and at the same time give substance to the object. Among the uneven plethora of works produced by Gilhooly, several masterworks emerge, notably *Cosmic Egg* (1975), *Tantric Frog Buddha* (1975), *Miscegenation* (1974), and the series of portraits of *Frog Victoria* and *Mao Tse Toad*. He is without doubt the most exhibited ceramic artist in the United States and has to date had over thirty one-man exhibitions, including a major retrospective at the Museum of Contemporary Art, Chicago, in 1976.

(See Bibliography: Art Gallery, 1972; Campbell Museum, 1976; Ceramics, 1968;

Cochran, 1976; Davis, D., 1971; Johnson, 1970; McConathy, 1975; Museum of Contemporary Art, 1976; Nordness, 1970; Pugliese, 1966; San Francisco Museum of Art, 1972; Selz, 1967; Shuebrook, 1973; Slivka, 1971; Victoria and Albert Museum, 1972; William Hayes Ackland, 1977; Zack, 1971, 1973)

GLICK, JOHN PARKER (1938–). Born in Detroit, Michigan, and studied at Wayne State University there, where he took his B.F.A. in 1960, and at the Cranbrook Academy of Art, Bloomfield Hills, Michigan, receiving his M.F.A. in 1962. After two years in the United States Army, he set up Plum Tree Pottery in Farmington, Michigan, producing hand-thrown functional wares. Over the years, Glick has developed a unique and distinctive style of decoration, drawing on the surface of forms with glaze and slips, strongly influenced by his interest in Japanese pottery, but at the same time reminiscent of the early Abstract Expressionist works of artists such as Mark Tobey. Unlike many potters in the United States who

John Parker Glick. Photograph: Mike Brady.

rely upon the state-fair system to market their work, Glick has over the years built up a strong audience, and more than two-thirds of the pots produced at his pottery are sold from his own showroom. In the 1970s he has been concentrating on commissions for dinnerware, which he produces on an individual, personalized basis. Despite his heavy work schedule, Glick sets aside time to participate in the broader educational requirements of his art. He provides tours through the pottery for schoolchildren, teachers, and craft groups and has lectured and given workshops extensively through the United States. Glick is one of a select cadre of functional potters whose example and free sharing of information have contributed to the rising standard of production pottery in the United States.

(See Bibliography: Broner, 1967; Campbell Museum, 1976; "Cranbrook 12," 1976; Kalamazoo, 1977; Kansas City Art Institute, 1976; "John and Ruby," 1975; Schwartz, 1968; Shafer, 1972)

GREGORY, WAYLANDE DESANTIS (1905–1971). Born in Baxter Springs, Kansas, and studied at the Kansas State Teacher's College, Emporia; The Art Institute of Kansas City; and under Lorado Taft at The Art Institute of Chicago. He also studied for some time in Florence, Italy. Gregory worked in both bronze and ceramics, and the latter gradually became his major medium. One of his last major works in bronze was the sculpture for the chapel at the University of Chicago, which he completed in May 1928. He left the studio that he had shared for several years with Lorado Taft in Chicago and joined the Cowan Art Pottery Studio in Rocky River, a suburb of Cleveland. Many of the major works of Cowan in 1929 were produced by Gregory, including *Diana and Two Fawns,* produced in a limited edition of 100, which won the first prize at the Cleveland Museum of Art's May Show in 1929; *Marguerite, at Her Lessons* (1929); and in 1932 *Burlesque Dancer.* After leaving the Cowan Pottery in 1932, he worked briefly as an artist in residence at the Cranbrook Academy of Art, Bloomfield Hills, Michigan, moving to Bound Brook,

New Jersey, where he set up his studio. In 1938 he completed a mammoth work, *The Fountain of Atoms,* comprising twelve ceramic figures each weighing over a ton. This was exhibited at the 1939 World's Fair in New York. In order to produce these pieces, Gregory developed a unique building technique that he described as "inner modeling." The later works by Gregory show a strong influence from Paul Manship. Although little is known about Manship's involvement with the Cowan Pottery, he did produce some designs in the last two years of the pottery, and it is likely that his influence on Gregory stemmed from that involvement and contact.

(See Bibliography: "Art with the Inferiority Complex," 1937; Everson Museum, 1976; Gregory, 1941; Syracuse Museum, 1935, 1936–1937, 1937; "Waylande Gregory's . . . ," 1944; Watson, 1944)

GROTELL, MAIJA (1899–1973). Born in Helsinki, Finland. She studied there at the School of Industrial Art, taking painting, design, and sculpture. She did six years of postgraduate work in pottery under Alfred William Finch, one of Europe's finest pioneer artist-potters. In 1927 she came to the United States and taught at the Henry Street Settlement House. From 1936 to 1938 she was instructor of pottery at Rutgers University, New Brunswick, New Jersey, in the School of Ceramic Engineering. In 1938, at the invitation of fellow Finn Eliel Saarinen, she joined the faculty of Cranbrook Academy of Art in Bloomfield Hills, Michigan, where she headed the ceramic department until 1966. During her career, Grotell received twenty-five major awards, including a diploma from the 1929 Barcelona International Exposition and six awards from the Syracuse Ceramic Nationals. She established Cranbrook as a major center for ceramic art education, even though the actual number of students was limited. Her graduates, such as Richard DeVore (who replaced her at Cranbrook), Toshiko Takaezu, John Glick, and Jeff Schlanger, have been strong influences in contemporary ceramics.

(See Bibliography: "Ceramics: Double Issue," 1958; Cranbrook Academy of Art,

Maija Grotell. Photograph: J. Eddy.

1967; Levin, E., "Maija Grotell, Herb Sanders," 1976; Schlanger, 1969; Syracuse Museum of Fine Arts, 1937)

GRUEBY, WILLIAM H. (1867–1925). At the age of fifteen, Grueby was apprenticed to the Low Art Tile Works, Chelsea, Massachusetts, where he remained for about ten years. In 1892 he formed his own company, Atwood and Grueby with Eugene R. Atwood, which was associated with a larger company, Fiske, Coleman and Co. In 1893 Grueby went to the World's Columbian Exposition in Chicago to manage the exhibition of tiles from Fiske, Coleman and Co. It was there that he became acquainted with the *grès flamme* of Chaplet and Delaherche, two pioneering French artist potters. Delaherche was a particularly strong influence in Grueby's work, and this relationship has been discussed in the main text. In 1894 Grueby opened his own firm, Grueby Faience Company, in Boston. He exhibited in February 1895 at the annual exhibition of the Architectural League, New York, and was at that stage primarily concerned with

architectural faïence, emphasizing historical style. In 1897 the company was formally incorporated and reorganized. From that year on, having discovered the mat glazes for which he was to become famous, Grueby began to produce art pottery, with the forms designed by George Prentiss Kendrick between 1898 and 1902. Hereafter the designs were the work of Addison B. Le Boutillier, a French architect, although they remained much the same as the early Kendrick designs. Grueby's wares won considerable acclaim including one Silver and two Gold Medals at the Paris Exposition Universelle of 1900; the Highest Award at the Pan-American Exposition in Buffalo, New York, in 1901; a Gold Medal at Saint Petersburg, Russia, in 1901; Highest Award at Turin, Italy, in 1902; and the Grand Prize at the Louisiana Purchase International Exposition, St. Louis, in 1904. However, the company was experiencing financial problems, and in 1908 Grueby ceded the presidency of Grueby Faience to Augustus A. Carpenter of Chicago, who brought new capital. In 1909 the company was declared bankrupt and went into receivership. But undaunted, Grueby opened another company in the same year, Grueby Faience and Tile Company, continuing at the same factory. The production of wares continued at Grueby Pottery (a marketing division formed in 1898), although there too operations were affected by financial pressure. The production of wares appears to have been ceased around 1909–1911. Grueby survived various crises until 1919, when C. Pardee Works of Perth Amboy, New Jersey, acquired the firm. Grueby died six years later, and his death went largely unnoticed except for a cursory obituary in *The Bulletin of the American Ceramic Society.*

(See Bibliography: *Art Journal*, 1901; Barber, 1909; Blackall, 1898; Blasberg, 1971; Bowdoin, 1900; Detroit Institute, 1976; Eidelberg, 1972, 1973; Henzke, 1970; Jervis, 1902; Keen, 1978; Kovel and Kovel, 1974; Perry, 1900, 1902; Russel, 1898; Saunier, 1901)

HAILE, THOMAS SAMUEL ("SAM") (1908–1948). Born in London, England.

He worked as a shipping clerk, taking night classes in art at the Clapham School of Art. In 1931 he won a scholarship to the Royal College of Art to study painting. His professors objected to his Surrealist tendencies, so he transferred to ceramics under William Staite Murray. In 1935 he taught full time at the Leicester College of Art and later shared a pottery studio with Margueret Rey at Raynes Park. In 1937 he held his first one-man exhibition of ceramics at the Brygos Gallery. In 1939 he came to the United States. He had by then married Marianne de Trey and was a member of the Surrealist Circle. For a time, he lived by doing a number of odd jobs. Then Charles Harder arranged for him to teach at Alfred University, where Harder taught ceramics, although he was ostensibly there as a student to satisfy immigration restrictions. In 1942–1943 he taught at the University of Michigan, Ann Arbor. He also presented a paper before the American Ceramic Society in 1942 on "English and American Ceramic Design Problems." In 1944 he joined the U.S. Army and then transferred to the British army. He set up a new pottery in Shinner's Bridge, Dartington Hall, Devon, in 1947 and was killed in a motorcar accident in the following year. Memorial exhibitions were held at the Southampton Art Gallery, 1948; the Institute for Contemporary Art, Washington, D.C., 1948; and the Crafts Centre, London, 1951.

(See Bibliography: "The Arts of Living," 1949; Clark, "Sam Haile," 1978; Haile, 1942; "Pottery of Sam Haile," 1949; Sewter, 1946, 1967; "T. S. Haile, Ceramist," 1949)

HARDER, CHARLES M. (1889–1959). Born in Birmingham, Alabama, and attended high school at Beaumont, Texas. He attended Texas A & M University as a member of the student U.S. Army training corps until 1919. After graduating from The Art Institute of Chicago in 1925, he taught at the Peabody High School in Pittsburgh, Pennsylvania. Harder joined the staff of the College of Ceramics at Alfred, New York, as an instructor in 1927 and was named assistant professor

Charles M. Harder.

in 1931. While teaching, he continued his own studies under Charles Fergus Binns and received his B.S. degree in ceramics in 1935. Harder spent the next year taking postgraduate studies at The Art Institute of Chicago and surveying the curricular course administration of other art schools. He returned to Alfred in 1936 as professor of ceramic art and reorganized courses and curriculum to conform to New York State's requirements for industrial and professional design. Harder was named acting head of the design department in 1938 and head in 1944. Harder received many prizes and honors during his career. Among the most treasured of these was the Gold Medal received from the Paris International Exposition in 1937. In the following year, he was awarded the Binns Medal of the American Ceramic Society. Harder joined the American Ceramic Society in 1928 and was made a fellow in 1947. He held all the offices of the design division and was a member of the Ceramic Educational Council.

(See Bibliography: Harder, 1942, 1945; Levin, 1977; McChesney, 1973; Norwood, 1950; Syracuse Museum, 1935, 1937)

HARE, SHARON (1950–). Born in Chicago and studied at Pitzer College, Claremont, California, from 1967 to 1970, where she received a B.A. in anthropology and sociology. During 1970–1971 she studied at the University of California, Los Angeles, receiving an M.A. in African studies. After graduating, she turned her interest to art and attended the Claremont College Graduate School, Claremont, California, receiving an M.F.A. in ceramics and sculpture in 1973. Her teaching experience includes being an instructor at Pitzer College (1972–1973); a visiting lecturer at California State University, Los Angeles (1973–1974); a visiting assistant professor at California State University, Northridge (1974–1975); visiting lecturer at California State University, Fullerton (1975–1976); and an assistant professor at Saint Cloud University, Saint Cloud, Minnesota (1976–1978). Hare established herself as an important figure in an emerging group of avant-garde artists working in clay in Southern California. Apart from her active exhibiting in both one-woman and group shows, Hare was also involved in the feminist art movement and was a founding member of Womanspace in Los Angeles. Her work evolved around a conceptualist handling of the material and frequently dealt with what might be termed *seen* experiences. One of the most significant of these was *Sharon Hare: A Desert Experience.* It was sponsored in part by R. Mutt Galleries, Los Angeles, and held near Lucerne Valley, California, in 1974. Viewers were bused into the desert where Hare had set up an installation of fired stoneware pieces that blended easily and naturally into the environment. The objects were deliberately ambiguous, requiring the viewer to examine detail in form to establish whether the object was manmade or fashioned by nature. In correspondence with the author in 1977, Sharon Hare made the following comment about her work: "Generally my work represents structures; these range from the very formal with an element of subversion to more literal images. At all times I have maintained that what I am speaking of is human interaction, social structures, thoughts/language exchanges—all presented as vis-

ual images. In more recent years, much of my work has employed the table image. I think of table as a metaphor for conversation and human exchange: conference table, truth table, tables turned, games table. At one level I enjoy working physically with clay. For the most part my approach to ceramics is technically simple and direct, utilizing the information the clay gives. At times the work is fired, at other times not. My work varies between installation pieces and objects. The making of object work allows me to rest from the hassles of installation and gives me relatively direct control over the environment on a small scale. I see the objects as more friendly human versions of the installations, which require an experiential involvement on the part of the viewer."
(See Bibliography: California State University, 1974)

HEINO, OTTO (1915–). Born in East Hampton, Connecticut, he became involved in ceramics in the late 1940s when he returned from duty with the U.S. Air Force in England, using his GI Bill to study ceramics at the League of New Hampshire Arts and Crafts, Concord. He married Vivika, his teacher, in 1950, and two years later they moved to California. Together the couple established a pottery in California on Hoover Street, Los Angeles. Otto worked almost full time as a potter while Vivika taught in various schools in California and elsewhere. The couple now operate a pottery in Ojai, California, producing a range of architectural, functional, and decorative wares. The Heinos have received numerous awards for their work, and in 1978 Otto received the Gold Medal from the Sixth Biennale Internationale de Céramique D'Art, Vallauris, France.
(See Bibliography: Levin, 1977; New Gallery, 1963)

HEINO, VIVIKA (1909–). Born in Caledonia, New York. Studied at Alfred University, Alfred, New York, and at the California School of Fine Arts. In the late 1940s, she taught ceramics for the League of New Hampshire Arts and Crafts, Concord, where she met Otto

Heino while he was studying ceramics on his GI Bill allocation. They were married in 1950 and moved two years later to California. In 1952 Vivika Heino relieved Glen Lukens, head of the ceramics department of the University of Southern California, while he was on sabbatical and remained there for three years. In 1955 she was invited by the Chouinard Art Institute in Los Angeles to reorganize their ceramics department and remained there for eight years. In 1963 she taught at the Rhode Island School of Design in Providence, reopening the Heinos' New Hampshire home and studio in Hopkinton in 1965. They later returned to California, acquiring the house built by Beatrice Wood in Ojai, a small community nestled in the mountains northwest of Los Angeles. There she operates a pottery together with her husband, producing work for architectural commissions as well as decorative and functional vessels. The work of the Heinos has won several awards, including a Silver Medal from the International Ceramics Exhibitions in Ostend, Belgium, in 1959.
(See Bibliography: Levin, 1977; New Gallery, 1963)

HEPBURN, ANTHONY (1942–). Born in England, Hepburn trained under Ian Auld and Hans Coper at the Camberwell School of Art, London. From the outset, Hepburn's work showed sculptural inclinations. After 1968, a series of visits to the United States drew him close to the ceramists he most admired: Kenneth Price, Peter Voulkos, Richard Shaw, and others. Hepburn's work ranges from the monumental to the intimate and, although not a potter per se, he does occasionally employ the vessel format in his work. It was from 1971 on that the free sculptural play with materials that identifies his current work began to show in a significant exhibition, "Materials Pieces," at the Camden Arts Centre, London. Since then he has developed an assemblage-Constructivist mode with extruded clay rod structures that he has produced through 1977. Hepburn's work has been extensively exhibited in Europe, Japan, and the United States, including ten one-person exhibitions, the

most recent being at the Portnoy Gallery, New York, in 1978. Hepburn has taught, written, and lectured extensively and he is one of the most analytical and eloquent commentators in the field. Before moving to the United States in 1976 he was head of the ceramics department at the Lanchester Polytechnic, Coventry, England. Hepburn is currently the head of the division of Art and Design, New York College of Ceramics at Alfred University, Alfred, New York.

(See Bibliography: Birks, 1969; Hepburn, 1970, 1976; William Hayes Ackland, 1977)

HIGBY, WAYNE (1943–). Born in Colorado Springs, Colorado, and educated at the University of Colorado, Boulder, and the University of Michigan, Ann Arbor, where he took his M.F.A. in 1968. From 1968 to 1973 he taught at Omaha, Nebraska; Scripps College, Claremont, California; and Rhode Island School of Design in Providence. In 1973 he was appointed Associate Professor of Ceramics at the New York College of Ceramics, Alfred. Higby's inventive use of raku and landscape imagery was a welcome and necessary break from the tradition of employing Alfred graduates and reinforcing the "Alfred vessel." His works have been widely exhibited, and in 1973 he was given a one-man show at the Museum of Contemporary Crafts in New York.

(See Bibliography: Campbell Museum, 1976; Clark, G., *Ceramic Art*, 1978; Cochran, 1976; The Evanston Art Center, 1977; Grossmont College, 1977; Kalamazoo Institute of Arts, 1977; Nordness, 1970; Peterson, 1973; Scripps College, 1974; Victoria and Albert Museum, 1972; Winokur, 1976)

HINDES, CHARLES AUSTIN (1942–). Born in Muskegon, Michigan, and studied at the University of Illinois, Champaign-Urbana, taking his B.F.A. and M.F.A. at the Rhode Island School of Design, Providence, in 1968. He has taught at several schools in Illinois and New York and was adjunct professor of ceramics at the Rhode Island School of Design in 1972–1973. In 1973 he became

Charles Hindes.

associate professor of ceramics and chairman of the ceramics department at the University of Iowa, Iowa City. Hindes's work is strongly influenced by the traditions of Japanese folk pottery as well as the early Pennsylvania German salt-glaze wares. He has been a strong influence both as a teacher and an artist in the Midwest, where he has actively exhibited and participated in numerous workshops.

(See Bibliography: Ohio State University, 1977)

HUDSON, ROBERT (1938–). Born in Salt Lake City, Utah, and studied at the San Francisco Art Institute, where he received his B.F.A. in 1962 and an M.F.A. in 1963. Hudson has become known for his distinctive polychrome metal sculpture and for his fastidious craftsmanship and creative attitudes. In 1972–1973 he produced a body of ceramic works in conjunction with Richard Shaw. Although they shared common molds and techniques, they worked individually, sharing inspiration and knowledge. Writing of these works, Peter Schjeldahl comments, "Even in California's twenty year history

of avant garde clayworks I wonder how many pieces, judged by the standard of Hudson and Shaw, seem primarily or even necessarily to be ceramic objects rather than extensions into the medium of generalized art intentions. The achievement of Hudson and Shaw was to perceive the limitation of the ceramic object as a thing of, if not domestic function, domestic scale and feeling and to realize within that limitation a maximum creative freedom. There is a kind of dreamlike abstract logic to these works, a blend of nonchalance and inevitability that can be best understood, I believe, in terms of a radical coming to grips with the medium" (Moore College, 1978).

(See Bibliography: Moore College, 1978; San Francisco Museum of Modern Art, 1973; William Hayes Ackland, 1977)

HUGHTO, MARGIE (1944–). Born in Endicott, New York, and studied at the State University of New York at Buffalo, where she received her B.S. degree in art education in 1966 with minors in ceramics and painting. She later studied at the Cranbrook Academy of Art in Bloomfield Hills, Michigan, where she took an M.F.A. degree in ceramics in 1971. Both before and after graduating from Cranbrook, she taught at public high schools in Michigan and New York State. In 1971 she joined Syracuse University, Syracuse, New York, and since 1974 has been a full-time ceramics instructor. In 1975 Hughto became project director and curator for the exhibition "New Works in Clay by Contemporary Painters and Sculptors," producing a ninety-six-page accompanying catalogue that documented the project and the exhibition. The project brought together ten major figures in the fine arts to work during a concentrated period on the production of a body of ceramic sculpture. The project was a considerable success, and with funds from the Ford Foundation, Syracuse University's Clay Institute was established, occupying the full top floor of the old Consolidated Can Company building. Since 1976 several of the original artists have returned to work with Hughto, including Anthony Caro and Friedel Dzubas as well as new artists: Kenneth No-

land, Mary Frank, Stephen De Staebler, and others. Hughto is also responsible for the exhibition "A Century of Ceramics in the United States 1878–1978," which this book accompanies. The exhibition is the largest contemporary ceramics show ever undertaken in this country, and it is because of her initiative and unflagging energy that the support and resources required for this project have been gathered. Hughto has continued a young but important tradition at Syracuse University of dedicated women artists who have extended their energies in support of the ceramics field at large. Much like editor-artist Adelaide Robineau and author-sculptress Ruth Randall, Hughto has been able both to develop her own work into one of the more original statements in contemporary ceramics today and to contribute richly toward the broader needs of the art through her directing of the Clay Institute and as adjunct curator of ceramics at the Everson Museum of Art, Syracuse. She has recently curated a major showing of ceramic sculpture by West Coast artists: "Nine West Coast Clay Sculptors: 1978," the first major exhibition of its kind to look specifically at the importance of the West Coast in the postwar development of ceramic art.

(See Bibliography: Clark, 1978; "Cranbrook 12," 1976; Everson Museum, 1976; Fletcher, 1978; Hartranft, 1972; Hughto, 1976; "Museum Clay," 1976; Nordstrom, 1978; Peterson, 1976)

HUI, KA-KWONG (1922–). Born in Hong Kong; attended Kong Jung Art School in Canton, China, and the Shanghai School of Fine Arts in Shanghai; and was apprenticed to Cheng Ho, a sculptor, before coming to the United States in 1948. He worked with the Wildenhains at Pond Farm in California and then went to Alfred University where he received both his B.F.A. and M.F.A. from the New York College of Ceramics. After obtaining his degrees, he taught at The Brooklyn Museum Art School and at Douglass College, part of Rutgers University in New Brunswick, New Jersey. In 1964–1965 Roy Lichtenstein invited Hui to be his technical collaborator in a series of cup

sculptures and ceramic mannequin heads later exhibited at the Leo Castelli Gallery in New York. Although Hui was not working in the Pop idiom as such, there was a strong affinity between his work and Lichtenstein's, as he used flat, bright color on his forms.

(See Bibliography: "Ceramics: Double Issue," 1958; Everson, Ceramic National, 1968–1970; Hepburn, 1970; Nordness, 1970)

IRVINE, SADIE (1887–1970). A graduate of the Sophie Newcomb Memorial College for Women, New Orleans, Louisiana, Sadie Irvine was one of the best-known decorators of Newcomb Pottery's mat-glazed pottery following the arrival of Paul Cox in 1910. Little firm biographical information is available on Irvine. In her correspondence with Robert Blasberg (see Bibliography: Blasberg, "The Sadie Irvine Letters," August 1971), she was herself vague about dates and gives her year of joining the pottery as being "between 1910 and 1912." She was the originator of one of the pottery's most popular designs, the live oak, an honor that she claims to regret. The beautiful moss-draped oak trees appealed to the buying public "but nothing is less suited to the tall graceful vases—no way to convey the true character of the tree—and oh how boring it was to use the same motif over and over again." She presented one of these vases to Sarah Bernhardt "on one of her many farewell tours." Irvine remained at Newcomb and taught there until 1952. In later years her creative activities were directed toward watercolors and block prints.

(See Bibliography: Barber, 1909; Blasberg, 1968, 1971; Eidelberg, 1972; Evans, "Newcomb Pottery," 1974; Henzke, 1970; Keen, 1978; Kovel and Kovel, 1974; Ormond and Irvine, 1976)

KANEKO, JUN (1942–). Born in Nagoya, Japan, and studied and practiced as a painter before coming to the United States in 1963. He studied at the Chouinard Art School in Los Angeles in 1964 under Ralph Bacerra; at the studio of Jerry Rothman in Los Angeles; at the

University of California, Berkeley, under Peter Voulkos; and finally at the Claremont Graduate School, Claremont, California, where he received an M.F.A. in 1971 under Paul Soldner. Thereafter he taught at the Rhode Island School of Design in Providence until his return to Japan. During his brief stay of ten years in the United States, Kaneko established himself as one of the most innovative artists in the medium, and his work was widely exhibited in many group and one-man exhibitions.

(See Bibliography: Everson, 24th Ceramic National, 1966–1968; Everson, Ceramic National, 1968–1970; Scripps College, 1974)

KARNES, KAREN (1920–). Born in New York City. She studied at the New York College of Ceramics at Alfred University, Alfred, New York, and together with her husband, David Weinrib, became potter-in-residence at Black Mountain College, North Carolina, from 1952 to 1954. While there, she and her husband organized two important ceramics symposiums. The first, in 1953, brought together Soetsu Yanagi, Shoji Hamada, Bernard Leach, and Marguerite Wildenhain. In 1954, Karnes and Weinrib established their own pottery studio in Stony Point, New York. Karnes has, over the years, emerged as a strongly independent potter, both in her work and in her refusal to ally herself to any teaching institutions. In her work, one sees a strong influence coming from the examples of Shoji Hamada. Karnes restricts herself to a simple range of form and the exploration of salt-glaze firing, seeking a gradual refinement in her sensitivity as both artist and potter. Karnes has received numerous awards: Everson Museum of Art, 1950 and 1958; Tiffany Fellowship, 1958; Silver Medal, 13th Triennale de Milano, Italy, 1964; Member of Academy of Fellows of the American Crafts Council, 1976; National Endowment for the Arts, Craftsman's Fellowship, 1976. In 1977 she had her first major one-woman exhibition at the Hadler Galleries, New York. Writing of the work in the exhibition catalogue, Judith Schwartz commented, "In an age of plastic icons, throw-

away bottles, consumable values and mercurial fashions, it is comforting to know that there are those among us who, in independent, peaceful, and disciplined ways, create works which are, at once, practical, beautiful, and timeless, and, in so doing, enrich us all. Karen Karnes is one of these people" (Schwartz, 1977).

(See Bibliography: American Crafts Council, 1972; Campbell Museum, 1976; Duberman, 1972; New Gallery [Iowa], 1963; Nordness, 1970; Richards, 1977; Robertson, 1978; Schwartz, 1977; Smith, 1958; Syracuse Museum, Ceramic International, 1958)

KOTTLER, HOWARD (1930–). Born in Cleveland, Ohio, and received his B.A. at Ohio State University, Columbus, in 1952, receiving an M.A. in 1956 and a Ph.D. in 1964 from the same institution. He received his M.F.A. at the Cranbrook Academy of Art, Bloomfield Hills, Michigan, in 1957 .He taught first at Ohio State University from 1961 to 1964 and then at the University of Washington, Seattle, from 1964 to the present. His early works deal with traditional stoneware, both functional objects and chunky, expressionist weed pots. An interest in surface imagery and china painting that he developed in the late 1960s led Kottler toward a new form of expression, which was explored in two directions: first, a successful series of Art Deco vessels such as *Playmate Pot* (1969), *Mondo Reflecto* (1968), and *Radio City Pot* (1967). Second, and running parallel to this series, was his plate series, a limited-edition presentation of commercial plates and decals. The "content" of the work was based on Kottler's interference with the known images that he used on his decals and the lavish packaging and presentation of the works. Illustrated in this study is Kottler's *The Old Bag Next Door Is Nuts* (1976), which was first exhibited in "Illusionistic Realism as Defined in Contemporary Ceramic Sculpture" at the Laguna Beach (California) Museum of Art in 1977. When the piece was subsequently illustrated in *Ceramics Monthly*, it caused a furor. A reader discovered that the house used in the piece was produced from a commercial mold,

and her outrage resulted in a long, ongoing correspondence between the left and the right wings of ceramic sculpture. In the 1970s Kottler has emerged strongly as what can only be termed a *supermannerist,* displaying a slick comedy of manners and a style that employs the visual sleight of hand of trompe-l'oeil painting. Kottler freely acknowledges the lack of content or depth in his work, and in a recent catalogue, he made the following statement: "Most of my work in ceramic sculpture involves the use of camouflage coupled with the relationship between non-related images. I like the perfection of industrial techniques and commercial ceramic ware, I am lazy, I use images already available —casting is simpler and faster than modeling. I purchase molded pieces already cast, use prepared glazes and junked ceramic objects; in fact, I seldom touch clay. I use other people's molds, other people's ideas and other people make my ceramic decals. I just assemble the parts. The resulting work ranges from the bad to the interesting with an occasional hot piece" (Laguna Beach Museum of Art, 1967). Kottler has been an influential teacher at Washington State University, Pullman, and a generation of artists who share his taste for banality have emerged from this school: Jacqueline Rice, David Furman, Anne Currier, and many others. Kottler exhibits extensively and indiscriminately and has been included in over 250 group and one-man exhibitions in the United States.

(See Bibliography: Campbell Museum, 1976; "Cranbrook 12," 1976; Grossmont College, 1977; Hepburn, 1976; Hoffman, 1977; Laguna Beach, 1977; Nordness, 1970; Pugliese, 1975; San Francisco Museum of Art, 1972)

LEVINE, MARILYN (1935–). Born in Medicine Hat, Alberta, Canada, and studied at the University of Alberta, Edmonton, where she received her B.Sc. in chemistry in 1957 and M.Sc. in 1959. Thereafter she studied at the School of Art, University of Regina, Regina. In 1970 she received her M.A. from the University of California, Berkeley, and in the following year her M.F.A. in sculpture.

Marilyn Levine.

Since graduating, she has taught extensively in both Canada and the United States and held a number of one-woman exhibitions. Levine attracted interest from the fine arts world for her leather/clay objects that faithfully translated suitcases, leather jackets, and satchels into stoneware. At first these seemed to be within the Super Realist style. Since her first impressive showings in the early 1970s at the Sidney Janis and O.K. Harris galleries in New York, it has become apparent that some of the interference and illusionary qualities of the school are missing from her work and that the objects deal with what has been termed *pure objecthood.* In speaking of her work, Levine emphasizes the importance of what she terms *traces:* "An acquaintance of mine, Marc Treib, described pretty neatly the two types of impact man has on the world, *intent* and *trace.* He defined intent as the result of man's acting consciously. This would include design, building and other purposeful action. *Trace,* on the other hand, is the accumulation of the marks left by the realization of man's intent, such as trampled grass, grease spots and dirt. In *trace* . . . we find richness, a humanity often omitted in intent" (Foote, 1972). Levine's

choice of leather was specifically because leather carried the history of man's traces in a particularly personal manner, she cited the way in which a leather jacket will eventually take on the shape of its wearer.

(See Bibliography: Battcock, 1975; Cochran, 1976; Foote, 1972; Grossmont College, 1977; Levin, K., 1974; Museum of Contemporary Crafts, 1975; Peterson, S., 1977; Renwick, 1977; San Francisco Museum of Art, 1972; Slivka, 1971; William Hayes Ackland, 1977)

LICHTENSTEIN, ROY (1923–). Born in New York City and studied under Reginald Marsh of the Art Students League. He attended Ohio State University from 1940 to 1949 (studies interrupted by service in the U.S. Army from 1943 to 1945), where he received his B.F.A. in 1946 and his M.F.A. in 1949. Thereafter he taught at Ohio State University, Columbus, and the State University of New York, Oswego, and in 1960 became assistant professor at Rutgers University, New Brunswick, New Jersey. In 1964 he resigned from the Rutgers faculty to devote himself full time to painting and began his maquettes for the ceramic "heads." In 1965, after a year-long collaboration with Ka-Kwong Hui, he exhibited his ceramic sculptures at the Castelli Gallery, New York, from November 20 to December 11, 1965. These works had a strong influence on the development of a Super Object/Pop idiom in ceramics. The works have been extensively exhibited and illustrated, and in 1977 the Art Galleries of the California State University at Long Beach organized a major exhibition of Lichtenstein's ceramic sculpture.

(See Bibliography: Alloway, 1967; Baro, 1968; Coplans, 1972; Glenn, 1977; Schlanger, 1966; Waldman, 1969)

LITTLE, KEN D. (1947–). Born in Canyon, Texas. He took his B.F.A. at the Texas Technical University, Lubbock, and his M.F.A. in 1972 at the University of Utah, Salt Lake City. From 1974 to the present, he has been assistant professor of art at the University of Montana, Missoula. Little was the recipient of several

research grants between 1971 and 1977, including the Research Advisory Council grant for ceramic and mixed-media sculpture (1975–1976), and "Spaces, an Artist-Teacher Exploration" (1976–1977). Little is actively involved in ceramic education and was director at large from 1975 to 1977 for the National Council for Education in the Ceramic Arts. His work consists of mixed-media assemblages and ceramic sculptural structures. His sculptures have been extensively exhibited since 1970 in one-man and group exhibitions.

(See Bibliography: Long Beach, 1977; William Hayes Ackland, 1977)

LUKENS, GLEN (1887–1967). Born in Cowgill, Missouri, into a farming family that later moved in search of better farmlands further west. It was appropriate that Lukens first studied agriculture in Oregon from 1921. But Lukens was destined to use earth in a different manner from that of his father. Toward the end of his course, he became interested in art and moved to Chicago, where he studied ceramics at The Art Institute under Myrtle French.

Glen Lukens.

His adapting of a sewing machine into a potter's wheel came to the attention of the Surgeon General, who invited Lukens to run a pottery program to help rehabilitate the wounded of World War I. He subsequently moved to California around 1924 and taught crafts on the junior and secondary school level. In 1936 he became the Professor of Ceramics at the University of California's School of Architecture and remained for thirty years. In the late 1930s he entered his most productive period as an artist, winning awards at the Ceramic Nationals and representing the West Coast at the 1937 Paris Exposition and the 1939 World's Fair in New York. After World War II, ceramics remained his main interest but less and less as a personal art form. In 1945 Lukens took a leave of absence and began an involvement with pottery training in Haiti, which lasted into the 1950s under the aegis of various sponsors, including UNESCO. Lukens was an important teacher with a contagious humanity and a gift for communicating his sensitivity to his students. He would frequently remind them of what had been his personal credo as a ceramic artist, "The new in art is incredibly old and the old is still vastly new" (see Bibliography: Lukens, 1937, p. 38). Lukens received an honorary doctorate in the ceramic sciences from his alma mater, Oregon State University, and the Charles Fergus Binns Medal, and in 1951 the government of Haiti awarded him L'Ordre National Honneur et Mérite.

(See Bibliography: "California Ceramics," 1938; Levin, E., "Arthur Baggs, Glen Lukens," 1976; Lukens, 1937; Peterson, 1968; "Pots and Pans . . . ," 1943; Syracuse Museum of Fine Arts, *Ceramic Nationals Catalogues*, 1935, 1936, 1938)

MACDONALD, WILLIAM PURCEL (1865–1931). Born in Cincinnati, Ohio, MacDonald studied at the Graduate School of Design at the University of Cincinnati, joining Rookwood Pottery in 1882. He spent his entire life working at Rookwood and became one of their most accomplished decorators, taking over the direction of the decorating department in 1899, following the departure of Valentien. He

later was responsible for the running of an architectural department at Rookwood Pottery. MacDonald was a member of the Duveneck Society, the Cincinnati Art Club, and the MacDowell Society.

(See Bibliography: Peck, H., *Book of Rookwood Pottery,* 1968)

MACKENZIE, ALIX (1922–1962). Graduated from The Art Institute of Chicago in 1946 and together with her husband, Warren MacKenzie, spent two years in the mid-1950s as an apprentice of Bernard Leach at the Leach Pottery, St. Ives, England. She established a workshop with her husband at Stillwater, Minnesota, working on the production of functional wheel-thrown reduction-fired wares.

(See Bibliography: "Ceramics: Double Issue," 1958; Everson, 21st Ceramic National, 1962)

MACKENZIE, WARREN (1924–). Graduated from The Art Institute of Chicago in 1947 and spent two years in the 1950s as an apprentice, together with his wife, Alix, at the studio of Bernard Leach, St. Ives, England. MacKenzie is professor of art at the University of Minnesota and has taught and lectured extensively throughout the country. He has been one of the major forces in establishing the aesthetic-philosophical credo of the functional potter in the United States, based on his affinities with the Anglo-Oriental beliefs of Leach. His pottery, produced at his own workshop in Stillwater, Minnesota, is all wheel-thrown and fired in a reduction atmosphere. The low cost of his work reflects MacKenzie's desire that they be objects of utility rather than mantelpiece ornaments. In a statement made some years back, MacKenzie outlined the basis of his belief: "A pot must be made with an immediacy, without unlimited change being possible, which is unique in the visual arts. For this reason each piece, in a sense, becomes a sketch or variation of an idea which may develop over hours, days, or months and requires up to several hundred pieces to come to full development. One pot suggests another, proportions are altered, curves are filled out or made more angular, a different termination or begin-

ning of a line is tried—not searching for the perfect pot but exploring and making statements with the language at hand. From thousands of pots produced some few may sing. The others are sound steppingstones to these high points and can also communicate between the artist and the user" ("Ceramics: Double Issue," 1958).

(See Bibliography: Campbell Museum, 1976; "Ceramics: Double Issue," 1958; Kalamazoo, 1977; New Gallery [Iowa], 1963; Reeve, 1976; Schwartz, 1976)

MARKS, ROBERTA B. (1936–). Born in Savannah, Georgia, and studied at the University of Florida, Gainesville; the University of Miami, Coral Gables; the Metropolitan Museum and Art Center, Miami; and the Penland School of Crafts, Penland, North Carolina. She has been a visiting artist at numerous schools throughout the United States, and her work has been extensively exhibited at group and one-woman exhibitions. In her work, she exploits primitive firing techniques, including pit, sawdust, raku, and dung firings—using the action of the fire to create the interest and patination on the surface.

(See Bibliography: Renwick Gallery, 1975)

MARTINEZ, MARIA (1884–). Born in San Ildefonso Pueblo, New Mexico. Martinez first made polychrome pottery in 1897, painting with red clays and a black pigment from wild spinach called *guaco.* Later she married Julian Martinez, and the couple were asked to re-create shapes from pottery shards found in the Frijoles Canyon. They experimented and soon discovered the technique of the burnished pottery with its silver-black sheen. Julian and Maria rapidly became famous for their skillfully executed wares. Martinez was invited to demonstrate at all the major world's fairs up until World War II, was feted by four presidents at the White House, is the holder of two honorary doctorates, and was chosen to lay the cornerstone at New York City's Rockefeller Center. Recently Martinez has been the subject of an excellent book by Susan

Peterson and a retrospective exhibition at the Renwick Gallery, Washington, D.C., in 1978.

(See Bibliography: Everson Museum, 1976; Peterson, 1977; Syracuse Museum, 1937)

MASON, JOHN (1927–). Born in Madrid, Nebraska, spending much of his youth in Nevada. He was educated at the Chouinard Art Institute in Los Angeles, where he worked under Susan Peterson, and at the Otis Art Institute (then Los Angeles County Art Institute) under Peter Voulkos. He subsequently taught at Pomona College, Claremont, California; the University of California, Irvine and Berkeley; and the Otis Art Institute and is currently on the faculty of Hunter College, New York. Mason's early involvement with ceramics was through pottery, and for some time he also designed dinnerware for industry. From 1957 he began to search for a more sculptural application of ceramics and produced his first monumental wall pieces. Arguably the finest and the most Abstract Expressionist of these is the work titled *The Blue Wall* (1959)—the technique of its creation being analogous to the manner in which Jackson Pollock painted some of his early Abstract Expressionist canvases. Mason's involvement in architectural ceramics continued, and several of his works were permanently installed: *The Blue Wall* at the now-defunct Ferus Gallery, Los Angeles; a work at the Tischman Building in Los Angeles; and works in several private homes. The development of the wall pieces continued through to the mid-1960s, when Mason began to create massive free-standing walls composed of modular panels, a "structuring device necessitated by the size of the kiln" (Haskell, 1974). But the modularity extends beyond pure structural requirements and is the distinguishing factor even in the smaller vessel-oriented works, where the even pacing of the modular compositional style was not determined by technical restraints. His free-standing ceramic sculptures follow the same progress as the walls, from an expressionist handling of the material to a cool, formalist statement, culminating in

1966 with an exhibition at the Los Angeles County Museum of monolithic primary forms up to six feet in height with bright monochrome glazes. These works were within the Minimalist school established earlier in the decade by artists such as Tony Smith, Robert Morris, Carl Andre, and others. But despite the careful planning by Mason, which included the constructing of a collapsible tubular system to withdraw the air evenly from within his forms and thus minimize any cracking or warpage, the character of the clay emerges forcibly and the surfaces of the forms are covered in a rich wash of expressive, streaked glaze, while the form itself is fissured with cracks. More successful during this period was the construction of slab-built totems, an exploration in Mason's work begun early in the 1960s and continued through to the end of the decade. One of these pieces, exhibited at the final Ceramic National in 1972, was undoubtedly the masterwork of the exhibition. Despite the success of this series, however, Mason had grown increasingly unhappy with the manipulation of clay and had earlier voiced his reservations about the medium: "Today's stigma is deeply rooted in our ceramic form. Timidity of spirit, coupled with little real conviction, has resulted in a ceramic form synonymous with hobbyists, dilettantes and three dimensional cartoonists. The self-conscious reaction of this association has been fastidious technical execution of craft in an effort to attain professional status. Unfortunately, individuals following this trend have too often sacrificed inner experience in favor of results, spotlighted in terms of techniques and standards of good taste. It can only follow that content must suffer. This professionalism has produced a ceramic form empty in content and lacking in vitality, as demonstrated by the examples seen in our stores, exhibitions and architectural commissions" ("Ceramics: Double Issue," 1958). In 1971–1972 Mason began to work with firebricks, the material with which kilns are constructed. In fact, the kiln proved to be the inspiration for his first piece involving an arch form, fitted together so the piece was structurally supported by the tension and

pressure of its own weight. From 1972 he began to work on a series of floor pieces, culminating in 1978 with his *Installations from the Hudson River* series (1978), a project funded by the National Endowment for the Arts, which involved the creation of a series of works at major museums across the United States. These works, employing the ultimate ceramic module and freeing Mason from material manipulation, have produced some interesting post-Andre formalist art. Mason's work of the last eight years now belongs directly to Conceptualist sculpture and only by association to ceramics. His major contribution to the field was made between 1958 and 1969, when he produced some of the finest abstract sculptural statements in the medium.

(See Bibliography: Ashton, 1967; Backlin, 1962; "Ceramics: Double Issue," 1958; Coplans, 1963, 1966, 1973; Giambruni, 1966; Nordland, 1960; Pasadena Museum of Modern Art, 1974; Plagens, 1974; Pugliese, 1975; San Francisco Museum of Art, 1972; Scripps College, 1974)

MCCLAIN, MALCOLM (1933–). Studied painting and sculpture in France, New York, Mexico, and California. He received his B.A. from Pomona College, Claremont, California, in 1956 and studied ceramics at Scripps College, Claremont, and with Peter Voulkos at the Los Angeles County Art Institute (Otis Art Institute). McClain's involvement with the material was strongly intellectual, dealing with carefully conceived compositions of form, and showed a Constructivist tendency. Although his involvement was brief, he made an important early contribution to a more conceptual-sculptural approach to the vessel. In the early 1960s he ceased working in ceramics and became a poet. Nonetheless he has retained throughout the years an involvement with ceramic education.

(See Bibliography: "Ceramics: Double Issue," 1958; Coplans, 1960; Scripps College, 1974)

MCINTOSH, HARRISON (1914–). Born in Vallejo, California, and studied at the University of Southern California

Harrison McIntosh.

in 1940 under Glen Lukens and at the Claremont Graduate School from 1949 to 1952. He worked at the Pond Farm workshop in California with Marguerite Wildenhain in 1953. McIntosh taught at the Otis Art Institute with Peter Voulkos in 1954 and has since concentrated on his studio work. In addition to creating individual vessels and sculptures with a distinctive hard-edged decorative treatment of glaze, McIntosh has been an active designer, in both glass and ceramics, working extensively in Europe and Japan. He is currently a resident of Claremont, California.

(See Bibliography: Bevlin, 1967; Loyau, 1974; Nordness, 1970; Syracuse Museum, 17th Ceramic National, 1953)

MCLAUGHLIN, MARY LOUISE (1847–1939). Born in Cincinnati to a prominent family, McLaughlin took an early interest in the arts and studied privately until 1873. She joined the Cincinnati School of Design, where in the following year she was introduced to china painting. In 1876 she exhibited in the Centennial Exposition in Philadelphia. She was graduated from the school in 1877, later returning to do life drawing with Frank Duveneck, "the only teacher

who had any influence on my artistic development" (McLaughlin, 1938, p. 217). In 1878 she produced her first technically successful Limoges faïence at Patrick L. Coultry Pottery, exhibiting the wares in Cincinnati and New York and at the 1879 Paris Exposition Universelle, where she received an Honorable Mention. In 1879 she founded and became president of the Cincinnati Pottery Club, where she made her famed *Ali Baba* vase, which was exhibited at the First Annual Exhibition of the club. In 1883, when the club was evicted from Rookwood Pottery, McLaughlin turned to on-glaze decoration and decorative metalwork. In 1889 she received a Silver Medal at the Exposition Universelle for her china painting and metallic effects. She returned to ceramics in 1895, working first in earthenware and then in porcelain. At the 1900 Exposition Universelle, she was awarded a Silver Medal for her metalwork, and a Bronze Medal at the "Buffalo Exposition" for her once-fired porcelain.

(See Bibliography: Barber, 1909; California State University at Fullerton, 1977; Cincinnati Art Museum, 1976; Eidelberg, 1972; Evans, *Art Pottery,* 1974; Henzke, 1970; Jervis, *Encyclopedia of Ceramics,* 1902; Keen, 1978; Kovel and Kovel, 1974; McLaughlin, 1880, 1897, 1917, 1938; Newton, 1939; Peck, H., *Book of Rookwood Pottery,* 1968; Perry, A., 1881; Syracuse Museum of Fine Arts, 1937)

MELCHERT, JAMES (1930–). Born in New Bremen, Ohio, and studied at Princeton University, receiving a B.A. in 1952, and at the University of Chicago, where he received his M.F.A. in 1957. In 1958 he moved to California and began to study with Peter Voulkos at the University of California, Berkeley, receiving his M.A. in 1961. His early works involved a vessel format, at first dealing with the clay in an Abstract Expressionist mode, but from 1960, producing carefully considered forms such as his *Legpot I* (1962). In this work, influenced by the manner in which the arm on a broken Greek torso would abruptly terminate in a cross section, Melchert revealed his impatience with "the conventions that seemed to

tyrannize potters, the vertical, bilaterally, symmetrical structure of a vessel and the unquestioning acceptance of a single material" (Nordness, 1970). He combined stoneware with lead and cloth inlay and, in developing the form, was furthermore influenced by an early interest in primitive art, in which the frequent juxtaposition of incongruous shapes without transition had impressed him. His involvement as a teacher at the San Francisco Art Institute led Melchert, and a group of artists with whom he was associated there, away from the decorative exuberance of stoneware and toward the use of low-fire, brightly colored glazes on whiteware. His works began to reflect the attitude of artists at the Art Institute such as William Wiley, William Geis, and Robert Hudson, in whose work content took precedence over form. He began to treat the surface with painted and relief images of pyramids, Mickey Mouse ears, fragments of words, Benday dots, and motifs that challenged the traditional relationships of surface and volume. In 1974, he held a one-man exhibition of *Ghostwares,* at the Hansen Gallery, San Francisco, which were influenced by a single line in Ingmar Bergman's movie *The Silence,* which was spoken by one of the sisters: "Tread carefully among the ghosts of the past." These pieces comprised a series of masks with blind, skeletal faces on boxes or plates surrounded by fragmented visual codes. In 1967 this series was followed by the *Games* series, comprising molded and at times identifiable objects placed on a grid or a rectangular base. These works, so reminiscent of the assemblages of Alberto Giacometti in the 1930s, now excluded the expressive qualities of the medium in favor of a more intensely intellectual statement. The last object series by Melchert was inspired by Raymond Queneau's book *Exercises in Style,* which retold an inconsequential story in 100 literary styles. Using the lower-case *a,* he began to create a series of sculptures made from various materials, with the title as the all-important key to the content of the form: *Precious a* (a small glazed and lustered piece mounted on a plinth), *Pre-a* (comprising twenty pounds of unfired clay), and *a Made*

Forty Pounds Lighter (a form from which handfuls of clay had been roughly gouged from the surface before firing). The most interesting of the three exhibitions that took place of this body of work was the installation at the San Francisco Art Institute in February 1970. The works were presented on a large grid taped to the floor, providing a continuity of the visual vocabulary that he first established with the *Games* series. His last work in clay was a happening titled *Changes* based on the drying processes of clay and took place at a friend's studio in Amsterdam in 1972. Melchert moved on to projection work and is currently director of the Visual Arts Division of the National Endowment for the Arts in Washington, D.C. In his sixteen-odd years in ceramics, Melchert was a strong influence, deemphasizing the romantic preconceptions of the medium and providing an intimidating example of a probing and intelligent sculptural application of the material.

(See Bibliography: Andreae, 1969; "Ceramics," 1968; Coplans, 1963, 1966; Giambruni, 1966; Johnson, 1970; Kalamazoo, 1977; Melchert, 1968, 1974; Nordness, 1970; Pugliese, 1975; Renwick, 1977; Richardson, 1969; San Francisco Museum of Art, 1972, 1975; Scripps College, 1974; Selz, 1967; Slivka, 1971; Victoria and Albert Museum, 1960)

MERCER, HENRY CHAPMAN (1856–1930). Born in Doylestown, Pennsylvania, into an old Quaker family and trained as a lawyer. Instead he became an archaeologist on the staff of the University Museum in Philadelphia, where he achieved some prominence for his unconventional scholarship. As an outgrowth of his interest in American pioneer handcraft tools and the discovery that the Pennsylvania German pottery tradition was almost extinct, he became a ceramist and in 1898 founded the Moravian Tile Works in Doylestown, named after the Moravian cast-iron stove plates that inspired his first tile designs. Mercer was responsible for all the tile designs, ensuring that the tiles reflected the handmade production methods and celebrated the qualities of the local red clay. Mercer was a confirmed eclectic and drew

his tile designs from many sources. One of the richest came from his friendship with Sir Charles Hercules Read of The British Museum, who became a personal friend and not only permitted Mercer to make impressions of and reproduce medieval English floor tiles in the museum's collection but also gave him access to large and valuable collections of drawings and tracings of ancient tiles from ruined English abbeys and priories. From Professor Hans Bausch of the Germanic Museum in Nuremberg, Mercer obtained designs of eighteenth-century German tiles. The original pottery was burned to the ground and was replaced between 1910 and 1912 by a larger structure of reinforced concrete. This was one of three reinforced-concrete buildings in the country and was designed by Mercer, who also supervised its building. This was his second building of the type, as he had previously built a concrete home. The third building was the Mercer Museum, constructed between 1914 and 1916 to house his collection of over 6,000 hand tools, a collection that he named "Tools of the Nation Makers." In 1904 Mercer was awarded the Grand Prize for his tiles at the St. Louis Louisiana Purchase International Exposition and went on to win many more awards and honors. Mercer's tiles became sought-after and were used throughout the United States, including at Grauman's Chinese Theater in Hollywood, California; the Casino at Monte Carlo, Monaco; the Isabella Stewart Gardner Museum in Boston; the Museum of Fine Arts in Boston; the now demolished Traymore Hotel in Atlantic City, New Jersey; the library of the Bryn Mawr College in Pennsylvania; and the state capitol building in Harrisburg, Pennsylvania. After his death, Mercer left his estate to the Bucks County Historical Society, which now operates the tile works as a living museum. Mercer's pottery and buildings are a memorial to one of the most complex and remarkable figures of the American Arts and Crafts Movement, a man who worked toward the single goal of "the acquisition and dissemination of knowledge concerning the arts and crafts fundamental to the development of a civilized society" (Fox, 1973).

(See Bibliography: Barber, 1909; Barnes, 1970; Blasberg, 1971; Eidelberg, 1972; Fox, 1973; Gabriel, 1978; Henzke, 1970; Keen, 1978; Kovel and Kovel, 1974; Swain, 1933)

MEYER, JOSEPH FORTUNE (1848–1931). Born in France and emigrated to the United States with his family, settling at Biloxi, Mississippi. After his marriage, Meyer operated a pottery for some time, producing simple wares from local clay. In 1886 he became the first of the potters at the New Orleans Art Pottery Company, soon being joined for a brief period by George E. Ohr. In April 1896, Meyer joined the Newcomb Pottery, a unique experiment by the Sophie Newcomb Memorial College, the woman's division of Tulane University in New Orleans, which provided a professional ceramic environment for the students to study the art of pottery decoration. He remained the main thrower at the pottery until 1925. Sadie Irvine wrote, about Meyer, one of the best known of the Newcomb designers, "He was truly a master craftsman and his failing vision did not seem too great a handicap. His strong, sensitive fingers drew up the clay as though it rose of itself. It was a joy to watch him. We had a constant flow of visitors from all over the world for whom Mr. Meyer would wordlessly perform" (Blasberg, 1971).

(See Bibliography: Barber, 1909; Blasberg, 1971; Eidelberg, 1972; Henzke, 1970; Jervis, 1902; Keen, 1978; Kovel and Kovel, 1974; Ormond and Irvine, 1976)

MIDDLEBROOK, DAVID (1944–). Born in Jackson, Michigan. He studied at Albion College, Albion, Michigan, where he received his B.A. in 1966, and at the University of Iowa, Iowa City, receiving an M.A. in 1969 and an M.F.A. in 1970. He has since taught at the University of Kentucky, Lexington; the University of North Carolina, Chapel Hill; and since 1974 at the San Jose State University, San Jose, California. Middlebrook's work involves the use of Surrealist imagery, such as converting a cactus into a four-legged stool in *The Journey* (1977), using trompe-l'oeil surface treat-

David Middlebrook.

ment to deflect the viewer's preconceptions about the ceramic medium and combining this with a whimsical visual sense of humor.

(See Bibliography: Campbell Museum, 1976; Everson, Ceramic Nationals, 1968–1970; Hepburn, 1976; Laguna Beach, 1977; Slusser Gallery, 1977; Syracuse Museum, 1937; William Hayes Ackland, 1977)

NADELMAN, ELIE (1882–1946). Born in Warsaw, Poland, where he studied briefly. After a period in the Russian army, for which he volunteered because volunteers served a shorter period than draftees, Nadelman moved to Paris, where in 1905 he decided to devote his energies to sculpture, becoming known to the Parisian avant-garde including the Steins, Apollinaire, Brancusi, and Picasso. In 1915, with the assistance of Helena Rubinstein, Nadelman came to New York and by 1920 was well established. After 1929 the Depression brought hardships, and Nadelman lost his studio and refused to exhibit or sell his works. In the 1930s he began to work with clay, having previously used papier-mâché, metalo-plastic, and bronze as his major materials. He

had become interested in ceramics through Mrs. Voorhees and Miss La Prince at the Inwood Potteries in Inwood Park, New York. He later set his own kiln, producing a body of figurative forms, using glazes that he had himself devised, between 1933 and 1935. Apart from this body of work, there is a second body of Nadelman ceramics produced posthumously at Inwood Potteries by Julius Gargani, who had been Nadelman's assistant during his limited involvement with ceramics in the 1930s. These terra-cottas were from the small plaster figures made by Nadelman in his last ten years; "There is no doubt that Nadelman intended these figures to be cast in baked earth. He preserved many fragments of Tanagrine and Myrrhine figures . . . his library was filled with catalogues of antique clay figures" (See Bibliography: Edwin Hewitt Gallery, 1950).

(See Bibliography: Bourdon, 1975; Edwin Hewitt Gallery, 1950; "Hirshhorn Collection," 1975; Kirstein, 1958, 1973; Kramer, 1974; Silver, 1975; Whitney Museum, 1975, 1976)

NAGLE, RON (1939–). Born in San Francisco, and received his art education and a B.A. at the San Francisco State College. Between 1961 and 1978, he taught sporadically at the San Francisco Art Institute; the University of California, Berkeley; the California College of Arts and Crafts, Oakland; and several other schools. He currently teaches at Mills College in Oakland. Nagle's early work reflected his contact with Peter Voulkos and shows a loose interpretation of Abstract Expressionism. However, Nagle has throughout used the vessel as his format, concentrating since 1968 on the cup form. From his expressive, energetic works of the early 1960s, Nagle went on to explore the potential of china painting and photo decals. In 1968 he held an exhibition at the Dilexi Gallery, San Francisco, showing the first of his now-familiar china-painted cup forms with their high stylization, intense, pulsating china-painted color, and molded form. In addition to the cups, Nagle produced an environment for his objects in the form of custom-designed wood and plastic boxes. These works were

"in a sense not a *cup:* but instead *about cups*" (Nordness, 1970). The Dilexi exhibition was his last major showing for seven years, during which time he concentrated on his parallel interest in pop music and developed something of a reputation as an underground figure in the ceramic arts. He returned in 1975 with a dazzling exhibition at the Quay Ceramics Gallery, San Francisco, showing twelve low-fire cup forms. These were meticulously slip-cast and multifired up to twenty times to achieve the saturation and depth of color that he required from the china-painted surfaces. Unlike the earlier cups, which had used flat, solid color, Nagle's painting now became more complex, as did the forms. These works have been sophisticated over the years, culminating with his showing at the San Francisco Art Institute in 1978 as a recipient of the Adaline Kent Award; his forms had returned to something of the informality of his earliest works. A strong emphasis in his pieces is placed on the defining lip and foot of the cup, abstracting the form to the point where the form comprises a bottomless cylinder. The work of Nagle shows strong reference to that of Kenneth Price, who has similarly used the cup as a format in his work. Nagle himself refers to his ceramics as being of the "precious asshole school" (Felton, 1978), with occasional visual punning, as with his *Frank Lloyd Wright* cup. But the keys to Nagle's aesthetics come from two words: *tasteful* and *style,* terms that recur fre-

Ron Nagle. Photograph: San Francisco Art Institute.

quently in his own discussion of his work. Certainly the cups of Nagle deal with both taste and style, but the best of his works transcend the aesthetic limitations implied by these terms and are among the major achievements of West Coast ceramic art.

(See Bibliography: Clark, *Ceramic Art,* 1978; Coplans, 1963, 1966; Felton, 1978; Haverstadt, 1971; McDonald, 1975; Nordness, 1970; San Francisco Museum of Art, 1972; Scripps College, 1974; William Hayes Ackland, 1977)

NAKIAN, REUBEN (1897–). Born in College Point, Queens, New York. He began to study art at the age of thirteen when he and his family moved to New Jersey. He worked in advertising for several years and studied at the Independent Art School and the Beaux-Arts Institute of Design in New York City. He later became an apprentice to Paul Manship in 1916 and shared a studio with Manship's assistant, Gaston Lachaise, during 1920–1923. From 1922 to 1928, Nakian was supported by the Whitney Studio Club. His first one-man show was held in 1926. He frequently worked in stylized animal sculptures in terra-cotta. Toward the end of the 1940s, he began two series of terra-cotta, incised-relief plaques and works that exploited more fully the three-dimensional potential of the material. Both series were based on erotic themes from classical mythology. This new body of work was first shown in 1949 at a one-man exhibition at the Egan Gallery in New York. This period was his last major involvement with terra-cotta, as he moved on to metal, plaster, and other materials.

(See Bibliography: Whitney, 1976)

NATZLER, GERTRUD (1908–1971) and OTTO (1908–). Born in Vienna and in 1933 met and began a collaboration in ceramics. Gertrud had studied at the Wiener Kunstgewerbeschule, but Otto had had no formal art training. They agreed upon a division of talent, Gertrud throwing the forms and Otto devising the glazes. In 1937 they achieved their first success, winning the Silver Medal at the Paris International Exposition. In the following year, they moved to the United States,

Gertrud and Otto Natzler. Photograph: Everson Museum of Art.

settling finally in Los Angeles in 1939. They rapidly established themselves as leading figures in American ceramic art. Their work involved the use of clean, sharply outlined classical forms, to which were applied Otto's remarkable decorative glazes. The Natzlers soon drew international attention for their mastery of glaze technology—particularly their definitive work with the so-called volcanic or crater glazes. The Natzlers have received numerous awards, both within the United States and abroad, and their work is represented in more than thirty-five leading museums, including The Metropolitan Museum of Art, New York; The Museum of Modern Art, New York; The Art Institute of Chicago; the Philadelphia Museum of Art; and the Los Angeles County Museum of Art. Otto has now begun to work with the forms as well as the glazes, following the death of Gertrud, and in 1977 he held a one-man exhibition of slab-built vessels at the Craft and Folk Art Museum in Los Angeles.

(See Bibliography: Andreson, 1941; "Ceramics: Double Issue," 1958; Everson, 21st Ceramic National, 1962; Henderson, 1948; Los Angeles County Museum, 1966; Natzler, 1964, 1968; Penny, 1950; Renwick Gallery, 1973; Syracuse Museum, 20th Ceramic International, 1958)

NERI, MANUEL (1931–). Born in Sanger, California, and studied at the University of California, Berkeley (1951–1952), California College of Arts and Crafts, Oakland (1952–1957), and the California School of Fine Arts, San Francisco (1957–1959). Since his first one-man show at 6 Gallery, San Francisco, in 1957, he has had twenty-two one-man exhibitions and has been included in numerous group shows. While studying at the California College of Arts and Crafts, he became involved in ceramics, producing his distinctive "loop" sculptures. These arch forms with their bright glazes were prophetic works in the medium and up to the mid-1960s had a strong influence on ceramic sculpture on the West Coast.
(See Bibliography: Coplans, 1966; Selz, 1967)

NEVELSON, LOUISE (1900–). Born in Kiev, Russia. By 1905 her family had emigrated to America and settled in Rockland, Maine. In 1920 she married and moved to New York, attending the Art Students League in 1929–1930. She continued her studies with Hans Hofmann in Munich in 1931 and also worked as assistant to the muralist Diego Rivera. She has since become established as one of the foremost sculptors in the United States and has been the subject of major retrospectives in 1967 and 1975. Her major involvement with ceramics was during the 1940s, when she used the material to explore a series of Cubist-Constructivist figural structures. Her major work of this series is *Moving-Static-Moving Figures* (1945), a group of eighteen terra-cottas now in the collection of the Whitney Museum of American Art. Further pieces from this period are in the collection of the Hirshhorn Museum and Sculpture Garden, Washington, D.C. Nevelson was one of the group of twelve artists who

participated in *Art in America*'s project "Ceramics by Twelve Artists." This work was produced in 1964, and writing of her accomplishments, Richard Lafean comments, "She has embraced clay as a medium for a particular expression and retains high clay quality when she presents the solidity of the slab, the imprint on plastic clay, and the burnishing of vitreous slip into the clay surface, exposing areas of the body. Louise Nevelson's work is the most professional presentation in the exhibit" (Lafean, 1965).

NEWTON, CLARA CHAPMAN (1848–1936). Born in Delphos, Ohio, Newton moved to Cincinnati in 1852. She was a classmate of Maria Longworth (Nichols) and studied at the Cincinnati School of Design from 1873 to 1874. She decorated china for the Centennial Exposition and for the "Cincinnati Loan Exhibition" in 1878. She was elected secretary of the Cincinnati Pottery Club in 1879 and then of Rookwood Pottery in 1881, where she functioned as general factotum and deco-

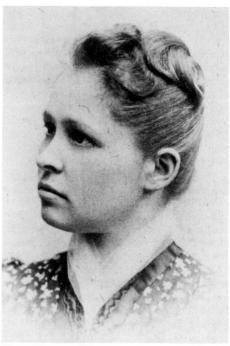

Clara Chapman Newton.

rator as well as giving instruction at the Rookwood School for Pottery Decoration. She left the pottery in 1884 as a result of her unhappiness over the eviction of the Pottery Club and maintained her own studio in downtown Cincinnati as well as teaching at the Thane Miller School. She was actively involved in a number of ceramics and crafts groups, her last appointment being secretary of The Crafters from 1911.

(See Bibliography: Cincinnati Art Museum, 1976; Newton, 1939, 1940; Peck, H., *Book of Rookwood Pottery,* 1968; Perry, A., 1881; Storer, 1919)

NG, WIN (1936–). Born in San Francisco, studying at the San Francisco City College in 1954 and the San Francisco Art Institute in 1959, where he received his B.A. He also studied at Mills College in Oakland in 1960. Ng worked through to the late 1960s, when he gave up his interest in ceramics. Despite the shortness of his involvement, Ng produced some important sculptures in ceramics, and two of his major works are in the collection of the Everson Museum of Art, Syracuse, New York. Ng's work involves Oriental dialecticism, and his sculptures are built around positive and negative forces in the universe: "The square symbolizes the dark or ground spirit (female); the round or circle symbolizes the light or floating element (male)" (Nordness, 1970).

(See Bibliography: "Ceramics: Double Issue," 1958; Everson, 21st Ceramic National, 1962; Everson, 22nd Ceramic National, 1962–1964; Riegger, 1963)

NICHOLAS, DONNA L. (1938–). Studied at Pomona College, Claremont, California, receiving her B.A. cum laude in 1959. She studied for her M.F.A. from 1964 to 1966 at the Claremont Graduate School and University Center. Between degrees, she studied ceramics for two years under the Kyoto potter Hiroki Morino in Japan. There she had her own studio from 1962 to 1964. While in Japan, she attended the weekly lectures on Japanese art given by Professor Torumo Mori of Osaka University. Nicholas has broad teaching experience, ranging from English

instructor at the Doshisha Woman's College in Kyoto, Japan, to her current post as professor of art at Edinboro State College, Edinboro, Pennsylvania, where she has been since 1969. She has been the recipient of numerous grants and awards, including Outstanding Educators of America in 1975. Nicholas has exhibited extensively in both one-woman and group shows, and her work has gradually grown away from the vessel format. She now concerns herself with a purely sculptural use of the medium.

(See Bibliography: Nicholas, 1972; Renwick, 1977; Slusser Gallery, 1977; William Hayes Ackland, 1977)

NICHOLS, MARIA LONGWORTH (1849–1932). Born in Cincinnati into a wealthy family with the tradition of supporting the arts. Her father, Joseph Longworth, was the major contributor to the founding of the Cincinnati Art Museum. She married Colonel George Ward Nichols at nineteen. Her first success in the arts came when she suggested the May Festival of Music, which was held for the first time in 1873, subsidized largely by Longworth money. In 1873 she became interested in china painting, and after seeing the exhibition of Japanese pottery at the 1876 Centennial, she decided to become more involved in the ceramic arts. In 1879 she began to work at the Frederick Dallas Pottery, and in the following year with Joseph Bailey, Jr., she set up her own pottery, Rookwood, named after her father's Grandin Road estate. In 1883, having set the project in motion, she handed over the management to William Watts Taylor, who became general manager. In 1886 she married Bellamy Storer after the death of Colonel Nichols and continued her involvement in the arts, returning to study painting at the Cincinnati Art Academy under Thomas Noble. She worked in metal and occasionally returned to pottery, exhibiting wares at the 1893 World's Columbian Exposition and at the 1900 Exposition Universelle, where she received a Gold Medal for her pottery and metalwork. After a brief involvement in politics (Bellamy Storer was the ambassador to Spain and Austria-Hungary), brought to

an early end by Mrs. Storer's "indiscretion and naïve interference in the affairs of church and state" (see Bibliography: Trapp, 1972), the Storers settled in Paris, where Mrs. Storer died at the age of eighty-three.

(See Bibliography: Barber, 1909; Cincinnati Art Museum, 1976; Eidelberg, 1972; Evans, *Art Pottery*, 1974; Henzke, 1970; Jervis, 1902; Keen, 1978; Kovel and Kovel, 1974; Newton, 1939; Newton, G. W., 1878; Peck, *Book of Rookwood Pottery,* 1968; Perry, A., 1881; Storer, 1919; Taylor, 1915; Trapp, 1972, 1973)

NOGUCHI, ISAMU (1904–). Born in Los Angeles to a Japanese poet father and an American writer-teacher mother. They moved to Japan, where he spent his childhood, moving back to America in 1918 to become a student at the Interlaken School in Indiana. Noguchi was apprenticed to Gutzon Borglum for a short period in 1922. From there he moved to New York City, where in 1924 he began to study sculpture under Onorio Ruotolo at the Leonardo da Vinci Art School. He went to Paris in 1927–1928 on a Guggenheim fellowship. There he met Alexander Calder and became studio assistant to Constantin Brancusi. From 1930 to 1932, he made a series of ceramic sculptures in Japan, influenced strongly by Haniwa figures and Bizen and Shigaraki wares. During the early 1950s, he returned to Japan and produced an even larger body of ceramic sculptures, encouraged and befriended by Rosanjin. Writing of his works, Shuzo Takiguchi commented that "Here in Japan he is seemingly devouring the Japanese clay, firing in the traditional kilns Karatsu, Shigaraki, Seto and Bizen; he has become a potter . . . this is an exhibition of pottery. Nevertheless Noguchi is firing his pottery as sculpture, or, at least they are being fired in a manner that captivates the fancy of the sculptor. Of course, in the Western world there is a tradition of terracotta sculptures and from there in springboard fashion Noguchi has jumped right into the world of Japanese pottery, which naturally accounts for his preserving the raw texture of the clay in the firing. He finds rightful justification in the primitive Haniwa sculptures; no modern potter shall deny the sculptural position of the Haniwa. The Haniwa is ultimately united with the ancient earthenwares and pottery; Noguchi's aim is the revivification of this primitive relationship. Moreover, he seeks in his pottery the possibility of the various idioms of modern sculpture. The adaptation of the characteristic spatial volumes caused by the hollowness of pottery, consequently, has been appropriately expressed in all his works" (*Isamu Noguchi,* 1953). The first exhibition of these works in the United States took place at the Stable Gallery, New York, in 1954.

(See Bibliography: *Isamu Noguchi,* 1953; Whitney Museum, 1976)

NOLAND, KENNETH (1924–). Born in Asheville, North Carolina, and after serving with the U.S. Air Force from 1942 to 1946, studied at the Black Mountain College, Black Mountain, North Carolina, near Asheville, from 1946 to 1948 on the GI Bill. The faculty at Black Mountain during Noland's stay included Josef Albers, John Cage, Peter Grippe, Willem de Kooning, Buckminster Fuller, Merce Cunningham, and Richard Lippold. During 1948 and 1949 he studied in Paris, holding his first one-man exhibition at the Galerie Raymond Creuze, Paris, in 1949, which showed a strong influence from the works of Paul Klee. Since his return to the United States he has become one of the major figures in postwar abstract painting. Commenting on his painting in the catalogue, *Kenneth Noland, A Retrospective,* for The Solomon R. Guggenheim Museum, New York, Diane Waldman comments that Noland is "unquestionably heir to Matisse and Klee in the realm of color expression, he is to his generation what they were to their own . . . The spare geometry of his form heightens the emotional impact of his color. The rational and the felt, distilled form and sensuous color intermesh to create a magic presence. His space is color, his color is space. Color is all." Noland brought these qualities to his work in clay from May to November 1978, when he produced a body of sixty-five works, mostly in porcelain colored with oxides and stains.

Kenneth Noland.

These were produced at the Syracuse Clay Institute with the collaboration of Margie Hughto and her students from Syracuse University.

(See Bibliography: Syracuse University, 1978)

O'HARA, DOROTHEA WARREN (1875–1963). Born in Malta Bend, Missouri, and studied in Munich, Paris, and London. She held her first exhibition of pottery at the Royal College of Art in London, where she attracted the patronage of J. Pierpont Morgan and found a great demand for her work. She returned to the United States, opening a studio in New York where she both produced objects and taught pottery to high school teachers. For seven years, she wrote and illustrated articles for the *Ladies Home Journal* and for sixteen years was a correspondent for *Keramik Studio*. In an interview (Colgate, 1955), she claims to have written a book on glazes, *The Art of Enameling on Porce-*

lain, although no record of this publication can be found. In 1915 O'Hara won Gold Medals at the Panama-Pacific International Exposition in San Francisco, and two of her vases were bought by the Japanese government for display in the Tokyo Museum. In 1920 she moved to Darien, Connecticut, where she converted an abandoned barn into a pottery workshop and established the Apple Tree Lane Pottery. She used ordinary Jersey and western red clays and perfected a strong white tin glaze. Although she continued to dabble in china painting, her most distinctive technique became her high-relief modeling on vessel forms. In common with the potters of her day, O'Hara became involved in the search for the Egyptian blue glaze and produced some good examples of it, notably a *Rooster* in the collection of the Bennington Museum. Her work is in the collection of The Metropolitan Museum of Art, New York; the Everson Museum of Art, Syracuse, New York; the William Rockhill Nelson Gallery, Kansas City, Missouri; the Henry Ford Museum, Dearborn, Michigan; and the Museum of the Cranbrook Academy of Art, Bloomfield Hills, Michigan. O'Hara was a member of the Society of Designers and Craftsmen of New York and an Honorary Life Member of the Keramik Guild of New York and the Pen and Brush Club.

(See Bibliography: American Federation of Arts, 1928; Colgate, 1955; Everson Museum, 1976; Syracuse Museum, 1937)

OHR, GEORGE E. (1857–1918). Born in Biloxi, Mississippi, the son of a blacksmith and a German mother from Württemberg. He ran away from home at an early age, working at a ship chandler's store in New Orleans. In the years that followed, he worked variously as an apprentice in a file cutter's shop, in a tinker's shop, and again in a ship's store. A family friend, Joseph Fortune Meyer, offered Ohr an opportunity to apprentice as a potter at a wage of $10 a month. After acquiring the rudimentary skills of his craft, he left on a two-year, sixteen-state tour of the nation's potteries. He returned to Biloxi to set up his own workshop with $26 in capital. During this period, Ohr also worked with Meyer at the

George E. Ohr.

New Orleans Pottery Company, possibly at the Crescent City Pottery, and at the Newcomb Pottery for a brief period, being dismissed as an unsuitable influence on refined young ladies. There is also an indication of Ohr's collaboration with Susan Frackelton, but no knowledge of how their collaboration came about. Ohr's pottery was burned down in 1893 and rebuilt in 1894, becoming one of the landmarks of Biloxi. It was even included on the souvenir porcelain plates made for the city in Europe. Ohr worked until 1909, when he closed down his Biloxi Art Pottery and decided to become a Cadillac dealer. Ohr's work was the most prophetic of his day, and Robert Blasberg accurately observes that Ohr was an aesthetic loner in his day who had little impact on his own time but instead "did a less common thing by anticipating much of the innovation in ours" (Blasberg, 1972). Apart from Ohr's gestural play with the material, he was also involved in an expression that, had the pieces been produced in the last twenty years, would certainly be labeled Funk. Ohr produced erotic-humorous objects, such as his vagina money boxes and pornographic buttons. Furthermore he

was also the father of the "verbal visual" in American ceramics, playing as freely with words as with clay. His attitude toward the relationship between title and object is indicated in a poster at one of his fair appearances: "Acts are fruit, words are leaves." An example of this application can be found with the naming of his many children. Their first names were also their initials, so the large Ohr brood went through life with the legacy of names such as Leo, Lio, Zio, Oto, Clo, Ojo, and Geo. In his ceramic work, Ohr used titles frequently as well as inscribing some of his wares with long rambling letters—one of which was addressed to the Smithsonian Institution. The Smithsonian has in its collection one of the more interesting works in this genre, a pair of top hats. The first is titled *Nine O'Clock in the Evening* (c. 1900) and is pristine and elegant, while the other, *Three O'Clock in the Morning* (c. 1900), is disheveled and crumpled. They anticipate the cartoon-strip Pop imagery in American clay of the 1960s and 1970s and are based on the same principles as Robert Arneson's *Sinking Cup* sequence (1972) and other objects that deal with the passage of time and with banal imagery. (See Bibliography: Barber, 1909; Blasberg, 1972; Clark, 1978; Eidelberg, 1972; Henzke, 1970; Jervis, 1902; Keen, 1978; Kovel and Kovel, 1974; Nelson, 1963, 1966; Ohr, 1901)

OLITSKI, JULES (1922–). Born in Gomel, Russia, and came to the United States at the age of two. He studied art at the National Academy of Design and the Beaux-Arts Institute, both in New York. He also attended the Ossip Zadkine School and the Académie de la Grande Chaumière in Paris. He received his B.A. and M.A. from New York University. Although Olitski was trained in portrait painting and still draws occasionally from life, he began to work in the 1950s in an abstract style, using thick pigments. His work has remained abstract in its concerns as he has developed a variety of means of applying pigment to the canvas. Olitski had some elementary involvement with ceramics before going to Syracuse, New York, in 1975 to participate in the Everson Museum of

Art's "New Works in Clay by Contemporary Painters and Sculptors." His major work for the exhibition was *Iron Cone 02-3,* which was executed by Margie Hughto, Stephen Calcagnino, and Jo Buffalo at Syracuse University in the old Consolidated Can building. This piece was built up in sections from a heavily grogged stoneware body, with small additions of iron oxide for color and chopped fiber glass for reinforcement. In addition, he produced eleven slab slip paintings where he applied the color by hand and several other sculptures, including *Yav I* and *Yav II.*

(See Bibliography: Everson Museum, 1976; "Museum Clay," 1976)

PERRY, MARY CHASE (1867–1961). Born in Hancock, Michigan, Perry studied at the Cincinnati Art Academy between 1887 and 1889. Among her fellow students were Maria Longworth Nichols and the Japanese artist Kataro Shirayamadani.

Mary Chase Perry. Photograph: Michigan State University.

She later returned to Michigan and studied with the Bohemian painter Frans Bischoff, a particular favorite of the china-painting movement. In 1903 she took much the same route as her close friend, Adelaide Robineau, ceased overglaze decoration, and opened Pewabic Pottery together with the inventor of the Revelation kiln, Horace J. Caulkins (1850–1923). The wares exhibited at the 1904 Louisiana Purchase International Exposition in St. Louis showed the strong influence of the French potter Auguste Delaherche as well as the styles of the Art Nouveau movement. She had all her forms thrown for her and concentrated on glaze chemistry, producing the much-sought-after "Egyptian blue," a superb but illusive iridescent glaze. Much of her creative energy went into architectural commissions, for which Perry and Pewabic were best known. Among her commissions were St. Paul's Cathedral, Detroit (1908); The Rice Institute, Houston (1913); National Shrine of the Immaculate Conception, Washington, D.C. (1923–1931), and The Detroit Institute of Arts (1927). Changes in architectural design did away with murals to a great extent, but the pottery remained active under Perry's guidance until her death in 1961 at the age of ninety-four. The pottery remained in operation until 1965 under the direction of Mrs. Ella Peters. It was given to the Michigan State University in 1965 and is now maintained as a museum. Perry was given several awards in her career, including the Binns Medal in 1947. A number of her works are in public collections, one of the most significant being the group of carefully selected pieces of her work given by the art connoisseur Charles L. Freer to The Detroit Institute of Arts.

(See Bibliography: American Federation of Arts, 1928; Ault, n.d.; Barber, 1909; Bleicher, 1977; Brunk, 1976; Detroit Institute, 1977; Eidelberg, 1972; Evans, *Art Pottery,* 1974; Flu, 1927; Hegarty, 1947; Henzke, 1970; Keen, 1978; Kovel and Kovel, 1974; Pear, 1976; Perry, 1902; Pewabic Pottery Archives, 1937; Plumb, 1911; Robineau, A., 1905; Stratton, 1941, 1946; Syracuse Museum of Fine Arts, 1937)

POMPILI, LUCIAN OCTAVIUS (1942–). Born in Washington, D.C. He studied at the Montana State University, Bozeman, taking his B.A. in 1968 and an M.F.A. in ceramic sculpture at the University of California, Davis, in 1971. Pompili taught from 1968 to 1975 at the University of California at Davis on an occasional basis and in 1976 became assistant professor at the Rhode Island School of Design in Providence. Pompili's work has been extensively exhibited in a number of one-man and group shows. He is known for his sensitive and delicate use of porcelain and more recently for his multimedia assemblages.

(See Bibliography: Renwick Gallery, 1977; San Francisco Museum of Art, 1972)

POONS, LARRY (1937–). Born in Tokyo, Japan, and studied first at the New England Conservatory, Boston, but discovered that he never "quite felt at home with really composing serious music" and transferred to the Boston Museum of Fine Arts School, where he studied painting. His early paintings involved the placing and painting of schemes of dots or "notes" on the ground color of the canvas. More recently his work has been based on responding to and working with the flow of paint—its thickness, thinness, and color. In February 1975 he visited Syracuse University, where a room was set aside for him with three walls of plywood loosely covered with burlap, each eight feet high and sixteen feet long. Thousands of pounds of heavily grogged wet stoneware of various colors was prepared and set up against the burlap walls. Poons then splashed, tossed, and dripped hundreds of pounds of slip onto these walls from buckets. In addition to the ceramic pigments, food coloring and paint dye were added to give Poons an indication of what colors to expect after firing. Before leaving, Poons devised a method of cutting the walls into sixteen-inch by twenty-one-inch tiles. These were fired at different temperatures to enhance various color tones in the clay and slip. On his second visit, Poons worked on a series of sculptural forms in stoneware, including two large mixed-media sculptures, and incorporated elements from the walls, the sculptural forms, and steel supports.

(See Bibliography: Everson Museum, 1976; "Museum Clay," 1976)

POOR, HENRY VARNUM (1888–1971). Born in Chapman, Kansas, and grew up on the prairie. He studied economics and art at Stanford University, Stanford, California, and later enrolled at the Slade School of Art in London. While studying there, he was strongly influenced by Roger Fry's First Impressionist Exhibition at the Grafton Gallery in 1910, which gave a startled English audience their first taste of Cubism. This inspired him to move to Paris, where he studied at the Académie Julian. On his return to the United States in 1912, he taught at Stanford and at the Mark Hopkins Art Institute, San Francisco. In 1923 Poor turned from painting to ceramics and had his first exhibition at the Montross Gallery in New

Larry Poons. Photograph: Stuart Lisson.

York. Until 1933 he devoted himself mainly to this medium, establishing a national reputation and winning a number of awards, including the Architectural League's Gold Medal of Honor. Poor's ceramic style at its best was characterized by the cutting off of the bold, abstract patterns at the edge of the plate to give a sense of fluidity and life to the decoration. Furthermore Cubism provided a solution for giving his forms weight and depth while respecting the two-dimensional surface through transparency, flattening of shapes, and shifts in vantage point. From the mid-1930s Poor continued to work in ceramics, although somewhat sporadically. In 1954 he published *From Mud to Immortality,* a book on the aesthetics of ceramics that expressed his personal and considered appreciation of the medium.

(See Bibliography: American Federation of Arts, 1928; *Art Digest,* 1947; "Art with the Inferiority Complex," 1937; "Ceramics: Double Issue," 1958; "Ceramics by Poor," 1947; Detroit Institute, 1977; "Henry Varnum Poor," 1971; Poor, 1948; Syracuse Museum, 1937, 1958)

PRICE, KENNETH (1935–). Born in Los Angeles, studied at the Chouinard Art Institute there in 1953–1954, and received his B.F.A. from the University of Southern California in 1956. In 1957–1958 he was one of the central participants in the experiment taking place at the Otis Art Institute under the loose but inspired leadership of Peter Voulkos. Seeking a new input and a break with a potentially claustrophobic California style, Price went to the New York College of Ceramics at Alfred University, where he received his M.F.A. in 1959. He returned to Los Angeles for a one-man show in 1960 at the Ferus Gallery. At this point, he broke strongly from his earlier work as a potter and began to develop a personal sculptural style, employing bright painted and glazed surfaces on biomorphic forms that extended the vision of the Surrealist sculptures of Brancusi, Arp, and Miró. It was an adventurous use of color in sculpture at a time when the polychrome metal movement on the West Coast was still in

its infancy. The works were well received, and writing of these forms in *Art International,* John Coplans commented on Sartre's remark that "Color is man smiling, modeling, man is in tears": "Price's work invokes to a remarkable degree a strange interplay between the joyful and the ominous. His color is physically brilliant, almost gaudy: these colors are set off against an imagery which would seem to be least congenial to it—it is dark, murky, very elementary and primordial—the last in the world that one would think to use this coloration with. It is this upsetting quality, the hard, bright, finite finishes against the vague, dark, elemental imagery that makes Price's sculpture so striking" (Coplans, 1964). From these sexually associative forms, Price moved on to an exploration of the cup as format, in such works as *California Snail Cup* (1965), dealing with the cup theme through drawings and lithographs. The most sophisticated of his cup themes were produced between 1972 and 1974, when he created a series of Constructivist cup assemblages. These forms

Kenneth Price.

dealt with a series of concerns: Price's distinctive play with flat, bright color; the tease between two and three dimensions; and the dialogue between fine and decorative art that flowed from the use of what was identified as functional form. The works were complex, witty, and sculpturally involving. Spatially they have reference to the Futurist sculpture theory of Umberto Boccioni. Boccioni demanded that the sculptor do more than simply present the volume of an object; he should also capture the spatial milieu that surrounds it. Writing of Price's work in 1976, the critic Mary King wrote that what Price brought off with these cups was taking the practical object—cup—and transforming it through "a great visual sophistication, and a dizzying shift of spatial gears. Like a ball in an enclosed court the spectator bounces off ideas of the humble cup into the rarified sophistication of Frank Stella reincarnated in 3-D, with persistent changes of scale wherein the curiously shaped container becomes an architectural monument, the bright fragment of an Art Deco dream" (King, 1976). Running parallel to this body of work was a major project that Price had intended to culminate in the creation of a huge curio shop. These "curios" were strongly influenced by the "airport" art of New Mexico and were eventually assembled into a smaller but immaculately presented exhibition, "Happy's Curios," at the Los Angeles County Museum of Art in 1978. The exhibition comprised mainly groups of painted ceramic forms—some produced with a stylistic reference to folk pottery—that were assembled in custom-made wooden shelving units. The exhibition, with its radiance and lush coloring, was a strong statement on decorative art and, in a sense, on painting as well. The reference to certain pieces, such as the *Shrine Assemblages*, was more directly related to cultural archetypes, but for the rest, the works dealt, as the art of Price has always done, with broad and major concerns in fine art today. The complexity of his style and issues cannot easily be condensed into a short biography, but one of the most succinct summaries of his work comes from a single paragraph in a review by Phyllis Derfner, writing in *Art in*

America: "Price is surely one of the most intelligent of contemporary American artists, and his intelligence is complete—it includes wit. He has discarded the idea that art can or should be a single-minded pursuit of a single quality or set of qualities. His selection from a grab-bag of stylistic possibilities that are very recent but just old enough to be quoted from has been assembled with an elegance so perfectly poised it seems incapable of slipping except, perhaps, into hilarity of the most exalted kind" (Derfner, 1975).

(See Bibliography: Ashton, 1969; "Ceramics," 1968; Clark, 1978; Coplans, 1964, 1966, 1973; Derfner, 1975; Giambruni, 1966; Hepburn, 1970; Hopkins, 1963; King, 1976; Layton, 1970; Lippard, 1960; Muchnic, 1978; Plagens, 1974; Scripps College, 1974; Tuchman, 1978)

RANDALL, RUTH HUNIE (1898–). Born in Dayton, Ohio. She took her diploma in design at the Cleveland School of Art in 1919 and her diploma in art education in 1921. In 1930 she took her B.F.A. at the College of Fine Arts at Syracuse University, New York. Influenced strongly by the art of Wiener Werkstätte potters, she traveled to the Kunstgewerbeschule in Vienna, working for the winter term of 1933 under Professor Michael Powolny. She taught at Syracuse University from 1930 to 1962, becoming first a professor of ceramics and then a professor of design and crafts. Through her tenacity, the ceramics department of Syracuse University has survived several attempts at closure and has grown into a significant force in the American ceramic arts. Randall now lives in retirement in northern Florida. Randall received several awards for her ceramic sculpture, including an Honorable Mention at the Ceramic National in 1934, Second Prize for ceramic sculpture at the Ceramic National in 1937, and First Prize at the Associated Artists of Syracuse exhibition in ceramic sculpture in 1939. One of her major works, *Madame Queen* (1935), is in the permanent collection of the Everson Museum of Art, Syracuse. Randall has contributed several articles on contemporary ceramic artists as well as a book of ceramic sculpture.

(See Bibliography: Randall, 1946, 1948; Syracuse Museum, 1937; Syracuse University, 1962)

RAUSCHENBERG, ROBERT (1925–). Milton Ernest (later Robert) Rauschenberg was born in Port Arthur, Texas. His first formal art training was at the Kansas City Art Institute, Missouri, in 1956 on the GI Bill, and in the following year he left for Paris, where he studied at the Académie Julian, so beloved of American artists. In 1948–1949 he studied under Josef Albers at Black Mountain College in North Carolina. Rauschenberg subsequently became known as a controversial, inventive figure in the arts and as an activist for his field, promoting several causes for the artist, including royalty legislation, a support system called "Change Incorporated," and Experiments in Art and Technology. Rauschenberg's involvement with ceramics came in 1972, when during a three-month stay at Graphicstudio at the art department of the University of South Florida, Tampa, he created a suite of five clay pieces related in imagery to the *Made in Tampa* prints suite. They employed a superrealist approach to the material and are among the major works of this particular expression in clay. Each of the five pieces was produced in limited edition with the collaboration of Allen Eaker and Julio Juristo.
(See Bibliography: Marshall, 1974)

RAYNOR, LOUIS B. (1917–). Raynor attended the New York College of Ceramics at Alfred University, Alfred, New York, where he received his B.F.A. in 1941 and his M.F.A. in 1946. He started teaching at Michigan State University, East Lansing, in 1946, where he has divided his time evenly between teaching and production.
(See Bibliography: "Ceramics: Double Issue," 1958)

REITZ, DONALD L. (1929–). Born in Sunbury, Pennsylvania, and studied at Kutztown State College, Pennsylvania, receiving his B.S. in 1957, and at Alfred University, Alfred, New York, where he

Donald L. Reitz.

received his M.F.A. He has taught at the University of Wisconsin, Madison, since the early 1960s. Reitz is one of the most sought-after potters on the workshop circuit and is known for his "Baroque" explorations of the medium of salt-glazing and his mastery of throwing techniques.
(See Bibliography: Brawer, 1971; Campbell Museum, 1976; Kalamazoo, 1977; Supensky, 1975; Troy, 1974; Victoria and Albert Museum, 1972)

RHEAD, FREDERICK HURTEN (1880–1942). Born in Hanley, Staffordshire, England, and followed the pottery tradition of his father by becoming art director of Waddle Art Pottery, Hanley, before he was twenty years of age. He came to the United States in 1902 and became associated with William P. Jervis at Vance/Avon Faience Works, later worked at Weller, and in 1904 became art director of Roseville Pottery, Zanesville, Ohio. In 1908 he rejoined Jervis at the Jervis Pottery on Long Island. In 1910 he became instructor in pottery at the University City Pottery, St. Louis, and in the following year joined the Arequipa Pottery. This pottery was influenced by the success of

Dr. H. J. Hall's Marblehead Pottery in Massachusetts. Arequipa was organized by Dr. Philip King Brown in Marin County, California. Rhead was employed as ceramist to give instruction to tubercular girls. After his departure, Albert Solon, the son of the renowned ceramic artist and historian, Louis Marc Solon, took over the pottery. Rhead moved to Southern California, where he opened the Rhead Pottery in Santa Barbara. There he experimented with glazes, managing to produce the Chinese black-mirror glaze after fifteen years of research. In 1917 he closed his pottery and returned to the Midwest, joining the American Encaustic Tiling Company of Zanesville as research director, and in 1927 he became art director of the Homer Laughlin China Company, Newark, West Virginia, remaining there until his death in 1942. Rhead was one of the most prolific, eclectic, and outspoken members of the ceramic community of his time. He won a Gold Medal at the San Francisco Panama-Pacific International Exposition in 1915 and the Charles F. Binns Medal of the American Ceramic Society in 1934. Early in his career, Rhead had attempted to publish a magazine, *The Potter*. The first issue came out in December 1916 and the third and final issue in February 1917. The magazine was excellently produced and included articles from some of the leading artists and historians of his day. Rhead used it to give vent to his opinions and points of view, and his singular independence as a critic is well illustrated in his comments regarding Adelaide Alsop Robineau's *Scarab Vase*. While everyone else hailed it as a masterpiece, Rhead called this work "a monstrosity" and added that it was "the sort of thing which a criminal condemned for life will whittle away to pass the time" (Rhead, 1916).

(See Bibliography: Alexander, 1970; Barber, 1909; Eidelberg, 1972; Evans, 1971; Henzke, 1970; Keen, 1978; Kohlenberger, 1976; Kovel and Kovel, 1974; Pasadena Center, 1974; Rhead, 1899, 1910, 1916, 1917)

RHODES, DANIEL (1911–). Born in Fort Dodge, Iowa, and studied at the School of The Art Institute of Chicago,

the University of Chicago, the Art Students League in New York, and Alfred University, Alfred, New York. In 1962–1963 he worked in Japan on a Fulbright research grant. He has taught at the University of Southern California, Black Mountain College in North Carolina, Haystack Mountain School of Crafts in Liberty, Maine, and Alfred University. Since 1948 he has had numerous one-man shows, including the Museum of Contemporary Crafts in New York in 1967. This exhibition centered mainly on work combining fiber glass and clay, a technique developed by Rhodes in 1964 to extend the sculptural possibilities of clay. Rhodes has written some of the most important handbooks for the postwar American potter, notably *Clay and Glazes for the Potter* (1957), *Stoneware and Porcelain* (1959), *Kilns* (1968), and *Pottery Form* (1976). Rhodes now lives in retirement near Santa Cruz, California, where he operates a studio and is currently working on vessel forms.

(See Bibliography: "Ceramics: Double Issue," 1958; "Ceramics East Coast," 1966; Everson, 22nd Ceramic National Exhibition, 1962–1964; Pyron, 1964; Rhodes, 1957, 1968, 1970, 1976, 1977; Richards, 1958)

RIEGGER, HAROLD EATON (1913–). Born in Ithaca, New York. He studied at the New York College for Ceramics at Alfred University, Alfred, New York, where he received his B.S. in 1938 and at Ohio State University, receiving his M.A. in 1940. After his studies he moved to San Francisco, eventually setting up home and workshop in Mill Valley. He soon became interested in raku and primitive firing techniques and is author of several how-to manuals on ceramic craft. He has taught ceramics at the Haystack Mountain School of Crafts, Liberty, Maine; California College of Arts and Crafts, Oakland; California School of Fine Arts, San Francisco; University of Oregon, Eugene; Museum of Industrial Art, Philadelphia; Ohio State University, Columbus.

(See Bibliography: "Ceramics: Double Issue," 1958; Riegger, 1970, 1972)

ROBERTSON, HUGH CORNWALL (1844–1908). Born in Wolviston, Durham County, England, of a potting family that originated from Edinburgh. In 1853 his family came to New Jersey and resettled in East Boston, Massachusetts. There his father, James Robertson, joined with Nathaniel Plympton to form the Plympton and Robertson Pottery. In 1866 one of his sons, Alexander, set up an independent art pottery in Chelsea, joined by Hugh in 1867 and amalgamating with their father in 1872. In that year the firm began to use the title Chelsea Keramik Art Works. After the death of his father and the move of his brother to California, Hugh became the master potter. The Victorian pastiche of the early artwares slowly gave way to Robertson's infatuation with the Orient. In particular, he became involved in the search for the sang de boeuf or oxblood glaze, which was achieved through the reduction of copper. He first achieved this in 1885 and finally perfected it in 1888. He received honors for this work at the Paris Exposition in 1900, in 1904 at the St. Louis Louisiana Purchase International Exposition, and at the Panama-Pacific International Exposition in San Francisco in 1915. Another of his achievements was the discovery of a gray-white Oriental crackle glaze in 1886, which later became the distinguishing feature of the Dedham Pottery. Robertson was so involved with his glaze experiments that he neglected the finances of his company, which closed in 1889. In 1891 a group of influential Bostonians provided the capital to reestablish the pottery, which was known as Chelsea Pottery, the name being changed to Dedham Pottery in 1893. The pottery became known for its distinctive crackle wares with their blue stencil decorations. Following his death in 1908, Robertson's son William assumed management of the Dedham works until 1929. The Dedham Pottery finally closed its doors in 1943 because of a combination of a shortage of skilled labor and escalating costs.

(See Bibliography: Barber, 1909; Detroit Institute, 1976; Eidelberg, 1972; Foster, 1913, 1914; Hawes, 1968; Henzke, 1970; Jervis, 1902; Keen, 1978; Kovel and Kovel, 1974; Nelson, 1963, 1966; Swan, 1926)

ROBINEAU, ADELAIDE ALSOP (1865–1929). Born in Middletown, Connecticut, Adelaide Alsop took an early interest in painting, intent upon earning an independent living. She was attracted to china painting and although largely self-taught soon became a prominent decorator and a member of the National League of Mineral Painters. She taught for a short time at St. Mary's in Minnesota and then returned to New York to study under William Chase. She exhibited watercolors at the New York Academy and became involved in painting miniatures on ivory. In 1899 she married Samuel Robineau, and in the same year, with an associate George H. Clark, they established *Keramik Studio,* which Adelaide Robineau edited until her death in 1929. From 1903 she turned to the making of fine porcelains, influenced by the French ceramist Taxile Doat. In 1911 she received the first acknowledgment of her work when it was declared "the best porcelain in the world" at the Turin Exposition. Robineau was awarded the Grand Prix and the Diploma della Benemerenza and in the following year exhibited at both the Paris Salon and the Musée des Art Décoratifs. Medals and prizes were given to her by The Art Institute of Chicago and the societies of arts and crafts in Boston and Detroit. In 1915 her porcelains won another Grand Prix at the Panama-Pacific International Exposition in San Francisco. Two years later Syracuse University conferred an honorary doctorate of the ceramic sciences and she joined the faculty two years later, remaining there until 1928. In 1929 The Metropolitan Museum of Art in New York held a memorial exhibition of her works, a tribute to the skill with which she "wrought the paste into forms of beauty, sometimes austerely massive, sometimes exquisitely fragile and graceful . . . in the difficult field of porcelain, the royal domain of the arts of fire" (see Bibliography: Metropolitan Museum of Art, 1929).

(See Bibliography: American Federation of Arts, 1928; Barber, 1909; California State University at Fullerton, 1977;

Eidelberg, 1972; Evans, *Art Pottery,* 1971, 1974; Everson Museum of Art, *Art Deco Environment,* 1976; Henzke, 1970; Hull, 1960; Keen, 1978; Kohlenberger, 1976; Kovel and Kovel, 1974; Levin, 1975; La Ligue Américain . . . , 1911; Metropolitan Museum of Art, 1929; Olmsted, A. W., 1931; Panama-Pacific International Exposition, 1915; Robineau, A. A., 1905, 1925–1926; Robineau, S., 1911, 1929; "Syracuse Gets . . . ," 1931; Wise, 1929)

ROTHMAN, JERRY (1933–). Born in Brooklyn, New York, and studied at the Los Angeles City College (1953–1955) and at the Art Center School, Los Angeles, where he took his B.A. in 1956. From 1956 to 1958 and again in 1960–1961, he studied at the Otis Art Institute, Los Angeles, taking ceramics and sculpture as his major and receiving his M.F.A. He has received many prizes and awards, including the purchase prize for ceramic sculpture in 1962 at the 17th National Decorative Arts and Ceramics Exhibition in Wichita, Kansas; the Louis Comfort Tiffany Award in 1963; and sculpture awards at the Ceramic Nationals in 1964, 1968, and 1969. In 1976 he had a one-man exhibition of large ceramic sculptures at The Oakland Museum, Oakland, California. Rothman's aesthetic credo has largely been based on the belief that there is no such thing as intrinsic beauty in any given material. He contends that the intrinsic qualities of a material are simply those qualities that the artist can see and extract. Therefore much of his technical development has been directed toward ending what he calls "the limitations of clay" and creating a shrink-free clay that has allowed him to produce sculptures of up to twenty feet in height. Use of clay has further allowed him the freedom of combining high-firing metals with his sculptural pieces. One of the finest of these recent works is *Coming Through #2* (1976), which is illustrated in this study. It shows an interesting return to his early involvement with metal and clay, when he exhibited with Paul Soldner and John Mason at the Ferus Gallery, Los Angeles, in 1957, showing large Constructivist clay assemblages on steel rods. In addition to

working sculpturally, Rothman has also consistently produced ceramic vessels, of which his series of *Sky Pots,* commenced late in the 1950s, is his best known. A strong new thrust is apparent in his work with a new series of vessels beginning with the tureens exhibited in the Campbell's "Soup Tureen" show, developing an area of what Rothman teasingly refers to as "Bauhaus Baroque," a combination of formal composition and sensual, expressionist elements.

(See Bibliography: Campbell Museum, 1976; Ceramic Arts Library, 1978; Clark, 1978; New Gallery [Iowa], 1963; Rothman, 1976; Scripps College, 1974; University Art Galleries, 1976; Victoria and Albert Museum, 1966; William Hayes Ackland, 1977)

RYAN, MAZIE THERESA (1879–1946). Ryan received her diploma of art from Sophie Newcomb Memorial College for Women, New Orleans, in 1899 and was a graduate student from 1901 to 1905. She later became an independent designer of pottery as well as producing fire screens, embroidery, and beaded lampshades.

(See Bibliography: Clark, *Ceramic Art,* 1978; Ormond and Irvine, 1976)

SANDERS, HERBERT (1909–). Born in New Waterford, Ohio. He studied at Ohio State University, Columbus, working as a graduate assistant to Arthur Baggs, chairman of the ceramics department in 1933. He continued at the university for three summers as an instructor in ceramics until his move in 1938 to San Jose State College, San Jose, California. In 1951 Ohio State University presented him with a Ph.D., the first granted in ceramics in the United States, and he returned to San Jose State as a full professor to establish a ceramics department at the college and to publish his research. Since then, he has published numerous books of glazes and decorative techniques in ceramics. Sanders is particularly known for his achievements in the field of crystalline glazes. By the time of his retirement in 1974, he had built up the San Jose State University ceramics course to a major department with 350 students and 4 full-time instructors. Since

his retirement, he has traveled throughout the United States, Italy, Japan, and Yugoslavia and has continued his research into glaze chemistry.

(See Bibliography: Everson, 22nd Ceramic National Exhibition, 1962–1964; Levin, 1976; Sanders, 1967, 1974; Syracuse Museum, 1937, 1938)

SAXE, ADRIAN (1943–). Born in Glendale, California, and received his education at the California Institute of the Arts, Valencia, California, receiving his B.F.A. in 1974. In 1971–1972, while still an undergraduate, he was instructor of art at the California State University at Long Beach, where he taught special subject courses in ceramics for senior and graduate level ceramics majors. From 1973 to the present, he has been assistant professor of art at the University of California at Los Angeles. Saxe works in porcelain, employing iconographic images for his hand-built vessel forms. A quality of Saxe's work is the manner in which he exploits the sensuality and richness of color and glaze on the porcelain bodies.

(See Bibliography: Long Beach, 1977)

SCHEIER, EDWIN (1910–) and MARY. Born in New York City and first studied at the New York School of Industrial Arts, where he remained for two years. He spent the summer months as a merchant seaman, which gave him his love for the art of tattooing, a skill in which he later became adept and which had a strong influence later in his work in pottery. After a period of time working for the Federal Art Project, he became the field supervisor of crafts for the southern states. In 1935 he met and married Mary Goldsmith, and the couple resigned their art supervision jobs and began to travel through the United States with a puppet show. Their itinerary took them to Norris, Tennessee, where one day Hewitt Wilson called on them and suggested that they work in clay. They set up their first pottery at Glade Spring, Virginia, having accidentally discovered the existence of a superb local red clay. They achieved early success, and pieces made during the first year were shown in the Contemporary In-

dustrial Arts Exhibit at The Metropolitan Museum of Art, New York. The exhibit of nine pieces was awarded First Prize later at the "Western Hemisphere" exhibit in Syracuse in 1941. In 1938 they moved, at the invitation of the League of New Hampshire Arts and Crafts, to teach ceramics at the University of New Hampshire. In 1945 the Scheiers became part of Operation Bootstrap, training Puerto Ricans in ceramic techniques. They remained at the University of New Hampshire until 1950 and on their retirement moved to Oaxaca, Mexico, where they continue to operate their pottery.

(See Bibliography: Levin, 1976; New Gallery [Iowa], 1963; Randall, 1946; Scripps College, 1974; Syracuse Museum, 12th Ceramic National, 1948; 20th Ceramic International, 1958)

SCHLANGER, JEFF (1937–). Born in New York City and studied at the Cranbrook Academy of Art, Bloomfield Hills, Michigan, under Maija Grotell and at Swarthmore College, Swarthmore, Pennsylvania, where he received his B.A. in 1959. From the outset, Schlanger was one of the early ceramic artists to consider ceramics in its conceptual mode. Although he produced objects as such, the gesture, the political statement, the intellectual message of the work ultimately became more important than the formal concepts of beauty within the object itself. Schlanger now deals mainly with political comment in his sculptural clay works and recently had a one-man exhibition at Alfred University, Alfred, New York.

(See Bibliography: Schlanger, "Ceramics and Photography," 1967; "Claes Oldenburg," 1966; Maija Grotell," 1969; "Roy Lichtenstein," 1966)

SCHRECKENGOST, VIKTOR (1906–). Born in Sebring, Ohio, the son of a potter. He studied at the Cleveland Institute of Art from 1924 to 1929 and did his postgraduate study at the Kunstgewerbeschule, Vienna, in 1929 and 1930, where he studied ceramics and sculpture under Michael Powolny. Returning to Cleveland, he accepted a post on the faculty of the Cleveland School of Art (Cleveland Art

Institute) and at the same time became assistant to R. Guy Cowan, Cowan Pottery Studio, where he worked as a designer. While working there, he produced a set of twenty punch bowls for Eleanor Roosevelt for a party at the governor's mansion in Albany, New York. They were produced in a sgraffito technique using a bright blue slip. The superb designs were an assemblage of words and images: skyscrapers, cruise ships, and words such as *stop, go,* and *cafe* interspersed with effervescent bubbles and stars. The pieces were later produced in a commercial version and became most popular during the closing period of the Cowan Pottery Studio (Cowan went into receivership in 1930 and finally closed one year later). After the closing of the Cowan Pottery, Schreckengost divided his time between the production of individual ceramic sculptures and working as a designer for several ceramics firms in the United States. In 1933 he reorganized the production of American Limoges Ceramics Company, Sebring, Ohio, then running at less than thirty percent of its production. Schreckengost's sleek, unadorned sculptural-style dinnerware proved to be extremely popular, and within a year the company had to expand production in order to meet the demand for these wares. This move toward an Art Moderne style was soon followed by the other potteries in the United States. Later he worked on similar projects for Sebring Pottery, Leigh Potters, Alliance, Ohio, and Salem China, Salem, Ohio. Throughout this period, Schreckengost was an active exhibitor in the May Shows at the Cleveland Museum of Art and at the Ceramic Nationals. After World War II, Schreckengost's interests were directed mainly toward industrial design, and he became chairman of the department of industrial design at the Cleveland Art Institute. He was for a time the art director and designer of the Murray Ohio Company, Cleveland, Ohio, manufacturer of children's toys. He has, however, retained an active involvement with ceramics. In the early 1950s, he developed a new style of working (carving vessels out of dry chunks of clay) and also worked on numerous architectural commissions, including a major series of terra-

cottas for the bird tower and the pachyderm building at the Cleveland zoo. Schreckengost's contribution to architectural ceramics was acknowledged in 1958, when he was the recipient of the Gold Medal of the American Institute of Architecture. Schreckengost has received numerous awards for his work in sculpture ceramics and painting: fifty-one awards, including nine special awards for outstanding excellence from the Cleveland Museum of Art; First Prize for sculpture (1938) at the 7th Ceramic National; the IBM Sculpture Award (1951); First Prize for sculpture from the New York Architectural League (1954); the Philadelphia Museum Award of Merit (1938); the Butler Institute of American Art Sculpture Award (1948); the Grumbscher Award (1955); and the Charles Fergus Binns Medal of the American Ceramic Society for Outstanding Contribution to the Ceramic Field (1939). Schreckengost is a past president of the American Ceramic Society and remains one of the most active and significant figures in the activities of the art and design division of this organization.

(See Bibliography: Cleveland Institute, 1976; Cullinan, 1976; Everson Museum, 1976, 1978; Grafly, 1949; Hoffman, Driscole, and Zahler, 1977; "New Designs . . . ," 1935; Stubblebine, 1975; Syracuse Museum, 1937, 1938; Syracuse Museum, 12th Ceramic National, 1948)

SHANER, DAVID (1934–). Born in Pottstown, Pennsylvania, taking his M.F.A. degree in ceramic design at Alfred University, Alfred, New York, in 1959. From 1959 to 1963, he was assistant professor of art, University of Illinois, Champaign-Urbana, and from 1963 to 1970 the resident potter and director of the Archie Bray Foundation, Helena, Montana. Since 1970 he has run his pottery near Big Fork, Montana, on a full-time basis, producing mainly functional wares. Shaner's work, distinguished by its sturdy forms, has been exhibited widely in over 150 regional, national, and international juries and invitational exhibitions since 1960. Shaner has received several awards, including the Louis Comfort Tiffany scholarship award in 1963

Donald Shaner. Photograph: Paul O'Hara.

Richard Shaw.

and the National Endowment for the Arts Craftsman Fellowship in 1973 and 1978.

(See Bibliography: Clark, 1975; Cox, 1976; Depew, 1972; Everson, 24th Ceramic National Exhibition, 1966–1968; Kalamazoo, 1977; Kansas City Art Institute, 1976; New Gallery [Iowa], 1963; Scripps College, 1974)

SHAW, RICHARD (1941–). Born in Hollywood, California, and studied at the Orange Coast College, Costa Mesa, California, from 1961 to 1963 and at the San Francisco Art Institute in 1965, where he received his B.F.A. He later studied at the New York College of Ceramics at Alfred University, Alfred, in 1965 and at the University of California, Davis, where he received his M.A. in 1968. Shaw has been the most influential figure in the development of a Super Object school in the Bay Area, although his influence among the younger generation of ceramics artists has extended throughout the country. Shaw's works are a continuation of the concerns

that began to surface among the Surrealist object makers during the 1930s. However, his work avoids the unease of objects such as the *Fur Teacup* (1936) by Meret Oppenheim and the *Lobster Telephone* (1936) by Salvador Dali. Instead his style follows the lead of that indicated by the gentle, sensual, and poetic assemblages by Miró that deal with scatalogical combinations of elements from stuffed birds to wooden legs. In addition, a strong early influence on Shaw is the graphic illustrative style of painter René Magritte as seen in Shaw's early series of ceramic couches in 1966–1967. In later works, however, Shaw began to deal less with the illustrative concerns of Surrealism and began to explore what might be termed *incongruity*. This was particularly apparent at his exhibition at the San Francisco Museum of Modern Art in 1973 with Robert Hudson, where birds, deer hooves, decoy ducks, twigs, and branches were assembled into what we identify as functional objects—teapots, teacups, and bowls. In these works, Shaw ap-

peared to be more concerned with the technical seduction of trompe-l'oeil surfaces than with content. While these objects deal with metamorphosis, they do so without employing the shock tactic of the Dada object makers. Nonetheless several reviewers have attempted to link Shaw's work to this early object-making expression. A particular example is the review of the exhibition by Mary Fuller McChesney (1973), who attempted to apply the words of the early Dadaist Tristan Tzara to the works of Shaw. In so doing, McChesney misunderstood both the essence of Dada and that of Shaw's works. Whereas Dada was concerned with the conceptual and contextual relevance of the object, Shaw's investigation has been primarily iconographic, unashamedly decorative, and based upon the Surrealist's belief in the sureness of the imagination. Shaw's work is now entering a period of intriguing maturity, and in works such as *Blue Goose* (1978) and *Whiplash* (1978), a complex and ambiguous dialogue is now growing between material and image and their play with reality and illusion.

(See Bibliography: Albright, 1976; Barcellona, 1976; Breckenridge, 1965; California State University, Fullerton, 1976; Campbell Museum, 1976; Cochran, 1976; Grosmont College, 1977; Laguna Beach, 1977; McChesney, 1973; Nordness, 1970; Pugliese, 1966, 1975; Renwick, 1977; San Francisco Art Institute, 1971; San Francisco Museum of Art, 1972, 1973; University Art Galleries, 1976; Victoria and Albert Museum, 1972; William Hayes Ackland, 1977)

SHEERER, MARY GIVEN (1865–1954). Born in Covington, Kentucky, and spent her youth in New Orleans. She won a scholarship to study at the Cincinnati Art Institute under Frank Duveneck, joining his classes in still life. In 1894 she joined the Sophie Newcomb Memorial College School of Art in New Orleans, where she eventually became professor of ceramics and drawing. At the college, a pottery was established that was run along professional lines, and the work of students was sold when it became proficient enough. Sheerer was responsible for the selection

of all objects for sale and so was largely responsible for the aesthetic direction and initial success of the pottery, which reached its peak with the receiving of the Grand Prize at the Panama-Pacific International Exposition in 1915. Writing of the pottery's dual role, Sheerer commented, "The fact of its being under the support of a college would make it possible to aim for only the truest and the best, and so it would not be forced to consider too closely the tastes of the public, but to follow honestly and sincerely its own principles. To this end it was decided that the decorator should be given full rein to his fancy . . . it was also decreed that no two pieces should be alike and that each should be fresh—inspired by the form demands of that particular vase or cup. The whole thing was to be a Southern product, made of Southern clays, by Southern artists, decorated with Southern subjects. There were possibilities in it. And so with these hopes and fears the Newcomb Pottery was given birth" (Sheerer, 1899). After World War I, the interest in the art-pottery movement diminished rapidly, although the work of the Newcomb Pottery remained a favorite. Its works were not seen in terms of a mainstream but rather as a form of nostalgia, and Sadie Irvine remarked that critics frequently began to use the term *Victorian* in describing their wares. Sheerer gave up her interest in china painting and turned to an active broader role in the ceramic arts. From 1924 to 1927 she was chairman of the art division of the American Ceramic Society and was made a fellow in 1931. In 1925 she was honored by being elected as a delegate on the Hoover Commission to the Exposition Internationale des Arts Décoratifs et Industriels Modernes in Paris. Sheerer retired from her post at the Newcomb College School of Art in June 1931 and settled in Cincinnati.

(See Bibliography: Henzke, 1970; Jervis, 1902; Keen, 1978; Kovel and Kovel, 1974; Ormond and Irvine, 1976; Sheerer, 1899, 1918, 1924)

SHIRAYAMADANI, KATARO (1865–1948). Born in Kanazawa, Japan, he came to the United States as part of a traveling Japanese village, and in May

1887 this talented Japanese artist was invited to join the decorating staff of Rookwood Pottery. While on the staff he studied at the Cincinnati Art Academy and soon became one of the finest artists on the staff. He remained at Rookwood Pottery until his death in 1948, except for ten years in Japan from 1915 to 1925. Shirayamadani is credited with developing the electrodeposit method on metal and also designed many of the standard shapes.

(See Bibliography: Peck, H., *Book of Rookwood Pottery,* 1968; Trapp, 1973)

SICARD, JACQUES (1865–1923). Born in France and came to the United States in 1901 after a long association with the pottery of Clement Massier of Golfe Juan in France. The pottery, established in 1881 in a small town close to Cannes, originally produced lusterwares—the result of Massier's inspiration from the Hispano-Moresque pots that he had seen in Italian collections. Massier soon developed an iridescent glaze, for which his pottery became renowned. In the United States, Sicard worked for the pottery of Samuel A. Weller, one of the most commercially successful of the American art potteries. Sicard produced individual works, together with his assistant Henri Gellie, that were known as Sicardo wares or Sicardo-Weller. He worked on fluid, simple forms, decorating them with floral and other motifs, achieving an exciting tonal range from purple and red and rich pink to peacock blue. Sicard returned to France in 1907, although Weller continued to offer the Sicardo wares for sale until after 1912. One of Sicard's finest works is in the collection of the Philadelphia Museum of Art, received by that institution as a gift from Samuel Weller, and in addition, there is a sizable collection of Sicard's work at the Zanesville (Ohio) Art Center museum.

(See Bibliography: Barber, 1909; Eidelberg, 1972; Henzke, 1969, 1970; Keen, 1978; Kovel and Kovel, 1974)

SIMPSON, ANNA FRANCES "FANNY" (1886–1930). Simpson received her diploma of art at Sophie Newcomb Memorial College for Women, New Orleans, in 1906 and remained as a decorator at the New-comb Pottery until her death in 1930. Six months after her death a memorial exhibition of her pottery was shown at The Museum of Fine Arts, Houston, Texas.

(See Bibliography: Blasberg, 1968, 1970; Clark, 1977; Evans, "Newcomb Pottery," 1974; Henzke, 1970; Ormond and Irvine, 1976)

SINGER, SUSI (1895–1949). Born in Austria, studied at the Kunstgewerbeschule, Vienna, under Professor Michael Powolny. She produced ceramics for the Wiener Werkstätte as well as independent pieces from her own studio, which she established in 1925 at Grunbach. Singer rapidly established herself as one of the leading European ceramic artists, exhibiting at the 1925 International Paris Exposition and winning several awards at later world's fairs, including a First Prize in London (1934), a Second Prize in Brussels (1935), and a First Prize at the "Arts and Techniques" exposition in Paris (1937). In the late 1930s, she moved to the United States, making her home in Pasadena, California. A Scripps College research grant from the Fine Arts Foundation in 1946 permitted Singer to expand her experiments with American slips and glazes. A collection of over thirty ceramic figures created under this grant are in the permanent collection of the Scripps College Museum, Claremont, California.

(See Bibliography: American Federation of Arts, 1928; Neuwirth, 1975; Scripps College, 1947)

SMITH, DAVID (1906–1965). Born in Decatur, Indiana, and after a period of working in an automobile factory, moved to New York City in 1926, where until 1932 he studied painting at the Art Students League. By 1931, influenced by the welded metal sculptures of Picasso and Julio Gonzalez, he began to add objects to his painted surfaces and also made sculpture. In Brooklyn, in 1932–1933, he began to work in welded steel, holding his first one-man show of drawings and sculptures at Marian Willard's East River Gallery in 1938. Through the 1940s and 1950s, Smith was an active exhibitor, with over thirty-five one-man shows, and was included in numerous group exhibitions

in both the United States and abroad. Smith is credited with introducing in the 1940s what became known as *Space Frame,* a means of establishing a pictorial plane but retaining, nonetheless, a three-dimensional result. In 1964 Smith produced a series of ceramics in collaboration with David Gil on a project initiated by *Art in America.* The small, but nonetheless successful, body of work employed slab sculptural forms as well as plates that he coated with slip while still damp; he then drew on the surface. These pieces, from the private collection of David Gil, were exhibited posthumously at the Everson Museum's "New Works in Clay by Contemporary Painters and Sculptors."

(See Bibliography: Everson Museum, 1976; Lafean, 1965; "Museum Clay," 1976)

SOLDNER, PAUL (1921–). Born in Summerfield, Illinois, and studied at Bluffton College, Ohio, where he received his B.A. While taking his master's degree at the University of Colorado, Boulder, he became interested in pottery through Katie Horseman, a visiting lecturer and

Paul Soldner.

head of ceramics at the Edinburgh College of Art in Scotland. In 1954 he decided to become a potter and enrolled at the Los Angeles County Art Institute, joining a group of students working with Peter Voulkos, the newly appointed head of the ceramics department. Soldner was one of the few artists to remain within a functional mode. However, he did not view his role as potter in a totally traditional sense, and he produced exploratory works such as his monumental floor pots while at Otis. In 1960, in response to a request to provide a pottery demonstration for students at a crafts fair, he decided to experiment with the raku firing technique. This technique involves throwing and bisque-firing earthenware vessels, which are then glazed and placed directly in an open raku kiln to be withdrawn a few minutes later and plunged into a bin of wood shavings while still red-hot. Soldner later adopted the technique as his major medium of expression and was responsible for establishing raku as one of the major areas of art expression in ceramics. Through the 1960s and 1970s, he has been an influential teacher both as the head of ceramics at Scripps College in Claremont, California, and through his numerous visiting lectureships and workshops around the country. Soldner acknowledges that raku has grown away from the Oriental traditions and has become a strongly American art form. Nonetheless the same demands for depth and sensitivity that are required of the Oriental raku artists are essential for their Western counterparts if the technique is to become more than an amusing parlor trick: "In the spirit of raku, there is the necessity to embrace the element of surprise. There can be no fear of losing what was once planned and there must be an urge to grow along with the discovery of the unknown. In the spirit of raku: make no demands, expect nothing, follow no absolute plan, be secure in change, learn to accept another solution and, finally, prefer to gamble on your own intuition. Raku offer us deep understanding of those qualities in pottery which are of a more spiritual nature, of pots by men willing to create objects that have meaning as well as function" (Soldner, 1973).

(See Bibliography: "Ceramics: Double Issue," 1958; "Ceramics West Coast," 1966; De Vries, 1976; Kalamazoo, 1977; Kester, 1976; New Gallery [Iowa], 1963; Nordness, 1970; San Francisco Museum of Art, 1972; Scripps College, 1974; Soldner, 1973; Victoria and Albert Museum, 1972)

SPINSKI, VICTOR (1940–). Received a B.S. in art and foreign languages from Kansas State Teachers College, Emporia, in 1963, and an M.F.A. from Indiana University, Bloomington, in 1967. He received a Craftsmanship Fellowship from the National Endowment for the Arts for 1974/75. Spinski lives in Newark, Delaware, and teaches at the University of Delaware. When discussing his work, he says he is "trying to be a statement-maker for our time," and he is currently involved in research in the field of ceramics.
(See Bibliography: Campbell Museum, 1978)

STAFFEL, RUDOLPH ("RUDI") (1911–). Born in San Antonio, Texas, and studied under various artists, including the Spanish painter Jose Arpa and Hans Hofmann in New York. In 1931 he studied at The Art Institute of Chicago under Louis Ripman and Laura Van Papelladam. In 1937 he was invited to teach ceramics at the Arts and Crafts Club of New Orleans. In addition to teaching there, he also worked on a part-time basis with Paul Cox, who established a sophisticated production pottery in New Orleans for the production of strawberry-canning pots for the Louisiana jam industry. Staffel was to learn a great deal from Cox about the traditions and history of ceramic art. In 1940 he joined the Tyler School of Art, Philadelphia, where he taught until his retirement in 1978. The breakthrough in Staffel's art came in the 1950s, when he was invited to produce a set of dinnerware in porcelain. Up until that point, he had felt that porcelain was alien to the craft tradition. He experimented with slip decorating and, fascinated by the translucence of the material, began to work toward a combination of form and material that would actually transmit light.

Staffel worked with highly volatile porcelaneous clay bodies, and his enjoyment of the considerable risk element in this work is emphasized by his comment: "The best body that I have ever worked with is the body that I know nothing about or very little about" (Winokur and Winokur, 1977). Staffel relates his work to the push-pull of the Hofmann mode of expression, emphasizing that one is not aware of the push until one sees the pull. Working on this basis, he builds and throws his vessels, known as "light gatherers," in order to create different intensities of light and dark in his forms by incising into the porcelain to reveal the light through the thin layer of clay or else building his forms out of a number of small clay slabs of different thinness and color. The 1970s have seen the most fertile growth of this unique expression in the medium, establishing Staffel as one of the most original vessel makers in American ceramics.
(See Bibliography: Cochran, 1976; Nordness, 1970; Victoria and Albert Museum, 1972; Winokur and Winokur, 1977)

STEINER, MICHAEL (1945–). Born in New York City, where he now lives and works. He has exhibited his sculptures at numerous museums in the United States and Europe and was the recipient of a Guggenheim fellowship in 1971. Steiner has taught at the University of Saskatchewan, Canada; the School of Visual Arts, New York City; and Wellesley College, Wellesley, Massachusetts. Steiner's principal medium is Cor-ten steel, although he also works in aluminum and brass. In 1975 Steiner created a body of fifteen stoneware sculptures at Syracuse University, New York, for the Everson Museum's "New Works in Clay by Contemporary Painters and Sculptors." The works ranged in scale from twelve inches to forty-eight inches in length, and he assembled them while the clay was still wet and plastic, cutting off corners of the slab, making right-angle concave cuts, and bending the rectangular slabs to emphasize the malleability of the material.
(See Bibliography: Everson Museum, 1976; "Museum Clay," 1976; Nordstrom, 1978)

John H. Stephenson. Photograph: Bill Rice.

Suzanne G. Stephenson. Photograph: Bob Vight.

STEPHENSON, JOHN H. (1929–).
Born in Waterloo, Iowa, and studied at
the University of Northern Iowa, Cedar
Falls, taking his B.Ed. in 1951. Between
1952 and 1956, he served in the U.S. Air
Force, returning in 1956 to his studies at
the Cranbrook Academy of Art, Bloom-
field Hills, Michigan, where he took his
M.F.A. in 1958. Since then, Stephenson
has taught in several schools and colleges
and in 1962–1963 studied natural glazing
in Japan. Since 1959 he has taught at the
University of Michigan, Ann Arbor, where
he is now professor of art. Stephenson has
exhibited extensively since 1950, and his
use of material has gradually evolved
away from the vessel toward purely sculp-
tural concerns. He has received many
medals and awards, including the Gold
Medal of the City of Faenza at the XXIII
Concorso Internazionale Della Ceràmica
d'Arte Faenza, Faenza, Italy.

(See Bibliography: Everson, 22nd Ce-
ramic National Exhibition, 1962–1964;
Long Beach, 1977; New Gallery [Iowa],
1963; "23rd Concorso . . . ," 1965; Uni-
versity of Michigan, 1978; William Hayes
Ackland, 1977)

STEPHENSON, SUZANNE G. (1935–
). Studied at the Carnegie-Mellon Uni-
versity in Pittsburgh, Pennsylvania, and
graduated with an M.F.A. from the Cran-
brook Academy of Art, Bloomfield Hills,
Michigan, in 1959. She taught at the Uni-
versity of Michigan in 1960–1961 and has
been professor of art at Eastern Michigan
University, Ypsilanti, since 1963. Stephen-
son's work involves an ongoing investiga-
tion of the vessel form, and her studies
took her to Japan in 1962–1963, where
she explored ash glazes in wood-fired
kilns. More recently, in 1973, she studied
luster glazes in Spain. She has exhibited
extensively since 1963 and has held sev-
eral one-woman exhibitions.

(See Bibliography: Abatt, 1977; Finkel,
1978; New Gallery [Iowa], 1963; Ohio
State University, 1977)

SWEET, ROGER L. (1946–). Born in
Huntington Park, California, and studied
at several colleges between 1960 and 1975.
He received his B.A. in 1972 and his
M.F.A. in 1975 from the University of
California, Irvine, after studying under
John Mason. He currently works at the

University of New Mexico, Albuquerque, where he is an instructor of ceramics and sculpture. Sweet was an active exhibitist throughout his student years and immediately after graduation was included in "Clay Works in Progress," an exhibition at the Los Angeles Institute of Contemporary Art, one of the major shows on the process art potential of the medium. Subsequently his work has moved away from an interest in process to the use of found objects in structured-conceptual situations. In 1976 he developed a series of pieces titled *Clay Artifacts,* which included an atomic glaze test from the first atom bomb blast; "healing clay" from a church in Chimayo, New Mexico; a pot form that was actually an insect nest; and a fragment of a tile from the Nagasaki bombing. In this work, the artist does not make the ceramic object but is involved only in the framing, packaging, and titling of the work. Says Sweet, "You don't have to actually make something to deal with clay . . . it's an alternative way of manipulating the material" (Vozar, 1976).

(See Bibliography: "Clay Works in Progress," 1975; Vozar, 1976)

TAKAEZU, TOSHIKO (1929–). Born in Pepeekeo, Hawaii, and studied at the Honolulu School of Art and at the Cranbrook Academy of Art, Bloomfield Hills, Michigan, under Maija Grotell. Takaezu taught for a while at the Cranbrook Academy; the University of Michigan, Ann Arbor; Haystack Mountain School of Crafts, Liberty, Maine; the Penland School of Crafts in North Carolina, and the Creative Arts Program at Princeton University on a part-time basis. In 1968 she decided to give up full-time teaching in order to concentrate mainly on her studio work. Takaezu's influences come from a blending of East and West: "Delicately asymmetrical forms reminiscent of a Zen tradition, are balanced and vitalized by the application of abstract and lyrical 'color clouds' that recall the floor and sky of Hawaii. For Toshiko the creative process is not a hurried affair: the works remain 'non-finito,'— continually presenting new possibilities to be explored until finally placed in the kiln"

(Nordness, 1970). Takaezu has been involved for several years in the exploration of sound and ceramics, placing pebbles of clay in her closed-form pots and in the bases of chalices before firing. Although her use of color, in both her plaques and her serene bulbous forms, is inspired strongly by Abstract Expressionist painting, her work frequently refers to an ongoing play with landscapes.

(See Bibliography: Brown, 1959; "Ceramics: Double Issue," 1958; "Cranbrook 12," 1976; Everson, 22nd Ceramic National Exhibition, 1962–1964; Hoffman, Driscole, and Zahler, 1977; Kalamazoo, 1977; New Gallery [Iowa], 1963; Pugliese, 1975; Pyron, 1964; San Francisco Museum of Art, 1972)

TAKEMOTO, HENRY (1930–). Born in Honolulu and studied at the University of Hawaii, where he received his B.F.A. in 1957, and at the Otis Art Institute in Los Angeles, where he received his M.F.A. in 1959. He taught at the San Francisco Art Institute; Montana State University, Missoula; Scripps College, Claremont, California; and the Claremont College Graduate School. His work during the 1950s, with its dynamic use of organic form and calligraphic and lively decoration, was among the finest work of the so-called Abstract Expressionist school that centered around Peter Voulkos at the Otis Art Institute. In the 1960s, Takemoto turned from art to design, working thereafter as a designer for Interpace Corporation.

(See Bibliography: "Ceramics: Double Issue," 1958; Clark, 1978; Coplans, 1966; Giambruni, 1966; San Francisco Museum of Art, 1972; Scripps College, 1974)

TIFFANY, LOUIS COMFORT (1848–1933). Born in New York, the son of the founder of the jeweler's Tiffany and Company. He studied painting with George Inness in 1866 and exhibited at the Philadelphia Centennial Exposition in 1876. In that year, he began his involvement with glass, producing his first ornamental stained-glass window. In 1879 Louis C. Tiffany & Co., Associated Artists, was founded in New York, along the lines of

Morris & Co. in London. The collaboration of artists was short-lived, however, and by the mid-1880s, Tiffany was working on his own with a team of craftsmen. By 1894 his experiments had led to his patenting of his famous Favrile glass, and he established himself as the major figure of the American Arts and Crafts Movement. In 1902 the commercial phase of Tiffany's operation began with the formation of Tiffany Studios. Tiffany Studios continued through the crash of 1929 and finally went into receivership in 1932. Tiffany's involvement with ceramics appears to have begun around 1898 (see Eidelberg, 1968). In that year, he began experiments at his factory in Corona, Long Island, proceeding with great secrecy until 1902, when rumors of Tiffany's new involvement began to circulate in New York. The wares he developed were first shown publicly in 1904 at the Louisiana Purchase International Exposition in St. Louis, where three Favrile vases with the "old ivory" glazes were shown as part of the Tiffany Studios display. In 1905 these went on display at an exhibition of the New York Keramik Society, but it was only in the latter part of that year that the pottery was made available for sale at the new building of Tiffany and Company at Fifth Avenue and Thirty-seventh Street. In addition to Tiffany's interest in producing wares, he also advanced interest in the ceramic arts by exhibiting the works of leading American ceramists, such as Adelaide Alsop Robineau, and in 1901 he held a major exhibition of French artist potters that included August Delaherche, Pierre-Adrienne Dalpayrat, Taxile Doat, and Alexander Bigot. By 1914 it was apparent that Tiffany's interest in ceramics, never a successful venture commercially, was beginning to wane, although the production of the wares continued until 1919. Tiffany's pottery was little appreciated in his day—never receiving the recognition of his sumptuous work in glass. In retrospect, the Favrile pottery now emerges as being among the finest achievements of American ceramic art during the first phase of development before World War I.

(See Bibliography: Barber, 1909; Eidelberg, 1972; Henzke, 1970; Keen, 1978; Kovel and Kovel, 1974)

TIMOCK, GEORGE P. (1945–). Born in Flint, Michigan, and educated at the Flint Community Junior College (1963–1966) and the Cranbrook College of Art, Bloomfield Hills, Michigan (1966–1971), where he received both his B.F.A. and his M.F.A. He has received several scholarships and grants including the Rocco DiMarco Scholarship for the Study of the Ceramic Arts, Cranbrook Academy (1967) and the Craftsman's Fellowship, National Endowment for the Arts, Washington, D.C. (1974). He began teaching on a part-time basis while a student at the Cranbrook Academy of Art and taught in such diverse situations as adult education at the Bloomfield Art Association, Birmingham, Michigan, and with the Special Services Division of the U.S. Army between 1969 and 1970, where he taught arts and crafts. Since 1973 he has been assistant professor of art in the ceramics faculty of the Kansas City Art Institute, Missouri. Timock has exhibited extensively since 1965, having his first one-man exhibition at the Yaw Gallery, Birmingham, Michigan, 1974.

(See Bibliography: Nordness, 1970)

TURNER, ROBERT (1913–). Born in Port Washington, New York. He received his B.A. at Swarthmore College, Swarthmore, Pennsylvania, in 1936 and thereafter studied painting for five years at the Pennsylvania Academy of Fine Arts, Philadelphia, and at the Barnes Foundation, Merion, Pennsylvania. He then spent several years in Europe, painting and studying at the public museums on a scholarship that he received from the academy. During this time, he discovered that he was not satisfied with the medium of painting and turned to pottery. In 1946 he entered the New York College of Ceramics at Alfred and worked there until 1949—part of a remarkable group of students, who at the time included Theodore Randall, David Weinrib, Minnie Negoro, David Gil, and Joan Jockwig Pearson. After leaving Alfred, Turner was invited to set up and build a pottery studio at the Black Mountain College in North Carolina. He remained there until 1951 and in the following year set up a pottery studio and home at Alfred Station in New York.

Since then, he has divided his time between his work and his teaching commitments at Alfred University. Except for a short period during his student years, Turner has consistently explored a single involvement with ceramics—the exploration of stoneware. He admits an early debt to Sam Haile, Alex Giampietro, and others who worked at Alfred during the 1940s, when the problems of working in stoneware, finding suitable stoneware bodies and glazes, and above all learning the disciplines of reduction firing were still being explored. Turner's early works were never imitative, however, and from the outset, he exhibited a clarity of style and identity in his work. Through the years, he has dealt with a very limited vocabulary of forms, constantly sophisticating and synthesizing these vessel formats. In speaking of his work, Turner states that he has not consciously tried to keep his pottery simple: "It seems to come out that way when I succeed in making the most complete statement that I am capable of. Since almost all of my pots leave the shop soon after they are made, I do not feel bound by what I have done previously, and in each style of work I find myself searching for new solutions to new problems. In most of my works I have tried to keep within the limitation of what the material will do quite naturally—to be true to its reality" (Rhodes, 1957). Recently Turner has been strongly influenced by the example of Nigerian traditional pottery, and forms and decorations such as *Niger I* (1974) pay homage to the forms, decoration, and vigor of the black potter's art. Although some of the influences in his work are cultural, Turner still draws, as he did in his earliest works, from nature, the desert, and the seashore. He likens his drawings on the vessel surfaces to the tidal traces left on the beach—drawing on the clay only what the clay accepts. But perhaps the most distinctive quality in Turner's refined stoneware is the sense of what could be termed *inner volume*. In common with the finest thrown forms of the past, the swelling sense of the form seems to grow from the volume contained within the pot rather than with a hard and conscious forming of the vessel from with-

out. Turner is the doyen of the traditionalists, his forms are an acknowledgment of an art of limitations, seeking an essence through repetition and interpretation of an existing form vocabulary that one can parallel to that of a sensitive classical musician. In drawing an analogy, one can see that Turner is the Yehudi Menuhin of the ceramic arts, providing a reminder of the purest notes of the pottery aesthetic.

(See Bibliography: Campbell Museum, 1976; "Ceramics: Double Issue," 1958; "Ceramics East Coast," 1966; Duberman, 1972; Evanston Art Center, 1977; Everson, 24th Ceramic National, 1966–1968; New Gallery [Iowa], 1963; Nicholas, 1972; Rhodes, 1957; Richards, 1977; Shapiro, 1972)

VALENTIEN, ALBERT R. (1862–1925). Born in Cincinnati, Valentine (later he changed the name to Valentien) studied at the Cincinnati Art Academy under T. S. Noble and F. Duveneck. He taught underglaze pottery decoration at Thomas J. Wheatley's pottery at 23 Hunt Street. In 1881 he joined Rookwood Pottery as their first full-time decorator, became head of the decorating department, and remained there until 1903. In 1907 Valentien and his wife, Anna Marie Bookprinter, moved to San Diego, California. There they established the Valentien Pottery. The move was prompted by a commission that Valentien received from Miss Ellen Scripps to paint all the California wild flowers. The commission influenced the choice of decorative motifs at the Valentien Pottery, which were produced both as painted decoration by Albert and in relief-modeled forms by Anna Valentien.

(See Bibliography: California State University, 1977; Evans, *Art Pottery*, 1974; Peck, H., "Amateur Antecedents of Rookwood Pottery," *Book of Rookwood Pottery,* 1968)

VALENTIEN, ANNA MARIE BOOKPRINTER (1862–1947). Born in Cincinnati, Anna Marie Bookprinter (anglicized from Buchdrücker) studied at the Cincinnati School of Design/Art Academy from 1884 to 1898. She joined Rookwood in 1884 and remained there until 1905. In

1887 she married Rookwood's first decorator, Albert R. Valentien. Together they traveled to France, where Anna studied under Auguste Rodin, Jean Antoine Injalbert, and Antoine Bourdelle. On her return to Cincinnati, she attempted to interest Rookwood in a sculptural style, but only a few pieces of the kind (one illustrated here) were produced. In 1907 she moved to San Diego, where she and her husband set up the Valentien Pottery (see also Albert Valentien).

(See Bibliography: Cincinnati Art Museum, 1976; Evans, *Art Pottery*, 1974; Keen, 1978; Peck, H., *Book of Rookwood Pottery*, 1968)

VAN BRIGGLE, ARTUS (1869–1904). Born in Cincinnati, Ohio, and encouraged by his ambitious parents to become an artist. He studied at the Cincinnati Academy of Art with Frank Duveneck from 1886, and in the same year, in order to pay for his studies, he began to work on a part-time basis at Karl Langenbeck's Avon Pottery in Cincinnati. In 1887 he became a decorator at Rookwood Pottery. He studied painting in Paris on a scholarship from Rookwood Pottery from 1894 to 1896 at the Académie Julian with Jean Paul Laurens and Benjamin Constant. He also studied clay modeling at the Beaux-Arts Académie. Upon his return to Rookwood Pottery in 1896, he began to experiment with mat glazes, achieving his first success in 1898. His interest in Art Nouveau and in a greater sense of movement in decoration and form was apparent during this period and had an impact on those with whom he worked. In 1899, having resigned from Rookwood because of illness, he moved to Colorado Springs, Colorado. While living with the family of Asaheal Sutton, he began to conduct experiments using the local clays and raw material and firing these at Colorado College with the assistance of Professor William H. Strieby. In 1901 he opened the Van Briggle Pottery Company at 650 North Nevada Avenue, Colorado Springs. In December of that year, the first exhibition of 300 pieces took place. The company was formally incorporated a year later and achieved early success. His twen-

ty-four-piece entry to the Paris Salon of 1903 was accepted in its entirety and was awarded two Gold, one Silver, and twelve Bronze Medals. In 1904 Van Briggle was at the Louisiana Purchase International Exhibition in St. Louis and won two Gold, one Silver, and two Bronze Medals. Only a ruling preventing the awarding of the Grand Prix to first-time exhibitors prevented him from receiving this honor as well. Van Briggle died while the exposition was in progress, and his exhibition cases were draped in mourning black. Van Briggle's work during the short period from 1901 to 1904 represents the finest achievement of American Art Nouveau. In particular, works such as *Despondency* and *Lorelei* are significant works of the Arts and Crafts period, as were later pieces using conventionalized leaf and flower motifs. The use of dense, mat monochrome glazes emphasized Van Briggle's distinct massing of volume in his form and the tense edge of the defining line. The pottery was continued after his death by his wife, Anne Lawrence Gregory Van Briggle, who managed it until 1913. In 1920 the pottery was reorganized and began to mass-produce industrial artwares. Some of the original Van Briggle designs were continued in production into the 1970s, although with steadily decreasing quality.

(See Bibliography: Arnest, 1975; Barber, 1909; Bogue, 1968; Eidelberg, 1972; Galloway, 1901; Henzke, 1970; Keen, 1978; Koch, 1964; Kovel and Kovel, 1974; Morris, 1975; Nelson, 1963, 1966)

VANDENBERGE, PETER (1935–). Born in Voorburg, Holland, and received his education at the Sacramento State College in California (B.S., 1959) and the University of California, Santa Barbara, where he received his M.A. He has taught at the San Francisco State College and is currently a resident of Sacramento. His early works involve low-fire, large-scale vegetable images, and although his interest in monumentality, inspired by Viola Frey, has continued, he has now become more involved in figurative work, as exemplified by *The Sheriff* (1977).

(See Bibliography: Campbell Museum, 1976; Nordness, 1970; Pugliese, 1966; San

Francisco Museum of Art, 1972; Slivka, 1971; Victoria and Albert Museum, 1972; William Hayes Ackland, 1977)

VOLKMAR, CHARLES (1841–1914). Born in Baltimore, Volkmar was the son of a German portrait painter and restorer. While in his teens, he studied in Paris under Antoine-Louis Barye at the Jardin des Plantes, spending nearly fifteen years in France with a brief return to the United States "for the purpose of voting for the second term of Lincoln" (see Bibliography: Walton, 1909, p. LXXV). Upon his return he took over a studio, just vacated by a fellow American, Will J. Low, and there became interested in ceramics. He made his first appearance at the Paris Salon in 1875 and became a regular exhibitor of paintings, etchings, and pottery. He was one of a group of young painters including Jean Charles Cazin, Hermanus Anker, and Leon Couturièr who had become involved in ceramics. Eugène Carrière, who later became a famous painter, invited Volkmar to set up a kiln in partnership with him. Instead Volkmar worked with the faïencier Theodore Deck in Paris and there learned the *procès barbotine* underglaze slip-painting technique. He returned to the United States, setting up kilns at Greenpoint, Long Island, in 1879; Tremont, New York, in 1882; Menlo Park, New Jersey, in 1888; and Metuchen, New Jersey, in 1902. He played an important role in the development of ceramics on the eastern seaboard, although his impact was more that of a teacher than of an artist. He gave classes at the Salmagundi Club in New York and at his various potteries and also was associated with Edwin Atlee Barber's School of Industrial Art in Philadelphia. His work was continued by his son Leon, who worked in the father's later style of simple Oriental forms and monochrome glazes. One of Charles Volkmar's best known students was Jeannie Rice, who founded the Durant Kilns in New York together with Leon in 1910.

(See Bibliography: Barber, 1909; Eidelberg, 1972; Evans, *Art Pottery*, 1974; Henzke, 1970; Jervis, *Encyclopedia of*

Ceramics, 1902; Keen, 1978; Kovel and Kovel, 1974; Volkmar, 1899; Walton, 1909; Whiting, 1900)

VOULKOS, PETER (1924–). Born in Bozeman, Montana, his family having recently arrived as immigrants from Greece. Voulkos was an apprentice molder in an Oregon iron foundry before entering Montana State University to study painting. In his last year his interest turned to ceramics, in which he showed an astounding facility. By 1950 he was winning prizes at the Ceramic Nationals, and in 1955 he won the Gold Medal at the Cannes International Ceramic Exposition. In the meanwhile he had taken his M.F.A. at the California College of Arts and Crafts in Oakland and from 1951 was working on and off at the Archie Bray Foundation in Montana with Rudy Autio. From 1954 to 1958 he served as chairman of the Otis Art Institute (formerly the Los Angeles County Art Institute). From 1959 Voulkos taught at the University of California at Berkeley. In 1962 Voulkos gave up clay as his major medium and turned to metal, winning the Rodin Museum

Peter Voulkos. Photograph: Ryusei A Ita.

Prize at the First Paris Biennale of Sculpture. His involvement with clay from then on became secondary, although he has continued to produce works sporadically and actively gives workshops around the country. The first sustained return to the medium occurred in 1973, when he began to work on a series of 200 plates. The plates were thrown for him, and Voulkos drew vigorously on the surface, seeding the surface with white porcelain pellets, cutting into the clay, and tapping holes into the piece while it was in its green state. The plates were a masterful statement on processes and material energies. They were also his most classical statements to date. Since 1974 the pace of involvement has quickened, culminating in a series of plates and vessels for his retrospective exhibition that opened at the San Francisco Museum of Modern Art, beginning a national tour to Houston, New York, and other venues.

(See Bibliography: Ashton, 1967; Brown, 1956; Ceramic International, 1958; "Ceramics: Double Issue," 1958; "Ceramics West Coast," 1966; Clark, G., 1978; Coplans, 1963, 1966; Depew, 1972; Duberman, 1972; The Evanston Art Center, 1977; Everson Museum of Art, 22nd Ceramic National, 1962–1964; Giambruni, 1966; Levin, E., "Portfolio: Peter Voulkos," 1978; Los Angeles County Museum of Art, 1965; Mathews, 1959; Melchert, 1968; Museum of Modern Art, 1960; New Gallery [Iowa], 1963; Nicholas, 1972; Nordness, 1970; Plagens, 1974; Pyron, 1964; Richards, 1977; Richardson, 1969; San Francisco Museum of Art, 1967; Scripps College, 1974; Selz, 1967; Slivka, 1974, 1978; Syracuse Museum of Fine Arts, 17th Ceramic National, 1953; Victoria and Albert Museum, 1966, 1972; William Hayes Ackland, 1977)

WALTERS, CARL (1883–1955). Born in Fort Madison, Iowa. He joined his first art class at the Minneapolis School of Art, remaining there as a student from 1905 to 1907, and then continued his education as a painter in New York City at the Chase School under Robert Henri from 1908 to 1911. After marrying in 1912, he established himself as an artist in Portland, Oregon, exhibiting continually from 1913 to 1919, and was considered one of the most promising young painters of the Northwest. Walters decided to return to New York in 1919, and it was there that his first experiments in ceramics took place. He spent almost two years in the development of Egyptian blue, the obsession of most of the potters of his day. He set up his first workshop in Cornish, New Hampshire, in 1921, moving in the summer of 1922 to Woodstock, New York, where he fired his earliest pieces of ceramic sculpture. In 1924 he showed at the Whitney Studio Club in New York, and the Whitney Museum of American Art in New York purchased the *Stallion* from this exhibition. His works have been included in leading American collections, including The Metropolitan Museum of Art, The Art Institute of Chicago, The Minneapolis Institute of Arts, and The Museum of Modern Art in New York. He was a Guggenheim fellow in 1936 and 1937. In looking at the work of Walters, one finds the comment by R. Guy Cowan that "he paints his sculpture like plates" to be highly instructive. Homer points out that Walters never forgot that his pieces were *decorated* clay: "Walters made an array of figures that were confident and unspoiled. For his animals he relied on the lively gesture, the gentle torsion and the overall stance to communicate; textural copying and literal details were not necessary in conveying the inner meaning of these creatures. Instead, the surface was made into an abstract pattern which usually covered the entire piece. Feathers, scales and fur were transformed into rosettes, hatching or stripes" (Homer, 1956). Following Walters's death in 1955, a memorial exhibition of his ceramic sculptures was presented from July to September of that year by the Museum of Art of Ogunquit, Maine.

(See Bibliography: American Federation of Arts, 1928; "Art with the Inferiority Complex," 1937; Brace, 1932; Everson Museum of Art, 1978; Hegarty, 1948; Homer, 1956; Scripps College, 1947; Syracuse Museum, 1935, 1937)

WARASHINA, PATTI (1939–). Born in Spokane, Washington, and studied at the University of Washington, Seattle, where she received her B.F.A. in 1962 and an M.F.A. in 1964. Together with her former husband, Fred Bauer, she concentrated on functional wares during the early 1960s, strongly influenced by Japanese ceramics, particularly the example of potter Kanjiro Kawai, as seen in the vigorous slip drawing on her porcelain bowl from the Marer Collection illustrated in this study. From 1968 she began to work in a new direction, painting ceramic hollowware with bright, acrylic paint. Subsequently her iconography has become more complex, and she has dealt with a series of issues in her works. Some are consciously satiric, such as *Air Stream Turkey* (1972), converting this bird into an American-dream caravan; her motorcar series, which included *Kiln Car* (1977) and *They Thought It Was My Last Trip* (1977). Other works, such as the *Fish in a Dish* series, are more esoteric, dealing with fantasies and personal references. Speaking of her work, Warashina comments, "As a child I collected dolls, dreams, fantasies. As an 'adult' I still collect dolls, dreams, fantasies, and feel lucky that my work involves translating these collective observations from my psyche into a tangible form, which I may or may not comprehend" (California State University, 1977).

(See Bibliography: Campbell Museum, 1976; Cochran, 1976; Kalamazoo, 1977; Pugliese, 1975; San Francisco Museum of Art, 1972; Schwartz, 1976; Scripps College, 1974; Slivka, 1971; Victoria and Albert Museum, 1972)

WAREHAM, JOHN HAMILTON DELANEY (1871–1954). Born in Grand Ledge, Michigan. He studied under Frank Duveneck at the Cincinnati Art Academy and became associated with the Rookwood Pottery at Cincinnati in 1893, remaining until 1954. He worked under William Watts Taylor and eventually succeeded Taylor as president of Rookwood Pottery. Wareham had broadly based cultural interests and was a major figure in the Cincinnati arts, working as an interior designer, muralist, and painter. Wareham's interest in Chinese ceramics was instrumental in bringing a greater sensitivity to the use of glazes to Rookwood Pottery in the twentieth century.

(See Bibliography: Peck, 1968)

WEINRIB, DAVID (1924–). Educated in the New York City schools, took an art course at Brooklyn College, and studied painting, sculpture, and pottery at Alfred University, Alfred, New York. He had also studied painting in the classic manner at the Accademia, Florence, Italy. He was potter-in-residence at the Black Mountain College from 1952 to 1954 with his wife, Karen Karnes. In 1954, with his wife, he joined friends in an incorporated community of artists established on 100 wooded acres at Stony Point, New York. At first, he assembled his forms from thrown and slabbed elements, later doing away with all throwing when in 1958 he invented a slabbing machine and from then on built all of his forms out of slab only. In 1958 he also extended his studio, working on both clay, metal, and later plastic sculpture. Weinrib rapidly established a reputation as an internationally known sculptor and ceased working in ceramics.

(See Bibliography: Ashton, 1967; Duberman, 1972; Mathews, 1959; Richards, 1977; Syracuse Museum, 19th Ceramic National, 1957–1958; Untracht, 1956)

WIESELTHIER, VALERIE ("VALLY") (1895–1945). Born in Austria and from 1914 to 1920 studied at the Kunstgewerbeschule under Professor Michael Powolny. Thereafter she worked closely with the Wiener Werkstätte, then under the artistic influence of Dagobert Peche, establishing herself as one of the leading ceramic artists in Europe. In 1928 her work was exhibited in the United States at the International Exhibition of Ceramic Art, which opened at The Metropolitan Museum of Art in New York and later toured to several museums throughout the country. In 1929 she decided to settle in the United States, joining the Contempora Group in New York, as well as designing for Sebring Pottery in Ohio. She estab-

Valerie Wieselthier. Photograph: Jane Courtney Frisse.

lished a studio in New York, where she produced large ceramic sculptures and was an influential figure in the early development of ceramic sculpture in the United States.

(See Bibliography: American Federation of Arts, 1928; Canfield, 1929; Everson Museum of Art, 1978; Neuwirth, 1975; Wieselthier, 1929)

WILDENHAIN, FRANS (1905–). Born in Leipzig, Germany. He attended the Bauhaus, where he specialized in pottery under Gerhard Marcks and the master potter Max Krehan in 1924–1925. After the closing of the pottery workshop at Dornburg, when the Bauhaus moved to Dessau, Wildenhain went to the State School of Applied Art at Halle-Saale where he received his M.A. Later he headed the pottery department at the Folkwang workshops in Essen-Ruhr, then taught at the State School of Applied Art at Halle-Saale. In 1933, having married Marguerite Friedlander, he went to Holland, and they established a workshop together in Putten. In 1941 he moved to Amsterdam, coming to the United States in 1947 by way of England, and briefly joined his wife at the Pond Farm workshop in Guerneville, California. From 1950 until his retirement in 1975 he was

instructor of pottery and sculpture for the School for American Craftsmen at the Rochester Institute for Technology, Rochester, New York. He has employed his medium in many directions, working as a potter and a sculptor, and was awarded a Guggenheim fellowship for his creative work in relating ceramics and architecture.

(See Bibliography: Campbell Museum, 1976; "Ceramics: Double Issue," 1958; Everson, 22nd Ceramic National Exhibition, 1962–1964; Everson, 24th Ceramic National Exhibition, 1966–1968; Johnston, 1975; Rochester, 1975)

WILDENHAIN, MARGUERITE (1896–). Marguerite Friedlander was born in France of German and English parentage and was educated in France, England, and Germany. Her early art training was in sculpture at The School of Fine and Applied Arts in Berlin. Later she worked as a designer of porcelain at a factory in Thuringia, and in 1919 she went to the Bauhaus in Weimar as an apprentice in pottery, where she studied with Max Krehan and the sculptor Gerhard Marcks. After six years at the Bauhaus, she became the head of the ceramics department at the Municipal School for Arts and Crafts in Halle-Saale. With the rise of National Socialism in 1933, she moved to Holland, where together with her husband, Frans Wildenhain, she operated a workshop in Putten. While in Germany, Wildenhain had produced several superb designs for the Royal Berlin Porcelain Manufactory. She continued this activity in Holland, producing designs for mass production at the Regout Porcelain Factory in Maastricht, Holland, winning a Second Prize for these designs at the international exhibition "Arts et Techniques" in Paris in 1937. Just before the Nazi invasion of Holland, she emigrated to the United States and taught for two years at the California College of Arts and Crafts in Oakland. In 1942 she started her own workshop in Guerneville, California, at Pond Farm, where she still lives and runs a popular summer school that attracts students from as far away as China and India. Wildenhain has been a strong influence on the functional school

of ceramics, having written two books and published numerous articles. She no longer produces designs for industry and insists on a stern craft ethic: "I have formerly made many models for mass production. Today, though, I feel it is increasingly important again to stress the values of the way of life of a craftsman, to try and educate towards a basic understanding of the essence of a life dedicated to an idea that is not based on success and money, but on human independence and dignity" ("Ceramics: Double Issue," 1958).

(See Bibliography: "Ceramics: Double Issue," 1958; Duberman, 1972; New Gallery [Iowa], 1963; Petterson, 1977; Scripps College, 1974; Syracuse Museum, Ceramic International, 1958; Wildenhain, 1950, 1959, 1973)

WOOD, BEATRICE (1894–). Born in San Francisco and in her late teens studied in Paris, taking art briefly at the Académie Julian, but attracted by the stage, transferred her studies to the Comédie Française. Upon her return to New York, she joined the French Repertory Theatre. In 1916, while visiting the French composer Edgard Varèse in a New York hospital, she was introduced to Marcel Duchamp and soon became an intimate friend of the painter and a member of his recherché cultural clique, which included Francis Picabia, Man Ray, Albert Gleizes, Walt Kuhn, and others, and became a contributor to Duchamp's avant-garde magazines, *Rogue* and *The Blind Man*—she produced drawings and shared editorial space with luminaries of the day such as Gertrude Stein. Wood's interest in ceramics did not come until around 1938, when she purchased a set of six luster plates. She wanted to produce a matching teapot, and it was suggested that she make one at the pottery classes of the Hollywood High School. In the next two years, she studied with Glen Lukens at the University of Southern California and with the Austrian potters Gertrud and Otto Natzler. Since then, Wood has developed a personal and uniquely expressive art form with her lusterwares. Her sense of theater is still vividly alive in these works, with their exotic palette of colors

Beatrice Wood.

and unconventional form. Wood's home for the last sixty years has been Ojai, California, and she recently moved to a new home and studio built on the land of the Happy Valley School of the Theosophical Society, with which she had been associated since its foundation in 1946 by Aldous Huxley, Krishnamurti, and Annie Besant. The 1970s have proved to be Wood's most productive decade in terms of her ceramic art, and 1978 saw three concurrent exhibitions at the Everson Museum of Art, Syracuse, New York; the Hadler Galleries, New York; and the

Philadelphia Museum of Art. In her work, Wood accepts no rules or theories, and its freedom reflects the aesthetic credo that she learned from Marcel Duchamp, who told her, "Never do the commonplace, rules are fatal to the progress of art" (Bryan, 1970).

(See Bibliography: "Beatrice Wood Ceramics," 1947; Bryan, 1970; "Ceramics by . . . ," 1946; "Ceramics: Double Issue," 1958; Hapgood, 1977; Hare, 1978; Phoenix Art Museum, 1973; Scripps College, 1974)

WOODMAN, ELIZABETH ("BETTY") ABRAHAMS (1930–). Born in Norwalk, Connecticut, and studied at the School for American Craftsmen at Alfred University, Alfred, New York, from 1948 to 1950, majoring in pottery. As soon as she completed her studies, she set up her own studio on a production basis and has since then been self-supporting. She has taught sporadically since 1953 and from 1957 to 1973 taught at and administered the City of Boulder (Colorado) Recreation Pottery Program, which has now evolved into a major course with its own building and 350 adult and child students and a teaching staff of 8. The course has become something of a model as one of the oldest, largest, and most successful programs of its kind, and Woodman has been consulted frequently by pottery-program developers and directors from other cities. Since 1951 Woodman has lived and worked in Italy for varying periods of time, ranging from two to twelve months. This constant cultural counterplay between the United States and Europe shows strongly in her work and particularly that of the last ten years, in which the forms and surface sensitivities, although explored with the dash and adventure associated with the more lively elements of American ceramics, nonetheless strongly reflect the Mediterranean ceramic tradition and ambiance. Writing of Woodman's work in *Craft Horizons,* her fellow potter Richard DeVore comments, "Raucously juxtaposing apparent disparate elements is an approach we have not witnessed since Oribeware. Yet Woodman is the only ceramist I know (other than Peter Voulkos with certain works) who so convincingly presents this idea with such a satisfyingly ordered chaos. Her pieces combine surface-piercing manipulation of planes and a clear record of the shaping process" (DeVore, 1978). Although Woodman has based her reputation on being a production and thereby a functional potter, function is becoming less and less of the reality in her work, even though each piece is theoretically made for a specific purpose: asparagus dishes, letter holders, etc. But the use of function in Woodman's work has now become abstracted to the point that it is now much like the functionalism in Plato's ideal republic and is applied simply to thwart arbitrariness.

(See Bibliography: DeVore, 1978; Kansas City Art Institute, 1976; Scripps College, 1974; Slusser Gallery, 1977)

Elizabeth Woodman.

WYMAN, WILLIAM (1922–). Born in Boston and received his education at the Massachusetts College of Art and Columbia University, New York. Since 1953 Wyman has been a professional potter and has operated the Herring Run Pottery in East Weymouth, Massachusetts, where he has created individually crafted functional and nonfunctional stoneware objects. Wyman is particularly noted for his inventive use of slab-built vessels. In the late 1960s, his pots became surfaces for sgraffitoed surfaces with cartoons, poems, and catch phrases relating to contemporary jazz and other popular expressions. Wyman has taught at Drake University, Des Moines, Iowa; the University of Maryland, College Park; the Massachusetts College of Art, Boston; and the De Cordova and Dana Museum and Park, Lincoln, Massachusetts.

(See Bibliography: Campbell Museum, 1976; Everson, 21st Ceramic National, 1962; Everson, 22nd Ceramic National, 1962–1964; New Gallery [Iowa], 1963)

BIBLIOGRAPHY

This bibliography has been culled from over 1,000 reference sources that deal with American ceramic art in the past century. What follows is a selection of the material that was of the greatest value during the research process and is by no means exhaustive. However, an attempt has been made to provide material for each of the artists represented in the Biographies. I should like to acknowledge the help of both Nolan Babin and Ann Snortum in the checking and indexing of this information. The many catalogues published for the Ceramic Nationals, an invitational exhibition hosted by the Syracuse Museum of Fine Arts from 1933 to 1967 (no catalogue was published for the first year of the exhibition), and thereafter by the Everson Museum of Art until 1972, have not been individually cited except for major catalogues dealing with special exhibitions and international shows. Exhibitions have been individually detailed.

Abatt, Corinne. "Ceramic Artist Makes a Forceful Statement." *Birmingham Eccentric,* September 15, 1977.

Adrian, Dennis. "Robert Arneson's Feats of Clay." *Art in America,* 62 (September 1974).

Albright, Thomas. "Zappy Artists in Richmond." *San Francisco Chronicle,* February 8, 1973.

———. "Grisly Experiments in the Medical Arts." *San Francisco Chronicle,* November 11, 1975.

———. "Mickey Mouse and Memorabilia." (Robert Arneson) *ARTnews,* 75 (March 1976).

———, "Digging in for the Magic." *San Francisco Chronicle,* May 6, 1976.

Alexander, Donald E. *Roseville Pottery for Collectors.* Richmond, Ind.: Privately published, 1970.

Alloway, Lawrence. "Roy Lichtenstein's Period Style." *Arts,* 42, no. 1 (1967).

American Crafts Council. *Salt-Glaze Ceramics.* New York, 1972.

American Federation of Arts. *Critical Comments on the International Exhibition of Ceramic Art.* Contributions by E. L. Cary, R. Cortissoz, and H. Read. New York, 1928.

———. *International Exhibition of Ceramic Art.* New York: The Metropolitan Museum of Art, 1928.

Andreae, Christopher. "Interview: Jim Melchert and His Games." *The Christian Science Monitor,* January 10, 1969.

Andreson, Laura. "The Natzlers." *California Arts and Architecture,* 58 (July 1941).

Archbold, G. "Ceramic Sculpture of Russell Aitken." *Design,* 36 (December 1934).

Armstrong, Lois. "Los Angeles: Roy De-

Forest and Robert Arneson." *ARTnews,* 68, no. 6 (October 1969).

Arneson, R. *My Head in Ceramics.* Davis, Calif.: Published by Robert Arneson, 1972.

Arnest, Barbara M., ed. *Van Briggle Pottery.* Foreword by R. E. Morris. Colorado Springs: Fine Arts Center, 1975.

Art Gallery, Hayward. *Nut Art.* Hayward: California State University, 1972.

Art Journal. "Some New Design and Methods in Rookwood and Grueby Faience." *The Paris Exposition Universelle.* London: Virtue, 1901.

Artner, Alan G. "Ceramics: From Craft to Class." *Chicago Tribune,* February 8, 1976.

"Arts of Living." *Architectural Forum,* 90 (March 1949).

"The Art with the Inferiority Complex." *Fortune,* 16, no. 6 (1937).

Ashton, Dore. *Modern American Sculpture.* New York: Harry N. Abrams, 1967.

———. "New York Commentary." *Studio International,* 178 (November 1969).

Ault, R. "Mary Chase Perry Stratton and Her Pewabic Pottery." *Great Lakes Informant,* n.d.

Avery, C. L. "Memorial Exhibition of the Work of Charles F. Binns." *The Metropolitan Museum Bulletin,* 30 (May 1935).

Bacher, H. R. "Problems of the Present-Day Art Pottery." *The Bulletin of the American Ceramic Society,* 17 (August 1938).

Backlin, Hedy. "Collaboration: Artist and Architect." *Craft Horizons,* 32, New York (May–June 1962).

Baggs, Arthur E. "The Story of a Potter." *The Handicrafter,* 1 (April–May 1929).

Ball, F. Carlton. *Decorating Pottery with Clay, Slip and Glaze.* Columbus, Ohio: Professional Publications, 1967.

———, and Lovoos, Janice. *Making Pottery Without a Wheel: Texture and Form in Clay.* New York: Reinhold, 1965.

Ball, Fred. "Arneson." *Craft Horizons,* 34 (February 1974).

Ballatore, Sandy. "The California Clay Rush." *Art in America,* 64 (July–August 1976)

Barber, Edwin Atlee. *Catalogue of American Potteries and Porcelain.* Philadelphia: Pennsylvania Museum and School of Industrial Art, 1893.

———. "Cincinnati Women Art Workers." *Art Interchange,* 36 (February 1896).

———. *Pottery and Porcelain of the United States: Marks of American Potters.* New York: Putnam's Sons, 1893. 2d ed. 1901, 3rd ed. 1909.

———. *Marks of American Potters.* Philadelphia: Patterson and White Company, 1904.

Barcellona, M. "Shaw Sculpture." *Ceramics Monthly,* 24 (March 1976).

Barnes, Benjamin H. *The Moravian Pottery: Memories of Forty-Six Years.* Doylestown, Pa.: Bucks County Historical Society, 1970.

Baro, Gene. "Roy Lichtenstein: Technique as Style." *Art International,* 12, no. 9 (November 1968).

Barrie, Dennis. "Edris Eckhardt Interviewed." *Link,* Cleveland Institute of Art Newsletter, 12, no. 3 (Spring 1978).

Battcock, Gregory. *Super Realism: A Critical Anthology.* New York: Dutton Paperbacks, 1975.

"Beatrice Wood Ceramics." *Arts and Architecture,* 64 (1947).

Belot, Léon. *Taxile Doat Céramiste.* Sèvres, France, 1909.

Benjamin, Marcus. "The American Art Pottery." *Glass and Pottery World,* 15 (February 1907, March 1907, April 1907, May 1907).

Bevlin, M. E. *Design Through Discovery.* New York: Holt, Rinehart & Winston, 1967, 1970.

Binns, Charles F. *Notes on the History and Manufacture of Pottery and Porcelain.* London: Newton, 1894.

———. *Ceramic Technology.* London: Scott, Greenwood, 1898.

———. *The Story of the Potter: Being a Popular Account of the Rise and Progress of the Principal Manufactures of Pottery and Porcelain in All Parts of the World, with Some Description of Modern Practical Working.* London: G. Newnes, 1898.

———. *The Potter's Craft.* London: Constable, 1910.

————. "Pottery in America." *The American Magazine of Art*, 7, no. 4 (February 1916).

———— et al. *Manual of Ceramic Calculations*. Columbus, Ohio, 1900.

Birks, Tony. "Anthony Hepburn." *Craft Horizons*, 24 (July–August 1964).

Blackall, C. H. "The Grueby Faience." *Brick Builder*, 7 (August 1898).

Blasberg, Robert W. "Newcomb Pottery." *Antiques*, 94 (July 1968).

————. "Reform Art for a Reform Era." *Craft Horizons*, 30 (October 1970).

————. "Moravian Tile: Fairy Tales in Colored Clay. *Spinning Wheel*, 27 (June 1971).

————. "Grueby Art Pottery." *Antiques*, 100 (August 1971).

————. "The Sadie Irvine Letters." *Antiques*, 100 (August 1971).

————. *George E. Ohr and His Biloxi Pottery*. Port Jervis, N.Y.: Carpenter, 1972.

————. "Twenty Years of Fulper." *Antiques*, 29, no. 8 (October 1973).

Bleicher, Fred, Hu, William C., and Uren, Marjorie E. *Pewabic Pottery: An Official History*. Ann Arbor, Mich.: Arts Ceramica, 1977.

Bogatay, P. "There's Madness in Method." *Design*, 49 (June 1948).

Bogue, Dorothy McGraw. *The Van Briggle Story*. Colorado Springs, 1968.

Bonham, Roger D. "Charles Lakofsky." *Ceramics Monthly*, 13 (October 1965).

Bopp, H. F. "Art and Science in the Development of Rookwood Pottery." *The Bulletin of the American Ceramic Society*, 15 (1936).

Boulden, Jane L. "Rookwood." *Art Interchange*, 46 (June 1901).

Boulding, Mark. "Projects." *A Collection of Work by Mark Boulding* (Forest Firing). Richmond, Ind.: Privately published, 1973.

————. *Parking Lot*. Richmond, Ind.: Privately published, 1976.

Bourdon, David. "The Sleek, Witty and Elegant Art of Elie Nadelman." *Smithsonian* (February 1975).

Bowdoin, W. G. "The Grueby Pottery." *Art Interchange*, 45 (December 1900).

Bower, Gary. "Clayton Bailey." *Craft Horizons*, 28 (January 1968).

Brace, E. "Carl Walters." *Creative Art*, 10 (June 1932).

Brawer, Katherine. "Don Reitz and Bruce Breckenridge." *Ceramics Monthly*, 19 (March 1971).

Breckenridge, Bruce M. "The Object: Still Life." *Craft Horizons*, 25–26 (September–October 1965).

————. "Critters/Clayton Bailey." *Museum of Contemporary Crafts* (November 1964–January 1965).

Brinker, Lea J. "Women's Role in the Development of Art as an Institution in Nineteenth-Century Cincinnati." Master's thesis, University of Cincinnati, 1970.

Brodbeck, John. "Cowan Pottery." *Spinning Wheel*, 29 (March 1973).

Broner, R. "Exhibitions." *Craft Horizons*, 27 (January–February 1967).

Brown, Christopher. "Karen Breschi's Fantasies." *Artweek* (March 18, 1978).

Brown, Conrad. "Peter Voulkos. *Craft Horizons*, 16 (October 1956).

————. "Toshiko Takaezu." *Craft Horizons*, 19–20 (March–April 1959).

Brunk, T. "Pewabic Pottery." The Detroit Institute of Arts, *Arts and Crafts in Detroit/1906–1976*. Detroit, 1976.

Brunsman, Sue. "The European Origins of Early Cincinnati Art Pottery 1870–1900." Master's thesis, University of Cincinnati, 1973.

Bryan, Robert. "The Ceramics of Beatrice Wood." *Craft Horizons*, 30 (April 1970).

Buxton, Virginia Hillway. *Roseville Pottery for Love or Money*. Nashville, Tenn.: Tymbre Hill, 1977.

"California Ceramics," *Art Digest*, 12 (March 15, 1938).

"California Crafts and Craftsmen." *Craft Horizons*, 16 New York (September–October 1956).

California State University. *Official Illustrated Report on the Electro-Medical Devices of Dr. Gladstone, M.S., B.S.: An Educational Exhibit by Prof. Clayton Bailey*. Hayward, Calif., 1977.

————, Fullerton. *Richard Shaw, Ed Blackburn, Tony Costanzo, Redd Ekks, John Roloff*. Introduction by Suzanne Foley. Fullerton, Calif.: Art Gallery, 1976.

————. *Overlaze Imagery*. Essays by Garth *Overglaze Imagery*. Essays by Garth Clark, Judy Chicago, and Richard Shaw. Fullerton, Calif.: Art Gallery, 1977.

————, Los Angeles. *Clay Images*. Catalogue of exhibition, 1974. Los Angeles, 1974.

Calkins, Donald H. "Cowan Pottery." *The Antique Trader Weekly*, November 30, 1977.

————. "Cowan Returns Home." *American Art Pottery* (March 1978).

Campbell Museum. *Soup Tureens: 1976*. Introduction by Ralph Collier, essay by Helen Drutt. Camden, N.J., 1976.

Canavier, Elean Karina. "Kohler Conference: Art Industry Alliance." *Ceramics Monthly*, 21 (November 1973).

Canfield, Ruth. "The Pottery of Vally Wieselthier." *Design*, 31, no. 6 (November 1929).

Cardozo, Sidney. "Rosanjin." *Craft Horizons*, 32, no. 2 (April 1972).

Ceramic Arts Library. *Jerry Rothman: Bauhaus Baroque*. Essay by Garth Clark. Claremont, Calif., 1978.

"Ceramics." *Time* magazine, 91, no. 17 (April 22, 1968).

"Ceramics by B. Wood." *Arts and Architecture*, 63 (January 1946).

"Ceramics by Poor at the Rehr Galleries." *Art Digest*, 22 (December 15, 1947).

"Ceramics by Twelve Artists." *Art in America*, 52 (December 1964).

"Ceramics: Double Issue." *Design Quarterly*, 42–43 (1958).

"Ceramics East Coast." *Craft Horizons*, 25–26 (June 1966).

"Ceramics West Coast." *Craft Horizons*, 25–26 (July 1966).

"Charles M. Harder." *The Bulletin of The American Ceramic Society* (November 1959).

Chicago, Judy. "World of the China Painter." California State University at Fullerton, *Overglaze Imagery*. Fullerton: Art Gallery, 1977.

————. "World of the China Painter." *Ceramics Monthly*, 26, no. 5 (May 1978).

Cincinnati Art Museum. *The Ladies, God Bless 'Em: The Women's Art Movement in Cincinnati in the 19th Century*. Essay by Carol Macht, chronology by Kenneth Trapp. Cincinnati, Ohio, 1976.

Cincinnati Historical Society. *Articles on Art and Artists in Cincinnati*. Cincinnati, Ohio, 1967.

Clark, Edna Maria. *Ohio Art and Artists*. Richmond, Ohio, 1932. Reprint. Detroit: Gale Research Co., 1975.

Clark, Garth R. "The Ceramic Canvas." California State University at Fullerton, *Overglaze Imagery*. Fullerton: Art Gallery, 1977.

————. *Ceramic Art: Comment and Review 1882–1978*. New York: Dutton Paperbacks, 1978.

————. "George E. Ohr." *The Biloxi Art Pottery of George E. Ohr*. Jackson: Mississippi State Historical Museum, 1978.

————. "George E. Ohr—Clay Prophet." *Craft Horizons*, 38 (October 1978).

————. "Sam Haile." *Studio Potter*, 7, no. 1 (1978).

Clark, Larry. "David Shaner." *Craft Horizons*, 35 (June 1975).

Clark, Robert Judson, ed. *The Arts and Crafts Movement in America 1876–1916*. Princeton, N.J.: The Art Museum, Princeton University and The Art Institute of Chicago, 1972.

Clark, Susan. "Intelligence Tempers Collages, Pottery." *Buffalo News*, March 29, 1978.

"Clay Works in Progress." *Journal of the Los Angeles Institute of Contemporary Art* (November–December 1975).

Cleveland Institute of Art. *Viktor Schreckengost*. Essay by Laurence Schmeckebier, essay by Joseph McCullough. Cleveland, 1976.

Cochran, Malcolm. *Contemporary Clay: Ten Approaches*. Hanover, N.H.: Dartmouth College, 1976.

Colby, Joy H. "Sculpture by Another Name." *Detroit News*, January 22, 1978.

Colgate, Beatrice. "Dorothea O'Hara." *Darien Review*, November 22, 1955.

Coplans, John. "Sculpture in California: the Clay Movement." *Artforum*, 2 (August 1963).

————. "Out of Clay; West Coast Ceramic Sculpture Emerges as a Strong Regional Trend." *Art in America*, 51 (December 1963).

————. "The Sculpture of Kenneth Price."

Art International, 8 (March 20, 1964).
———. *Abstract Expressionist Ceramics.* Irvine: University of California, 1966.
———, ed. *Roy Lichtenstein: Documentary Monograph in Modern Art.* New York: Praeger, 1972.
Cowan Pottery Museum. *Cowan Pottery Studio.* Rocky River: Ohio Public Library, 1978.
Cowan, R. G. "Fine Art of Ceramics." *Design,* 38 (November 1937).
Cox, David. "Utah." *Craft Horizons,* 36 (February 1976).
Cox, George. *Pottery for Artist, Craftsmen and Teachers.* New York: Macmillan, 1914.
Cox, Paul E. "Newcomb Pottery Active in New Orleans." *The Bulletin of The American Ceramic Society,* 13 (May 1934).
———. "Potteries of the Gulf Coast." *Ceramic Age,* 3 (April 1935).
Cox, Warren E. *The Book of Pottery and Porcelain.* 2 vols. New York: Crown, 1944.
Cranbrook Academy of Art. *Maija Grotell.* Bloomfield Hills, Mich., 1967.
"Cranbrook 12: Portfolio." *Ceramics Monthly,* 24 (June 1976).
Cullinan, Helen. "Clay Set Wheels of Genius Going." *Plain Dealer,* Cleveland, sec. 5, March 14, 1976.
"Daniel Rhodes: Pottery and the Person." *Ceramics Monthly,* 25 (January 1977).
Davis, Douglas. "Crock Art." *Newsweek,* 78 (July 5, 1971).
Davis, Elrick B. "Ceramic Sculpture Is City's Unique Industry." *Cleveland Press,* July 26, 1928.
Delius, Jean. "25th Ceramic National." *Craft Horizons,* 29 (January–February 1969).
Depew, Dave. "The Archie Bray Foundation." *Ceramics Monthly,* 20 (May 1972).
Derfner, Phyllis. "New York Letter." *Art International,* 19 (April 1975).
———. "Kenneth Price at Willard." *Art in America,* 63 (May–June 1975).
The Detroit Institute of Arts. *Arts and Crafts in Detroit 1906–1976: The Movement, the Society, the School.* Detroit, November 26–January 16, 1977.
DeVore, Richard. "Ceramics of Betty Woodman." *Craft Horizons,* 38 (February 1978).
De Vries, Jan. "Exhibitions." *Craft Horizons,* 36 (July 1976).
Digby, George Wingfield. *The Work of the Modern Potter in England.* London: John Murray, 1952.
Dillenberger, Jane, and Dillenberger, John. *Perceptions of the Spirit.* Indianapolis: Indianapolis Museum of Art, 1977.
Doat, Taxile. *Grand Feu Ceramics: A Practical Treatise on the Making of Fine Porcelain and Grès.* Translated by Samuel E. Robineau, with essay by Prof. Charles F. Binns. Syracuse, N.Y.: Keramik Studio Publishing Co., 1905.
Donhauser, Paul. *A History of the Development of American Studio-Pottery.* Ann Arbor, Mich.: University Microfilms International, 1967.
———. *History of American Ceramics.* Dubuque, Iowa: Kendall/Hunt, 1978.
Donohoe, Victoria. "Major Ceramic Artist Keeps Things Fundamental." *Philadelphia Inquirer,* December 30, 1976.
Duberman, Martin. *Black Mountain: An Exploration in Community.* New York: E. P. Dutton, 1972.
Duckworth, R., and Westphal, A. *Ruth Duckworth.* Evanston, Ill., 1977.
Earley, George W. "New 'Kaolithic Age' Discoveries in California." *Info Journal,* 5, no. 3 (September 1976).
Edwin Hewitt Gallery. "Small Sculptures by Elie Nadelman." *New York 1950,* November 28–December 16, 1950.
Eidelberg, Martin. "Tiffany Favrille Pottery." *The American Connoisseur,* 169 (September 1968).
———. "Art Pottery." *The Arts and Crafts Movement in America 1876–1916.* Edited by Robert J. Clark. Princeton: Princeton University Press, 1972.
———. "The Ceramic Art of William H. Grueby." *The American Connoisseur,* 184 (September 1973).
Elliot, Charles Wyllus. *Pottery and Porcelain: From Early Times Down to the Philadelphia Exhibition 1876.* New York: Appleton, 1878.
Elliot, Maude Howe, ed. *Art and Handicraft in the Woman's Building of the World's Columbian Exposition.* Paris and New York: Guptill, 1893.

Emerson, Gertrude. "Marblehead Pottery." *Craftsman,* 29 (March 1916).

Emery, Olivia H. *Craftsman Lifestyle: The Gentle Revolution.* Pasadena: California Design Publications, 1977.

Evans, Paul F. "American Art Porcelain: The Work of the University City Pottery." *Spinning Wheel,* 27 (December 1971).

———. *Art Pottery of the United States: An Encyclopedia of Producers and Their Marks.* New York: Scribner's Sons, 1974.

———. "Newcomb Pottery Decorators." *Spinning Wheel,* 30 (April 1974).

The Evanston Art Center. *The Ceramic Vessel as Metaphor.* Essay by Alice Westphal. Evanston, Ill., 1977.

Everson Museum of Art. *Ceramic Nationals Catalogues.* Syracuse, N.Y., 1968–1972.

———. *The Art Deco Environment.* Introduction by Peg Weis, preface by Ronald Kuchta. Syracuse, N.Y., 1976.

———. *New Works in Clay by Contemporary Painters and Sculptors.* Text by Margie Hughto. Syracuse, N.Y., 1976.

———. *The Animal Kingdom in American Art.* Syracuse, N.Y., 1978.

"Fantasy at Kohler." *Craft Horizons,* 34 (December 1974).

Felton, David. "Nagle Among the Termites." *Rolling Stone,* August 24, 1978.

Finkel, Marylyn. "Suzanne Stephenson." *Craft Horizons,* 38 (January 1978).

Fitz Gibbon, John. "Sacramento!" *Art in America,* 59, no. 6 (November–December 1971).

Flu, E. B. "The Pewabic Pottery at Detroit." *The Ceramic Age* (January 1927).

Foley, Suzanne. "Introduction." San Francisco Museum of Art. *A Decade of Ceramic Art: 1962–1972.* San Francisco, 1972.

———, and Prokopoff, Stephen. *Robert Arneson.* Chicago: Museum of Contemporary Art; and San Francisco: Museum of Modern Art, 1974.

Foote, Nancy. "The Photo-Realists." *Art in America,* 60 (November–December 1972).

Fosdick, M. L. "Modeled Treatment of Pottery." *American Ceramic Society Journal,* 9 (1926).

Foster, Edith Dunham. "William A. Robertson, Master Potter." *International Studio,* 51 (November 1913).

———. "Dedham Pottery." *The House Beautiful,* 36 (August 1914).

Fox, Claire Gilbride. "Henry Chapman Mercer: Tilemaker, Collector, and Builder Extraordinary." *Antiques,* 104 (October 1973).

Frackelton, Susan Stuart. *Tried by Fire: A Work on China Painting.* New York: Appleton, 1886.

———. "Our American Potteries." *The Sketch Book,* 5 (October 1905).

———. "Rookwood Pottery." *The Sketch Book,* 5 (1906).

Frankenstein, Alfred. "The Ceramic Sculpture of Robert Arneson." *ARTnews,* 75 (January 1976).

Frazier, T. "Art of Ceramic Sculpture." *American Artist,* 5 (November 1941).

French, Myrtle. "Modern Pottery Class: School of The Art Institute of Chicago." *Design,* 26 (May 1924).

———. "Freeing the Creative Power of the Individual Through the Making of Pottery." *Design,* 29 (April 1927).

Frimkess, Michael. "The Importance of Being Classical." *Craft Horizons,* 25–26 (March–April 1966).

Fryatt, F. E. "Pottery in the United States." *Harper's New Monthly Magazine,* 62 (February 1881).

Gabriel, Cleota. *The Arts and Crafts Ideal: The Ward House.* Syracuse, N.Y.: Institute for the Development of Evolutionary Architecture, 1978.

Galloway, George D. "The Van Briggle Pottery." *Brush and Pencil,* 9 (October 1901).

Gaunt, W. "Design in Pottery: The Position of the Artist; Abstract." *Commercial Art,* 18 (February 1935).

Giambruni, Helen. "Abstract Expressionist Ceramics." *Craft Horizons,* 36 (November 1966).

———. "Exhibitions: John Mason." *Craft Horizons,* 37 (January–February 1967).

Glenn, Constance W. *Roy Lichtenstein Ceramic Sculpture.* Long Beach: The Art Galleries, California State University, 1977.

Goodheart, John. "Don Pilcher." *Craft Horizons,* 32 (June 1972).

Grafly, Dorothy. "Viktor Schreckengost." *American Artist,* 13, no. 5 (May 1949).

Gray, Walter Elsworth. "Latter-day Developments in American Pottery." *Brush and Pencil,* 10 (January 1902).

Gregory, W. "Ceramic Sculpture." *Design,* 43 (December 1941).

Gronborg, Erik. "The New Generation of Ceramic Artists." *Craft Horizons,* 29, no. 1 (January–February 1969).

Grossmont College. *Viewpoint: Ceramics 1977.* Foreword by Erik Gronborg. El Cajón, Calif., 1977.

Haile, T. S. "English and American Ceramic Design Problems." *The Bulletin of The American Ceramic Society,* 21 (1942).

Hall, Alice C. "Cincinnati Faience." *Potter's American Monthly,* 15 (August 1880).

Hall, Herbert J. "Marblehead Pottery." *Keramik Studio,* 10 (June 1908).

Hansen, Hans Jurgen, ed. *Late Nineteenth-Century Art: The Art, Architecture, and Applied Art of Pompon's Age.* New York: McGraw-Hill, 1972.

Hapgood, E. R. "All the Cataclysms: A Brief Survey of the Life of Beatrice Wood." *Arts Magazine,* 52 (1977).

Harder, Charles M. "Functional Design." *The Bulletin of The American Ceramic Society,* 21, no. 8 (August 15, 1942).

———. "A Message to Ceramic Designers." *Ceramic Industry* (June 1945).

Hare, Denise. "The Lustrous Life of Beatrice Wood." *Craft Horizons,* 38 (June 1978).

Hartranft, Ann. "Everson Offers Varied Shows." *Herald Journal American* (Syracuse), May 28, 1972.

Hasselle, Bob. "Rookwood: An American Art Pottery." *Ceramics Monthly,* 26 (June 1978).

Haverstadt, Hal. "Ron Nagle in Rock and Glass" (The Songwriter/Ed Ward, the Potter/Joseph Pugliese). *Craft Horizons,* 31 (June 1971).

Hawes, Lloyd E. "Hugh Cornwall Robertson and the Chelsea Period!" *Antiques,* 89 (March 1966).

———. *The Dedham Pottery and the Earlier Robertson's Chelsea Potteries.* Dedham, Mass.: Dedham Historical Society, 1968.

Hegarty, M. "Selected Pieces from Pewabic Pottery by M. C. Stratton." *The Detroit Institute of Arts Bulletin,* 26, no. 3 (1947).

———. "Caterpillar by Carl Walters." *The Detroit Institute of Arts Bulletin,* 27, no. 3 (1948).

Henderson, R. "Gertrud and Otto Natzler." *Design,* 49 (January 1948).

Henry, Gerrit. "The Clay Landscapes of Mary Frank." *Craft Horizons,* 31 (December 1971).

"Henry Varnum Poor 1888–1970." *Craft Horizons,* 31 (April 1971).

Henzke, Lucile. "Weller's Sicardo." *Spinning Wheel,* 25 (September 1969).

———. *American Art Pottery.* Camden, N.J.: Nelson, 1970.

Hepburn, Tony. "American Ceramics 1970." *Ceramic Review,* no. 7 (1970).

———. "Issues for American Ceramics." *Ceramic Review,* no. 37 (January–February 1976).

Herrera, Hayden. "Myth and Metamorphosis: Mary Frank." *Artscanada* (April–May 1978).

The Hewitt Gallery. *Figures and Figurines of Elie Nadelman.* New York, 1958.

"Hirshhorn Collection." *Ceramics Monthly,* 23 (May 1975).

Hoffman, J., Driscole, D., and Zahler, M. C. *A Study in Regional Taste, The May Show 1919–1975.* Essay by Jay Hoffman, preface by G. P. Weisberg. Cleveland, 1977.

Homer, William I. "Carl Walters, Ceramic Sculptor." *Art in America,* 44 (Fall 1956).

Hopkins, Henry T. "Kenneth Price, Untitled Ceramic." *Artforum,* 2, no. 2 (August 1963).

Hughto, Margie. *New Works in Clay by Contemporary Painters and Sculptors.* Syracuse, N.Y.: Everson Museum of Art, 1976.

Hull, William. "Some Notes on Early Robineau Porcelains." *Everson Museum of Art Bulletin,* 22 (1960).

Hutson, Ethel. "Newcomb Pottery, A Successful Experiment in Applied Art." *The Clay Worker,* 45 (1906).

Isaacs, W. F. "Paul Bonifas, Potter from

Switzerland." *Design,* 49 (September 1947).

Isamu Noguchi. Introductions by Shuzo Takiguchi, Saburo Hasegawa, and Isamu Noguchi. Tokyo: Bijutsu Shuppan-Sha, 1953.

Jaffe-Friede and Strauss Galleries. *Contemporary Clay: Ten Approaches.* Hanover, N.H.: Dartmouth University Press, 1976.

"Jerry Rothman." *Ceramics Monthly,* 26 (November 1976).

Jervis, William Percival. *The Encyclopedia of Ceramics.* New York, 1902.

———. "Taxile Doat." *Keramik Studio,* 4 (July 1902).

"John and Ruby Glick." *Ceramics Monthly,* 23 (January 1975).

Johnson, Evert. "Two Happenings at Southern Illinois University: 1) Clay Unfired." *Craft Horizons,* 30 (October 1970).

Johnson, Philip. *Machine Art.* New York: The Museum of Modern Art, 1934.

Johnston, R. H. *Frans Wildenhain.* New York: Rochester Institute of Technology, 1975.

Jones, Kenneth W. "Richard E. DeVore." *Philadelphia Arts Exchange,* 1, no. 2 (March–April 1977).

Judd, Donald. "Robert Arneson." *Arts Magazine,* 39 (January 1965).

Kalamazoo Institute of Arts. *Contemporary Ceramics: The Artist's Viewpoint.* Kalamazoo, Mich., 1977.

Kansas City Art Institute. *Eight Independent Production Potters.* Kansas City, Mo., 1976.

Keen, Kirsten Hoving. *American Art Pottery 1875–1930.* Wilmington: Delaware Art Museum, 1978.

Kester, Bernard. "Laura Andreson." *Craft Horizons,* 30 (December 1970).

———. "Los Angeles." *Craft Horizons,* 36 (December 1976).

———, and Peterson, S. "Exhibitions." *Craft Horizons,* 27 (November–December 1967).

King, Mary. "Ceramics Exhibit by Kenneth Price." *St. Louis Post-Dispatch,* October 3, 1976.

King, William A. "Ceramic Art at the Pan American Exhibition." *Crockery and Glass Journal,* 53 (May 30, 1901).

Kingsley, Rose. "Rookwood Pottery." *Art Journal,* 23 (1897).

Kircher, Edwin J., Agranoff, Barbara, and Agranoff, Joseph. *Rookwood: Its Golden Era of Art Pottery 1880–1929.* Cincinnati, Ohio, 1969.

Kirstein, Lincoln. *Figures and Figurines by Elie Nadelman.* New York: The Edwin Hewitt Gallery, 1958.

———. *Elie Nadelman.* New York: Eakins Press, 1973.

Kline, Katy. "Pots, Paintings: A Common Thread." *Courier Express,* April 1978.

Knute, Stiles. "Robert Arneson." *Artforum,* 3, no. 1 (November 1964).

Koch, Robert. "The Pottery of Artus Van Briggle." *Art in America,* 52 (June 1964).

Kohlenberger, Lois H. "Ceramics at the People's University." *Ceramics Monthly,* 24 (November 1976).

Kovel, Ralph, and Kovel, Terry. *Kovel's Collector's Guide to American Art Pottery.* New York: Crown, 1974.

Kramer, Hilton. "The Sculpture of Mary Frank: Poetical, Metaphorical, Interior . . ." *The New York Times,* February 22, 1970.

———. "For Nadelman, There Is No Lost Grandeur." *The New York Times,* March 17, 1974.

———. "Art: Sensual, Serene Sculpture." *The New York Times,* January 25, 1975.

———. "Sculpture—From Boring to Brilliant." *The New York Times,* May 15, 1977.

Lafean, R. "Ceramics by Twelve Artists." *Craft Horizons,* 25–26 (January 1965).

Laguna Beach Museum of Art. *Illusionistic Realism as Defined in Contemporary Ceramic Sculpture.* Foreword by E. Levin, essay by Lukman Glasgow. Laguna Beach, Calif., 1977.

Last, Martin. "Robert Arneson." *ARTnews,* 68, no. 8 (December 1969).

Lawson, Donna. "The Constant Cup." *Craft Horizons,* 30 (December 1970).

Layton, Peter. "Kenneth Price Cups at Kasmin Until 8 February." *Studio International,* 179 (February 1970).

Leach, Bernard. *A Potter's Book.* London: Faber & Faber, 1940.

———. "American Impressions." *Craft Horizons,* 10 (Winter 1950).

Leonard, Ann B. "Pottery and Porcelain at the Paris Exposition." *Keramik Studio* (August 1900).

Levin, Elaine. "Pioneers of Contemporary American Ceramics: Charles Binns, Adelaide Robineau." *Ceramics Monthly,* 23 (November 1975).

————. "Pioneers of Contemporary American Ceramics: Arthur Baggs, Glen Lukens." *Ceramics Monthly,* 24 (January 1976).

————. "Pioneers of Contemporary American Ceramics: Laura Andreson, Edwin and Mary Scheier." *Ceramics Monthly,* 24 (May 1976).

————. "Pioneers of Contemporary American Ceramic Art: Maija Grotell, Herbert Sanders." *Ceramics Monthly,* 24 (November 1976).

————. "Ralph Bacerra." *Ceramics Monthly,* 25 (April 1977).

————. "Otto and Vivika Heino." *Ceramics Monthly,* 25 (October 1977).

————. "Peter Voulkos: A Retrospective, 1948–1978." *Artweek* (March 18, 1978).

————. "Portfolio: Peter Voulkos." *Ceramics Monthly,* 26, no. 6 (June 1978).

Levin, Kim. "The Ersatz Object." *Arts Magazine* (February 1974).

Licka, C. E. "A Primafacie Clay Sampler: A Case for Popular Ceramics, Part I." *Currant,* 1 (August–September 1975). Part II, October–November 1975.

La Ligue Américaine de la Femme. *Catalogue des Porcelaines Robineau.* St. Louis, Mo.: University City Publishing, 1911.

Lipofsky, Marvin. "Young Americans: Clay/Glass." *Craft Horizons,* 38 (June 1978).

Long Beach Museum of Art. *Ceramic Conjunction 1977.* Long Beach, Calif., 1977.

Los Angeles County Museum of Art. *Peter Voulkos: Sculpture.* Los Angeles, 1965.

————. *The Ceramic Work of Gertrud and Otto Natzler.* Los Angeles, 1966.

————. *Ken Price Happy's Curios.* Introduction by Maurice Tuchman. Los Angeles, 1978.

Lovoos, Janice. "F. Carlton Ball, Master Potter." *Ceramics Monthly,* 13 (September 1965).

Low, J. G., and Low, J. F. "Art Tile Works." *Illustrated Catalogue of Art Tiles.* Chelsea, Mass., 1884.

Loyau, Maggy. "Harrison McIntosh." *Cahiers de la Céramique,* 56 (1974).

Lukens, Glen. "Ceramic Art at the University of Southern California." *Design,* 38 (May 1937).

————. "The New Craftsman." *Design,* 38 (November 1937).

MacSwiggan, Amelia E. "The Marblehead Pottery." *Spinning Wheel,* 26 (March 1972).

Madsen, S. Tchudi. *Sources of Art Nouveau.* Oslo: H. A. Aschehoug, 1956.

Malcolm, J. "On and Off the Avenue: About the House." *The New Yorker* (September 4, 1971).

Mannel, E. "Pacific Coast Ceramic-Sculpture and Pottery Exhibition: Sixth Annual with List of Prize Winners." *Design,* 49 (October 1947).

Marling, Karal Ann. *Federal Art in Cleveland 1933–1943.* Cleveland: Cleveland Public Library, 1976.

————. "New Deal Ceramics; The Cleveland Workshop." *Ceramics Monthly,* 25 (June 1977).

"Mary Louise McLaughlin: Originator of Plastic Slip Underglaze Painting and Maker of One-Fire Porcelain Artware: Her Own Story: Newspaper Accounts of Her Faience: Letters." *The Bulletin of The American Ceramic Society,* 17 (May 1938).

Mathews, J. M. "Ostend: International Show of Ceramics Today." *Craft Horizons,* 19 (September–October 1959).

McChesney, Mary Fuller. "Porcelain by Richard Shaw and Robert Hudson." *Craft Horizons,* 33 (October 1973).

————. "Michael Frimkess and the Cultured Pot." *Craft Horizons,* 33 (December 1973).

McConathy, Dale. "David Gilhooly's Mythanthropy: From the Slime to the Ridiculous." *Artscanada* (June 1975).

McDonald, Robert. "New Work by Ron Nagle." *Artweek* (November 22, 1975).

McKinley, D. "24th Ceramic National." *Craft Horizons,* 36 (December 1966).

McKinnell, J. "Introduction." *Clay Today.* Iowa City: School of Fine Arts, New Gallery, State University of Iowa, 1963.

McLaughlin, Mary Louise. *Pottery Decoration Under the Glaze.* Cincinnati, Ohio: Clarke, 1880.

———. *Suggestion to China Painters.* Cincinnati, Ohio: Clarke, 1883.

———. *China Painting: A Practical Manual for the Use of the Amateur in the Decoration of Hard Porcelain.* Cincinnati, Ohio: Clarke, 1897.

———. "Losantiware." *Craftsman,* 3 (December 1902).

———. *The China Painters' Handbook: The Practical Series.* vol. 1. Cincinnati, Ohio, 1917.

———. Paper read at the meeting of the Porcelain League, April 25, 1914, Cincinnati Artists File, Cincinnati Art Museum Art Library. Edited and published in *The Bulletin of The American Ceramic Society,* 17 (May 1938).

Mehring, Howard. "Richard DeVore." *Washington Review* (December 1977 and January 1978).

Meisel, Alan R. "Robert Arneson." *Craft Horizons,* 24 (September–October 1964).

———. "Heavy Clay by Stephen De Staebler." *Craft Horizons,* 35 (February 1975).

Melchert, Jim. "Peter Voulkos: A Return to Pottery." *Craft Horizons,* 28 (September–October 1968).

———. Essay in Scripps College, *The Fred and Mary Marer Collection.* Claremont, Calif., 1974.

———. "Fred Marer and the Clay People." *Craft Horizons,* 34 (June 1974).

Mellow, James R. "About Woman as a Sexual Being." *The New York Times,* April 22, 1973.

———. "Mary Frank Explores Women's Erotic Fantasies." *The New York Times,* January 19, 1975.

The Metropolitan Museum of Art. *Adelaide Alsop Robineau.* Essay by Joseph Breck. New York, 1929.

Meyer, Fred. *Sculpture in Ceramics.* New York: Watson-Guptill, 1971.

Milliken, William M. "Modern Ceramics and the Museum." *The Bulletin of The American Ceramic Society,* 16 (November 1935).

———. "Ohio Ceramics." *Design,* 38 (November 1937).

Miro, Marsha. "What Makes Art Out of a Pottery Bowl?" *Detroit Free Press,* January 22, 1978.

Mississippi State Historical Museum. *The Biloxi Art Pottery of George E. Ohr.* Essay by Garth Clark. Jackson, Miss., 1978.

"Modern Ceramics, 1934 Century of Progress Exhibition." *Design,* 36 (June 1934).

Moore College of Art Galleries. *Robert Hudson.* Essay by Peter Schjeldahl, foreword by Perry Vanderlip. Philadelphia, 1977.

Morse, Barbara White. "Low Art Tiles." *Spinning Wheel,* 25 (March 1969).

Morse, Sidney. *The Siege of University City: The Dreyfus Case in America.* St. Louis: University City Publishing, 1912.

Mowry, L. "Ceramic Guild at Mills." *Design,* 48 (December 1946).

Muchnic, Suzanne. "Curios from the Home Folk." *Los Angeles Times,* April 16, 1978.

"Museum Clay at Everson." *Craft Horizons,* 36 (April 1976).

Museum of Contemporary Art. *Robert Arneson—Retrospective.* Essays by S. Prokopoff and S. Foley. Chicago, 1974.

———. *David Gilhooly.* Chicago, 1976.

Museum of Contemporary Crafts. *Craft Forms from the Earth: 1000 Years of Pottery in America.* New York, 1961.

———. *Clayworks: 20 Americans.* New York, 1971.

———. *Porcelains by Jack Earl.* Introduction by Karl F. Cohen, New York: American Crafts Council, 1971.

———. *Baroque '74.* New York, 1974.

———. *Homage to the Bag.* Essay by Ruth Amdur Tanenhaus. New York, 1975.

———. *Young Americans: Clay/Glass.* New York: American Crafts Council, 1978.

The Museum of Modern Art. *Peter Voulkos.* New York, 1960.

Nasisse, Andy. "The Ceramic Vessel as Metaphor." *New Art Examiner* (January 1976).

Natzler, Otto. "The Natzler Glazes." *Craft Horizons,* 24 (July–August 1964).

———. *Gertrud and Otto Natzler Ceramics: Catalog of the Collection of Mrs. Leonard M. Sperry.* Los Angeles: County Museum of Art, 1968.

Nelson, G. *Ceramics: A Potters Handbook.* New York: Holt, Rinehart & Winston, 1966, 1971, 1977.

Nelson, Marion John. "Art Nouveau in American Ceramics." *Art Quarterly,* 26, no. 4 (1963).

———. "Indigenous Characteristics in American Art Pottery." *Antiques,* 89 (June 1966).

Neuwirth, Waltraud. *Wiener Keramik.* Braunschweig: Klinkhardt & Biermann, 1975.

"New Designs for Mass Production: Four Sets of Tableware Designed by V. Schreckengost." *Design,* 37 (November 1935).

New Gallery. *Clay Today.* Introduction by James McKinnell, essay by Abner Jonas. Iowa City: School of Fine Arts, State University of Iowa, 1962.

Newton, Clara Chapman. "Early Days at Rookwood Pottery." Manuscript in the Cincinnati Historical Society, edited and included in *The Bulletin of the American Ceramic Society,* 18 (November 1939).

———. "The Cincinnati Pottery Club." *The Bulletin of the American Ceramic Society,* 19 (September 1940).

"New York Reviews: Robert Arneson." *ARTnews,* 74 (April 1975).

Nicholas, Donna. "The Ceramic Nationals at Syracuse." *Craft Horizons,* 32 (December 1972).

Nichols, George Ward. *Pottery, How It Is Made, Its Shape and Decoration, Instructions for Painting on Porcelain and All Kinds of Pottery with Vitrifiable and Common Oil Colours.* New York: G. P. Putnam's Sons, 1878.

Nordland, Gerald. "John Mason." *Craft Horizons,* 19–20 (May–June 1960).

Nordness, Lee. *Objects: USA.* New York: The Viking Press, 1970.

Nordstrom, Sherry C. "Getting Their Hands In." *Syracuse Guide* (February 1978).

Norwood, John Nelson. *Fifty Years of Ceramic Education at State College of Ceramics, Alfred.* Alfred, N.Y., 1950.

The Oakland Museum. *California Ceramics and Glass 1974.* Introduction by Hazel Bray, juror's comment by James McKinnel. Oakland, Calif., 1974.

———. *Stephen De Staebler: Sculpture.* Essay by Harvey L. Jones. Oakland, Calif., 1974.

Ohio State University. *Beaux Arts Designer.* Columbus, Ohio, 1977.

Ohr, George E. "Some Facts in the History of a Unique Personality." *Crockery and Glass Journal,* 54 (December 1901).

Olmsted, Anna Wetherill. "The Ceramic National Founded in Memory of Adelaide Alsop Robineau." Manuscript, Syracuse, N.Y.: Everson Museum of Art, n.d.

———. "The Memorial Collection of Robineau Porcelains." *Design,* 33 (1931).

———. "First Annual Robineau Memorial Ceramic Exhibition." *Design,* 34 (June 1932).

———. "American Ceramic Sculpture to the Fore." *American Artist,* 11 (January 1947).

Ormond, Suzanne, and Irvine, Mary E. *Louisiana's Art Nouveau: The Crafts of the Newcomb Style.* Gretna, La.: Pelican Publishing, 1976.

Panama-Pacific International Exposition. *High-Fire Porcelains: Adelaide Alsop Robineau, Potter.* San Francisco, 1915.

Paris, Harold. "Sweet Land of Funk." *Art in America,* 30 (March–April 1967).

Parks, Dennis. "Paul Soldner." *Craft Horizons,* 36 (January–February 1976).

Pasadena Center. *California Design, 1910.* Edited by Timothy J. Anderson, Eudorah M. Moore, Robert W. Winter. Pasadena: California Design Publication, October 15–December 15, 1974.

Pasadena Museum of Modern Art. *John Mason Ceramic Sculpture.* Essay by Barbara Haskel. Pasadena, Calif., 1974.

Pear, Lillian Myers. *The Pewabic Pottery: A History of Its Products and People.* Des Moines, Iowa: Wallace-Homestead Book Co., 1976.

Peck, Herbert. "The Amateur Antecedents of Rookwood Pottery." *Cincinnati Historical Society Bulletin,* 26 (October 1968).

———. *The Book of Rookwood Pottery.* New York: Crown, 1968.

———. "Rookwood Pottery and Foreign Museum Collections." *The American Connoisseur,* 178 (September 1969).

———. "Some Early Collections of Rook-

wood Pottery." *Auction* (September 1969).

Peck, Margaret. *Catalog of Rookwood Art Pottery Shapes.* New York: Kingston, 1971.

Peeler, Richard. "Clay." *Craft Horizons,* 34 (December 1974).

Penny, Janice. "The Natzlers, Masters of Ceramic Art." *American Artist,* 14 (March 1950).

Perry, Mrs. Aaron F. "Decorative Pottery of Cincinnati." *Harper's New Monthly Magazine,* 62 (April–May 1881).

———. "The Work of Cincinnati Women in Decorated Pottery." *Art and Handicraft in the Woman's Building of the World's Columbian Exposition, Chicago 1893.* Edited by Maud Howe Elliot. Chicago and New York: Rand McNally, 1894.

Perry, Mary Chase. "Grueby Potteries." *Keramik Studio,* 2 (1900).

———. "Grueby Potteries." *Keramik Studio,* 4 (1902).

Peterson, Susan. "Antonio Prieto 1912–1967." *Craft Horizons,* 27 (July–August 1967).

———. "Glen Lukens 1887–1967." *Craft Horizons,* 28 (March–April 1968).

———. "Wayne Higby." *Craft Horizons,* 33 (June 1973).

———. "The Ceramics of Marilyn Levine." *Craft Horizons,* 37 New York (February 1977).

———. *Maria Martinez.* Tokyo: Kodansha International, 1977.

Petterson, Richard B. *Ceramic Art in America.* Columbus, Ohio: Professional Publications, 1969.

———. "Marguerite Wildenhain." *Ceramics Monthly,* 25 (March 1977).

Pewabic Pottery Archives. *Inventory of the Parker Collection by Mary Chase Stratton.* Detroit, December 1937.

Phoenix Art Museum. *Beatrice Wood: A Retrospective.* Foreword by Robert H. Frankel. Phoenix, Ariz., 1973.

Pierre, Jose. "Funk Art." *L'Oeil,* 190 (October 1970).

Plagens, Peter. *Sunshine Muse.* New York: Praeger, 1974.

Plumb, Helen. "The Pewabic Pottery." *Art and Progress,* 2 (January 1911).

Polley, Elisabeth M. "Robert Arneson." *Artforum,* 2, no. 7 (January 1964).

Pomeroy, Ralph. "Breschi and the Beasts." *Art and Artists,* 7 (November 1973).

"Poor, H. V." *Art Digest,* 22 (December 1947).

———. "Ceramic Exhibition." *Baltimore Museum News,* 12 (November 1948).

———. *A Book of Pottery: From Mud to Immortality.* Englewood Cliffs, N.J.: Prentice-Hall, 1958.

———. "Foreword." Syracuse Museum of Fine Arts, *Ceramic International.* Syracuse, N.Y., 1958.

"Pots and Pans by Students of Lukens at University of Southern California." *Magazine of Art,* 36 (November 1943).

"A Potter Called DeVore." *The Cranbrook Magazine* (Fall 1972).

"Pottery of Sam Haile." *Architectural Forum,* 90 (March 1949).

"Professor Charles F. Binns." *Design,* 36 (January 1935).

Pugliese, Joseph. "Ceramics from Davis." *Craft Horizons,* 25–26 (November–December 1966).

———. "The Decade." *Craft Horizons,* 35 (February 1975).

Purviance, Louise. *Weller Art Pottery in Color.* Des Moines, Iowa: Wallace-Homestead, 1971.

———, Evans, and Schneider, Norris F. *Roseville Art Pottery in Color.* Des Moines, Iowa: Wallace-Homestead, 1968.

Pyron, Bernard. "From Pottery to Amateur Science: Clayton Bailey's Digs." Manuscript, Institute for Ceramic History, Claremont, Calif., n.d.

———. "The Tao and Dada of Recent American Ceramic Art." *Artforum,* 2 (March 1964).

Randall, R. "Ceramics by Edwin and Mary Scheier." *Rhode Island School of Design Bulletin,* 4 (January 1946).

———. "Potter Looks at Scheier Pottery." *Design,* 47 (January 1946).

Randall, Ruth Hunie. *Ceramic Sculpture.* New York: Watson-Guptill, 1948.

Raven, Arlene, and Rennie, Susan. "Interview with Judy Chicago." *Chrysalis,* 1, no. 4 (1978).

Rawson, Jonathan A., Jr. "Recent Ameri-

can Pottery." *The House Beautiful,* 31 (April 1912).

Reeve, John. "Warren MacKenzie and the Straight Pot." *Craft Horizons,* 36 (June 1976).

Reif, Rita. "American Art Pottery—A Craft Tradition." *The New York Times,* March 26, 1978.

Renwick Gallery. *Form and Fire: Natzler Ceramics 1939–1972.* Washington, D.C.: Smithsonian Institution Press, 1973.

———. *Crafts-Multiples.* Washington, D.C.: Smithsonian Institution Press, 1975.

———. *Object as Poet.* Essay by Rose Slivka. Washington, D.C.: Smithsonian Institution Press, 1977.

Rhead, Frederick Hurten. "Some Dutch Pottery." *The Artist,* 24 (January–February 1899).

———. "America as a Ceramic Art Center." *Fine Arts Journal,* 23 (April 1910).

———. *Studio Pottery.* University City, Mo.: People's University Press, 1910.

Rhodes, Daniel. *Clay and Glazes for the Potter.* Philadelphia: Chilton, 1957.

———. "Robert Turner." *Craft Horizons,* 17–18 (May–June 1957).

———. *Stoneware and Porcelain: The Art of High-Fired Pottery.* Philadelphia: Chilton, 1959.

———. *Kilns: Design, Construction and Operation.* Philadelphia: Chilton, 1968.

———. "The Potter and His Kiln." *Craft Horizons,* 29 (March–April 1969).

———. *Tamba Pottery: The Timeless Art of a Japanese Village.* Tokyo: Kodansha International, 1970.

———. *Pottery Form.* Radnor, Pa.: Chilton, 1976.

———. "Daniel Rhodes: Pottery and the Person." *Ceramics Monthly,* 25 (January 1977).

Richards, Agnes Gertrude. "Important Exhibition of American Ceramics." *Fine Arts Journal,* 33 (1915).

Richards, Charles R. "The International Ceramic Exhibition." *Creative Art,* 3 (1928).

Richards, M. C. "Dan Rhodes." *Craft Horizons,* 17–18 (September–October 1958).

———. "Frans Wildenhain." *Craft Horizons,* 35 (February 1975).

———. "Black Mountain College: A Golden Seed." *Craft Horizons,* 37 (June 1977).

Richardson, Brenda. "California Ceramics." *Art in America,* 51 (May 1969).

Riegger, Harold Eaton. "The Pottery of Win Ng." *Ceramics Monthly,* 11 (April 1963).

———. *Raku: Art and Technique.* New York: Van Nostrand Reinhold, 1970.

———. *Primitive Pottery.* New York: Van Nostrand Reinhold, 1972.

Ripley, L. A. "When Mantle Fell on New Dean of Artists." *Cincinnati Times-Star,* December 4, 1933.

Robbins, Carle. "Cowan of Cleveland, Follower of an Ancient Craft." *Bystander* (September 7, 1929).

Robertson, Seonaid. "Karen Karnes." *Ceramic Review* (March–April 1978).

Robineau, Adelaide Alsop. "Mary Chase Perry—the Potter." *Keramik Studio,* 6, no. 10 (1905).

———. "Ceramics at the Paris Exposition" (a series of ten articles). *Design,* 27–28 (December 1925–September 1926).

Robineau, Samuel. "The Robineau Porcelains." *Keramik Studio,* 12 (1911).

———. "Adelaide Alsop Robineau." *Design,* 30 (April 1929).

Rochester Institute of Technology. *Frans Wildenhain.* New York, 1975.

Rose, Muriel. *Artist Potters in England.* London: Faber & Faber, 1955.

Rosenberg, Harold. "Reality Again." In Gregory Battcock, ed., *Super Realism: A Critical Anthology.* New York: Dutton Paperbacks, 1975.

Ruge, Clara. "Amerikanische Keramik." *Dekorative Kunst* (January 1906).

———. "American Ceramics—A Brief Review of Progress." *International Studio,* 28 (March 1906).

Russel, Arthur. "Grueby Pottery." *The House Beautiful,* 5 (December 1898).

"Russell Barnett Aitken." *Milwaukee Art Institute Bulletin,* 10 (February 1936).

Sanders, Herbert H. *Glazes for Special Effects.* New York: Watson-Guptill, 1974.

———, and Tomimoto, K. *The World of Japanese Ceramics: Historical and Modern Techniques.* Tokyo: Kodansha International, 1967.

San Francisco Art Institute. *Centennial Exhibition.* Essay by Philip Linhares, juror's statement by Carl Andre. San Francisco: San Francisco Museum of Art, January 15–February 28, 1971.

San Francisco Museum of Modern Art. *Abstract Expressionist Ceramics.* Essay by John Coplans, San Francisco, 1967.

———. *A Decade of Ceramic Art: 1962–1972.* Essay by Suzanne Foley. San Francisco, 1972.

———. *Richard Shaw/Robert Hudson: Works in Porcelain.* Essay by Suzanne Foley. San Francisco, 1973.

———. *Jim Melchert.* Essay by Suzanne Foley. San Francisco, 1975.

Sargent, Irene. "Potters and Their Products." *Craftsman,* 4 (August 1903).

———. "Chinese Pots and Modern Faience." *Craftsman,* 4 (September 1903).

———. "Taxile Doat." *Keramik Studio,* 8 (December 1906).

Saunier, Charles. "Poteries de la Cie Grueby." *L'Art Décoratif* (August 1901).

Sawin, Martica. "The Sculpture of Mary Frank." *Arts Magazine,* 51 (March 1977).

Schlanger, Jeff. "Ceramics and Pop—Roy Lichtenstein." *Craft Horizons,* 26 (January–February 1966).

———. "Roy Lichtenstein." *Craft Horizons,* 26 (March 1966).

———. "Claes Oldenburg." *Craft Horizons,* 26 (June 1966).

———. "Ceramics and Photography." *Craft Horizons,* 27 (January 1967).

———. "Maija Grotell." *Craft Horizons,* 29 (November–December 1969).

Schneider, Norris F. *Zanesville Art Pottery.* Zanesville, Ohio, 1963.

Schwartz, Fred R. "Exhibitions." *Craft Horizons,* 28 (January–February 1968).

Schwartz, Judith S. "The Essential Karnes." *Karen Karnes: Works 1964–1977.* New York: Hadler Gallery, 1977.

———. "Tureens. Soup's In." *Craft Horizons,* 36 (April 1976).

Schwartz, M. D., and Wolfe, R. *A History of American Art Porcelain.* New York: Renaissance Editions, 1967.

Scott, Gail. "Robert Rauschenberg." Maurice Tuchman, ed., *Art and Technology: A Report on the Art and Technology*

Program of the Los Angeles County Museum of Art. Los Angeles, 1971.

Scripps College. *Second Bi-Annual Ceramic Exhibition.* Claremont, Calif., 1947.

———. *The Fred and Mary Marer Collection.* Essays by J. Melchert and P. Soldner. Claremont, Calif., 1974.

Selz, Peter. *Funk.* Berkeley: University of California Art Museum, 1967.

Sewalt, Charlotte. "An Interview with Ken Ferguson." *Ceramics Monthly,* 26 (February 1978).

Sewter, A. C. "T. S. Haile, Potter and Painter." *Apollo,* 44 (December 1946).

———. *The Surrealist Paintings and Drawings of Sam Haile.* Manchester, U.K.: City Art Gallery, 1967.

Shafer, Tom. "John Glick." *Ceramics Monthly,* 20 (September 1972).

Shapiro, H. Y. "I Love You Bob Turner." *Craft Horizons,* 32 (August 1972).

Sheerer, Mary G. "Newcomb Pottery." *Keramik Studio,* 1 (1899).

———. "The Development of the Decorative Processes at Newcomb." *American Ceramic Society Journal,* 7 (August 1924).

———, and Paul E. Cox. "Newcomb Pottery." *American Ceramic Society Journal,* 1 (August 1918).

Shuebrook, R. "Regina Funk." *Art and Artists,* 38 (August 1973).

Silver, Jonathan. "Elie Nadelman: A Single Notion of Style." *ARTnews,* 74 (November 1975).

Siple, Ella S. "The International Exhibition of Ceramic Art." *American Magazine of Art,* 19 (1928).

Slivka, Rose. "The New Ceramic Presence." *Craft Horizons,* 21 (July–August 1961).

———. "Laugh-In in Clay." *Craft Horizons,* 31 (October 1971).

———. "The New Clay Drawings of Peter Voulkos." *Craft Horizons,* 34 (October 1974).

———. *The Object as Poet.* Washington, D.C.: Renwick Gallery, 1977.

———. *Peter Voulkos: A Dialogue with Clay.* New York: New York Graphic Society, 1978.

Sloane, W. J. "American Ceramics." *ARTnews,* 30 (November 14, 1931).

Slusser Gallery. *Fiber, Metal and Clay.* Ann Arbor, Mich., October 1977.

Smith, Dido. "Karen Karnes." *Craft Horizons,* 18, no. 3 (May–June 1958).

Smith, Kenneth E. "Laura Anne Fry: Originator of Atomizing Process for Application of Underglaze Colour." *The Bulletin of The American Ceramic Society,* 17 (1938).

———. "The Origin, Development and Present Status of Newcomb Pottery." *The Bulletin of The American Ceramic Society,* 17 (1938).

———. "Ceramics at Newcomb College." *Design,* 46 (December 1944).

Smith, Walter, and Wilson, Joseph M. *The Masterpieces of the Centennial International Exposition.* 3 vols. Philadelphia: Gebbie & Barrie, 1876.

Soldner, Paul E. "Raku as I Know It." *Ceramic Review* (April 1973).

Stewart, Lewis W. "Breaking the Bone Barrier." *Pacific Sun* (November 1975).

Stiles, Helen E. *Pottery in the United States.* New York: E. P. Dutton, 1941.

Stone, D. J. "Robert Arneson." *Arts Magazine,* 39 (January 1965).

"Stoneware Vases of Charles Fergus Binns." *The Bulletin of The American Ceramic Society,* 15 (July 1935).

Storer, Maria Longworth (Nichols). *History of the Cincinnati Musical Festival and of the Rookwood.* Paris, 1919.

Stover, Frances. "Susan Goodrich Frackelton and the China Painters." *Historical Messenger of the Milwaukee County Historical Society* (March 1954).

Stratton, Mary Chase. "Pewabic Records." *American Ceramic Society Bulletin,* 25 (October 15, 1946).

Stratton, Mary Chase Perry. *Ceramic Processes.* Ann Arbor, Mich.: Edwards, 1941.

Stubblebine, James, and Eidelberg, Martin. "Viktor Schreckengost and the Cleveland School." *Craft Horizons,* 35 (June 1975).

Sturgis, Russell. "American Potters." *Scribner's Magazine,* 32 (1902).

———. "American Pottery, Second Paper." *Scribner's Magazine,* 33 (January–June 1903).

Supensky, Tom. "Exhibitions." *Craft Horizons,* 35 (June 1975).

Swain, F. K. "Moravian Pottery and Tile Works Founded by H. C. Mercer, Doylestown Pa." *Antiques,* 24 (November 1933).

Swan, Mabel M. "The Dedham Pottery." *Antiques,* 10 (August 1926).

"Syracuse Gets Robineau Memorial Group." *Art Digest,* 5 (January 15, 1931).

Syracuse Museum of Fine Arts. *Contemporary American Ceramics.* Foreword by Anna W. Olmsted, preface by Richard F. Bach. Syracuse, N.Y., 1937.

———. *Contemporary Ceramics of the Western Hemisphere.* Syracuse, N.Y., 1941.

———. *Ceramic Nationals Catalogues.* Syracuse, N.Y., 1953–1967.

———. *Twentieth Ceramic International.* Foreword by Henry V. Poor. Syracuse, N.Y., 1958.

Syracuse University. *Ruth Randall Retrospective.* Syracuse, N.Y.: Lowe Art Center, 1962.

———. *New Works in Clay II.* Essay by Garth Clark. Syracuse, N.Y.: Lowe Art Center, 1978.

"T. S. Haile, Ceramist." *Craft Horizons,* 9 (Summer 1949).

Tarshis, Jerome. "Playing Around." *ARTnews* (December 1974).

Taylor, William Watts. "The Rookwood Pottery." *Faenza,* 3 (1915).

"Thelma Frazier Winter." *American Artist,* 5 (November 1941).

Trapp, Kenneth R. "Maria Longworth Storer: A Study of Her Bronze Objet d'Art in the Cincinnati Art Museum." Master's thesis, Tulane University, 1972.

———. "Japanese Influence in Early Rookwood Pottery." *Antiques,* 103 (January 1973).

Traux, H. A. "Daniel Rhodes: A Study of His Work as Exemplary of Contemporary American Studio Ceramics." Ph.D. dissertation, Columbia University, 1969.

Triggs, Oscar Lovell. *Chapters in the History of the Arts and Crafts Movement.* Chicago, 1902. Reprint. New York: Benjamin Blom, 1971.

Troy, Jack. "Don Reitz." *Craft Horizons,* 34 (October 1974).

"23rd Concorso Internazionale della Ce-

ràmica d'Arte," *Faenza,* Italia (1965).

Uchida, Yoshiko. "Win Ng." *Craft Horizons,* 20 (January–February 1960).

U.S. Department of Commerce. *Report on the Exposition Internationale des Arts Décoratifs et Industriels Modernes 1925.* Washington, D.C., 1926.

University Art Galleries. *Clay: The Medium and the Method.* Santa Barbara: University of California, 1976.

University of California. *Alexander Archipenko: A Memorial Exhibition.* Los Angeles: University Art Galleries, 1967.

University of Michigan. *School of Art Faculty.* New York: Lever House, 1978.

Untracht, Oppi. "Architectonics in Clay." *Craft Horizons,* 16 (January–February 1956).

Valentine, John. "Rookwood Pottery." *House Beautiful,* 4 (September 1898).

Verneuil, M. D. "Taxile Doat." *Art et Decoration* (September 1904).

The Victoria and Albert Museum. *20 American Studio Potters.* London, 1966.

———. *International Ceramics 72.* London, 1972.

"Viktor Schreckengost." *The Studio,* 1 (1933).

Volkmar, Charles. "Hints on Underglaze." *Keramik Studio,* 1 (May 1899).

Volpe, Todd M., and Blasberg, Robert W. "Fulper Art Pottery: Amazing Glazes." *American Art and Antiques* (July–August 1978).

Vozar, Linda. "A Conceptual Ceramic Artist." *Ceramics Monthly,* 24 (November 1976).

Waldman, D. *Roy Lichtenstein.* New York: The Solomon R. Guggenheim Foundation, 1969.

Walton, William. "Charles Volkmar, Potter." *International Studio,* 36 (January 1909).

Watson, E. W. "Waylande Gregory's Ceramic Art; Interview." *American Artist,* 8 (September 1944).

Weiss, Peg. "Bernard Frazier: American Sculptor of the Plains." *Everson Museum of Art Bulletin* (March 1978).

Wenger, Lesley. "Viola Frey." *Currant,* 1 (August 1975).

———. "Special Un-Scientific Supplement." *Currant,* 1 (October 1975).

Westphal, Alice. "The Ceramics of Ruth Duckworth." *Craft Horizons,* 37 (August 1977).

Whiting, Margaret C. "Charles Volkmar's Crown Point Pottery." *The House Beautiful,* 8 (October 1900).

Whitney Museum of American Art. *Sculptures and Drawings of Elie Nadelman 1882–1946.* New York, 1975.

———. *200 Years of American Sculpture.* New York: Godine, 1976.

Wieselthier, Vally. "Ceramics." *Design,* 31, no. 6 (November 1929).

Wildenhain, Marguerite. "Pottery as a Creative Craft." *Craft Horizons,* 10, no. 2 (1950).

———. *Pottery: Form and Expression.* New York: American Crafts Council and Reinhold Corp., 1959.

———. *Invisible Core: A Potter's Life and Thoughts.* Palo Alto, Calif.: Pacific Books, 1973.

William Hayes Ackland Art Center. *Contemporary Ceramic Sculpture.* Essay by Louise Hobbs. Chapel Hill, N.C., 1977.

Winokur, P. "Wayne Higby." *Craft Horizons,* 36 (August 1976).

———, and Winokur, Robert. "The Light of Rudolph Staffel." *Craft Horizons,* 37 (April 1977).

Wise, E. B. "Adelaide Alsop Robineau—American Ceramist." *The American Magazine of Art* (December 1929).

Wonders of the World Museum. *Catalogue of Kaolithic Curiosities and Scientific Wonders.* Porta Costa, Calif.: Clayton Bailey, July 1975.

Woodman, Betty, and Woodman, George. "Ceramists' Odyssey of Clay: Italy." *Craft Horizons,* 30 (June 1970).

Wright, Frank Lloyd. "In the Cause of Architecture: The Meaning of Materials —the Kiln." *Architectural Record,* 63 (June 1928).

Yaeger, D. "Rookwood, Pioneer American Art Pottery." *American Collector,* 12 (July 1943).

Young, Jenny. *The Ceramic Art: A Compendium of the History and Manufacture of Pottery and Porcelain.* New York: Harper, 1878.

Zack, David. "Funk Art." *Art and Artists,* 2, no. 1 (April 1967).

———. "California Myth Making." *Art and Artists,* 4, no. 4 (July 1969).

————. "San Francisco." *ARTnews,* 68, no. 5 (September 1969).

————. "Saga of Clayton Bailey: Beyond Criticism and the Nose-Pot Aesthetic." *Arts in Society,* 7, no. 1 (Spring 1970).

————. "The Ceramics of Robert Arneson." *Craft Horizons,* 30, no. 1 (February 1970).

————. "Nut Art in Quake Time." *ARTnews,* 69, no. 1 (March 1970).

————. "California Myth Makers," *Art and Artists,* 4 (March 1970).

————. *Nut Pot or Art Without Tears.* Davis, Calif.: The Art Center of the World, 1971.

————. "An Authentik and Historikal Discourse on the Phenomenon of Mail Art." *Art in America,* 61 (January 1973).

INDEX

Page numbers in **boldface** type indicate pictures

a Made Forty Pounds Lighter (Melchert), 307–308
a series (Melchert), 165, 307
"Abstract Expressionist Ceramics" exhibition (Irvine, Calif.), xxiv, 158, **171**
"Adventures in Art" exhibition (Seattle), xxiii
After the Catch (Warashina), **235**
Air Stream Turkey (Warashina), 339
Aitken, Russell, 82, 96, 269; **Pl. 13**
Aladdin vase (Nichols), 8
Albers, Josef, 137, 314, 321
Alfred University (Alfred, N.Y.), 80, 98, 116, 137, 263, 276, 280, 287, 295–296, 298, 319, 322, 325, 335
Ali Baba Vase (McLaughlin), **13,** 307
Alice House Wall (Arneson), 161, **179**
Alice in Wonderland series (Eckhardt), **105,** 286
Alice Street series (Arneson), 271
All-California Ceramic Art Exhibition, 98
American Ceramic Society, xxii, xxiii, xxiv, 46, 131, 274, 276, 278, 280, 295, 296, 322, 326, 328
"American Crafts 76: An Aesthetic View" exhibition (Chicago), xxv
American Encaustic Tiling Company, 322
American Limoges Ceramics Company, 326
American Women's League Teapot (Rhead), **71**
Andre, Carl, 200, 305
Andreson, Laura, **125,** 269–270, **270**
Annual Exhibition of Work by Cleveland Artists and Craftsmen (May Show), xxii, **13,** 81, 269, 274, 286, 293, 326
Antinaeus (Jacobsen), **90**
Anuszkiewicz, Richard, 268
Apocalypse '42 (Schreckengost), **Pl. 14**
Apotheosis of the Toiler (Robineau), 68

Apple Tree Lane Pottery, 315
Archie Bray Foundation (Helena, Mont.), 131, 133, 136, 266, 272, 275, 287, 326, 337
Archipenko, Alexander, 94, **99,** 270
Arequipa Pottery, 321–322
Arneson, Robert, xv, xxiv, xxv, **145,** 157, 159, 160–162, 163, 164, **178, 179, 180,** 197, 199, 200, 206, **218, 219, 220, 221,** 267, 270–272, 274, 284, 316; **Pl. 29**
"Arts and Techniques" exposition (Paris), 329, 340
Art Institute of Chicago, The, 198, 280, 286, 287, 311, 323, 338
Art League Pottery Club (New Orleans), 261
Art Works series (Arneson), 162
Artichoke Blossom Vase (Tiffany), **54**
Arts and Crafts Movement, 19, 21, 22, 44, 47, 69, 262, 308, 334
Associated Artists of Syracuse exhibition, 320
Atomic Glaze . . . Applied (Sweet), **209**
Atwood, Eugene R., 294
Autio, Rudy, 133, **144, 175, 246,** 266, **272,** 272–273, 337; **Pl. 23**
Avery, Milton, 268
Avon Pottery (Cincinnati), 336
Ax in a Stump Bottle (Shaw), **232**

Bacerra, Ralph, **187, 273,** 273, 300
Baggs, Arthur Eugene, **59,** 80, 82, 97, **108, 109,** 115, 264, 265, **273,** 273–274, 277, 278, 280, 324
Bailey, Clayton, 162–163, 164, **181, 223, 274,** 274–275
Bailey, Henrietta, 21
Bailey, Joseph, Jr., 313
Ball, F. Carlton, **121,** 270, 275
Ball, Kathryn, **121**
Bank (Ohr), **40**
Barber, Edwin Atlee, xxii, 24, 288, 337

Barcelona International Exposition (1929), 115, 294
Barlow, Hannah, 291
Baseball Vase (Broome), 2, **4**
Basket (Ferguson), **253**
Basket (Storer), **14**
Baskin, Leonard, 268
Baudisch, Gudrun, 264
Bauer, Fred, 163, 166, **182, 275,** 275–276, 339; **Pl. 27**
"Bay Area Ceramics" exhibition (San Francisco), xxiv
Bengston, Billy Al, 134, 136, **150,** 199, **212,** 276
Bennington Pottery, 45, **56, 57**
Big Ellie (Autio), **246**
Bigot, Alexander, 334
Biloxi Art Pottery, 23, 316
Bindesboll, Theobald, 23
Binns, Charles Fergus, xxii, xxiii, 24, 45, 46, 47, 48, **60,** 69, **74, 87,** 97, 263, 264, 273, **276,** 276–277, 280, 296
Bischoff, Frans, 317
Black Camera (Bauer), **182**
Black Mountain College (Asheville, N.C.), xxiii, 131, 137, 138, 266, 300, 322, 334, 339
Blackburn, Ed, **234,** 277, **277**
Blazys, Alexander, xxii, 81, **91**
Blue Goose (Shaw), 203, **239,** 328
Blue Wall, The (Mason), 305
Boch Frères Pottery (Belgium), 68, 284
Bogatay, Paul, 82, **104, 277,** 277–278
Bohnert, Thom R., **241,** 278
Bonifas, Paul, 97
Boston Museum of Fine Arts, xii, 262, 308
Boston Society of Arts and Crafts, 263, 274, 276, 288, 323
Bottle (Fulper Pottery), **75**
Bottle (Heino), **254**
Bottle (Pilcher), **256**
Bottle (Soldner), **174**
Bottle (Turner), **154**
Bottle (Voulkos), **171**
Bottle Vase (MacKenzie), **142**
Bottle Vase (Wareham), **50**
Bottle with Stopper (Nagle), **Pl. 20**
Boulder (Colo.) Recreation Pottery Program, 342
Boulding, Mark, 198
Bowl (Binns), **87**
Bowl (Diederich), **86**
Bowl (Fosdick), **121**
Bowl (Glick), **Pl. 33**
Bowl (Grotell), **139; Pl. 16**
Bowl (Mason), **151**
Bowl (Natzler), **123**
Bowl (O'Hara), **109**
Bowl (Pilcher), **193**
Bowl (Valentien), **52**
Boxer, Stanley, 199

Bracquemond, Felix, 259
Bray, Archie, **143,** 266
Breadfrog and Pigeons (Gilhooly), **222**
Breschi, Karen, **236,** 278, **278**
Bricoleuse (Frey), **Pl. 35**
Brooklyn Museum Art School, The, 282, 299
Broome, Isaac, 2, **4**
Brown, Joan, 160
Brown, Philip King, 322
Brown Slab Two (Olitski), **211**
Bucher, Hertha, 80, 264
Buffalo, Jo, 317
Buick (Dodd), **183**
Burlesque Dancer (Gregory), 293
Burns, Mark A., 278–279; **Pl. 32**

Calcagnino, Stephen, 317
Calder, Alexander, 113
California College of Arts and Crafts (San Francisco), 132, 133, 271, 275, 290, 310, 322, 340
California Snail Cup (Price), 319
Call Girl (Arneson), 161
Canfield, Ruth, 277
Cardew, Michael, xvi, 80
Cardozo, Sidney, 131, 266
Caro, Anthony, 199, **213, 279,** 279, 299, 362
Carrière, Eugène, 337
Cat (Walters), **107**
Caterpillar with Flying Buttresses (Bailey), **181**
Caulkins, Horace J., 46, **60,** 317
Cazin, Jean Charles, 337
Centennial Exposition (Philadelphia), xxi, 2, 5–6, 306, 312, 333
Century 21 Exposition (Seattle, Wash.), xxiii, 281
Century Vase (Müller), 2, **4**
Ceramic Form (Hui), **Pl. 24**
Ceramic International (Syracuse), xxiii
Ceramic National Exhibitions, ix, xii–xiii, xxiv, 82, 93, 95–96, 97, 114, 133, 157, 195–197, 264–265, 267, 269, 270, 274, 278, 280, 287, 288, 294, 303, 305, 307, 320, 324, 326, 337, 345, 362
Ceramic #29 (Hudson), **232**
Ceramic Relief #3 (Noland), **Pl. 40**
Ceramic Sculpture 12 (Lichtenstein), **186**
Ceramic Technology (Binns), **277**
"Ceramics by Twelve Artists," xxiii, 312
"Ceramics from Davis" exhibition (San Francisco), 284
"Ceramics International '73" exhibition (Alberta, Canada), xxiv
Cern Abbas Giant (Haile), 117
Changes (Melchert), 198, **204,** 308
Chaplet, Ernest, 6, 10, 20, 21, 259, 294
Chelsea Pottery, 10, 323
Chenango (Steiner), **210**
Cherry, Kathryn E., 68, **70,** 284

Chicago Exhibition of Applied Art, 274
Chichén Itzá Vase (Haile), 117
Chief Joseph of the Nez Percés (MacDonald), **28**
Chouinard Art Institute (Los Angeles), 273, 297
Cikansky, Victor, 197
Cincinnati Museum of Art, 260, 261, 291, 313
Cincinnati Pottery Club, xxi, 7–8, 9, **13**, 20, 259, 307, 312, 313
City, The (Grotell), **111**
Clark, George H., 323
Classical Exposure (Arneson), 271
Clay Artifacts (Sweet), 333
"Clay" exhibition (New York), xxv, 197
Clay Gravity Piece (Soldate), **209**
"Clay Images" exhibition (Los Angeles), xxiv–xxv, 198
Clay Institute (Syracuse, N.Y.), 203, 279, 286, 289, 299, 315, 362
"Clay Today" exhibition (Ames, Iowa), xxiii
"Clay Works in Progress" exhibition (Los Angeles), xxv, 198, **208**, 333
"Clayworks: Twenty Americans" exhibition (New York), xxiv
Clay Works studio workshop (New York), 268
Cleveland Museum of Art, xii, 286, 293, 326
Cleveland School of Art, 81–82, 269, 274, 286, 325
Cleveland Tile and Pottery Company, 280
Clouds over Lake Michigan (Duckworth), 285
Cocks Fighting over Art (Arneson), **180**
Coffee Set (Scheier), **125**
Colenbrander, Theodoor A. C., 20
Colgrove, Tom, 198, 267
Coming Through #2 (Rothman), **224**, 324
"Common Art Accumulations" exhibition (San Francisco), 160
Con-Can Tablet (Caro), **213**
"Concepts: Clay" exhibition (Mt. Pleasant, Mich.), xxv
"Concepts in Clay: Ten Approaches" exhibition (Hanover, N.H.), xxv
Conner, Bruce, 160
Contemporary American Ceramics Exhibition, xxiii
"Contemporary Ceramic Art: Canada, U.S.A., Mexico, Japan" exhibition (Japan), xxiv
"Contemporary Ceramic Sculpture" exhibition (Chapel Hill, N.C.), xxv
"Contemporary Ceramics of the Western Hemisphere," xiii, xxiii
Cookie Jar (Andreson), **124**
Cookie Jar (Baggs), 97, **108**, 274
Coplans, John, xxiv, 24, 134, 137, 158–159, 264, 266, 267, 319
Cornell, Joseph, 113
Cosmic Egg (Gilhooly), 292

Costanzo, Tony, **227**, 279–280, **280**
Cotton Centennial Exposition (New Orleans), xxi
Cotton States and International Exposition (Atlanta), xxii
Couch and Chair with Landscape and Cows (Shaw), **185**
Couch works (Shaw), 203
Coultry Pottery, 6, 7, 8, 307
Covered Bowl (Voulkos), **146**
Covered Jar (Cushing), **193**
Covered Jar (Frimkess), **Pl. 25**
Covered Jar (Stephenson), **257**
Covered Jar (Warashina), **190**
Covered Vessel (Autio), **Pl. 23**
Cowan, R. Guy, ix, xii, **77**, 80, 81–82, **90**, **91**, 96, 98, 269, 277, 280, 326, 338
Cowan Pottery Museum, 280
Cowan Pottery Studio (Rocky River, Ohio), 81, 82, 274, 280, 286, 293, 294, 326
Cowboy Mounting Horse (Diederich), **87**
Cox, Paul, 20, 277, 300, 331
Crab Vase (Robineau), 49, **66**
Craft and Folk Art Museum (Los Angeles), 311
Cram, Ralph Adams, 47
Cranbrook Academy of Art (Bloomfield Hills, Mich.), 115–116, 265, 278, 293, 294, 315, 333, 334
Creates Life Out of Mud (Bailey), **223**
Crescent City Pottery, 316
Cretan Forest (Haile), 117
Crisco (Arneson), 271
Cup (Nagle), **185**
Cup (Price), **228**
"Cup Show, The," exhibition (Los Angeles), xxiv
Currier, Anne, 301
Cushing, Val Murat, 137, **193**, 280, **281**

"Dada, Surealism and Their Heritage" exhibition (New York), xxiv
Daley, William, **246**, 280–281, **281**
Dali, Salvador, 160, 267, 327
Dallas, Frederick, 7
Dallas Pottery, xxi, 7, **13**, 313
Dalpayrat, Pierre-Adrienne, 334
Daly, Mathew A., **29**, 260, **281**, 281–282
Death Valley Plate (Lukens), **Pl. 15**
"Decade of Ceramic Art: 1962–1972" exhibition (San Francisco), xxiv
Deck, Theodore, 10, 337
Decoeur, Emile, 80
Dedham Pottery, 21, **32**, 262, 323
De Forest, Roy, 267, 274
Delaherche, Auguste, 20, 21, 22, **35**, 43, 44, 262, 294, 317, 334
Demitasse Set (Karnes), **156**
Despondency (Van Briggle), 44, 336; **Pl. 6**

De Staebler, Stephen, 136, 164, 167, 199, **216, 217, 282,** 282, 299
Detroit Institute of Arts, The, xii, 265, 317
DeVore, Richard E., 116, 204, **241, 248, 283,** 283, 294, 342; **Pl. 34**
Diana and Two Fawns (Gregory), 293
Dictator, The (Schreckengost), 114, **118**
Diederich, Hunt, 80, **86, 87,** 284
Dinner Plate (Bengston), **212**
Directions (Ng), **169**
Doat, Taxile, xxii, 48, 49, 67, 68, **70, 71,** 284, 323, 334
Dodd, Margaret, 161, **183,** 284–285
Dodd, Mrs. William, 259
Dog (Earl), **234**
Dog with Pink Shoes (Earl), **Pl. 26**
Dominick, Mrs. George, 259
Double Lady Vessel (Autio), **175**
Double Necked Vase (Ohr), **40**
Drutt, Helen, xxv
Duchamp, Marcel, 160, 271, 341, 342
Duck Plate (Poor), **87**
Duckworth, Ruth, **252, 253,** 285
Duo I (Nicholas), **225**
Dyer, Mrs. A. R., 82
Dzubas, Friedel, 199, **213,** 285–286, 299

Eaker, Allen, 321
Earl, Jack, 165, **234,** 286; **Pl. 26**
Earth Crater Bowl (Natzler), 140
Eckhardt, Edris, 82, 95, **104, 105,** 286
Elephant Ottoman (Gilhooly), 162, **181,** 292
Ella (Walters), 80; **Pl. 12**
Europa (Gregory), **107**
Everson Museum of Art (Syracuse, N.Y.), v–vi, ix, xi–xiv, xxv, 49, 114, 195–196, 197, 199, 265, 267, 269, 276, 279, 285, 286, 289, 290, 299, 300, 313, 315, 316–317, 320, 330, 331, 341, 345, 362
Ewer (Valentien), **17**
Exposition Internationale des Arts Décoratifs 35 Industriels Modernes (Paris), xxii, 82, 328
Exposition Universelle (Paris), xxi, 6, 9, 43, 284, 288, 295, 307, 313

False Fronted Man (Breschi), 278
Fan 5 (Hughto), **Pl. 37**
Fan 9 (Hughto), **239**
Farrell, William, 198, **208,** 286–287, **287**
Ferguson, Kenneth, 137, **189, 253,** 266, 287
Fern Vase (Shirayamadani), **Pl. 1**
Figure of a Duck (Walters), **89**
Finch, Alfred William, 294
First Kumu (Takemoto), **151**
First Sidewalk Plaque (Kaltenbach), **180**
Fish in a Dish series (Warashina), 339
Flögel, Matilde, 264
Floor Pot (Daley), **246**
Floor Pot (Soldner), **152**

Foley, Don, 276
Foley, Suzanne, 160, 197, 267
Fontana, Prospero, 133
Footed Bowl (Arneson), **145**
Footed Bowl (Poor), **140**
"Forest Firing" (Boulding), 198
Form (Duckworth), **253**
Form (Price), **184**
Form (Rhodes), **169**
Form (Takaezu), **191**
Formal Dinner (Bauer), **Pl. 27**
Fosdick, Marion Lawrence, **121,** 287–288, **288**
Fountain, The (Duchamp), 160, 271
Fountain of Atoms (Gregory), xxiii, 95, **105,** 294
Frackelton, Susan, xxi, 20, **30,** 43, 261, 288, 316
Fragments of Western Civilization (Arneson), 161, **219,** 271
Frank, Mary, 199–200, 206, **214, 215,** 288–289, **289,** 299, 362
Frank Lloyd Wright cup (Nagle), 310
Frankenthaler, Helen, 199, **210, 212,** 268, 289, 362
Frazier, Bernard, 114, **119,** 289–290
Frazier, Thelma Winter, 82, **106,** 280
French, Myrtle, 277, 303
Frey, Viola, 132, 199, 200, **221,** 266, 268, 290, 336; **Pl. 35**
Frimkess, Michael, 136, 157, 165, **168,** 290–291, **291;** **Pl. 25**
Frog Victoria (Gilhooly), 292
Fry, Laura Anne, xxi, 9, **15,** 261, 291
Fry, Roger, 319
Fujio, Koyama, 266
Fulper, William H., 45, 291–292
Fulper Pottery, **75, 76,** 291
"Funk Art" exhibition (Berkeley, Calif.), xxiv, 159
Funk John (Arneson), **178**
Fur Teacup (Oppenheim), 327
Furman, David, 301

Gallé, Émile, 23
Games series (Melchert), 165, 307, 308
Garden Slab (Shaner), **190**
Gargani, Julius, 310
Gash (Voulkos), **258**
Gauguin, Paul, xviii
Gellie, Henri, 329
Geyer, George, 267
"Ghostwares," 164, 307
Giampietro, Alex, 335
Gift (Ray), 160
Gil, David, 267, 330, 334
Gilhooly, David, 159, 161, 162, 164, **181,** 197, **222, 223, 292,** 292
Ginger Jar (Cowan), **77**
Glick, John Parker, 116, 204, **248, 254, 293,** 293, 294, 362; **Pl. 33**

Golden Gate International Exposition (San Francisco), xxiii
Gomez, Ricardo, 164
Gourd Vase (Doat), **71**
Gourd Vase (Robineau), **85**
Graham Pottery (Brooklyn), 261
Grainger and Company, 262
Gray, Cleve, 267, 268
Gregory, Waylande DeSantis, xxiii, 81, **92**, 95, 96, **105, 107,** 264, 265, 280, 293–294
Grey Sand Basin (Higby), **249**
Grotell, Maija, xv, xxiii, 97, **111,** 115–116, **126, 127, 139,** 265, 283, **294,** 294, 325, 333; **Pl. 16**
Grueby, William H., xxii, 2, 20, 21–22, **34,** 43, 44, 45, 262, 294–295
Grueby Faience Company (Boston), **33, 34, 36,** 262, 294–295
Grueby Pottery, **33, 34, 36,** 262, 295
Guggenheim Museum (New York), 205, 271, 314
Guimard, Hector, 263
Gun Shot Garbage Pail (Spinski), **252**

Haile, Thomas Samuel, xxiii, 116–117, **128,** 265, 295, 335; **Pl. 17**
Hall, Herbert J., 273, 274, 322
Hall, Michael, 199
Hamada, Shoji, xxiii, 131, 137, **143,** 300
Hand and Teapot (Pompili), **232**
Hand with Rose (Pompili), **236**
Handled Vase (Grueby Pottery), **33**
Handled Vase (Ohr), **41; Pl. 4**
Handled Vase (Valentien), **16**
Handled Vase (Volkmar), **18**
Hanging Bag with Rope Strap (Levine), **231**
"Happy's Curios: Kenneth Price" exhibition (Los Angeles), xxv, 203, 320
Harder, Charles, 97, 98, 116, 277, 295–296, **296**
Hare, Sharon, 198, 296–297
Haviland Auteuil studio, 5, **11,** 259
Head with Black Shadow (Lichtenstein), **187**
Heino, Otto, 115, **254,** 297
Heino, Vivika, 115, **254,** 297
Hepburn, Anthony, 297–298
Herrick, Joseph, 47
Herring Run Pottery (East Weymouth, Mass.), 343
Higby, Wayne, **245, 249,** 298
Hindes, Charles Austin, **250, 298,** 298
Hirshhorn Museum and Sculpture Garden (Washington, D.C.), 271, 312
Hokusai, Katsushika, 260
Holabird, Alice B., 259
Hollow Jesture, A (Arneson), **Pl. 29**
Hollyhock Vase (Tiffany), **55**
Hood, Dorothy, 199
Hooker (Frimkess), 290
Horseman, Katie, 330

Huckleberry Finn (Eckhardt), **104**
Hudson, Robert, xxiv, 159, **232, 233,** 298–299, 307, 327
Hughto, Margie, xi–xix, xxv, 196, 199, 203, **210, 239,** 279, 286, 289, 299, 315, 317, 362; **Pl. 37**
Hui, Ka-Kwong, 165, 282, 299–300, 302; **Pl. 24**
Humble, Doug, 198
Hurley, Edward T., **52**

"Illusionistic Realism as Defined in Contemporary Ceramic Sculpture" exhibit, 301
Incantation Plate (Ball), **121**
In-Pugmill Art (Rothman), 167
Installations from the Hudson River (Mason), 306
Institute for Contemporary Art (Washington, D.C.), xxiii, 295
International Ceramic Exposition (Cannes, France), xxiii, 337
"International Ceramics" exhibition (London), xxiv
"International Ceramics" exhibition (Ostend, Belgium), xxiii, 157, 297
International Ceramics Symposium, xxiii, 137
International Cotton Exposition (Atlanta), xxi
International Exhibition of Ceramic Art (New York), xxii–xxiii, 80, 82, 284, 339
International Invitational Ceramics Exhibit (Tokyo), xxiii
Inwood Potteries (New York), 310
Iron Cone 02-3 (Olitski), 317
Irvine, Sadie, 21, **78,** 300, 309, 328
Israel, Margaret, 288

Jacobsen, A. Drexler, **90,** 280
Jar (Perry), **Pl. 11**
Jar (Shaner), **251**
Jar (Turner), **249; Pl. 31**
Jar (Voulkos), **147**
Javanese Mother and Child (Bogatay), **104**
Jervis, William P., 321
Jervis Pottery (Long Island), 321
John series (Arneson), 161, 271
Johnston, Sargent, 94
Journey, The (Middlebrook), **238,** 309
Juristo, Julio, 321

Kaltenbach, Stephen, 161, 162, **180**
Kaneko, Jun, **176, 242,** 300
Kaneshige, Toyo, 131
Kansas City Art Institute, *See* William Rockhill Nelson Collection
Karnes, Karen, 137, **155, 156, 255,** 300–301, 339
Kawai, Kanjiro, 339
Kebler, Mrs. Charles, 259

Kendrick, George P., 22, **34,** 295
Kiln Car (Warashina), 339
Kissing Pot (Bailey), 163
Kooning, Willem de, 157, 314
Kopriva, Erna, 264
Kottler, Howard, 166, **187, 237,** 278, 301
Krehan, Max, 340
Kuhn, Dina, 264

Labarrière, Eugene, 67, 284
Lachaise, Gaston, 311
Laguna Beach Museum of Art, 202, 268, 301
Langenbeck, Karl, 5, 9, 336
Lap Dog, The (Nakian), **100**
Lavender Throne (De Staebler), **217**
Leach, Bernard, xxii, xxiii, 1, 80, 98, 130–131, 132, 137, **143,** 259, 265–266, 300, 304
Leach Pottery (St. Ives, England), 304
Leafhead (Frank), **215**
League of New Hampshire Arts and Crafts, 297, 325
Leaping Man (Frank), **214**
Léger, Fernand, 133
Legpot I (Melchert), **172,** 307
Leigh Potters (Alliance, Ohio), 326
Lenoble, Emile, 80
Leonard, Mrs. Harriet, 259
Letter Rack (Woodman), **Pl. 38**
Levine, Marilyn, xxiv, 201, 202, **230, 231,** 301–302, **302**
Levy, Sara B., **58**
Liberman, Alexander, 268
Lichtenstein, Roy, xxiv, 165, **186, 187,** 267, 299, 300, 302
Lidded Jar (Baggs), **59**
Lidded Jar (Price), **149**
Lidded Jar (Wood), **194**
Lidded Vessel (Timock), **241**
Ligature (Stephenson), **226**
Lipton, Seymour, 268
Little, Ken D., **227**
Littlefield, Edgar, **122**
Lobster Telephone (Dali), 327
Löffler, Bertholdt, 264
Lone Moon Buffler (Blackburn), **234**
Lonhuda Pottery (Steubenville, Ohio), 19, 261, 291
Loop (Neri), **153**
Lorelei (Van Briggle), 44, 336
Los Angeles County Art Institute, *See also* Otis Art Institute, xxiii, 129
Los Angeles County Museum of Art, xii, xxiv, xxv, **172,** 197, 203, 265, 305, 311, 320
Los Angeles Institute of Contemporary Art, xxv, 198, 333
Losanti (McLaughlin), **Pl. 2**
Louisiana Purchase International Exposition (St. Louis), xxii, 44–45, 262, 295, 308, 317, 323, 334, 336
Low Art Tile Works (Chelsea, Mass.), 294

Lukens, Glen, xv, 97, 98, **112,** 265, 297, **303,** 303, 306, 341; **Pl. 15**

MacDonald, William Purcel, **28,** 303–304
MacKenzie, Alix, **142,** 304
MacKenzie, Warren, 137, **142, 188, 244,** 304
Madame Queen (Randall), **104,** 320
Made in Tampa prints suite (Rauschenberg), 321
Madonna and Child (Cowan), **91**
Maki's Shoulder Bag (Levine), **230**
Man Disguised as Dog (Breschi), **236**
Man with Mickey Mouse Ears (Melchert), **183**
Manga (Hokusai), 260
Manship, Paul, 280, 294, 311
Mao Tse Toad (Gilhooly), **223,** 292
Marblehead Pottery (Mass.), 273, 274, 322
Marcellus Casket Company, 96
Marcks, Gerhard, 340
Margarita (Gregory), **92**
Marguerite, at Her Lessons (Gregory), 293
Marks, Roberta B., **255,** 304
Marshall, Richard, 197
Martinez, Julian, 304
Martinez, Maria, **111,** 304
Mason, John, xxiv, 134, 136, **150, 151,** 157, 166–167, **170, 172, 177,** 305–306, 324, 332; **Pl. 19**
Massier, Clement, 329
"Materials Pieces" exhibition (London), 297
Mattress I (Frankenthaler), **212**
McClain, Malcolm, 134, 136, **150,** 306
McDonald, William P., 43, 44
McIntosh, Harrison, 133, **141, 306,** 306
McLaughlin, Mary Louise, xxi, 2, 5, 6–8, 9, **11, 13,** 22–23, **36, 37,** 43, 259, 260, 262, 306–307; **Pl. 2**
McMillan, Tom, 267
Meissen, 9, 68
Melchert, James, 134–135, 136, 157, 164–165, **172, 183,** 197, 198, **207, 229,** 266, 307–308
Mercer, Henry Chapman, 45, 47–48, **64,** 263, 308–309
Merriam, Mrs. A. B., 259
Metcalf, James, 268
Metropolitan Museum of Art, The (New York), xii, xiii, xxiii, 80, 82, 264, 277, 284, 287, 290, 311, 315, 323, 325, 338, 339
Meyer, Joseph Fortune, 21, **31,** 261, 309, 315
Middle America, Post and Lintel (Patrick), **235**
Middlebrook, David, **238, 309,** 309
Milles, Carl, 265
Milliken, William M., 81, 264
Minneapolis Institute of Arts, 338
Miró, Joan, 129, 133, 319
Miscegenation (Gilhooly), 292
Mondo Reflecto (Kottler), 301
Montana Museum, 272

Moravian Tile Works (Doylestown, Pa.), 47, **64,** 308
Morino, Hiroki, 313
Morris, Robert, 305
Moser, Koloman, 264
Mother Goose series (Eckhardt), 286
Mountain and Lake (Arneson), 271
Moving—Static—Moving Figures (Nevelson), 114, **118,** 312
Müller, Karl, 2, **4**
Murray, William Staite, 80, 116, 295
Musée des Arts Décoratifs (Paris), 68, 323
Museum of Contemporary Art (Chicago), xxiv, xxv, 270, 292
Museum of Contemporary Crafts (New York), xxiv, 165, 267, 271, 274, 298, 322
Museum of Fine Arts (Houston, Tex.), 329
Museum of Modern Art, The (New York), xxiii, xxiv, 79, 80, 97, 166, 205, 311, 338
Mushroom Pot (Wildenhain), **194**

Nadelman, Elie, 94, **102, 103,** 264, 309–310
Nagle, Ron, 136, 164, **185,** 201, **310,** 310–311; **Pls. 20, 39**
Nakian, Reuben, 94, **100, 139,** 288, 311
Nash, Harold, 277
Nasisse, Andy, 205, 268, 283
National Council for Education in the Ceramic Arts, xxiv, 280, 287, 303
National Decorative Arts and Ceramics Exhibition (Wichita, Kans.), 324
National Endowment for the Arts, 300, 306, 308, 327, 331, 334
National League of Mineral Painters, xxi, 20, 46, 288, 323
National Museum of Modern Art (Japan), xxiv
National Robineau Memorial Ceramic Exhibition, 264
Natzler, Gertrud, 97, 115, **123, 140, 311,** 311–312, 341
Natzler, Otto, 97, 115, **123, 140, 311,** 311–312, 341
Neri, Manuel, 132, 136, **153,** 164, 267, 312
Neuberger Museum (Purchase, N.Y.), 289
Nevelson, Louise, 114, **118,** 268, 312
"New Ceramic Forms" exhibition (New York), xxiii, 165
New Jersey School of Clayworking and Ceramics, xxii
New Orleans Art Pottery, 261, 309
New Orleans Pottery Company, 316
"New Works in Clay by Contemporary Painters and Sculptors" (Syracuse, N.Y.), xiv, xxv, 196, 199, 203, 267, 276, 279, 285, 289, 299, 317, 330, 331, 362
"New Works in Clay II" exhibition (Syracuse, N.Y.), xxv, 362
New York School of Clayworking and Ceramics (Alfred), xxii, 46, 276, 280

Newcomb Pottery (New Orleans), xxii, 20, **31,** 43, 261, 300, 309, 316, 328, 329
Newton, Clara Chapman, 7, 8, 9, **15,** 20, 259, 260, 261, **312,** 312–313
Ng, Win, **169,** 313
Nicholas, Donna L., 196, **225,** 267, 313
Nichols, Maria Longworth, xxi, 5, 7, 8–9, **12, 14,** 43, 260, 312, 313–314, 317
Niger I (Turner), **244,** 335
Night with Young Moon (Frazier), **106**
Nine O'Clock in the Evening (Ohr), **39,** 316
"Nine West Coast Clay Sculptors" exhibition (Syracuse, N.Y.), xxv, 299, 362
1955 Chevy (Frey), **221**
Nite Pot (Bailey), 163
No Return (Arneson), 261, 271
Noguchi, Isamu, 94, **101,** 314
Noland, Kenneth, 203, 299, 314–315, **315,** 362; **Pl. 40**
Nude (Poor), **110**
Nymph (Nakian), **139**

Oakland Museum, The, 270–271, 282, 324
"Object as Poet, The," exhibition (Washington, D.C.), xxv, 202, 268
"Object Transformed" exhibition (New York), 166
"Objects are . . . ?" exhibition (New York), xxiv
"Objects USA" exhibition (Washington, D.C.), xxiv
"Objets Surréalistes" exposition (Paris), 160
Ocean Liner Sinking into a Sofa (Shaw), 165
O'Hara, Dorothea Warren, **109,** 315
Ohr, George E., xv, 22, 23–24, **38, 39, 40, 41, 42,** 261, 262, 309, 315–316, **316; Pls. 3, 4**
Old Bag Next Door Is Nuts, The (Kottler), **237,** 301
Olitski, Jules, 199, **211,** 316–317
Olive Jar (Frackelton), **30,** 288
Olmsted, Anna, 95–96, 196, 197, 264, 265
One Woman Doing Another's Hair (Nadelman), **102**
Onondaga Pottery Company, ix, 280
Oppenheim, Meret, 160, 327
Orpheus (Haile), 116; **Pl. 17**
Orton, Edward, xxii, 263, 276
Otis Art Institute. *See also* Los Angeles County Art Institute, xxiii, 129, 134–136, 161, 163, 266, 272, 276, 290, 305, 306, 319, 333, 337
"Overglaze Imagery" exhibition (Fullerton, Calif.), xxv
Owens, J. B., 19, 261
Ozenfant, Amédée, 97

Paddled Bottle (Sanders), **192**
Painted Mask (Eckhardt), 286
Panama-Pacific International Exposition (San Francisco), xxii, 69, 292, 315, 322, 323, 328

Pan-American Exposition (Buffalo, N.Y.), xxii, 295, 307
Paris, Harold, 136, 159, 164, 267
Paris Exposition, 97, 115, 296, 303, 311, 323, 329
Parmelee, C. W., xxii, 263
Patrick, Vernon, **235**
Pennsylvania Museum, xxi, 288
Perry, Mary Chase, 44, 45, 46–47, 48, **60–61, 62, 63,** 93, 262, 263, 264, 288 **317,** 317; **Pl. 11**
Peruvian Serpent Bowl (Robineau), **73**
Peterson, Susan, 268, 304–305
Pewabic Pottery (Detroit), xxii, 44, 46, 47, **60, 62, 63,** 263, 264, 317
Philadelphia Museum of Art, xii, 43, 271, 292, 311, 326, 329, 342
Picasso, Pablo, 129, 133, 135, 166, 266, 309, 329
Pilcher, Don, **193, 256**
Pilgrim Flask (Newton), **15**
Pilgrim Jar (McLaughlin), **11**
Pink Pile-Up (Dzubas), **213**
Pitcher (Ohr), **39**
Pitcher (Raynor), **123**
pitchers (parianware), **56, 57**
Pitman, Benn, 5, 261
Plaque (Soldner), **243**
Plaque (Fry), **15**
Plate (Dedham Pottery), **32**
Plate (Doat), **71**
Plate (Glick), **248**
Plate (Haile), **128**
Plate (Martinez), **111**
Plate (Prieto), **124**
Plate (Rhead), **57**
Plate (Voulkos), **242; Pl. 18**
Plate A (Voulkos), **256**
Platter (Bengston), **150**
Platter (Frimkess), **168**
Platter (Kaneko), **242**
Platter (Soldner), **177**
Platter (Voulkos), **173**
Playmate Pot (Kottler), **187,** 301
Plum Tree Pottery, 293
Plympton and Robertson Pottery (East Boston, Mass.), 323
Pompili, Lucian Octavius, 202, **232, 236,** 318
Pond Farm workshop (Guerneville, Calif.), 306, 340
Pool with Splash (Arneson), **221,** 271
Poons, Larry, 199, **318,** 318
Poor, Henry Varnum, xiii, xxii, 80, **87, 110,** 129, **140,** 318–319
Poppy Vase (Robineau), **Pl. 10**
Porcelain and Pottery Exhibition (Philadelphia), xxi
Pot (DeVore), **241; Pl. 34**
Pot (Rothman), **Pl. 22**
Pot (Voulkos), **148**

Powolny, Michael, 82, 264, 269, 320, 325, 329, 339
Prairie Combat (Frazier), 114, 290
Pre-a (Melchert), 307
Precious a (Melchert), **229,** 307
Price, Kenneth, xxv, 134, 136, **149,** 159, 164, **184,** 201, 203–204, 206, **228, 240,** 267, 297, 310, **319,** 319–320; **Pl. 36**
Prieto, Antonio, **124,** 132, **140,** 270, 271
Punch Bowl (Schreckengost), **99**

Queen, The (Noguchi), **101**

Rabbit plate (Dedham Pottery), 262
Radio City Pot (Kottler) 301
Randall, Ruth, 82, **104,** 299, 320–321
Rattlesnake Teapot (Burns), **Pl. 32**
Rauschenberg, Robert, 137, **230,** 321
Rawson, Philip, 206, 268
Ray, Man, 160, 341
Raynor, Louis B., **123,** 321
Read, Helen Appleton, 82, 264
Read, Herbert, 1, 206, 259, 268
Red Form (Bacerra), **187**
Reitz, Donald L., **247, 321,** 321
Rhead, Frederick, xxii, 48, **57,** 68, **71,** 261, 263, 264, 284, 321–322
Rhead Pottery (Santa Barbara, Calif.), 322
Rhodes, Daniel, 137, **169,** 322
Rice Bottle (Voulkos), **146**
Riegger, Harold Eaton, **123,** 322
Robertson, Hugh, 6, 10, **16,** 21, **32,** 262, 323
Robineau, Adelaide Alsop, ix, xii, xv, xxii, xxiii, 2, 24, 43, 45, 46, 47, 48–49, **65, 66,** 67, 68, **72, 73,** 80, 82, **84, 85,** 95, 196, 262, 263, 264, 265, 284, 288, 299, 317, 322, 323–324, 334; **Pls. 7, 9, 10**
Robineau, Samuel, 48, 49, 68, 264, 284, 323
Robineau Memorial Ceramic Exhibition (Syracuse Museum of Fine Arts), xxiii
Rookwood Pottery (Cincinnati), xxi, xxii, 5, 6, 7, 8–9, 19, 20, **25,** 43–44, 260, 261, 262, 282, 291, 303, 304, 307, 312–313, 329, 335, 336, 339
Rookwood School for Pottery Decoration, xxi, 313
Rooster (O'Hara), 315
Rosanjin, xxiii, 131–132, 266, 314
Roseville Pottery (Zanesville, Ohio), 321
Rothman, Jerry, 134, 136, **148, 152,** 157, 167, **224,** 300, 324; **Pl. 22**
Russian Peasants (Blazys), **91**
Ryan, Mazie Theresa, 21, **58,** 324

Saarinen, Eliel, 265, 294
Saarinen, Loja, 265
St. Louis Art Museum, 284, 291
Salem China (Salem, Ohio), 326
"Salt-Glaze Ceramics" exhibition (New York), xxiv

Sanders, Herbert, **192**, 265, 324–325
San Francisco Art Institute, xxiv, 164, 278, 307, 308, 310, 333
San Francisco Museum of [Modern] Art, xii, xxiv, xxv, 158, 197, 267, 270, 327, 338
Sarcophagus on Stand (Bauer), **182**
Sax, Sara, 43, **50**
Saxe, Adrian, **249**, 325
Scarab Vase (Robineau), 68–69, **73**, 322
Scenic Vellum (Hurley), 52
Scheier, Edwin, 115, **125**, 325
Scheier, Mary, 115, **125**, 325
Schlanger, Jeff, xxiv, 196, 294, 325
School of Ceramic Art (People's University, St. Louis), xxii, 67
School of Industrial Art (Philadephia), xxi, 337
Schreckengost, Viktor, 82, **99**, **107**, 113–114, **118**, 265, 325–326; **Pl. 14**
Sea, The (Robineau), **85**
Seated Nude (Nadelman), **102**
Sebring Pottery (Ohio), 339
Selz, Peter, xxiv, 159, 267
Sermon on the Mount, The (Autio), 272
Sèvres, 9, 68, 284
Shahn, Ben, 268, 282
Shallow Bowl (Duckworth), **252**
Shallow Painted Bowl (Takaezu), **Pl. 21**
Shaner, David, **190**, **251**, 266, 326–327, **327**
"Sharp-Focus Realism" exhibition (New York), xxiv, 201
Shaw, Richard, xxiv, 161, 165, **185**, 201, 202–203, **232**, **239**, 267, 297, 298, 299, **327**, 327–328
Sheerer, Mary G., 20, 21, **31**, 328
Sheriff, The (Vandenberge), **222**, 336
Shirayamadani, Kataro, xxi, 9, **16**, **28**, 43, **51**, 317, 328–329; **Pl. 1**
Shrine Assemblages (Price), 320
Sicard, Jacques, **57**, 329; **Pl. 5**
Simpson, Anna Frances, 21, **77**, 329
Singer, Susi, 80, 82, **120**, 264, 329
Sinking Cup sequence (Arneson), 316
Sky Pots (Rothman), 136, 324
Slab Pots (Weinrib), **155**
Slate Cup (Price), **228**
Slivka, Rose, 134, 157–158, 202, 267, 268
Smith, David, 113, **175**, 199, 268, 329–330
Smorgy Bob, the Cook (Arneson), **218**
Snake Vase (Robineau), **Pl. 9**
Solaryama (Nagle), **Pl. 39**
Soldate, Joe, 198, **209**
Soldner, Paul, xiii, 134, 136, **152**, 157, **174**, **177**, **243**, 300, 324, **330**, 330–331
Soup Tureen (Reitz), **247**
"Soup Tureens" exhibition (Camden, N.J.), xxv, 324
Spinners series (Hughto), 203
Spinski, Victor, 165, **252**, 331
Spring (Schreckengost), **107**, 114
Stack (Farrell), **208**

Staffel, Rudolph (Rudi), xiii, **247**, **250**, 331; **Pl. 28**
Stallion, The (Walters), 80, **88**, 338
Standing Man and Woman (De Staebler), **216**
Stangl, J. Martin, 292
Steiner, Michael, 199, **210**, 331
Stephenson, John, 116, **143**, **226**, **332**, 332
Stephenson, Suzanne, 116, **257**, **332**, 332
Storage Jar (Ferguson), **189**
Storage Jar (Turner), **188**
Strawberries (Costanzo), **227**
Strieby, William H., 44, 336
Student Singers (Aitken), **Pl. 13**
Sweet, Roger, 198, **208**, **209**, 267, 332–333
Swimming Pool (Arneson), 161
Symbolic Screen (Daley), 281
Syracuse China Corporation, ix, 276
Syracuse Museum of Fine Arts, xxiii, 95–96, 265, 269, 345
Syracuse University, xxii, xxv, 199, 203, 299, 315, 317, 318, 320, 323, 331, 362

T Pot (Arneson), **178**
Takaezu, Toshiko, 116, **191**, 196, 274, 294, 333; **Pl. 21**
Takemoto, Henry, 134, 136, **148**, **151**, 157, 333
Taming the Unicorn (Wieselthier), **119**
Tampa City Piece I (Rauschenberg), **230**
Tantric Frog Buddha (Gilhooly), 292
Taylor, William Watts, 9, **26**, 260, 261, 313, 339
"Tea, Coffee and Other Cups" exhibition (New York), xxiv
Teapot (Glick), **254**
Teapot (Robertson), **16**
Teapot (Wood), **Pl. 30**
Teapot and Coffee Pot (Ohr), **42**
Tea Set (Wildenhain), **124**
Tegata (Kaneko), **176**
Thiebaud, Wayne, 267, 274
Three O'Clock in the Morning (Ohr), **39**, 316
Tiffany, Louis Comfort, 44, 45, **54**, **55**, 333–334
Tile (Mercer), **64**
Tile Unit (Price), 204; **Pl. 36**
Timock, George P., **241**, 334
Toasties (Arneson), 161, **179**, 271
Tokyo Museum, 315
Toledo Museum of Art, The, 286
Town Unit 2 (Price), **240**
Trey, Marianne de, 265, 295
Tried by Fire (Frackelton), 20
Trinity of Dragons, A (Shirayamadani), **28**
Tureen (MacKenzie), **244**
Tureen (Woodman), **250**
Turin Exposition (Italy), xxii, 68, 323
Turner, Robert, xxiv, 137, **154**, **188**, 196, 204, **244**, **249**, 334–335; **Pl. 31**
"Twenty American Studio Potters" exhibition (London), xxiv

"25 Years of American Art in Clay" exhibition (Claremont, Calif.), xxiv
Two Acrobats (Nadelman), **103**
Typewriter (Arneson), 161, 271

"Unfired Clay" exhibition (Carbondale, Ill.), xxiv, 197
University City Pottery, 284, 321
Untamed (Frazier), 114, **119**, 290
Untitled Ceramic #21 (Hudson), **233**
Urn (Woodman), **191**

Valentien, Albert R., **15, 16, 17, 27, 74,** 260, 303, 335, 336
Valentien, Anna, 44, **52,** 80, 335–336
Van Briggle, Anne Gregory, 45, 336
Van Briggle, Artus, xxii, 2, **29,** 43, 44–45, **53,** 80, 262, 282, 336; **Pl. 6**
Van Briggle Pottery, 44, 336
Vandenberge, Peter, 161, 164, **222,** 336–337
Vase (Autio), **144, 145**
Vase (Baggs), **59**
Vase (Binns), **74**
Vase (Cherry), **70**
Vase (Daly), **29**
Vase (Fulper Pottery), **76**
Vase (Gregory), **92**
Vase (Grotell), **126, 127**
Vase (Grueby Pottery), **33, 34, 36**
Vase (Haile), **128**
Vase (Irvine), **78**
Vase (Levy), **58**
Vase (Littlefield), **122**
Vase (MacKenzie), **188**
Vase (Mason), **150; Pl. 19**
Vase (McClain), **150**
Vase (McIntosh), **141**
Vase (McLaughlin), **36, 37**
Vase (Nichols), **12**
Vase (Ohr), **39; Pl. 3**
Vase (Perry), **63**
Vase (Prieto), **140**
Vase (Riegger), **123**
Vase (Robertson), **32**
Vase (Robineau), **66, 84**
Vase (Ryan), **58**
Vase (Sax), **50**
Vase (Sheerer and Meyer), **31**
Vase (Shirayamadani), **16, 51**
Vase (Sicard), **57; Pl. 5**
Vase (Simpson), **77**
Vase (Staffel), **Pl. 28**
Vase (Tiffany), **54**
Vase (Valentien), **15, 27, 74**
Vase (Van Briggle), **29, 53**
Vase (Voulkos), **146, 177**
Vase (Wilcox), **Pl. 8**
Vase (Woodman), **245**
Vase with Nudes (Soldner), **243**
Vessel (Hindes), **250**
Vessel (Karnes), **255**

Vessel (Marks), **255**
Vessel (Staffel), **247**
Vessels (Staffel), **250**
Viking Vase (Robineau), 49; **Pl. 7**
Volkmar, Charles, 6, 10, **18,** 21, 261, 337
Volkmar, Leon, 337
Voulkos, Peter, xiii, xv, xxiii, xxiv, xxv, 129, 133, 134–136, **143, 146, 147, 148,** 157, **171, 173, 177,** 196, **242, 256, 258,** 266, 271, 276, 282, 290, 297, 300, 305, 306, 307, 310, 319, 330, 333, **337,** 337–338, 342; **Pl. 18**

Walking Woman (Archipenko), **99,** 270
Walters, Carl, 80–81, **88–89,** 96, **107,** 264 338; **Pl. 12**
Warashina, Patti, 166, **190, 235, 278,** 339
Wareham, John, 43, **50,** 339
Weed Pot (Rothman), **152**
Weinrib, David, 137, **155,** 300, 334, 339
Weller, Samuel A., 19, 45, 329
"Western Hemisphere" exhibit (Syracuse, N.Y.), 325
Wheatley, Thomas J., 8, 22, 260, 335
Whiplash (Shaw), 203, 328
Whistling in the Dark (Arneson), **220**
Whitney Museum of American Art (New York), xii, xxiii, xxv, 96, 195, 197, 205, 264, 271, 289, 312, 338
Whitney Studio Club, 80, 311, 338
Wichita Ceramics National Exhibition, 271
Wiener Werkstätte (Vienna), 82, 264, 320, 329, 339
Wieselthier, Valerie (Vally), 80, 82–83, **92, 119,** 264, 339–340, **340**
Wilcox, Harriet Elizabeth, 43; **Pl. 8**
Wildenhain, Frans, **194,** 340
Wildenhain, Marguerite, xvii, xxiii, 97, 114, **124,** 137, 266, 299, 300, 306, 340–341
William Rockhill Nelson Collection (Kansas City, Mo.), 261, 287, 315, 334
Woman with Outstretched Arms (Frank), **214**
Wonders of the World Museum, 275
Wood, Beatrice, 115, **194, 341,** 341–342; **Pl. 30**
Woodman, Elizabeth (Betty), **191,** 204, **245,** 250, 342, **342; Pl. 38**
Woodman, George, 191
"Works in Clay by Six Artists" exhibition (San Francisco), xxiii, 164
World's Columbian Exposition (Chicago), xxi–xxii, 20, 21, 260, 288, 294, 313
Wright, Frank Lloyd, 21, 79, 264
Wyman, William, **173,** 343

Yanagi, Soetsu, xxiii, 131, 137, **143,** 300
Yav I (Olitski), 317
Yav II (Olitski), 317
Yellow Bowl (Lukens), **112**
Yellow Rock Falls (Higby), **245**

Zanesville (Ohio) Art Center museum, 329

GARTH CLARK was born in 1947 in Pretoria, South Africa, and received an M.A. in Modern Ceramic History from the Royal College of Art in London in 1976. Since then he has been involved in research and lecture tours in Africa, Asia, and America. He has taught at the University of California, Los Angeles and Santa Cruz, Oakland College of Arts and Crafts, and has been a guest lecturer at over fifty universities and art schools in the United States.

Mr. Clark's books include *Potters of Southern Africa* (1974), written with his wife Lynne, *Michael Cardew: A Portrait* (English edition 1976), and *Ceramic Art: Comment and Review 1882–1977* (1978). *Ceramic Review, Crafts, Studio Potter, Ceramics Monthly,* and *Craft Horizons* are some of the periodicals in which his articles have appeared. He is currently Director of the Institute for Ceramic History, Claremont, California.

MARGIE HUGHTO was born in 1944 in Endicott, New York, and received a B.S. in Art Education from the State University of New York at Buffalo and an M.F.A. in Ceramics from Cranbrook Academy of Art, Bloomfield Hills, Michigan. After graduation from Cranbrook in 1971, she moved to Syracuse, New York, and began teaching ceramics at Syracuse University where she is currently an assistant professor of ceramics. At Syracuse University Hughto is Resident Ceramist for the Syracuse Clay Institute and has done numerous workshops and collaborated with such artists as Anthony Caro, Mary Frank, Helen Frankenthaler, John Glick, and Kenneth Noland. She is a nationally recognized ceramic artist with an extensive exhibition record that includes many one-person shows as well as such major exhibitions as the "25th Ceramic National" (1968) and "New Works in Clay II" (1978). Since 1971 she has worked at the Everson Museum of Art as teacher, consultant, lecturer, and currently as Curator of Ceramics. She has curated such important exhibitions as "New Works in Clay by Contemporary Painters and Sculptors" and "Nine West Coast Clay Sculptors."